Afrofuturisms

Ohio University Research in International Studies

This series of publications on Africa, Latin America, Southeast Asia, and Global and Comparative Studies is designed to present significant research, translation, and opinion to area specialists and to a wide community of persons interested in world affairs. The series is distributed worldwide. For more information, consult the Ohio University Press website, ohioswallow.com.

Books in the Ohio University Research in International Studies series are published by Ohio University Press in association with the Center for International Studies. The views expressed in individual volumes are those of the authors and should not be considered to represent the policies or beliefs of the Center for International Studies, Ohio University Press, or Ohio University.

Afrofuturisms

ECOLOGY, HUMANITY, AND FRANCOPHONE CULTURAL EXPRESSIONS

Isaac Vincent Joslin

Ohio University Research in International Studies

Africa Series No. 96
Ohio University Press
Athens

Ohio University Press, Athens, Ohio 45701
ohioswallow.com
© 2023 by Ohio University Press
All rights reserved

To obtain permission to quote, reprint, or otherwise reproduce or distribute
material from Ohio University Press publications, please contact our rights
and permissions department at (740) 593-1154 or (740) 593-4536 (fax).

Printed in the United States of America
Ohio University Press books are printed on acid-free paper ∞ ™

Hardcover ISBN 978-0-89680-329-9
Paperback ISBN 978-0-89680-330-5

Library of Congress Cataloging-in-Publication Data available upon request.

Contents

Acknowledgments
vii

Introduction
Africanfuturism, Development, and Humanities
1

1. Afrofuturist Ecolinguistics
Redefining the "Science" of Science Fiction
25

2. Birthing the Future
Métissage and Cultural Hybridity in Francophone African Women's Writing
49

3. Child Soldiers
Reinscribing the Human in a Culture of Perpetual War
78

4. Alienation, Estrangement, and Dreams of Departure
*Emigration and the Politics of Global Inequality in
(and out of) Francophone Africa*
109

5. "We Don't Need No Education"
Alternative Pedagogies and Epistemologies in Bassek Ba Kobhio's Sango Malo
(1990) *and* Le Silence de la forêt (2003)
163

6. Paradis Artificiels
The Lottery of Global Economies in Djibril Diop Mambety's Le Franc,
Imunga Ivanga's Dôlè, *and Fadika Kramo-Lanciné's* Wariko
190

v

7. Arguing against the Shame of the State
Sony Labou Tansi's Ecocritical Womanism and Gaiacene Planetarity
217

Conclusion
Toward an Afrofuturist Ecohumanist Philosophy of Experience
247

Notes
263

References
315

Index
327

Acknowledgments

I would like to acknowledge the institutional support of Arizona State University and the Institute for Humanities Research, as well as the support of numerous colleagues who have been involved, directly or indirectly, in the process of writing this book over the years. I would like to thank the students in my classes where I tested some of the ideas that would later inform the content of this book. I would also like to acknowledge the African Literature Association and the College Language Association where iterations of this project were presented and elaborated further through discussions and conversations with friends and colleagues, of whom there are too many to name. I would like to thank Thomas Knight for his assistance in translating sections of chapters 1, 2, and 7 from the original French language in which I wrote them. And I would like to thank Kimberly Koerth for her patient and detailed help in copyediting the initial drafts of each chapter of the manuscript. I also wish to acknowledge the African writers and artists whose courageous efforts to express the complexities of existence through creative activity have provided the inspiration and foundation for this book project. Lastly, I want to thank my family for sticking with me through the ups and downs of this process; I also thank those friends who continued

to believe in and support me through the creation of this book. And a special thanks to my older brother Aaron for introducing me to words, guiding me through the ways of manipulating them, and sharing with me the joy of learning and understanding.

Introduction

Africanfuturism, Development, and Humanities

It's time for us as a people to start making some changes. Let's change the way we eat. Let's change the way we live. And let's change the way we treat each other. You see, the old way wasn't working, so it's on us to do what we got to do to survive.

—2Pac, "Changes"

In these times of crisis of meaning for a technological society, offering a different perspective of social life, coming from other mythological universes and borrowing a common dream of life, of balance, of harmony, of meaning.[1]

—Felwine Sarr, *Afrotopia*

Today we are still waiting for the propositions of an Africa that need either join the world, or propose an alternative to the world.[2]

—Jean-Pierre Bekolo, *Africa for the Future*

You cannot carry out fundamental change without a certain amount of madness. In this case, it comes from nonconformity, the courage to turn your back on the old formulas, the courage to invent the future.[3]

—Thomas Sankara

The world begins with imagination. With a possible exception of prehistoric megalithic ruins dotting the earth's crust, at no time in recorded history has a planetary civilization faced a crisis of such magnitude as the emergent reality of a necessary cultural, ecological, pathogenic, economic, political, moral, and psychological reorientation precipitated by irresponsible practices of globalization. The twenty-first century has spawned a fundamentally technocratic global society of generally uprooted multinational and polycultural individuals residing primarily in highly concentrated urban areas spread across the planet's surface: the majority of these individuals are almost entirely dependent upon the continued functioning of basic human services controlled and operated predominantly by a corporate and politically influential elite social class. These conditions belie systemic inequalities that undergird the functioning of societal systems, from health and welfare and educational institutions to the economic and political models through which such inequalities are often imposed and sustained. Populations and regions that are the most vulnerable to the destructive human and environmental impacts of such processes are those that have been historically marginalized and exploited by the centuries-long developments of globalized neoliberal democratic capitalism spawned by the age of European exploration in the fifteenth century.[4] Consequently, there is an emergent bifurcated discourse that pretends to maintain a definitively decaying social order and its supporting global institutions, while also endeavoring to anticipate and predefine a future through speculation, projection, extrapolation, and imagination.

The death and rebirth of civilizations is a phenomenon as common as the cycling of the seasons, only that in some instances the death rattles and birth pangs are perceived and experienced in more acute and extreme ways. Consider the rise and fall of the Ghana Empire between the Niger and Senegal Rivers, which flourished for over five hundred years until the early 1200s CE, only to be reincarnated by the Islamic Mali Empire for the next half a millennium and later expanded into the Songhai Empire,

Introduction

which eventually gave way to French colonial expansion and the incorporation of the region's people and resources into the global capitalist network of exchange that violently spread throughout the world in the twentieth century. This and other European expansionist projects are intrinsically linked to a colonialist worldview with a supporting vocabulary steeped in constructs of religious, racial, and civilizational superiority and correlative inferiorities. In order for future-oriented concerns on a global scale to engender positive and productive changes, it is essential to interrogate and deconstruct the entrenched and engrained biases in the concepts that define the perceptions and experiences of humans in the context of global civilization. In response to this, the work that follows constitutes a multidisciplinary study of Francophone African cultural expressions to identify and congeal alternative societal orderings of educational, political, economic, cultural, and communal practices that coalesce around the dual foci of long-term human and planetary sustainability.

The imperative moving forward must involve an interrogation of the value systems and practices that led to this tipping point in order to appropriately pivot toward a new direction, one capable of disengaging from destructive paradigms while creating new opportunities in which life can thrive on the planet. Such visionary projects have continuously been realized over countless centuries by artists, painters, poets, and philosophers who experience and represent the moments of their own civilizational transformations. In the Islamic world we have the travel narratives of Ibn Battuta that provide us with a glimpse of an expansive caliphate that is about to buckle beneath the weight of the growing civilizations on its borders, namely Asia and Europe of the Middle Ages. The authors of the European Enlightenment in many ways signal a transitional moment of overture into the global capitalist arena marked by nationalism, conquest, and exploitation of human and planetary resources on a then-unimaginable scale. In the current era, writers of speculative fiction and Afrofuturist thinkers point out societal disparities through imaginative extrapolation. In an

essay originally published in 1989, Octavia Butler writes on science fiction's capacity for "thinking about the present, the future, and the past . . . to consider alternative ways of thinking and doing [and] its examination of the possible effects of science and technology, or social organization and political direction" (1996, 134–35).

Authors of what may be characterized as global Black culture herald the ever-elusive escape from the enduring legacies of racism that wrought current global socioeconomic and cultural order. In reading Laurence Dunbar, W. E. B. DuBois, Langston Hughes, Aimé Césaire, Frantz Fanon, Malcolm X, Octavia Butler, Chinua Achebe, Ngugi wa Thiong'o, Sony Labou Tansi, Spike Lee, or Djibril Diop Mambety, there emerges a common imaginary thread that cohabits the conflicted and contradictory spaces of loss and grief, coupled with creativity and hope, and in this temporal momentariness of *le pleurer-rire* (or the "laughing-cry" to borrow from Henri Lopes) that new worlds and worldviews are ushered into existence. André Carrington's work *Speculative Blackness* outlines the intrinsic Whiteness of science fiction, noting how "the production of literature and culture fits within the structure of societies in which it takes place" (2016, 1). For this reason, building on the work of Achille Mbembe, Felwine Sarr, and other contemporary African philosophers, this book proposes that a sustainable planetary future must necessarily be one which dispenses with the limitations that have been unequally imposed upon different humanities by the mechanisms of an inhuman global capitalist democracy which exists only through its continuous relation to that "other" always lurking in the shadows of exclusion. Reconstituting the Black Atlantic world through its creative cultural signifiers can trace the vectors of a new civilization built upon differing scientific codes, ideological structures and belief systems, cultural practices, educational processes, linguistic and ecological diversification, and ethical human interrelations in order to transcend the aporias of our contemporary world order, which appears to be on the brink of collapse. And while Carrington's *Speculative Blackness* expertly

Introduction

interrogates racialized and gendered biases and constructions of the genre, it remains steeped in Western (and specifically American) modes of cultural production and identification. In response to this apparent lack of diversity with regard to global Blackness in speculative fiction, I draw from the theoretical and artistic imaginings of African writers and thinkers such as Jean-Pierre Bekolo whose work *Africa for the Future, sortir un nouveau monde du cinema* (2009) depicts the potency of African narratives, expressed cinematically as a means of realizing—*réaliser* is the French verb for directing a film—a more inclusive and innovative future for Africa and Africans on a global scale.

Beginning with a reformulation of the concept of *development* through its disassociation with purely quantitative measures of economic abstractionism, humanistic inquiry into the creative visions of African artists and thinkers will provide alternative visions of how an inclusive, sustainable global society might appear. Numerous prominent Africanist scholars have long advocated and argued for new frameworks through which development in Africa could be conceptualized differently by appealing to indigenous forms of knowledge, societal organization, and cultural values. In *A Prescience of African Cultural Studies,* Handel Kashope Wright argues that "if we reconceptualize development as more than a process of economic growth, then we can begin to see how orature contributes to development by creating the space to put forward ideas about how, why, and in what direction social change should take place" (2004, 133). For Wright, the notion of development for human society needs to be viewed through the lens of humanities, in the African sense of a communal practice of sharing ideas, such as the griotic oral traditions of ancient Mali. He claims that the study of literature, including oral literatures, as a form of cultural expression is tantamount to creating a society that is capable of self-determination through shared knowledge and communal interaction. Wright continues by invoking Chinua Achebe's essay "What Has Literature Got to Do with It?" in order to make an argument for the importance of literature for African

studies, with a focus on elaborating on socioculturally sensitive development discourses and practices in Africa. He writes, "So-called pragmatic changes fail to recognize not only that people need a well-rounded education but perhaps more significantly that the liberal arts themselves in general, and literature in particular, can contribute significantly to addressing the issues faced in considering the direction, pace, and requirements of development and social change" (133). Felwine Sarr further describes "Francophone Literature as an Ecology of Knowledge,"[5] noting the ways in which the multiple forms of knowing, including those of "oral reason" represented in African literatures, constitute a counter-archive to the (neo)colonial library, proposing alternative epistemological avenues for understanding Africa and the world. Reconceptualizing the thought-worlds in which humans operate is a key component of reconfiguring humanity's relation to the planet-world that supports and sustains it.

In the seminal work *How Europe Underdeveloped Africa*, Walter Rodney describes the importance of "development" for the individual and the society in which they are embedded, pointing out the predominant, limited understanding of development "in an exclusive economic sense—the justification being that the type of economy is itself an index of other social features" (4). Accordingly, the reduction of development to a purely economic abstraction allows for the very conditions of underdevelopment to be spawned, disseminated, and maintained. Furthermore, as Felwine Sarr argues in *Afrotopia*, this narrowly defined conception of what is developed and underdeveloped constitutes an epistemic invasion: "Development is one of the West's entrepreneurial expressions, an extension of its episteme in the world" (2019, 4).[6] Sarr goes on to further elaborate on the particular language of this Western enterprise, which includes *development, economic emergence, growth,* and the *struggles against poverty* among its key concepts (xiii),[7] indicating that such views are in fact antithetical to humanity as such, adhering to an inverted perspective of the human via "the mandate of quantity over quality, of having over being" (xi).[8] In

Introduction

response to this complex set of sociocultural conditions that ultimately contribute to dehumanization in favor of the hegemony of economic primacy emerges what Sarr terms "quantophrenic bias: the obsession to count everything, to evaluate, to quantify, and to place everything into equations" (1).[9] Numerous theoretical works exist on development in Africa, from textbooks to critical analyses,[10] yet by and large what these works typically fail to consider are the underlying cultural-linguistic biases of development discourses steeped primarily in neoliberal expansionist and democratic capitalist economic ideological terms—the hallmarks of colonialist practices.[11] Consequently, through critical approaches and humanistic literary analyses of African fictions, *Afrofuturisms* aims to extract alternative notions of development from the quagmire of neocolonialist global economics and then relocate it within the domain of the human and planetary relationality.

At a moment when technology and the environment appear to be at odds, when humanity and the biosphere that it inhabits are struggling to establish a suitable balance for sustainable existence, it becomes imperative to imagine new *épistemès*, in the Foucauldian sense, to accommodate—materially, socioculturally, psychologically, as well as spiritually—the ever-evolving realities of any given epoch. Any change in collective human consciousness, thought, and imagination is first and foremost a question that resides in the nature of language. The quest for a fundamental alteration in the conceptualization of humanity's continuous relationship with its environment, both the biosphere and the technosphere, must originate within the realms of signification and representation. The concept of ecolinguistics delineates the processes by which language, serving as the elemental cognitive filter of human experience, determines the perception of the environment.[12] If language is limited to purely abstract economic indicators as reflective of the quality of life of a given human culture, then the reality of human experience will be limited to those very basic substances. The concept of "ecoliteracy"[13] can therefore be defined as the capacity to read and decipher particular nuances

and particularities of the non-self, the "other," one's "environment," which is simultaneously our singular planet, Earth, and the civilizational modifications that have inhabited it.

In this nexus of relation between human and nonhuman, this book proposes a rethinking of the signifying term "development" through an alternative conceptual framework that foregrounds the interconnected circularity of time, space, and consciousness. In this regard, Achille Mbembe proposes the following: "The Afrofuturist current declares that the category of humanism is now obsolete. If the aim is to adequately name the contemporary condition, its spokespersons suggest, it will be necessary to do so based on all the assemblages of object-humans and of humans-objects of which, since the advent of modern times, the Negro is the prototype or prefiguration" (2019, 164).

While many of the works analyzed and discussed in this project may not be considered "Afrofuturist" in the conventional sense of science-fictional norms steeped in Western science, I contend nevertheless that speculative fiction, science fiction, and Afrofuturist themes, rhetorics, and motifs are prevalent in African cultural expressions, namely in the expounded vision of the human and nonhuman entities that animate and inhabit the material and ideological planes of existence. While some African writers do operate in the speculative and futurist modalities of Afro–science fiction,[14] I contend that intrinsic ecolinguistic biases concerning the nature of "science" and "speculation," hinged on materialistic, quantitative limitations of Western science, can preclude certain works from consideration within the salient critical sphere of Afrofuturist discourse. For this very reason, Nigerian American sci-fi writer and Afrofuturist scholar Nnedi Okorafor has coined the term "Africanfuturism" to further differentiate works of speculative fiction that center and foreground African cultural modalities over those that are encoded by the conceptual biases of Western and diasporic thought.[15] Although I use the term "Afrofuturism" throughout this work, it is important to clarify the distinction between the generic Afrofuturist science fiction of

Western diasporic construction and a speculative fiction that is directly rooted in African modalities of thought, expression, and mythologies. In the expository theoretical chapter of this book, I will underscore the cultural contingencies of scientific discourse. By drawing on the critical works of Valentin Yves Mudimbé, Fabien Eboussi-Boulaga, and other prominent voices from African philosophy, bolstered by literary examples from Sony Labou Tansi, Jean-Marie Adiaffi, and Gerges Ngal, I will outline the intrinsic ecolinguistic biases in the construct of positivist, objective science in order to broaden the scope of Afrofuturist science fiction to include not only magical and mystical sciences but also the science of everyday experience[16] as related through works of filmic and literary fiction.

An expanded understanding of science will allow for a consideration of African works that depict the condition of subalternity in dialogue with dominant Western discourses, a hybrid cultural encoding that informs conceptions of individual and collective identities, economic progress and societal development, cultural and linguistic values, as well as ecological and cosmological relationality. Critical pedagogies, which argue specifically for the importance of arts and humanities for imagining equitable and sustainable futures for global societies, yield alternative frameworks of reference and exchange for engaging with the complexities of human societies from a planetary perspective. There is an underlying generic thread in this book that pushes the boundaries of what might be considered literature, taking into account the recent technological advancements that inform the emerging field of digital humanities, while engaging with poetry, music, film, orature, and other forms of cultural expression. Consequently, broadening our understanding of various forms of new media, in addition to standard literary and cinematic texts, can contribute to a fuller understanding of the diverse facets of societal development from postcolonial and indigenous African perspectives, with a speculative approach to creating and nurturing sustainable future civilizations for humanity.

Following the expository theoretical chapter of this book, the second chapter outlines multidimensional epistemological frameworks for analyses of métisse logics through the incarnation of mixed-race pregnancies, births, and children in the fictional works of women writers from Africa and the diaspora, including Mariama Bâ, Ken Bugul, Marie NDiaye, Véronique Tadjo, and Werewere Liking. Building on the feminist and womanist critiques of Françoise Lionnet, Odile Cazenave, Valérie Orlando, and others, the matrix of motherhood, femininity, and childbirth is cast in terms of a postcolonial societal schism, providing an embodied analysis of the notion of "cultural *métissage*" espoused by Léopold Sédar Senghor and other contemporary theorists of (post)colonial Africa. Read against the backdrop of early and canonical novels, such as Ousmane Socé's *Mirages de Paris*, and works by Camara Laye, Ferdinand Oyono, and Henri Lopes, the trope of a real or imagined infant born of two distinctly different parentages in African literary texts is adopted and expanded by the women writers in this chapter, who depict two fundamentally different views of the idea of *métissage*, one hopeful and another tragically negative. Examining the nuance and sociocultural contexts of these five postcolonial woman writers' texts, chapter 2 delineates points of contact and convergence between these two perspectives through the trope of motherhood in order to interrogate the intricate complexities—physical, emotional, psychological, social, and cultural—of postcolonial identity construction.

This point is exemplified in the work of Cameroonian writer Calixthe Beyala, who characterizes this state of indeterminacy when she explains the notion of *l'écriture lunatique*, or "lunatic writing,"[17] as the constant negotiation between hope and despair. Focusing on the future grants the capacity to access other modes of thinking and being, a transformation that is visible in her novel *Tu t'appelleras Tanga* when the young African protagonist Tanga requests that her French-Jewish interlocutor take her hand, a gesture that joins the two women together along a physical and spiritual plane of coexistence: "Give me your hand, and heretofore

Introduction

you will be me . . . my story will be born in your veins" (Beyala 1988, 18).[18] Such a transformation is possible if one believes in its possibility. The ability to envision the future and to see oneself as one or several being(s) perpetually in the future constitutes the fundamental power to withstand the influence of societal illusions and to traverse, even transgress, the barriers between the self and the other, thereby permitting the possibility of sharing common experiences and creating a society reflective of its composing members.[19] This calling into question of the real, or rather engaging a new set of potential perspectives through which to approach the real, constitutes a fundamental aspect of the African literary imagination. Accordingly, this chapter analyzes the complexities and contradictions of giving birth to the metaphorical métisse society of the future, focusing on the fundamental role of women in the creation of the future, both in a literary sense—the women writers of the works express their vision of what a culturally métisse society may be—and in a more literal sense, of mothers as leaders who exercise a highly influential role in the physical, psychological, and emotional formation of the future generations whose task it is to overcome the obstacles left by preceding generations. This move toward racial transcendence and conciliation, and gender inclusivity derived from strong femininity, constitutes an essential grounding for newly imagined forms of societal development, which will be elaborated on in further detail in chapter 4.

The third chapter of this book addresses one of the major stumbling blocks for the development of future generations in African society, namely, a socially destructive culture of perpetual war that destabilizes societal structures and creates a market for child soldiers, further mortgaging the futures of African societies. Following Joseph Slaughter's assertion that human rights are predicated on a person's "right to narration" (2007, 39), one must inevitably accept the new forms of narration that such a practice may take as we approach the quarter mark of the twenty-first century. In this context, I examine fictional and nonfictional accounts of child soldiers, including those by Ahmadou Kourouma,

Emmanuel Dongala, Ismael Beah, and others, within the context of internationally motivated intranational violence in Africa, which illustrates the problematic nature and devastating consequences of systemic political corruption, foreign intervention, and human avarice for the most vulnerable of citizens—children—and the crippling effect of this self-perpetuating cycle on the future development potential of these areas. I draw from an array of critical approaches, including Mbembe's notion of necropolitics, Maureen Moynagh's discussion of human rights discourses, and Christina Lux's conception of "peacebuilding." These perspectives engage with the textual accounts, whether biographical or fictional, as a tool to promote healing for the individual, the collective society, and the larger international community, whose involvement in the conflict is often as ambivalent (in some cases, profiteering and arming multiple sides in a conflict) as the child soldier's. The dichotomous lines between victim and perpetrator are blurred on all levels, and as a result, these accounts force us to rethink the ways in which global market forces, humanitarian agencies, political alliances, and persisting (neo)colonial legacies all participate in the factors that give rise to a culture of war in which child soldiering becomes a viable career path for survival. From this standpoint, then, one is required to rethink the societal value placed on products and persons, emphasizing communitarian well-being and a robust social dynamic rather than ruthless individualism and the unfettered pursuit of corporate profit.[20]

The tension between the destitution of the present and future possibilities finds definitive form in the infamous warning of Sony Labou Tansi's *La vie et demie*, in which he warns of a world of tomorrow dominated by authoritarian dictatorship, violence, and general dehumanization: "But we cling to war. War is our tic. Before when it was war for peace we fought like men; now that we've entered into war for war, we fight like savage beasts, we fight like things" (1979, 185).[21] Although Tansi does invent several spaces of survival in his story (both natural and technological) where one might always discover a more apocalyptic world yet to

Introduction

come, beyond the horizon, *La vie et demie* serves to apprise humanity of the dangers of life denial, of drawing one's life force from absolutist artifice, the censored histories that are the invention of nationalist despots, the Providential Guides.[22] Mbembe articulates the "generalized instrumentalization of human existence" as the operational mechanism in the necropolitical exercise of sovereignty, in which "becoming a subject . . . supposes upholding the work of death" (2019, 68). The necropolitical antieconomy that Mbembe theorizes reveals the philosophical and epistemological underpinnings of modernity as inherently violent, resulting in the perpetual war, even if only ideological, that has infused the global history and culture of the twentieth and twenty-first centuries. The consequence, as we see in the works discussed in this chapter, is a population divided upon itself, much like the ambivalent figure of the child soldier who embodies the contradictory practices of innocence and complicity, a conception that is drawn out further in terms of the figure of the migrant in the following chapter.

The fourth chapter analyzes literary and cinematic works that depict the problematic processes of migrant experiences through an existential lens, focusing in on the innate human desire for change, novelty, or merely difference, which can be abated through humanistic educational adaptations in local societies. At the crux of this project lies a reorientation of the ideological and linguistic relationships between global civilization and its composite cultures, allowing for a nonbinary reading of the imaginative spaces created by artists representing historically oppressed and marginalized peoples, namely through the figure of the migrant in chapter 3 whose simultaneous presence and absence necessitates an embrace of paradoxical ambiguity. Much like the dialogical narrative and psychic structures in Ngal's *Giambatista Viko*, the identity doublings in Beyala's *Tu t'appeleras Tanga*, the time dilation in Tansi's *La vie et demie*, or the geohistorical inversions in Abdourahmane Waberi's *Aux États Unis d'Afrique*, Afrofuturist and speculative narratives create ancillary spaces, concepts, and methods through which to imagine and then enact significant

change in global narratives, thus critiquing and creating alternative global futures. The twenty-first century has ushered in an epoch of virtual exploration in which once again the potential existence of other possible worlds incites the imagination to project its utopic or dystopic visions from the present. This is no less the case for African writers than for any others, as illustrated by Waberi's novel *Aux États-Unis d'Afrique*, in which he relates a transcontinental vision of an Africa that has become the ideal place to earn a comfortable and pleasant life for oneself in a world in which political and cultural stereotypes, as well as the origins, destinations, and ethnicities of migrant figures as they are typically conceived, have been reified and reversed. In the United States of Africa, we find Africanized consumer industries, such as the McDiop restaurant, Safari beer, or Guelwaar tires, as well as museums of art and culture that display the significance of Africa's civilizational exploits.[23] In addition to giving a fictional home to the musings and visions of the negritude poets of the past century, the richness of African arts constitutes a poignant critique of the debate over African cultural and artistic artifacts pillaged during the original colonial era to their rightful repatriation to continental inheritors. In an article on Waberi's novel, Anjali Prabhu (2011) outlines the discursive power play that Waberi's speculative fiction enacts through a systematic inversion of reality, likening it to Voltaire's *Candide*. She writes: "The author of *In the United States of Africa* presents a story (an enunciation) in which Africa emerges as the legitimate and comfortable space of that enunciation. In situating this fabulous story as an inversion of the real relationships of authority, the author goes beyond pessimistic irony . . . in order to suggest the contingency, not only of 'facts,' but also of the play of power in the act of enunciation that results from these facts" (83).[24]

The inversion of the static order of North-South power relations that has for centuries dictated the "facts" of reality undermines the truth of that reality through its fictionalization. Moreover, Prabhu argues that through the enunciative act of

Introduction

the novel itself, the primacy or veracity of those very power relations themselves, is further called into question. One powerful illustration of this fictionalizing fact-checking in Waberi's novel is illustrated through the figure of the clandestine immigrant, a principal character in many African narratives. However, in Waberi's rendering, the prosperous standard of living found in the United States of Africa is only understood in contrast to the poverty and misery found elsewhere in the world: "Do they not know that they owe their health and their prosperity to the gray silhouettes dressed in rags that cross the Mediterranean to sell themselves to the industrialists in the Transvaal or to the marine merchants of Nouakchott?" (2006, 107).[25]

Showing that wealth and success for some are dependent upon the exclusion of others, a historical reality that Western powers—built upon the exploits of colonialism and the slave trade—continue to deny through their imposition of a colonial debt upon their former colonies, Waberi assumes the responsibility on their part and brings a bitter sense of realism to his otherwise utopic narrative.[26] Recognizing the suffering of the other becomes essential for appreciating the status of the self.

Through the literary trope of the migrant, a lack of relational authenticity in postcolonial cultural exchanges is clearly dictated primarily by media politics and precedent, which is rooted in colonialist ideologies and the accompanying remnants and reincarnations of their institutions. This notion was first represented in African fiction by Ousmane Socé (1937) in his novel *Mirages de Paris*, which describes the artificiality of the images of the colonial metropole that are produced in the imaginations of the colonized African subjects. Building upon Julia Kristeva's conception of alienation in her work *Étrangers à nous-mêmes*, this chapter approaches the phenomenon of emigration from the perspective that the desire to emigrate is a fundamental human longing for completion that is misplaced through fictitious representations of Europe dating back to the very first colonial encounters. Beginning with canonical texts in Francophone literature, including Cheikh Hamidou

Kane's *L'aventure ambiguë*, this chapter addresses the indeterminacy of human experience in terms of Samba Diallo's alienation. From that, the notion of humanitarianism is further critiqued through Aminata Sow Fall's short story "La fête gâchée," which, along with NDiaye's *Trois femmes puissantes*, depicts in dramatic fashion the mediatic mechanisms responsible for reproducing endemic poverty and its corollary: mass migration. These notions of territoriality and interculturality are further elucidated through analyses of African films, including Abderrahmane Sissako's *Heremakono* (2002), Djibril Diop Mambety's *Touki Bouki* (1973), and Amadou Saalum Seck's *Saaraba* (1988). All these films represent an immigrant's incomplete journey as an injunction against the virtual narrative of linear trajectory toward a better future elsewhere. Rather, these films propose—through circularity and multiplicity—an affirmation of life in the present circumstances as the key to self-creation toward a better collective future in the here and now. Against such divisive illusions and systemic inversions of the real, of the human, and of life, the third chapter of this book proposes a valuation of nonhuman life in migrant narratives as a means of rehumanizing the dehumanized. An example of this is seen in Youssouf Amine Elalamy's beautifully poetic novel *Les Clandestins*, which in its depiction of lives lost to a failed emigrant journey also includes the "lives" of an apple, a worm, and even the boat itself, which has been battered by the waves of the Mediterranean. The decentering of human life by including other living entities in the same common environment serves as a metaphor for an expanded understanding of the interrelationality of life-forms on a planetary, or even cosmic, scale. The chapter concludes with an explication of Fatou Diome's *Le ventre de l'Atlantique*, which illustrates both the illusory nature of the "European dream" and the tragic consequences of its vain pursuit from the perspective of a "successful" immigrant. In so doing, Diome proposes alternative modes of constructing African identities and sustainable economies in the era of twenty-first-century diasporic displacements, cultural transplants, and globalized commodity capitalism.

Introduction

In response to the illusionism and artificial paradises[27] of current global politics, chapter 5 explores ways to meet the challenges of the physical and ideological borderlands that have succeeded in dividing humanity into interminable sequences of selves and others by focusing on education as a crucial tool for overcoming violence, racism, sexism, and institutionalized inequalities that are often latent in development problematics. In the book *Africa for the Future* (2009), Bekolo reformulates knowledge construction as a kind of cinematic language, "le mentalais," which is based on a narrative rendering of reality and the relationality of the subject position. Bekolo's cinematic language exemplifies an indigenous epistemology grounded in precolonial oral traditions in which fact and fiction are inherently intertwined. Drawing from this perspective, fictional and nonfictional accounts such as Ba Kobhio's films *Sango Malo* and *Silence de la forêt* illustrate the importance of education for the well-being of society while simultaneously subverting commonly accepted educational methods and structures that are steeped in Occidentalism. For example, to again cite Wright, "Indigenous African education would conventionally be considered to be regressive and antithetical to development" (2004, 131), but "if we reconceptualize development as more than a process of economic growth, then we can begin to see how orature [and other indigenous cultural practices] contributes to development by creating the space to put forward ideas about how, why, and in what direction social change should take place" (133). Education must be conceptualized in terms of humanistic development, nurturing the whole person for the betterment of the community. The ability of the voice to name and to enunciate holds the creative power to bring into existence that which one can conceive, which leads Mélédouman to exclaim in Jean-Marie Adiaffi's novel *La carte d'identité*: "It is others who are the proof of our existence" (2002, 128).[28] This notion of being because of others is summarized in the ancient African wisdom and philosophy of *ubuntu*, an insistence on the commonality of human being, which Sarr summarizes as "I am because we are" (2019, 68).[29] After his

rebirth through the mirror's mediation and the life-giving words of Ebah Ya that function like a transfusion of lifeblood, Mélédouman seeks out his place in the community of Bettié, a city described as mere ruins in comparison to its former grandeur.

Mélédouman's clairvoyance in *La carte d'identité* helps to illustrate this synthetic didactic method and its accompanying hybrid epistemic forms when he encounters a teacher with whom he debates the values of an educational system that alienates through its imposition of a particular set of linguistic, scientific, and cultural principles. Unlike the past, in which "African school was adapted to African society" (101),[30] Mélédouman again perceives the double standard by which knowledge systems are ultimately produced. The teacher makes eloquent arguments about the value of the French language and the various "sciences" that it codifies—medicine, biology, physics, chemistry, mathematics—even going so far as to propose: "It's for the good of Africa's future" (106).[31] Mélédouman responds by expressing the need to extol the philosophical virtues of African civilizations like the Ashanti, the Manding, the Congo, and Benin, ending with a plea to preserve the languages that drive the wisdom and knowledge systems of these indigenous African cultures: "If we bury our languages, in the same coffin, we forever lock away our cultural values" (107).[32] In a surreal rendering of the consequences of the epistemological substitution enacted by colonialist institutions, Mélédouman and Ebah Ya find themselves wading through a literal shitstorm as torrential rains have produced a "purée of poo and black muck" (113)[33] that reaches to midthigh. Yet they continue to struggle, revealing the internal force of human desire that can overcome the greatest of obstacles: man's desire to be what he is, to find his true self. Almost like a superpower or a spacesuit from science fiction, the willpower to persevere in the face of adversity represents a defense mechanism that allows for Mélédouman to survive the physical and epistemological impacts of an alien civilization.[34]

The analysis in this chapter addresses first and foremost how Ba Kobhio's films highlight the shortcomings of an alien education

Introduction

system imported from France and maintained after independence as a system that does not sufficiently address the needs of the populations that it is intended to serve. Dissecting these films, which have been grossly understudied, and other related texts, reveals two alternative epistemologies, one material and the other metaphysical, both of which emphasize the collective good and the relationship between humans and the natural environment in contrast with the status quo of modernist educational discourses. The subtext of both of these films is a virtuous educational program that does not reproduce slaves to a system of corruption driven by personal greed and societal degradation. This chapter thus constitutes a pivotal juncture in the elaboration of ways in which African literature and film can provide alternative modes of understanding key developmental issues and propose model solutions that are rooted in indigenous African modes of communal knowledge production and dissemination. Thus, it demonstrates alternative frameworks for understanding and confronting developmental concerns, sometimes in direct opposition to some of the Western industrialist and nationalist biases and linear reasoning that persist and exert tremendous influence in the affairs of postcolonial African societies. This project as a whole, therefore, rests upon the premise of this chapter, employing alternative forms of data and analysis, specifically those forms that have traditionally been excluded from fields of rigorous "scientific" studies. Demonstrating ways in which literary studies can be undertaken with an eye toward understanding the social context of the works, including the problems and solutions that they imply, this chapter effectively elucidates the ways in which we can engage intelligently with developmental issues in Africa from a culturally sensitive narrative position.[35] Because development problematics are often aligned with particular global political and financial interests and are therefore subject to a degree of bias in their "objective" representation, works of art may escape from these implicit or inherent prejudices while still presenting a realistic interpretation of a particular set of developmental issues. For, as Albert Memmi

posits in *Decolonization and the Decolonized*, "Fifty novels from a given time period provide a richer source of insight than tons of newsprint published during the reign of a dictator" (2006, 36). It is precisely this interplay of the political, the socioeconomic, and the aesthetic that leads Wright to propose the imperative that "literature studies in Africa must become part of African cultural studies" (136). This project is therefore emblematic of the intentional study of literature and the arts as vehicles of socially responsible and culturally sensitive commentary in contemporary African cultural and developmental discourses.

The idea that cultural awareness and sensitivity attained through literary study can have a positive impact on developing and implementing effective economic policies in modern African nations is at the core of an emergent "Africa Rising" debate, particularly in the sense that the general continental shift toward playing a major role in the twenty-first-century global economy will transform the very nature of global economics through endogenous African contributions.[36] Consequently, this project offers an in-depth examination of complex issues facing African nations that have historically been relegated to developing nations, through an analysis of African literary and filmic texts that propose critical alternatives to the educational, economic, gendered, ecological, racial, and geopolitical inequalities embedded in African societies through European colonialism and its aftershocks.[37] The principal theoretical dilemma associated with discourses of development in African contexts is that they are most often framed by Western conceptions of progress and often associated with a Eurocentric linear narrative of history. In the context of globalization, many development strategies that have been proposed or imposed upon African nations, whether in the educational, financial, or infrastructural sectors, are implemented according to a predominantly Western framework. As a result, these tactics often exhibit an underlying bias for Western interests. Edward Goldsmith has, in fact, argued that development is merely a new form of colonialism, and Kwame Nkrumah's poignant critique of neocolonialism

Introduction

and capitalist imperialism would certainly indicate a similar understanding of postcolonial Western interventionism. Dambisa Moyo's (2009) *Dead Aid* elaborates specifically on the ways in which the model of Western aid distribution on the African continent is inherently flawed.[38]

Through the trope of the lottery, the sixth chapter analyzes films by Ousmane Sembène, Djibril Diop Mambety, Fadika Kramo-Lanciné, and Imunga Ivanga, each of which epitomizes money as the ultimate object of desire and source of hardship. The mechanism by which economic illusionism operates, namely derivative profits from promises of future returns for a modest initial buy-in, oppresses and disenfranchises the poor through an intentional signaling of false hopes or "artificial paradises," inviting their complicity in maintaining the inherent inequalities of the status quo. In contrast with indigenous African subsistence economies that were designed and implemented in such a way as to ensure the prosperity and longevity of entire communities, the imposition of a Western capitalist model predicated on endless economic growth and agency on the global economic stage often contributes to poverty and further entrenches inequality. Like the high hopes that accompanied political independence in the 1960s, much of the promise of economic independence turns out to be illusory and grossly problematic. Measures imposed by global financial institutions such as the World Bank and the International Monetary Fund, as well as inequitable economic policies that fall under the obscure yet ubiquitous umbrella of "Françafrique," operate in a disproportionately negative way that often outweighs the perceived benefits of global networks of exchange. Through the trope of the lottery, however, African writers and filmmakers are able to critique how arbitrarily infused economic shifts and comparatively astronomical sums of money exacerbate a number of underlying social and economic issues, thereby increasing alienation and causing further anguish for the supposed winner. Furthermore, these filmmakers all propose alternative models of wealth and prosperity, which are grounded in satisfaction with

oneself and one's physical, mental, and emotional well-being in a familiar context. Building on the theoretical concept of artificial paradises (*Les Paradis artificiels*) written about by Charles Baudelaire in 1860, money is likened to the kind of high that one associates with the use of intoxicating substances. Much like drug addiction, the prospect of obtaining a large unwarranted sum of money (e.g., winning the lottery), rather than providing relief from the harsh realities facing protagonists in these films, creates an entirely new set of problems and further exacerbates the pressures of daily life in a postcolonial society. The conclusion that one can glean from these filmmakers' critiques of global economic policies is precisely that external economic stimuli, whether in the form of international aid, debt relief policies, or multilateral trade agreements, often operate like a drug in ways that perpetuate and increase dependence, rather than affording opportunities for "developing" nations.

Returning full circle to the métisse logics espoused in the first chapter, the seventh chapter of this book entails an ecofemininst societal ethic that stands in stark contrast to the shameful simulations of absolute state authority.[39] In light of Alain Suberchicot's proposal that literatures from the so-called Third World, and specifically those from the African continent, represent a space in which the discourses of development, ecology, and the human coincide, this chapter explores the notion of ecocriticism as presented in the literary corpus of Tansi through the futurist environmental philosophy of Michel Serres and others. Drawing on the works of Mary Ebun Modupe Kolawole, Obioma Nnaemeka, and others, this chapter explores the ecological themes in Wanuri Kahiu's short film *Pumzi* (2009) and in Sony Labou Tansi's work, specifically, via the marginal yet essential presence of the forest and the river in his narratives *La vie et demie* (1979) and *L'anté-peuple* (1983). In these narratives, privileged natural spaces provide links between ecology and femininity in contrast to the shameful state of a male-dominated modernity, which is the overarching sociopolitical context in these two novels. The communal

Introduction

eco-logic driven by the strong female characters in these novels defies the destructive forces of the state. Drawing out this alternative counter-logic of the human and planetary environments, Sony Labou Tansi's work represents a performative model for exorcising societal shame and opening up an alternative pathway for the future of environmental dignity.[40]

In the conclusion to this book, Gayatri Spivak's (2012) notion of planetarity and planetary being are further elaborated as just such an alternative to the countless problems posed by societal divisions plaguing global civilization.[41] In the context of the Francophone works of fiction that embody Afrofuturist themes related to gender dynamics and the environment, educational and economic practices, as well as the global politics of conflict and migration, planetary thought requires a cultural and linguistic reorientation toward open imaginaries and creative processes, rather than an overreliance on the fixed forms and rationalities that have driven human civilization to its current state. Thirty years after the appearance of the seminal work *The Empire Writes Back*, the French and Francophone literary scene has experienced an intense growth in popularity of writers and artists from former colonies, usually grouped under the polemic and politically ambivalent umbrella of *la francophonie*. Afrofuturism has long been prevalent in the philosophical and literary endeavors of prominent thinkers from the African continent. Following in the tradition of Mongo Beti, Ngugi wa Thiong'o, Valentin Yves Mudimbé, and others, many contemporary writers, including Fatou Diome and Léonora Miano (to give two outspoken examples), have also participated significantly in the evolution of critical, theoretical, and philosophical discourses, particularly as they pertain to the intersectionality of art and politics, or more precisely, literature as societal critique.[42] Since Mudimbé first proposed in 1973 that African intellectuals must "invest in the sciences, beginning with the social sciences and human sciences in order to grasp the tensions at play, to reexamine for our own sake the contingent findings and sites of enunciation, of knowing," African writers

and intellectuals have continually endeavored to express the tensions of African epistemologies marred by the blight of colonial encounters (qtd. in Sarr 2019, 73). As a result of the increased visibility and popularity of cultural and literary criticism by African intellectuals such as Mbembe, Sarr, Bekolo, and others, I propose that an important new direction in literary and cultural theory is a maturation of the decolonizing impulses first announced by Aimé Césaire, Frantz Fanon, and the negritude poets, which has come to fruition in the postcolonial articulations of subaltern humanity by critical theorists such as Achille Mbembe, Ambroise Kom, Fabien Eboussi-Boulaga, and creative writers such as Werewere Liking, Aminata Sow Fall, and many others. Like their Anglophone counterparts Chimamanda Ngozi Adichie, Nnedi Okorafor, Wangari Maathai—whose collective work builds on the legacies of Ngugi wa Thiong'o, Kwame Nkrumah, Steve Biko, and others—the articulation of African futures has been a constant struggle within the domain of representation, as Stuart Hall clearly articulates. As humanity enters the third decade of the twenty-first century (according to the Gregorian calendar), the interconnectedness of societies on a global scale is practically complete, and as a consequence, the integration of "postcolonial" critical perspectives into the mainstream is an important means of better interrogating our human pasts in an effort to delineate a sustainable and humane future on a planetary scale. This book can therefore serve as an example of ways in which one might consider Afrofuturism as an alternative discourse for imagining and elaborating the ideas necessary to create a new world for all of humanity.

1

Afrofuturist Ecolinguistics

Redefining the "Science" of Science Fiction

The legitimacy of this method, which consists of attempting to grasp the African real or reality [*le réel African*] through the tool we call science, has not been called in to question. . . . Other modes of apprehension for grasping the real also exist; Western forms of knowledge do not exhaust all methods of scientific inquiry.[1]

—Felwine Sarr, *Afrotopia*

Orature is a living tradition precisely because orality, its base, is always at the cutting edge of the new and the experimental in words and experience.

—Ngugi wa Thiong'o, *Globalectics*

The information age and the advent of digital humanities have broadened our understanding of various forms of new media, which, in addition to standard literary and cinematic texts, can contribute to a fuller understanding of the diverse facets of societal development from an indigenous African perspective. In terms of what Handel Kashope Wright calls "The Political Economy

of the Internet in African Studies" (2004, 172), African cultural expressions in their contemporary manifestations are more accessible than ever to a wide audience as myriad blogs, Facebook pages, Twitter accounts, YouTube channels, and countless other readily accessible semiprivate platforms for the dissemination and recollection of various textual codes can be studied and interpreted critically by cultural scholars in order to gain a grounded, localized, and indigenous understanding of the complex social, cultural, political, and economic issues at play in the narration of African selves and societies. However, with these new technologies, one also runs the risk of losing information that can disappear within the massive sea of data that engulfs our daily existence. Bringing together sociopolitical and cultural theory with international development discourse and African humanist expressions, this interdisciplinary book contributes to a more complete scientific understanding of our collective global future potential. This project therefore suggests that adding a little magic to the science, a little orality to language, and a little humanity to development can open access to the communicative spaces and bridge the gaps in our fragmented understanding of the selves and others that populate our conceptual spheres of planetary and cosmic existence.

Afrofuturism is a critical discourse that combines indigenous and ancient African mythologies with modern and postmodern (even science-fictional) discourses in evocative and promising ways. In *Afrofuturism: The World of Black Sci-fi and Fantasy Culture*, Ytasha Womack cites Ingrid LaFleur's definition of Afrofuturism as "a way of imagining possible futures through a black cultural lens" (9), adding that it "counteracts historical assumptions" (15) and "inverts reality" (16). She goes on to wonder: "Were stories about aliens really just metaphors for the experience of blacks in the Americas?" (17). Like many historical, political, cultural, and artistic movements that have influenced global African thought (e.g., Marcus Garvey's Pan-Africanism or Aimé Césaire's negritude), the diaspora is oftentimes the source or origin, reaching

back toward the continent for solidarity and companionship. Afrofuturism is no exception, and this book aims to narrow the gap between diasporic and continental African works in order to enrich the scope of its simultaneous critique and creativity through an expansion of its corpus. Given that science fiction, speculative, and fantasy genres tend to defy or *dépasse* the logical constraints of pure rationalism, either by envisioning a future universe that has been technologically, spatially, temporally, or psychologically liberated from the material limitations of the present, or by creating an alternative universe in which these limits simply do not apply, African creative and imaginative works participate fully in this conceptual space. From the ancient mythologies depicted in Souleymane Cissé's (1987) *Yeelen* to Jean-Pierre Bekolo's (2005) dystopic urban rendering of life in his sexy thriller *Les Saignantes*, Africa occupies a conceptual space that inevitably reaches across oceans, across centuries, across languages, and across the thinly veiled theoretical demarcations that separate fact from fiction, life from death, and reality from reverie.

Moving beyond the Western bias of pure rationalism that undergirds the linear narrative of modern progressivism, Afrofuturist texts explore and imagine viable alternatives for endogenous development through the theoretical lens of Afrofuturism, a contemporary social aesthetic that combines cultural literacy with ecology and technology to imagine an inclusive and innovative future in which the humanized diversity of African experiences is foregrounded. Reynaldo Anderson describes the Black Speculative Arts Movement in the following terms: "Although contemporary Black speculative thought has *roots* at the nexus of 19th century scientific racism, technology, and the struggle for African self-determination and creative expression, it has now matured into an emerging global phenomenon" (2016, 230). Speculative futurity tells another set of stories and speaks in a different language. Futurity, as a matter of fact, has been one of the central focuses of postindependence African nationalisms of various iterations. As Cecil Blake cogently argues, "The [African nationalist] ideology

was constructed around the following tenets: a vision of the future that is willed and to be managed by Africans with political, economic, social, and cultural ramifications, and an apotheosis of African history and service to humanity as the basis of its authority" (2005, 580).

The concept of an independent, future-oriented agency for African polities is central to questions of developmental, political, economic, and cultural autonomy. The potential promise of alternative worldviews may be the paradigmatic question of the age as Western neoliberal capitalism has reached its apogee and regressed into baroque decadence. According to Anderson, Afrofuturism denotes *"a critical project with the mission of the groundwork for a humanity that is not bound up with the ideals of white Enlightenment universalism,* critical theory, science or technology" (230–31). Consequently, Afrofuturism as a theoretical framework can not only give voice to the Afro-diasporic "aliens" around the globe but also serve as a means for marshaling the aesthetic productions of the African continent, particularly those from France's former colonies, into the arsenal of liberatory rhetorics and aesthetic practices that can be made accessible to a popular global imagination. Reading the futurity in Francophone African literature affords opportunities for better understanding globality from a subaltern perspective, while simultaneously enriching the discursive field of Afrofuturist expressions. As such, Afro-futures are futures that have been imagined by artists living within and at the margins of socially constructed paradigms of thought, education, economic development, and social mobility, all of which are fraught with contradictions in the context of postcoloniality.

In the twenty-first century, at a historical juncture where isolationism and conservative modes of thought and cultural expression are returning to the global political and discursive landscape in the form of geopolitical backlash, it is more important than ever to foreground openness and inclusion with respect to humanity's common planetary future. Based on an ethic of individual and collective empowerment, Afrofuturist works explore the multiple

interrelated realms of societal possibilities through creative expressions that incorporate ancient African mythologies, cosmologies, and traditions while also adapting the technical and artistic elements of global modernity for new and innovative applications. Much like earlier literary and philosophical discourses, including Pan-Africanism, negritude, or even Afropolitanism, Afrofuturist discourse originated in the diaspora as a mechanism for simultaneously retrieving a lost and fragmented African past, while also projecting an alternative future in which present oppressions are overcome. Expanding the scope of Afrofuturism to a more geographically diverse and sociolinguistically inclusive platform, one that considers the validity of alternative epistemological forms and a plurality of potential science-fictional universes, can only contribute to the advent of a future society in which humans can fully realize their common planetary being. The resultant transnational corpus of fictional texts selected for this project, while primarily (though not exclusively) from Francophone Africa, represent the diversity of continental African cultures and peoples and their respective histories, philosophies, and epistemes. Drawing on works from diverse regions of Africa, including Kenya, Sierra Leone, Senegal, Côte d'Ivoire, Congo, Algeria, Djibouti, Cameroon, Mali, Mauritania, and Gabon, as well as the European and American diasporas, this project examines both the specificities of these artists' critiques and future projections, as well as the commonalities of their imaginative efforts to represents the critical spheres of heuristic potential for world re-creation through fiction. While these writers and filmmakers might not characterize their works as Afrofuturist, part of the theorist's work is to unearth the textual subtleties of creative works in order to assist in rendering their potentialities accessible.[2]

The plurality of voices represented in this project reflects the theoretical approach of an Afrocentric or, as Keto describes in his groundbreaking work, an "Africa centered perspective," which advocates that "different regions of the world should declare and affirm their right to create and develop independent intellectual

perspectives from which a global and 'pluriversal' perspective will emerge" (1989, 16).[3] This notion corresponds closely to what Bidima has termed "the multiple scansions of African philosophies" (1995, 3).[4] Likewise, my approach here involves interweaving interpretive frameworks of African philosophies, critical cultural studies, diasporic interventions such as Afrofuturism, existentialist perspectives, and critical literary analysis. This approach will also draw out the global implications of African cultural products typically relegated to discursive marginality in order to reveal a more equitable and "pluriversal" inquiry into humanity and its socializations. Unlike many hegemonic and reductivist narratives reinforcing the Orientalist exoticized otherness of Africa, or the inverse, the overgeneralized and vague conception of "world literatures," or *littérature-monde* in French, a study of African textual products from a globally integrated interpretive framework represents a landmark shift toward a more complete and accurate conception of human experiences—past, present, and future. Decentering the centrality of Western European logics allows for the recentering of the peripherality of African thought production as a multilingual, heterogeneous, iterative, and inclusive process, primarily expressed through its creative agents, many of whom have embodied the poetic project of auto-critique and auto-determination through their inventive and imaginative expressions. In doing so, the multipronged methodological approach of this project encourages the emergence of diverse, pluralist engagement with Afrofuturist thought and humanistic productions on a leveled global scale, which interrogates not only the implicit cultural biases of social discourses, from gender and education to economics and consciousness.

As a result of this approach, it is necessary to engage directly with questions of translation. The Francophone cultural expressions that comprise the predominant corpus of this oeuvre have by and large been quoted in their original language with translations provided for the sake of the prospective audience. In many cases, such as Jean-Pierre Bekolo's *Africa for the Future*, an

English-language translation does not exist, and I must therefore rely on my own translations for the reader. In the case of Felwine Sarr's *Afrotopia* and a few other select references, I have provided the official translation when it does exist. In other cases, I have retained my own translation even though there exists an English translation of the text: this is for the simple reason that I wish to convey my unique understanding of the original French as it relates to the theoretical perspective and philosophical ideas espoused in this book. I have read the 1983 Zimbabwe Publishing House translation of Jean-Marie Adiaffi's *The Identity Card*, by Brigitte Katiyo, and the Dundy translation of Sony Labou Tansi's *Life and a Half*, as well as English translations of *So Long a Letter*, *It Shall Be of Jasper and Coral*, *The Blind Kingdom*, *The Abandoned Baobab*, and many others. And although in many instances these are very good, I have decided to maintain my own translations of the works for the very simple reason of avoiding unnecessary complication. Even in the official translations of Sarr's work that are provided, one will notice numerous instances where the English translation deviates—perhaps in tone, perhaps in form, or perhaps in other significant or insignificant ways from the original French version. In some cases, I have discovered some rather revealing errors in official translations. This is a necessary consequence of translation, as one cannot possibly translate with absolute accuracy anything as intricate and inherently incomplete as human expressive forms. My English translations of the original French are undertaken with the aim of providing clarity while remaining as faithful as possible to my initial interpretation of the original texts. And this question of language infuses the entirety of this project, as one must always question the ecolinguistic implications of the words that one employs to conjure the specters of reality and form them into a comprehensible rendering of the world as it is experienced. In the semiotic and symbolic representations of these talented writers and cultural critics, the chapters that follow endeavor to encapsulate the worldview of Afrofuturist imaginings in Francophone cultural expressions in relation to the

global (*mondialisation*) and planetary (*mondialité*) structurings of thought and existence.

The literary genre of science fiction, like much of modern literary, philosophical, and epistemological discourse, is primarily a product of Western imagination; it is fundamentally based on a history of technological progression born of the Industrial Revolution in Europe. Certain authors, such as Jules Verne and many others, project a future world dependent upon surpassing technological advances—these offer an escape from modernity's material obligations,[5] allowing humanity access to other possible worlds, such as the surface of the moon, the center of the earth, or the inner realms of the human spirit. The concept of utopias, and the means by which such realms might be accessed, stems from antiquity with the mythical land of Arcadia. In the early sixteenth century, Thomas Moore conceived and published his *Utopia* in response to the opening up of global frontiers ushered in by the age of exploration. Similarly, Rabelais's mythical giant, Pantagruel, finds his origins in Utopia, which is situated in Africa, interestingly enough. To that end, in an article titled "Africa as Science Fiction," Orlando Reade (2012) remarks that "the science fiction genre as a Western imposition . . . imagines Africa from an alien perspective." Accordingly, Achille Mbembe counter-theorizes the colonial archive, or what he terms "la bibliothèque coloniale," borrowing from Valentin Yves Mudimbé's (1988) terminology in *The Invention of Africa*, which has yielded an unworldly image of Africa. Mbembe states, "From this perspective, the outer-World is the equivalent of a zone outside of humanity, outside of the space where human rights are exercised" (2013, 95).[6] A simultaneous utopia and dystopia, Africa has been constructed through various fantasies of the imagination as that "different" place par excellence and continues to occupy, from the dominant Western perspective, a space of the other or the "alien." In writers' longing to imagine new worlds, perhaps far beyond or else deeply intertwined with one's current plane of existence, there exists a notable thematic affinity with the genre of world literature

(that of "literature-worlds," if we may) and its elemental principle of resistance against the material restraints of subjugating societal discourses.[7] The twenty-first century has ushered in an epoch of virtual exploration in which once again the potential existence of other possible worlds incites the imagination to project its utopic visions from the present. This is no less the case for African writers and artists than for any others.

Considered within the enhancing framework of Afrofuturism, the science fiction, mythology, and fantasy in African literatures are rich with myriad novel interpretations of fantastical dimensions and mystical, cosmic themes that resemble the science fiction genre in their narrative function, thus creating a deep, dynamic universe in which Africa becomes a self-redefining concept in service only to itself and the planet. Accordingly, Sarr writes: "The future is a site that does not yet exist, but which one can already shape within a mental space. For societies, this nonexistent site must be the object of a prospective thought. As such, one works within the present in order to help to create its *occurrence*. The Afrotopos is Africa's *atopos*: the as-yet-inhabited site of this Africa to come" (Sarr 2019, 99).[8] In a manner reminiscent of the theoretical analysis of the archive, the creation of the future occupies, according to Sarr, an important part of our activities in the present. In the particular case of the African continent, it is necessary to remember that the situation of the present continues to suffer the influence, even the direction, of a history profoundly marked by colonial and later, neoliberal subjugation. Therefore, in attempting to determine the proper route that would lead the countries of Africa into the freedom of self-determination, one must begin by redefining temporality altogether. Sarr writes that what is essential for Africa is precisely "the refusal of externally imposed cadences . . . taking the time to try things out, to experiment, to carefully gather up various flowers coming from a variety of different gardens, to delight in their fragrances and to serenely arrange the bouquet according to the art of flower arrangement" (26–27).[9] This beautifully organic metaphor transcends that of

a melting pot,[10] constituting rather a heterogeneous ensemble of distinctly different plants, which serves as the basis of the continent's liberating action, resisting essentialism and accepting the inherent multiplicity of Africa's indigenous and exogenous heritage. This plurality differentiates the African consciousness from Afrofuturistic concepts that were inspired by the diaspora and that currently make up the African continent as one unity, a setting resembling the world of the 2018 Marvel film *Black Panther*. In truth, however, it would be valuable to move beyond the imposed limits of a real-life Wakanda and to consider the diverse forms that might contribute to the range of possible Africas to come.[11] To fully realize such Africas, language barriers must be broken down and geographical frontiers spanned; in short, everything possible must be done to understand all of the cultural values that have contributed to the twenty-first century's Afrocontemporaneous complexity.

Beginning with the epistemic biases of Western science, Valentin Mudimbé proposed that African intellectuals must "invest in the sciences, beginning with the social sciences and human sciences in order to grasp the tensions at play, to reexamine for our own sake the contingent findings and sites of enunciation, of knowing" (qtd. in Sarr 2019, 73).[12] Accordingly, Sarr envisions the emergence of a scientific discourse that, rather than reinscribing the implicit racism and European cultural superiority inherent in the modern scientific project, responds first and foremost to the social conditions of African social and human life, and from there extrapolates the emergence of an embedded and contextualized African scientific discourse: "*a scientific discourse that would be the expression of material life within their own sociopolitical contexts*" (2019, 75).[13] Taking a case in point from Jean-Marie Adiaffi's *La carte d'identité*, the protagonist Mélédouman remarks: "In fact, if we consider science not in its method, but in its results, it defies the craziest imagination of magicians; science in its results is more magic than magic: a magic that proves, a magic of proofs, that is the big difference" (2002, 141).[14] This quote, illustrating

Afrofuturist Ecolinguistics

the cultural contingency of knowledge, echoes the formulation of Arthur C. Clarke in *Profiles of the Future* that "any sufficiently advanced technology is indistinguishable from magic" (1973, 21).

Culturally embedded semantic distinctions are also highlighted in René Maran's autoethnographic account of his experience as a colonial administrator in the central African colony of Ubangi-Chari. He comments on a particular linguistic differentiation and delineation of terms, noting: "'doctorro'—that's the name that whites give to the one who, in their country is in the magic business" (1988, 31), and again later on: "The whites have their doctors; the blacks their sorcerers. Rest assured that they are alike and that the latter are worth as much as the former. There are good doctors and bad sorcerers. There are good sorcerers and bad doctors" (145). From this perspective, science and magic function as fundamentally identical cultural processes and practices, albeit by different verbal designations, each intending to render accessible to the human mind, the nonhuman existential sphere.

In fact, Boulaga (2011a) critiques European ethnographic explanations and generalizations concerning African thought and practices, which are generated from the perspective of uninformed outside observers. However, he also identifies a perspective elaborated by European anthropologists, citing a particular example from Gerard Van der Leeuw's *L'Homme Primitif et sa religion*, of which Boulaga writes, "Magic, Van der Leeuw states, is an attempt to transform nature into culture, or, to express ourselves in a less modern fashion, it is an effort intending to make the given world into a world for oneself, to dominate the world. A magical attitude is thus an essential condition to all cultures" (21).[15] Accordingly, one can clearly understand the functional correlation between "magic" and other processes by which human cultures differentiate themselves from the natural world around them, including "science," which is the primary process for contemporary global civilization to convert the natural world into a world deemed suitable for a particular "human" culture.[16] Mbembe refers to such extreme neoliberalism as a "return to animism" in that ordinary

objects are augmented by their technologically determined transactional value, explaining that it is a result of "science's having turned into fiction and fiction into the real" (2019, 108). The "scientific" bases of global systems can thus be read as mere fictions, perhaps even magically real, which have come to supplant alternative understandings of "reality."

Afrofuturism further conflates this science/magic question by integrating ancient African mysticisms and mythologies into modern scientific universes, what Rollefson (2013) terms "Robot Voodoo Power."[17] The performative power of manifested thought, how individual selves and communities are imagined, holds great power for shaping the future in which cultural systems have been and will continue to be upended and reconstituted under new terms and new orders. What remains to be determined in this newly speculated global landscape is whether these new cultural systems will tend toward a continuation of monolithic hegemony, or whether they will engage and enact novel epistemes of multiplicity, openness, and inclusivity, such as those afforded by Afrofuturism.[18] If one seeks to alter the modes of symbolic representation in order to deconstruct the accepted "realities" of dominant societal discourses and refocus one's attention on the potential alternatives that may exist, one can play an important part in crafting a new, more equitable, and more sustainable global society. This epistemological rupture necessary to refresh the views we apply to the world is what Spivak (2012) describes. She envisions planetary being in contrast to a dystopic all-encompassing globalism: "This is where educating into the planetary imperative—assuming and thus effacing an absolute and discontinuous alterity comfortable with an inexhaustible diversity of epistemes—takes its place" (346). Such a project requires that "both the dominant and the subordinate must jointly rethink themselves as intended or interpellated by planetary alterity, albeit articulating the task of thinking and doing from different 'cultural' angles" (347).[19] Therefore, in exploring the aesthetic, thematic, and linguistic characteristics of the Francosphere's cultural productions—literary, cinematic,

Afrofuturist Ecolinguistics

visual, digital, etc.—that enact or enunciate a vision of futurity different from the West's imposed predictions, one may discover the futures of Africa, growing from the roots of its pasts.

Georges Ngal's (1984) auto-reflexive work on writing and language depicts an African science, mixed and multiple in nature, and expounds upon its implications for the future of the African continent. A novel written in dialogical style, employing first- and second-person pronouns to advance the intrigue, much in the fashion of a theatrical script between Professor Giambatista Viko, his spouse, and other interlocutors, both in person and over the phone, the text itself embodies Giambatista's expressed desire to revolutionize writing on the basis of the traditional folktale: "the fecundation of the novel through orality" (13).[20] The principal tension in Ngal's text is precisely that of the text itself: namely, the epistemological difference between the discursive registers of written and oral expression, a contrast that evokes the postcolonial condition of a continent born of cultural encounters, contrasts, and contradictions: "a heterogeneous text" (48).[21] The protagonist struggles with the weight of historical misrepresentations that have given primacy to the Western standard while simultaneously marginalizing those other discursive forms that animate the cultural lives of indigenous peoples. He is adamant that he does not seek to codify these indigenous knowledge systems into an Occidental framework: "I am indignant and rise up against the pretention to seek to codify African myths, legends, and folktales into scientific discourses."[22] Rather, he seeks to develop and express "a properly African scientific practice" (52).[23] Ngal brilliantly prefigures the pluralist iterative process of an African episteme later espoused by theorists such as Sarr and Jean Bidima. Ngal's text voices the vehicle for the patient, underground work of bringing this African philosophical ethos to light through successive cycles of success and failure, ultimately resulting in new understandings of time and space: "It is then that a certain kind of rationality will come about, good and bad. Dialectic of success and unsuccess, or of failure and maintenance at all cost of this or

that degrading custom. What one might call an 'epistemological rupture' will take place, which will cause Africans to see the real with a new look and will have them treat time and space—master words—in a prospective manner. The patient underground work of the mole" (87).[24]

The key to this vision is an orientation toward the future, owning the space and time of one's own individual and collective being with others on the planet. This *regard neuf*, or the epistemological rupture that affords a new perspective of the real, begins in the mind and in its linguistic functions, a certain mentality nourished by experience and a desire to sense oneself, to sense the world(s) undergoing transformation(s) of becoming, from a plurality of perspectives, thereby establishing a different archival point of view from which to approach the future.[25]

Several examples of futuristic speculative fiction can be found within the Francophone African literary corpus, including Juminer (1968), in which France has been colonized by Africa, including a renaming of its streets, a reification of its culture, and a reversal of its geopolitical status. One can also note Dongala's (1982) science fiction short story "Jazz et vin de palme" (Jazz and palm wine), in which, following an extraterrestrial invasion, the human race unites beneath the tree of debate, in accordance with ancient African tradition, to solve the world's problems over palm wine while listening to John Coltrane records. Abdourahman Waberi's (2006) novel *Aux États-Unis d'Afrique* portrays an uncolonized African continent that has become the ideal place to lead a comfortable and pleasant life in a world in which political and cultural stereotypes have been reversed, and Sylvestre Amoussou's (2007) film *Africa Paradis* is set in the year 2033, in which Africa is a destination for European immigrants fleeing the economic and societal devastation of a faltering continent.[26]

Yet there remains, unlike in the corpus of Anglophone African literature, a general vacuum when it comes to works of science fiction.[27] However, if one reconsiders "science" from an ecolinguistic standpoint, the field becomes more diverse. Beginning with the

Latin root *scientia*, meaning "knowledge" or "experience," one can recast "science" and science fiction (or the fiction of knowledge and experience) from an alternate perspective that includes scientific understandings of non-European, indigenous, and diasporic African cultures. Thus, much like the example of doctors and magicians discussed previously, the interpretive possibilities for science and science fiction become much more rich and salient. Science need not be limited to metallic structures, super computers, and bubbling test tubes as the principal means for traveling through space and time. Rather, if science is reconceived in terms of nature, cosmic consciousness, mystical clairvoyance, aesthetic sensibilities, and esoteric wisdom, then one can count innumerable examples of Francophone African works of science fiction.[28] Sony Labou Tansi's *La vie et demie*, for example, which is discussed in further detail in the final chapter of this book, opens with a warning or "avertissement" that states: "*La vie et demie* becomes the fable that perceives tomorrow through today's eyes" (1979, 10).[29] In this novel, the fantastic fictionalization of science is paramount, from the floating half-corpse of Martial that refuses to die (in a way that perhaps recalls the "talking heads" on television screens) to the eighteen months and sixteen days of Chaïdana's pregnancy (74). One also encounters in that novel a stone encoding the secret histories of the thirty-nine Pygmy civilizations (89), as well as the all-encompassing sacred knowledge of the forest that is imparted to Chaïdana by one of these Pygmies (98).[30] Finally, the novel concludes with an apocalyptic cataclysm that includes devastating flies engineered by Jean Calcium with the ability to kill a man within seconds of their sting (168). These brief selected examples illustrate a "cultural dissonance" that results, as Edward Shizha proposes, from the marginalization of indigenous knowledge systems within African (and, I would argue, global) educational institutions insofar as "school science reinforces and reproduces Eurocentric or Western cultural capital, and conversely views indigenous science as 'mythical and mystical' despite its applicability to indigenous people's health systems, agricultural

production, agroforestry, and biodiversity" (19).[31] This perspective allows for African cultural and literary entities, such as the sacred forest, spirits of the ancestors, and ancient mythologies, to be incorporated into the universe of science fiction discourses. The notion of multiple epistemologies is developed further in chapter 4 of this book, which is on education in Bassek Ba Kobhio's films. While indigenous knowledge systems are specifically suited to cultural particularities as they are situated within both human and ecological environments, and adapted in such a fashion to enable the survival of the community, they are consistently eschewed on the basis of a false narrative that valorizes abstractionism and a set of predetermined universal principles of Western scientific discourses, which are nonetheless presented as absolute "global" knowledge. Science fiction, therefore, should also be considered within an inclusive framework that valorizes other forms of "science," understood in the sense of knowing and experiencing multiple cultural and epistemic realities, inviting the proliferation of scientific discourses grounded in life and experience rather than calculated sequences of simulacra or a spectacular progression of illusory images and purported absolutes. The history of the twentieth century has been marred by the repercussions of centuries of Eurocentric dominance, geographically, politically, economically, and ideologically. The principal axes of development that will be reconceptualized in this book include: (1) long-term social stability and occupational possibilities for future generations; (2) a sustainable, integrated economy, both at the local level and within a larger network of global exchange; and (3) the integrity of both human and environmental cultures, which implies striking a harmonious balance between genders and generations within a holistic ecological narrative that produces cultural mores and practices designed to maintain sustainable populations through environmentally conscious activities. As such, this project works to diversify epistemic perspectives in order to reimagine life, education, progress, development, and sustainability in a variety of futuristic conditions, ultimately creating multiple frameworks for

Afrofuturist Ecolinguistics

reintegrating human and planetary relational processes for the future enhancement of living entities by emphasizing experiential depth and richness.

To date, numerous scholars have proposed critiques of the overwhelming tendencies of development to reinscribe the same societal inequalities residing at the base of Western and European colonialism.[32] Wright has gone so far as to propose that "despite interventions and very gradual mutation, dominant development discourse was and is always already liberal, capitalist, economistic, modernist, male-centered and colonialist and/or imperialist. It has therefore drawn criticism from feminists, anticolonialists, postcolonialists, anti-imperialists, leftists, nationalists, traditionalists, postmodernists, environmentalists, and critics who subscribe to various combinations of these political standpoints" (138).

In particular, an increasing number of forward-thinking Africanist scholars have imagined alternative modalities for investing in the future of the African continent by envisioning economic growth more holistically, humanistically, and maybe even aesthetically. The central tenet of my argument is that cultural production (i.e., film and literature in their many forms) is fundamental for communal identity, which in turn defines the intrinsic values of society expressed as extrinsic political, economic, social, spiritual, educational, ecological, and mediatic models and institutions. Consequently, in this project, a critical pedagogy of evaluating postcolonial African, Afro-indigenous, and Afrofuturist cultural productions in their imaginative capacities reveals alternative expressions of social and cultural institutions and practices that not only have implications for the future of development on the continent but also could provide insights into more sustainable models to be implemented on a global scale.

Adiaffi (2002) again provides a cogent example of the conflated and ambiguous political and existential status of the relegation of the human to liminal spaces, such as prisons, of limited being or even nonbeing.[33] Thus, it must be noted that Mélédouman is described as a "cadavre ambulant" (71) (walking corpse)

like a zombie in the world of the living, but not living, because he has been denied his identity card, and "it is life . . . the identity card is more than life" (66).[34] On the first day of their journey, Mélédouman and Ebah Ya discover the power of art as an aesthetic and religious or spiritual activity, a creative process that the blinded Mélédouman perceives through a "sixth sense," revealing the symbolic power of representation as well as the historic richness of past African civilizations. This first step into the recovery of his identity evokes a number of science fiction elements, from the heavy mirror, which paradoxically weighs very little, to the perception of vast continental civilizations in the most minute gestures of the artists. These discursive elements operate like antigravitational apparatuses or holographic projections and therefore embody a certain kind of science fiction writing, albeit from a different cultural-linguistic register. The following day, they are confronted by the religious institution of Catholicism, which conflicts with indigenous religious practices: "Conflict of two worlds, two forces, two powers" (86).[35] Mélédouman remarks with irony on the hypocrisy of an epistemological hierarchy that defines one set of religious representations as sacred icons and those of a different religious symbolism as sacrilegious fetishes. Mélédouman's transcendental understanding of these two conflicting esoteric narratives leads him to the conclusion that religion is not a question of belief but of respect: "The question is not one of belief or unbelief. BUT OF RESPECT OR CONTEMPT" (97).[36] It is as if Mélédouman's magic mirror allows him to pierce straight to the heart of the debate, synthesizing the dialogical conflict between religious discourses through an acknowledgment of the potential plurality of belief systems, thereby congealing the key issue into an appeal for mutual respect, beyond the constructed inequalities of competing systems. As the author of *Gouverner par le chaos* contends, "The culture of inequality does not only concern the economic domain. It also touches the configuration of perception. . . . Illusionism and applied prestidigitation in every social field result in a life space of optical illusion, a rigged reality where the real rules

have been intentionally camouflaged" (2014, 32).[37] This is not unlike the "Society of Enmity" that Mbembe theorizes about in terms of the necessity to create and dehumanize outsiders as "others" as a cultural hallmark of contemporary global society. Mbembe argues that the various political and social expressions of a "desire for an enemy" constitute "the fundamental vectors of contemporary brain-washing," which "thrive on a vision of the world that is threatening and anxiogenic" (48). Part and parcel of the Afrofuturist project is to invent new ways of relating information and sentiments so as to contribute to commonality and mutual understanding rather than divisiveness and perpetual violence.

The entire diegesis of Adiaffi (2002) constitutes a fictional voyage into the scientific universe of ancient African wisdom, involving a visit to a strange planet inhabited by alien beings in a reality that elevates the unreal (a bureaucratic system of isolation and artificial identification), while denying the more immediate reality of the body, history, nature, and communal experience. Surviving the encounter with an encroaching alien civilizational race, Mélédouman is tasked with articulating a new episteme that enables human consciousness to essentially bypass the cloistering effects of a hypermediated individualistic global techno-economy through a fundamentally aesthetic and continuous reimagining of the relationship between the human and the planetary on a cosmological plane of existence.[38] In the frenetic and entrancing dances of the ritual, the shared rhythms and embodied move-ments intent upon resuscitating the past and reanimating the peo-ple's collective memory, Mélédouman rediscovers the lost sciences of his ancestors, the forgotten mystical powers of a supernatural science—a kind of Robot Voodoo Power. A new day dawns, and after Mélédouman realizes that he needs help in his quest to be what he is, to find himself, he and Ebah Ya go looking for home. Although it had been his goal all along, after four days of search-ing he is still unable to find his home. He describes his house as a fleeting mirage, "a house that walks and flees toward the horizon like the horizon" (117).[39] When they arrive at the place where his

house should be, it is not there, and the surrounding houses of his extended family appear to be merely walls without roofs or roofs without walls, suspended in midair. This abstraction of the real illustrates a fracturing of society in which logic and order are suspended and in which "home" is a concept that no longer exhibits its structure intact. In this absurd world, Mélédouman is told by his grieving widow that he is deceased. Therefore, like a ghost returning from the dead, Mélédouman occupies an alternative universe where he sees his former world, like the fading photograph in *Back to the Future*, slowly decomposing before his eyes. As a result, he goes to the cemetery the next day to verify his inexistence and that of the world around him, musing, "Do others live in a world that they think to be real and alive, or do they live in another world that they no longer know how to name?" (124).[40] These reflections call into question the very basis of reality and of life itself, implying the coexistence of different planes or dimensions of being. It is into one of these potential existential planes—that of the creative power of naming—that Mélédouman is reborn into the world of things when his Ebah Ya describes to him his physical characteristics as reflected in the mirror. The importance of the others to reflect upon our collective existence is an essential outpouring of eco-feminist thought, a concept that recurs in myriad ways within the African literary imaginary.

The critical counterdiscourses presented by African writers, filmmakers, and artists propose alternative conceptions of ways in which development can be reenvisioned through a futuristic perspective that also constitutes a recovery of indigenous, precolonial forms of societal understanding, including oral logics, performative aesthetics, and communal forms of knowing and communicating. An Afrofuturist perspective thereby engenders the potential for African social sciences to transcend the residual influences of outmoded Western ideologies[41] and to respond through ancient and futurist methods to precise needs of global populations through modified political communities that aspire toward independent, sustainable, and socioculturally embedded

Afrofuturist Ecolinguistics

economic viability through the twenty-first century. Adiaffi writes, "We have always maintained throughout our struggle that development is a trap-word, a façade-word, a simpleton trick. Every people follows the internal logic of its own development" (1992, 193).[42] He later confirms, "Yes, development has become a myth emptied of its historical content. In its name we do too many things that have only a distant relation to it: massacres, rapes, thefts, pillages, embezzlement of public funds, and the dictatorships of tyrants, cute little presidentiables" (193).[43] According to Adiaffi's formulation, development is a process in which each and every level of collectivity is engaged according to its own principles. By contrast development has been deployed historically by global superpowers, much like civilization and Christianity before it, to justify various atrocities associated with maintaining an unequal set of economically driven relations that define and determine human societies. Such a radical shift necessarily implies a reevaluation of the value of humanity within a global economic system, such as that which Mbembe attributes to the "Afrofuturist repudiation of the idea of 'man' stemming from modernity" (2019, 164). When the whole of humanity, and not just a subset of it deemed "civilized," "qualified," or other, can be recast as an intrinsic asset as opposed to an biopolitical economic instrument, the seeds for endogenous sustainable development can begin to sprout through what Sarr terms "a relational economy [which] seems to be the most powerful determinant of trade and of the framework of the material economy" (2019, 58).[44]

There is one final illustration from Adiaffi (2002) to consider. After Mélédouman is imprisoned, tortured, and blinded, he experiences an allegorical awakening from a cave, textually encoded through a rapturous poetic interlude, which culminates with the revelation of his being in time and an imperative to give rise to a new Africa, like that of Ancient Kemetic civilizations: "Let us sow the seeds of the future Nile" (65).[45] The generic change from prose to poetry in this pivotal chapter signals an epistemological rupture, like that referenced by Ngal, at which point the protagonist finds

himself freed to master the elements of his own destiny, beginning with temporality: "Since I inaugurate a new time, a new calendar. The calendar of my identity. The sacred time of my memory. The sacred time of my identity, lost, stolen, raped during my slumber. The long slumber of forgetfulness, the long slumber of mortality!" (68).[46] This passage sets a tone of discovery and of awakening for the remainder of the novel: a spiritual (or science-fictional) journey that Mélédouman undertakes with his granddaughter Ebah Ya, a symbol of future generations and a mirror that reflects the world in miniature. Here, the notion of an African scientific discourse that pushes against the limitations of the purely rational is rendered through the musical, rhythmic invitation to consciousness of a new temporality through the poetic interlude. Taking this postulation as a point of departure, the ensuing reflections in the young Ebah Ya's "magic mirror" reveal a new dimension of existence in which irregularities function as futuristic inventions of science fiction. She literally holds the future.

Consequently, in the chapters that follow, this book explores the notion that the next development for human society is to engage with the plurality of humanities and their cultural expressions that exist on a planetary scale, and that the study of literature, film, and digital new media is tantamount to creating a society that is capable of self-determination through shared knowledge and communal interaction. As Wright states, "Certain African-centered advances in the fields of development studies, reappraisals of the place of indigenous African education, and literature studies reconceptualized as cultural studies can, in combination, create a discursive environment in which it is possible for literature studies as cultural studies to contribute significantly to the development process in Africa" (2004, 131). Similarly, one can also read Giambatista's project of a new form of language to express the paradoxical condition of the postcolonial subjectivity as impervious to the hegemonic forces that accuse him of sacrilege: "In so doing, you have introduced subversion into orality and into Western discourse" (Ngal 1984).[47] Although realizing

his dream of a hybrid discourse to reflect the hybrid cultural and social realities of his world is a daunting task (and his efforts are initially judged as heretical), the subversive orality that he introduces is the vehicle for his cultural episteme. This episteme will continue to spread in rhizomatic fashion in order to not be subsumed beneath the weighty impositions of the status quo. This book appeals to such sensibilities, opening up conceptual spaces for scholars and academics from many disciplines to engage in thoughtful aesthetic and thematic analyses of African literary and cinematic texts in order to discover the latent and implicit societal critiques that issue from the rich historical and cultural fabric of African experiences and perspectives.

What differentiates this project from other theoretical works on Afrofuturist speculative fiction is that it takes African material realities as a science fiction in and of itself, a fiction imposed upon Africa by the West. And although there are relatively few works of Francophone African origin that exhibit the specific narrative and stylistic qualities of the science fiction genre, certain elements of the Franco-African literary corpus indicate a fictionalization of Western "science,"[48] opening the way for and giving voice to other forms of Afrofuturist expression.[49] For instance, the multiplicity of narrative voices, the asymmetry and nonlinearity of chronology, plot detemporalization, a spatial universe free from known material limitations and a fourth, spiritual dimension constituting the invisible nature of reality all constitute literary tropes and devices for interrogating the deeper significances of experiences in the delineation of any given "reality." To this end, Jean-Pierre Bekolo, who has himself dabbled in the science fiction genre, outlines his view of cinema as an immediate and direct form of communication that juxtaposes the real with the fictional and the existent with the possible. In so doing, he explores the implications of approaching the world cinematically. Bekolo writes, "I want to do what cinema does, which is simultaneously a support and a semantics for our utopias, I want to create that space in which we can geographically situate that exemplary society" (2009, 65).[50]

The immediacy of cinema's spectacular semantics of representation that Bekolo identifies operates in the same manner as other meaning-producing mechanisms of society, through a universally human and sensorial language that belies the in- or unhuman illusions that have proliferated across the planet. One particularly salient way in which cinema expresses its vision of a better world within this world is by turning a given "reality" on its head through ironic and sometimes tragicomic twists that confront and critique common preconceptions. In the case of the multifaceted developmental problematics explored here, many examples in African cinema literature and digital new media challenge the biases and preconceptions of dominant civilizational discourses. By transcending the epistemological limitations that have thus far dictated the nature of globalization and its varied developmental processes that have continued to exacerbate the insecurities and precariousness of human lives and the planet, this project proposes a way out through a series of guideposts that signal toward the ways in which our collective humanities can reconceptualize our relationships between ourselves; the systems, structures, and institutions that we as a society have created; and the planet that so far continues to sustain our civilizations.

2

Birthing the Future

Métissage and Cultural Hybridity in Francophone African Women's Writing

Métissé, prisé ou méprisé j'ai dû m'adapter . . .
Je suis mulâtre, ébène, albâtre, voulant abattre le miroir
Et comme l'Afrique est en instance de sang entre ciel et terre
Et que j'ai l'cul entre deux chaises . . . j'ai décidé de m'asseoir par
terre.[1]

—Gaël Faye "Métis," *Pili pili sur un croissant au beurre*

We know, however, that there is no such thing as
pure civilization and that all civilizations are hybrid.
The hybridity of civilizations is not something that is
derivative. It is original.[2]

—Felwine Sarr, *Afrotopia*

The global reality of the twenty-first century is one of entanglement and increasing complexity, characterized by mass migrations and accompanying intercultural encounters. Consequently, one can attempt to theorize the notion of cultural intermixing, or *métissage* in French, as a means to elaborate on the ways in

which human dignity can be preserved and celebrated in all of its forms, as deterritorialized and reterritorialized agents in a global network of identifications.[3] In her work *Postcolonial Representation: Women, Literature, Identity*, Françoise Lionnet argues that women writers employ "logiques métisses" (métis, mixed or hybrid logics) in their works, which are simultaneously universal and plural, in order to create a transformative multiverse (1995, 4–5).[4] According to Lionnet, there is a linguistic axis of "transculturation" in the context of global reality in which everything, including cultures and identities, is subject to various kinds of métissage. The task of these women writers, therefore, is one in which they must employ the linguistic and narrative systems of the dominant patriarchal culture, while at the same time giving voice to the specific cultural values of their locales through techniques of appropriation that combine different languages and traditions.[5] Against the backdrop of several canonical Francophone texts in which métissage appears as a driving narrative vector, I will discuss the theme of cultural and biological métissage as a metaphor for postcoloniality in all of its ambiguities, contradictions, and complexities through the works of five African women writers: Mariama Bâ's *Un chant écarlate*, Ken Bugul's *Le baobab fou*, Marie NDiaye's *Trois femmes puissantes*, followed by Véronque Tadjo's *Le royaume aveugle* and Werewere Liking's *Elle sera de jaspe et de corail*. Navigating the intricacies of physical and cultural métissage through the trope of maternity and infancy, one may conceptualize the birth of future African societies in a temporality, which Felwine Sarr defines as Afrocontemporaneous: "Afrocontemporaneity is this present time, this psychological continuum of the lived experience of Africans, incorporating its past and with a ripe future ahead of it, a future in need of thinking" (2019, 22).[6] The metaphor of a society with a ripe future, incarnated in the protagonists of the narratives of these African women writers, reveals the potential to reconceptualize future societal practices in ways that valorize the human lives of mothers and their children.

Mama Africas—Mothers of Métissage

Women have always held important roles in the African societies labeled as "Francophone." In her essay "La femme, source de vie dans l'Afrique traditionelle," Colette Houeto writes: "In the foundational myths of regions and cities, it is often a woman who determines the choice of the placement of a future city, as if the woman who bears the children of society should also give life to their environment. . . . The authority of women at the heart of African systems of authority is real and her participation in governance is effective in various societies" (1975, 62).[7]

As these textual references clearly show, women participated in various forms of resistance during the European colonization period in Africa. In the recent past, women have also taken charge of certain social movements. This was the case in Mali, when women consolidated their voices to force the end of Moussa Traoré's dictatorial regime in March 1991.[8] Similarly, in Liberia, an organization named Women of Liberia Mass Action for Peace advocated through nonviolent protest for peace talks between warring factions in 2003, leading to the conclusion of the civil wars that had ravaged the country for more than a decade.[9] To this end, Houeto continues: "And if the African woman is a symbol of life, she wishes life to every important institution of modern African society" (64).[10] Women's roles as active agents of change in African societies constitute a fundamental aspect of social critique and evolution.

Today, literature represents another form of resistance in which women exert an equal influence. Such is the idea that Cazenave presents when she states that since the 1970s, female African writers have engaged in forms of resistance and criticism targeting society, politics, and culture in postcolonial Africa through the medium of their writing:

> It is in adopting from the beginning a process of marginalization of their characters, a process of audacious exploration of forbidden zones like sexuality, desire, passion, love, but also like

the mother-daughter relationship, or like the questioning of obligatory reproduction and maternity as consecrations of womanhood, that they have inscribed themselves successfully in the very center, assuring for themselves the appropriation of lingual zones previously perceived as the prerogative of men. (1996, 14)[11]

While maternity need not be an obligatory characteristic nor an essentializing quality, it nonetheless represents a powerful locus of creative potential for a future-oriented society, for as Marie NDiaye astutely points out: "In any case, it is woman who is the bearer of the future, she is the condition that gives birth" (2009, 286).[12] In a way similar to the manner in which women writers from Francophone Africa have appropriated the discursive spaces of the written word and its authoritative function to engage topics that are properly feminine from a subjective position,[13] Cazenave remarks that "the female writers have begun the development of a new political novel, more visionary in the quality of the delivered message, a potential porter of promising changes" (1996, 14).[14] I contend here that the theme of childbirth as a feminine locus of power in the fictive creations of Bâ, Bugul, Tadjo, Liking, and NDiaye proposes a social and political critique of cultural hegemony through the thematic element of métissage, depicting a new political vision with regard to the regeneration of future societies in Africa and around the world.

Métissage in Its Francophone Literary-Cultural Context

While the theme or trope of métissage is not altogether absent in African literary works, it generally is not a central concern for many. For example, in his article "L'enfance métisse ou l'enfance 'entre les eaux': *Le chercheur d'Afriques* de Henri Lopes," Sow (2004) analyzes the experiences of mixed-race childhood from the perspective of male Congolese novelists, emphasizing first of all the relatively rare occurrence in African Francophone literature of works containing themes of this nature. Despite the

Birthing the Future

rarity, however, there exist certain examples that Sow presents in his essay. First, he identifies the poems of Léon-Gontran Damas, which express a "refusal of assimilation to the White race" (68),[15] a theme that links Damas's poetry with twentieth-century African American literature. Second, Sow identifies the character Marie in Camara Laye's *L'enfant noir*, who represents an intermediary figure in the narrator's unidirectional trajectory toward France and the West. Lastly, Sow discusses Abdoulaye Sadji's (1988) novel *Nini, mulâtresse du Sénégal*, in which the author depicts "the anguish linked to the narration of métis identity" (68–69).[16] Yet one might still propose that the whole of African literature makes up a type of métis story, because all African literature produced thus far represents the psychological and identitarian modes of the so-called African author, expressed through Western forms of writing and language. Thus, we find that cultural critic Boniface Mongo-Mboussa (2002a) asserts the existence of two great "esprit[s] synthétique[s] sénégalais" (synthetic Senegalese spirit[s]): namely, poet-president Léopold Sédar Senghor and writer-storyteller Birago Diop. Mongo-Mboussa describes both men as working for the harmonization of their native ways with the seemingly opposite European way. He refers to Diop's work *Les contes d'Amadou Koumba* as an example of a métis text, for the way it innovatively inscribes indigenous African storytelling within the fixity of French and European literary forms (17–18).[17]

In his investigation of Henri Lopes's *Le chercheur d'Afriques*, Sow focuses on the character André—the son of a colonial commandant, a figure he hardly knows. The commandant's departure alludes to the rupture of Europe's "marriage" with Africa: that is, the historical moment in 1960 of the "independences," when each French territory of Western and Equatorial Africa successively witnessed the breaking of the formal bonds that had linked them to European rule. In relation to this rupture, Sow argues that André's story represents a textual "métissage": a blending of childhood stories of the Congo with adult reminiscences of life in France (70). Sow also discusses the character Joseph, whose very name might implicitly refer to

another fictional character, Toundi-Joseph, the fascinating "hyphen" between two cultures brought to life in Ferdinand Oyono's *Une vie de boy*. According to Sow, Joseph also "personifies 'the métis problem'" (74).[18] Yet Joseph's behavior is contrary to André's, according to Sow. When the latter embraces his African heritage and renames himself Okana in a sort of baptism, this baptism reveals to him that "the details differentiating him from the other village boys are not signs of a curse but the mark of the sacred" (Lopes, qtd. in Sow 2004, 74–75).[19] Thus, André-Okana succeeds in creating a world in which he is free to express his inner nature, which is in stark contrast to Toundi-Joseph's alienation in *Une vie de boy*.[20]

Applying Frantz Fanon's concept of the "border line," which characterizes colonial societies as Manichaean worlds dividing colonizer and colonized,[21] Sow reveals the double nature of the métis character in Lopes's novel. No longer does the image represent a monstrous ambiguity, struggling to insert itself artificially into one or the other of the two worlds making up its soul. Rather, the métis character becomes an active mode (or, from a Hegelian point of view, perhaps a "synthetic" mode) of simultaneous participation in both worlds, thereby inhabiting a sort of third dimension of identity productivity, which will allow the character to seek out "a path between negritude and White race" (78).[22] The liminality of the métis subject is in many ways an incarnation of the discursive ambivalence inherent in the colonialist project, which defines and situates the colonized identity in the interstitial space between citizen and subject.[23]

However, Sow's essay neglects to analyze the theme of métis childhood in African literature from the perspective of the female novelists who have approached the subject. The existing body of work concerning métissage is attributed equally to both women and men. Concerning the work of male authors, we might take the first published African novels as examples of métis stories: for example, Camara Laye's *L'enfant noir*, Cheikh Hamidou Kane's *L'aventure ambiguë*, or Ferdinand Oyono's *Une vie de boy*. Each of these represents the experience of a childhood lived out

Birthing the Future

completely under the yoke of the colonial system, an inegalitarian system of cultural, political, and geographical métissage that transforms the descendants of the pharaohs into "descendants of the Gauls" and ultimately results in a nearly complete métissage of their very psyche. In *Giambatista Viko ou le viol du discours africain*, Congolese author Mbwil a Mpanga (Georges) Ngal (1984) stages a deliberate attempt at métissage in the efforts of the story's narrator, the writer and teacher Giambatista Viko, to create a new novel form that expresses psychological realities through the "first-person narrative" medium of telephone conversations. With this element, Ngal injects a theatrical, oral element into his work in a style similar to that of Alain Robbe-Grillet's "cinematic" novels.[24]

Yet from the outset we also begin to see the métis figure on display in certain works of sub-Saharan African authors, often in ambiguous formulations. As early as Ousmane Socé's (1937) novel *Mirages de Paris*, one sees the competing, ambivalent, and somewhat contradictory constructions of métissage. When the protagonist Fara, who is a young Senegalese immigrant in Paris, learns that his wife, Jacqueline, a blonde-haired, blue-eyed French woman, will soon give birth to their child, he visits his philosopher friend Sidia to ask him if he can name his child after him. What follows is a discussion around the nuances of physical and cultural intermixing. Sidia is visibly annoyed by the idea of his friend having a métis child, and he engages in a prolonged speech about the importance of racial purity in support of an elite Black class to help "heal oneself from the evil that suffocates and weakens him" (146).[25] Fara's counter-argument is that in reality, "*tout est métis*" (everything is mixed), citing the dual intellectual and cultural heritage of his interlocutor as a case in point, who responds in turn by specifying that he is concerned only with "métissage physique" (149; physical métissage, or mixing). While Sidia continues to insist upon the importance of maintaining racial purity in order to confront the established hierarchies born of European colonialism in Africa, Fara proclaims the advantages of physical and cultural intermixing: "*the métis will be the man of the future*" (147).[26] Christopher

Miller (1998) discusses the question of métissage in Socé's work in the context of the Colonial Exhibition, which took place in Paris in 1931 and makes up the principal content of the third chapter of Socé's novel, including Fara's encounter with Jacqueline. Miller notes that Socé's novel constitutes a description, not a prescription, concerning métissage, reflecting a certain intercultural reality that is nonetheless obfuscated by the illusions created in support of the unequal hierarchization of the (post)-colonial world. The problem thus resides not in the fact of métissage itself, as Fara contends, but in the dominant myths that exist on either side of the rift, which erect "incompossible worlds," to borrow from Deleuze: hyperbolic rhetorical constructions of France and Africa that cannot possibly inhabit the same ideological or cultural space.[27] An Afrofuturist reading of these texts, however, can allow for the cohabitation of antithetical constructs within a hybrid and pluralist universe.

Un chant écarlate: Murderous Métissage

During the colonial period, Africa and the West entered into a sort of troubled marriage. As an underlying narrative, this history is an integral part of female Senegalese author Mariama Bâ's (1981) second and final novel, *Un chant écarlate*. The action of this novel focuses on a love story between the young Ousmane—the child of a modest family living in Niari talli, a working-class neighborhood in Dakar during the Senghor era—and Mireille, the daughter of a French diplomat. They happen to meet at school, but when Mireille's father learns that his daughter is associating with a local boy, he sends her straight back to France. She continues the relationship, exchanging letters with Ousmane via the post. Later, having received a study grant, Ousmane travels to France, where he and Mireille are married. Before long, the new couple returns to Senegal to begin their life together. In many ways, this story incarnates the intercultural "marriage" represented by the influence of French (neo- / post-)colonialism in Francophone Africa.[28] Reversing the typical anecdote of the alienation felt by the

young African man as he wanders the streets of a Paris vacillating between racism and negrophilism, Bâ's story describes the life of a young French woman cloistered in a cultural milieu that, to her, is no less cold and strange. Driven mad by the stubborn habits of a mother-in-law who does not accept her and abandoned by her husband who has begun an affair with a childhood friend named Ouleymatou, Mireille finds herself alone and isolated, suspended between the two worlds and cultures that define her life.

Daouda Loum argues that in *Un chant écarlate*, Bâ denounces mixed marriage for reasons of cultural, traditional, and religious incompatibility (2008, 84–87). Loum points out a distinction that Sadji makes in his novel *Nini, mulâtresse du Sénégal* (1988) between straightforward, bluntly assimilating métissage (which Loum opposes) and métissage of "critical, active and reciprocal assimilation" (93),[29] which he approves of. To Loum, this perspective builds "un pont" (a bridge) between the flat-out refusal of métissage that Bâ or Ousmane Socé Diop (*Mirages de Paris* [1937]) have expressed, and its encouragement, like we find in Léopold Sédar Senghor's idea of the "civilisation de l'universel" (93; civilization of the universal). While Loum's analysis is enlightening, one must make note of a crucial point in Bâ's novel, that is, the important role of feminism, or its *feministe* aspects.[30] Agreeing with Obioma Nnaemeka's opinion, I propose that Bâ's novel, instead of denouncing mixed marriage in and of itself, attempts to reveal the signs of "cultural hemorrhage"—the result of a culture torn between two traditions (the indigenous and the colonial), adopting elements from both influences in pell-mell fashion and ultimately maintaining inequality between groups. Like Miller's comments regarding Socé's novel, it would seem that the Bâ's novel is also more descriptive than prescriptive concerning the questions of métissage. In this view, Ousmane and Mireille's marriage symbolizes a tragic failure in the universal ideal proposed by Senghor and others, rather than any kind of position taken against métissage itself.[31]

It is not surprising that the couple receives the nickname "Belle et la Bête" (Beauty and the beast) from their neighbor Guillaume,

a man who disapproves of mixed couples on principle (Bâ 2005, 174). This allusion invokes all the racial and racist stereotypes of the colonial period, yet it also inspires the question of love (we know well the fabled story of the beast earning the affection of Beauty, who saw beyond his ferocious exterior to the soft humanity within). But Mireille and Ousmane's love also resembles the Shakespearean tragedy of Romeo and Juliet, even if it is life, rather than death, that separates them: a forbidden love, budding despite obstacles, yet ultimately unable to evolve in the face of seemingly insurmountable cultural, religious, and societal differences. *Un chant écarlate* also contains a counter-example to Ousmane and Mireille: another couple, Pierrette and Lamine, whom Mireille admires because "Lamine was an open man" who "embraced the Western way of life" and "continued more gaily to turn his back toward certain social demands that did not have essential significance in his eyes" (193).[32] Here we have an image of the dangerous mixed couple that is "appauvrissant pour l'Afrique" (impoverishing for Africa), according to Loum (2008, 86–87). It is exactly this figure of the "assimilated" man against whom Ousmane rebels—however, Lamine proves himself wise in the marriage advice that he shares with Ousmane, saying, "Married life is more like human approach and tolerance" and "It's the African wisdom advising it" (Bâ 2005, 194–95).[33] Ousmane refuses to make even a single compromise for his wife or child. Both his pride—influenced by the ill will of his mother, Yaye Khady—and Ouleymatou's seductive actions, motivated by her materialistic desires, ultimately contribute to the corruption of the young couple's innocent love (187, 203, 211). Accordingly, one can clearly read a postcolonial metaphor when considering Mireille and Ousmane's engagement and the granting of independence, not only for Senegal but for the majority of former French colonies in Africa. These colonies then suffer the inequalities imposed by the "cooperative" politics and economics that Kwame Nkrumah (1966) would characterize as neocolonialist, and which would later be described by Verschave (1998) under the umbrella of Françafrique. The problem that Bâ poses in her

Birthing the Future

novel is that of a reactionary negritude that has become exclusive and essentialist, an ideal that has been corrupted and co-opted by interests and converted into destructive social force.[34]

We see the exclusionary ideology of reverse racism in the calculated efforts of Yaye Kady and Ouleymatou to undermine Ousmane and Mireille's relationship in ways that are not dissimilar to what Fanon cautions regarding the efforts of an indigenous elite to invoke or define a national consciousness in the wake of decolonization.[35] Even though Mireille attempts to participate in the customs of her husband's family, with the help and guidance of Rosalie, the wife of Ousmane's friend Ali, prejudice overwhelms her: "Ousmane Guèye visibly mocked his wife's efforts to adapt" (191).[36] Ali even seems justified when he accuses Ousmane of having become racist himself regarding his own wife and child and of rationalizing his extramarital affair with a false conception of his heritage or cultural duty: "You're trying to give cultural content to the enslavement of your senses" (264–65).[37] The métissage that Ousmane perceives as enriching for Africa and that he notices in certain other couples, in which "the African had imposed himself and was asserting his ancestry" (234),[38] has never occurred in his own relationship. Yet, this is entirely the fault of Ousmane, who, failing to assert himself, simply withdrew to take up with someone else, someone more easily accepted among his friends (282, 286).

It would appear that Bâ laments the fact that certain cultural influences and social practices continually prop up an unrealistic conception of African masculinity that, when embodied in Ousmane, prevents his negotiation of matrimonial conditions suitable for his young wife. Bâ describes this failed love: "Her heart and her body contained only Ousmane now. And Ousmane had not wanted to sacrifice anything. Even better, he was ridding himself of her, every day a little more" (300).[39] Their mixed marriage is incarnated in Gorgui, the métis fruit of their love, whom Ousmane describes as "placed at the border of two worlds destined never to mix" (237).[40] Incapable of escaping her isolated solitude, even despite the sympathies of her sister-in-law Soukeyna, who helps her

discover Ousmane's betrayal, Mireille kills her child called "*ñuulul xeesul*,"[41] because "[he] has no place is this world. World of bastards! World of liars!" (309).[42] The mercy killing of her innocent child symbolizes the failure of Senghor's much-vaunted métissage, but its cause does not lie in a cultural incompatibility stemming from French colonization/decolonization but instead lies in an ultimately unsuccessful decolonization effort that continues to entrench difference and animosity as a means to govern.[43] The image of Ousmane emerges as a man manipulated into doubting the validity of his own feelings by social pressures that eroded his ability to love the woman whose hand he had demanded in marriage and the child born of their intimacy, whom he was unable to keep. With Gorgui's tragic end, a symbol of the universality resulting from the encounter of European and African civilizations, Bâ suggests the possibility of building a future in which the civilization of this universality lights the way, and métissage occurs positively for all members of society, women and children included. Bâ's novel suggests that the world of lies and illusions is the perpetrator of affective violence, and the transformation of society ultimately depends on developing a collective consciousness to better love, tolerate, and humanize above and beyond differences—a state of being that her novel projects as an unrealized potential.

Le baobab fou: Vision of an Aborted World

The sad outcome for the ñuulul xeesul—this child born of an encounter between two worlds just as different and apparently incompatible with one another as night and day—is examined once more in the autobiographical story of Ken Bugul (this name is a Wolof phrase for "no one wants any part of it").[44] The voyage to the other's country seen this time through a woman's eyes constitutes a development of one of the principal plots of Francophone Africa's first novels, such as *Un nègre à Pairs* (Bernard Dadié), *L'aventure ambiguë* (Cheikh Hamidou Kane), *L'enfant noir* (Camara Laye), or *Ville cruelle* (Eza Boto a.k.a. Mongo Beti), in which a protagonist

leaves his homeland to visit a historically White country. Bugul (1984) depicts the alienating experience through Ken, a Black female protagonist who arrives in Brussels and immerses herself in Western life, soon finding herself intimately involved with a young man named Louis. The young Ken recalls the longing she had always felt back in Senegal for the chance to date a White person, and not long after her engagement to Louis, she realizes she is pregnant (53–55). Much as Ousmane senses a shift in his feelings for his dear Mireille, Ken begins to feel an intense hatred toward Louis, the White man and the object of her former fascination.[45] She repeats, "I detested Louis to the point of nausea" (60)[46] and "I detested him right down to his skin, this skin that had fascinated me back home in the village" (62).[47] Pregnant, married to a White man, and incapable of imagining a return to Africa, Ken decides to end the relationship and seek out an abortion procedure with a doctor who proclaims himself "contre le mélange" (60; against mixing). This novel, however, contains another example of a potential future born of encounters between Africa and the West that this time finds symbolic representation as an aborted fetus in a woman's womb. Though this métis child never sees the light of day in Bugul's novel, we nevertheless find evidence that a struggle between these two worlds has already taken root in Ken's body and in her conscience, and in a remarkable fashion: not as a physical métissage but as a form of cultural métissage, a process much like what Keith Walker calls "cultural schizophrenia."[48]

The conflict between African and Western cultures that would have found embodiment in the aborted child continues to play out visibly in the character of Ken, made manifest in the alienation inflicted upon her and in the distancing of the two cultures she inhabits. It is clear from the beginning of the story that Ken feels cut off from her cultural roots, most likely having been abandoned by her mother at a very young age. Influenced by her grandmother's concessions and even never having known her own brother (139–40), she sets out on a quest to "Westernize" herself, with remarkable success.[49] However, the pursuit of her

education distances her from her traditional family life, casting her as a potential symbol of a "generation fashioned by the French school who entered into solitude, opposite the traditional family" (146).[50] Thus, she transforms into something other, a hybrid being, suspended between two worlds. She remembers: "What I represented for others, compared to what I felt within myself—it was like day and night," and "in the village I passed for a *toubab* [a 'White' European]" (132, 140).[51] She summarizes this consummation of "two realities . . . contradictory"[52] as a "neocolonial imitation [that] was harvesting 'the elite' like a green mango plucked while its juice was still bitter" (143, 145).[53]

Ken struggles with this impossible identity throughout her life,[54] and once she finds herself in Europe, things go from bad to worse. Although believing herself Westernized, she soon must confront the undeniable fact that "Yes, I was a Black, a foreigner" (50),[55] and this assertion is made again and again by those who judge her from the outside on the sole base of her phenotypical and gendered traits (120, 123). In this way, instead of experiencing a confluence of the two cultures in which she could have grown, Ken participates in neither.[56] Thus, she represents perhaps the worst form of alienation: "Me, never having known milieu nor family, the child of a condemned generation, me, without any point of reference, how, then, could I alienate myself? Yet the *established* ambiguity, *the impossibility* of alienation, was perhaps a form of alienation itself" (50).[57] Ken represents a sort of ñuulul xeesul of the conscience. Lost in the inner space of identity conflict, she states: "I had distorted the conscience" (172).[58] Because of her culturally métis status, the world offers no place where Ken may escape from criticism. She is too Westernized for her native milieu yet appears too "exotic" to lead a truly normal life in the West.

Ken feels like she is a foreigner not only in the West but also in her own Africa—Senegal, the Ndoucoumane—just as Mireille, after becoming the mother of a métis child, no longer has a place in her native society, nor in the new society she would choose to adopt. Both women experience the rejection of two societies that

Birthing the Future

will never truly outdo one another; neither woman, recognizing the impossible "marriage" represented by neocolonization, can bring herself to inflict this same pain on a ñuulul xeesul child who would live forever marked with the exterior signs of this cultural and psychological métissage. However, in the minds of our two Senegalese novelists, this murdered, aborted future does not represent a position against physical métissage in and of itself. Rather, it is an elegy for a métis society incapable of survival because of its social prejudice. In this light, the novelists' feminine characters each assert their chosen conception of a future métis generation (whether by physical or mental métissage), but this generation will have no place in a cold, closed, xenophobic world. In the murder and abortion of this child-symbol of métissage, each woman reserves for herself the possibility of a return to the way she was, of a reintegration into a life in which the tragic dilemma of "a ñuulul xeesul," whom "ken bugul,"[59] is completely forgotten. As such, Bâ's and Bugul's novels resist the directives of postcolonial society in their refusal to submit to a false métissage based on inequality and in their envisioning of another time and another place, more ideal for giving birth to the future world.

Trois femmes puissantes: Future Reincarnations and Diaspora

The aforementioned Senegalese novelists Bâ and Bugul depict a society no less unjust and inhospitable than the colonial world. In these two Senegalese novels, the possibility of a future where métissage represents a constructive force remains doubtful, due in part to residues of familial, religious, and cultural prejudices. However, one may well recognize the tragic absurdity of a system in which métis children receive immediate death rather than a life in a sad world that will only reject them. The advent of globalization in all of its forms, including literary and cinematic cultural production, has created spaces and faces that defy the Black and White dichotomies of Europe/Africa, tradition/modernity, and civilization/savagery that constitute the legacy of European

colonialism on the African continent. Today, the distance between Africa and the West may be as small as the distance between two Parisian arrondissements, as exemplified in the work of diaspora writers such as Calixthe Beyala or Baenga Bolya, in whose works European urban geographies constitute an inverted image of the segregated colonial districts so strikingly depicted by Ferdinand Oyono's Toundi, or Jean-Marie Adiaffi's Mélédouman. Accordingly, one can note the ways in which Francophone African women writers have appropriated the ambiguous social spaces in which differences readily cohabitate as a means of restaging the past, resisting present pressures, and projecting the future of Africa and of humanity. Although their stories and messages concerning métissage are fraught with ambiguities, each writer resists a mentality that cannot accept the existence of the Other. This is just as much the case in Europe as it is in Africa and more so in the liminal cultural spaces that inexplicably cohabitate in these topographies, which is where Marie NDiaye situates her writing.

Marie NDiaye's Goncourt Prize–winning novel, *Trois femmes puissantes* (2009) represents an up-close perspective of the experiences of mixed families. The first story of this collection regards a young woman, Norah, whose father invites her into his home, which she has never known, having always lived with her mother, a French woman. Indeed, Norah recounts the tragic story of "the demons that had sat down upon their stomach when she was eight years old and Sony was five" (97).[60] She vaguely recalls the painful details of the moment when her father came and took her brother away to raise him in his own fashion in his Dakar home. We might notice the problems in such a familial situation—one torn between separate sexes and separate continents. The father represents a wholly negative presence in the lives of his daughters, whom he ignores and scorns: "'He was overwhelmed, submerged among useless, mortifying females who weren't even pretty,' Norah calmly thought, as she remembered how she and her sister had had always, in their father's eyes, this crippling fault of being too much of one type, that is to say, of looking more like him than their mother,

Birthing the Future

they were obnoxious witnesses to the futility of his marriage with a French woman—for what good had he hoped to gain from this situation, if not some children who were basically white, some well-made sons?" (26).[61] Disappointed with his daughters, who, contrary to his desires, were born too Black, he directs all his hope and energy toward his son, Sony, whom he raises with an adoptive mother. Yet Sony, too, has his fair share of problems; he sleeps with his father's original wife, who gives birth to twins, and he is later imprisoned for her murder—even though we eventually discover that his father committed the crime, killing his wife to avenge the dishonor she had brought upon him (74, 86). In the end, Norah decides to help her brother pick up the pieces of his life.

To interpret the element of métissage in this story, one must measure the father's hate, so strong that it negates any attempt at love: "despising . . . his own daughter and all the feeble, feminized West" (22).[62] Meanwhile, Sony also embodies the image of the Western child, with his Legos and his basketball; he even adorns his room with posters of American athletes. Norah, in turn, begins a relationship with a European, Jakob, a good-for-nothing who receives money from his parents back in Europe every month (41). Both of these instances can be interpreted as signaling the overwhelming assimilationist tendencies of the culture of the colonizer, as well as a latent desire to become more like the colonizer, as Fanon has demonstrated in *Peau noir, masques blancs,* and as also illustrated by the protagonists in Ken Bugul's *Le baobab fou* and Abdoulaye Sadji's *Nini, mulâtresse du Sénégal.*

The second story in N'Daiye's text tells the troubled tale of Rudy Descas. Forty-three years old and suffering from chronic hemorrhoids, Rudy, a former professor of French literature from the Middle Ages at the Mermoz School, has left his post and returned to his native France, even though he has spent much of his life in the village of Dara Salam, where his father, Abel Descas, had previously settled in a nearby resort town on the Senegal River (175–76). Rudy, who has just lost his job working for a friend of his family, Manille, resembles a sort of crude Tin-Tin,

"a foreigner with a white brow with blond locks of hair" (138),[63] which conjures up the representational specters of the colonizer's privileged gaze that depicts and defines a Eurocentric conception of Africa.[64] Rudy does admit that he received this position thanks to his mother, a quasi-mystical figure strongly present in Rudy's prayers to a powerful, yet near and friendly deity: "good little god of my Mama, compassionate father . . ." (131),[65] or again, "my God, brave little father, good and brave little god of my mother" (135, 140).[66] But the height of his misery comes with the rupture of his marriage to Fanta, a beautiful apparition whom he had met in the streets of Colobane (126) and had brought with him from Senegal, where she also taught French literature at the Mermoz School. He knows it will be impossible for her to find such work again in Provence: "this certainty that he had tricked her in luring her here" (180).[67] So Rudy finds himself alone. He has pushed everyone away, and we read that Fanta ignores him after an incident in which he utters the deplorable phrase, "You can go back where you came from" (114),[68] which effectively constitutes a repudiation of his marriage and thus grants Fanta the freedom to depart as she pleases.

The aspect of this story most pertinent to our analysis lies in the character of Djibril, a young boy of five, the offspring of Rudy and Fanta. He becomes a sort of pawn in Rudy's struggle to keep in touch with his wife; one evening, Rudy proposes bringing his son over to sleep at his mother's house, despite Fanta's protests that "elle ne l'aime pas" (113; she doesn't love him). Djibril is an image of the ambiguous child occupying two cultures, inhabiting the conflict zone of his parents. NDiaye writes: "The child lived in the house like a little undecided spirit, brushing the tiles lightly with his little feet, even seeming sometimes to float above the ground as if he feared contact with his father's house" (121–22).[69] And later: "The child was afraid of Rudy and Rudy also, in a way, was afraid of the child, for this child, his own son, did not love him, even if, in his young heart, he was not fully conscious of his father; and he did not love his house, his own father's house" (132).[70] Yet, Rudy is humanized as we read later on about the

memories that torment Rudy from within. For example, he has witnessed his father cruelly murder one swindling associate, Salif, by driving over the man's head with his four-wheel-drive vehicle (217–19). Rudy himself bears the guilt of losing his teaching position after referring to three young Black students as "putains de négros" (229; fucking negroes). The White guilt that Rudy carries continues to haunt him to the point that one wonders if he has completely lost his cultural bearings. He is entrapped between his implicit positionality as a bearer of France's (neo)colonial legacy in Senegal and his tacit participation in the gradual genesis of a postcolonial métis society. The ambivalent spaces of struggle and confrontation that have doomed Rudy and Fanta's romantic relationship are those same skewed power dynamics of benevolent domination that continue to trouble the geopolitical relations of France and its former colonies.

NDiaye's descriptions of the provincial French countryside reinforce the sense of cultural ambiguity present in the sad lives of Rudy and his family. These descriptions might just as well apply to life in any African village: "He started the car and drove until he had left the village. He parked on a dirt road between two cornfields and, without even exiting the car, set himself to devouring the bread and ham, biting alternately into one and then the other" (230).[71] The image of bites alternating between cured pig's flesh and baked goods made from wheat flour lends a taste and a visibility to Rudy's feelings when he finds himself both figuratively and literally "between two fields of corn"—his native country and his adopted land. This ambiguity is even more strongly accentuated in the character of his son Djibril; it is also present, albeit silently, in the character of his wife, Fanta. In all of NDiaye's characters and relationships and in the echoes of Fanonian psychology that permeate her text, one is confronted with an emergent picture of métissage born of a complicated patchwork of circumstances from which society cannot fully extricate itself. In this regard, Glissant proposes "*métisse thought,* from the trembling value of not only cultural métissage, but prior, or cultures of métissage, which

may preserve us from the limits and intolerances that confront us, opening up new spaces of relation" (1997, 15).[72] Ultimately, the potential for an open civilization or a culture in which métissage is an integral component resides in humanity's capacity to dispense with its Manichaean illusions and to interrogate the relational spaces that come about in the in-between moments of identification.

Le royaume aveugle: Twinhood Utopia

Such themes of xenophobia and of worlds encountering one another arise again in the work of Véronique Tadjo, an author hailing from Côte d'Ivoire and of métis birth herself (her mother being French). In this case, however, we find a purely allegorical approach to the issue in Tadjo (1990). This work describes a society divided by the arrival of a race "venant d'au-delà les montagnes" (12; coming from up over the mountains), whose invincible power and superiority have no equal. This invasive force imposes its kingdom, the Blind Kingdom, upon the earth. One might approach the reading of this Blind Kingdom from several different angles: perhaps they are an extraterrestrial race who, contrary to the peace-enforcing visitors who arrive in Emmanuel Dongala's novella "Jazz et vin de palme,"[73] bring only destruction and terror. This interpretation quickly inspires a second possible one, as a symbol of the colonization period in Africa. Thirdly, we might read the novel as critiquing the excesses of a postcolonial regime living in decadence at the expense of the impoverished popular classes.[74] A uniting factor of these interpretations is Tadjo's image of a world split in two. In her story, she makes the nocturnal bat into a symbol of the Blind rulers' monstrous societal construction: "The beasts multiplied at an uncontrolled rhythm. Thus they colonized all the trees of the village and hunted the sparrows, who began little by little to flee toward the North" (14).[75]

The conflict in the bats' hunting of the sparrows is a sure sign of the conflict between the Blind rulers and the Others. While the Blind live luxurious lives in and around the king's palace, the

Birthing the Future 69

Others inhabit a languishing world of slums: "only [they] had to go about the city on foot, [they] were coughing, spitting, suffocating" (27).[76] The segregation between the Blind and the Others is both intercultural and intracultural, and this takes shape in the characters Akissi and Karim. Akissi is the daughter of King Ato IV, supreme leader of the Blind. She falls in love with Karim, the king's new secretary, who as we learn later is one of these Others, having come out of the Great North and after deciding "to flee the slums, to leave everything behind them and to depart to live among the Blind" (30).[77] Whether we are observing a colonial or neocolonial elite in this case (to recall a thematic thread of Bugul's novel), it is clear that the Blind wish to dissociate themselves from the Others on the basis of certain racial, ethnic, or, at the very least, socioeconomic forms of prejudice. Karim remains intact in such a world by leading a "double vie" (double life). He collaborates with the Blind regime, yet he associates himself clandestinely with the residents of the slums, where he nourishes his dream of a "kingdom that would rule neither palaces nor slums" (41–42).[78]

Karim's character represents a métis individual conscious of the degree to which he exists between two worlds and two distinct lives: his life in the palace of the Blind and the life in his soul, or "the son of the dust and of the red soil, the care of the genies of the dry wind" (41).[79] When the political situation begins to deteriorate, Karim insists that Akissi flee the palace to take refuge in the north of the country with his grandmother. It is here, by participating in a mask ritual, that she regains her vision; here she becomes also, in her own proper way, a conscious métis individual. Now Akissi, who previously had "only the experience of the palace" (35),[80] now recognizes fully the exterior world, the world beyond, represented by the mask, which has given her "a piercing gaze and a lucid reason" (93).[81] When Karim dies in the palace prison, only Akissi remains to hold the future in her hands (or, more precisely, in her womb).[82] While the king and his followers cling ever more despairingly to power, Akissi wonders just how the baby could be born so that it will not end up blind itself, cloistered "within

the four walls of its gilded prison" (136–37).[83] The novel ends on a hopeful note when Akissi gives birth to a boy and a girl, the living symbols of a new life and of a new world.

Just like her counterparts from Senegal, Tadjo depicts a novelistic world where there is a fundamental opposition to integration and equality, which incites diverse forms of resistance in its own turn. The two worlds in *Le royaume aveugle* correspond less clearly to a single concrete reality, but we can still identify certain essential characteristics making this connection: for example, a schism between a dominant population and a dominated one, which might well represent the tense relationship between Africa and Europe. This choice of perspective suggests that Karim and Akissi are hybrid entities each participating in their own way in both worlds: that of the Blind and that of the Others. Their resistance against the hierarchical structures maintaining the status quo of inequality is embodied in their transcendental love, which lasts beyond all material constraints, engendering at least the possibility of vanquishing injustice. The main difference between Akissi's fatherless twins and the ñuulul xeesul children of the two female characters discussed above is that the twins' parents had in fact shared a true love, one never stained by their society's values. Beyond this, they had even chosen to operate in their society's marginal zones for the sake of preserving the potential of a generation capable of rebuilding a successful métis society founded on principles of sharing, respect, and conviviality. Yet what is perhaps most striking in this novel is the incorporation of magico-mystical elements from indigenous practices and rituals, invoking the power of the mask as a mechanism to transform oneself and one's relationship to the world and its perceived reality through a "pouvoir-souvereign-et-à -la-langue-de-terre" (92; sovereign-power-and-language-of-earth). Through a language that is tied to the earth and embodied in practice, Tadjo's novel enacts an ecolinguistic gesture toward the sovereign power of the individual in a community to transform and be transformed, engendering the capacity to change not only oneself but one's relation to being in the world.

Birthing the Future 71

Elle sera de jaspe et de corail: The Rainbow Children

The experimental futuristic currents in Werewere Liking's (1983) song-novel titled *Elle sera de jaspe et de corail,* are particularly salient, as it outlines the tenets for a productive, free, and inclusive future civilization embodying ideals adapted from indigenous knowledge and practices. The text portrays the ongoing concerns and questions among Africa and the West through two characters, Babou and Grozi, whose names and behaviors contradict the racial stereotypes typically assigned to Black or White people.[84] In the story, the *misovire* (meaning "woman who no longer has confidence in men") keeps a journal about her life in a postcolonial world in which both the West and Africa play principal, intertwining roles. Even on the first page of her controversial journal, she envisions these two world powers as the ancestors of her prophesied new race: a race "de jaspe et de corail" (23, 55; of jasper and of coral). Proceeding in the form of a mediated Socratic dialogue on the fundamental tenets of instituting a new equitable society, the misovire's nine-page journal provides a blueprint for the birthing of a more humane and feminine social fabric. After an epigraph on the second page, the third page of this infamous journal pays homage to womanhood: "Eternal Mother [you are] Manifest even here and now / The next humanity" (96).[85] Liking's approach to critiquing society from a female perspective is a creative vision of a future race, one not pure, yet still much more than a hybridization, more than a mere "twinning": for it will be as multicolored as jasper and coral.

In the story, the misovire shares with Babou and Grozi a procedure for forming and even raising this new infant humanity, because a new humanity must necessarily be the product of multiple individuals. This procedure begins with the creation of a new language, and on her journal's fourth page, the misovire writes that "for a new language. . . . A race breathing new life in the verbal power of the word" (109).[86] The question of language in postcolonial societies, since Fanon, has been fundamental to

any theoretical project concerning the development of Africa and Africans, and it constitutes an ever-present theme, both implicitly and explicitly, in the works of numerous African writers, whether the concern is orality or other means of encoding indigenous African linguistics and concepts in Western written narrative forms.[87] This new language, according to the misovire's journal, will be "capable of shaking shaking shaking us until the total evacuation of the scabs of ignorance of indifference of limitations and of complexes inoculated by two centuries of obligatory inactivity of periods of non-creativity of times severed of originality" (106).[88] It is important to note, as Felwine Sarr (2019) does, the interconnectedness of indigenous African cultural practices in which the material, the communal, the esoteric, and the aesthetic are all interconnected in their functions of structuring daily life. A language that does not dissociate these elements through categorical biases is therefore essential to the construction of alternative futures, such as that which Liking outlines in her novel, and for which Sarr also advocates. He writes: "The thought and articulation of an African social project that has as its end goal the completion of its economic, cultural, and social mutation [occurs] . . . at the sites where discourses are produced that Africa has created for itself: within the spheres of culture, art, religion, demography, urbanity, and politics" (23–24).[89]

The reconstruction of African futures involves a dissociation from Western modes of thinking that have traditionally relegated African cultures to marginal statuses resulting in a reactionary and justificatory modus operandi of a constant struggle for self-assertion *against* the dominant values of globalization. For this very reason, on the journal's fifth page, the misovire attributes an essential quality to this new creative language: "the critique of a culture by cultivated men" (117).[90] This implies a constant rearticulating of societal structures to accommodate the fluctuations of social evolution but rooted in a cultivation process that helps to delineate the ideological bases of such a critical practice. Sarr describes such a rootedness in the deployment of a new temporality

Birthing the Future

and autonomy, which consists in the capacity to take the "time to try things out, to experiment, to carefully gather up various flowers coming from a variety of different gardens, to delight in their fragrances and to serenely arrange the bouquet according to the art of flower arrangement" (2019, 26).[91] The iterative process described in terms of a gardening metaphor, which blooms with imagery of agricultural métissage, is one way to envision the process of cultural auto-critique that Liking's novel insinuates.

Building upon the necessity to constantly reinvent and rearticulate the forms and contents of cultural practices, the misovire introduces a choice in her journal: "the pausing gaze that poses its problems / And sees and distinguishes" (127).[92] Once again, the reader is confronted by the predominance of an alternative temporality, an interruption or a pause that initiates a reflective moment for meditation: the ultimate objective of which is the advent of a new human race that will adopt a lifestyle of originality, dignity, quiet reflection, and unyielding deliberation. In addition to Sarr's depiction of the art of floral arrangement, one can also identify affinities between Liking's proposed social project and Spivak's (2012) conception of *An Aesthetic Education in the Era of Globalization*, which involves "the training of the imagination for epistemological performance of a different kind, called an aesthetic education when institutionalized" (345). An essential aspect of Spivak's conception of a new epistemological performance is that "both the dominant and the subordinate must jointly rethink themselves as intended or interpellated by planetary alterity, albeit articulating the task of thinking and doing from different 'cultural' angles" (347).[93] Consequently, bringing together a heteroclite sampling of perspectives, or a variety of floral and vegetal species in Sarr's analogy, all with the common understanding of a shared planetary being, is what will allow for new ways of knowing and experiencing the world and its others to emerge.

Along these very lines, on the seventh page of the misovire's nine-page personal journal, she underscores the importance of friendship for this new human race: "the triumphal voyage to the

depths of oneself / And of the other" (133).[94] Seen from this perspective, the misovire's idea of friendship capably allows for any difference that might exist between the self and other persons or groups. On the following page, she makes an ode to education: "a plan for harmonious evolution that will work automatically through education" (142).[95] Later, she explains how this requires the foundation "of a veritable education that replies to the aspirations of a human soul in its quest for evolution, resolving equilibratory problems existing as the necessary result of a reproduction of bodies susceptible to be chosen for a conscious orientation" (144).[96] Here, the misovire reveals herself quite firmly with regard to the necessity of this (r)evolution in the education of the youth because she refuses to have another child until the life offered to her family will be one "full of experiences of enriching emotions of sources of inspiration of exaltation of possibilities of creative actions" (144).[97] The power within women to give body and spirit to future generations is absolutely clear in this case. The misovire does not accept bearing a ñuulul xeesul in an ungrateful and ignorant society, and beyond this, she proposes a concrete plan of action to realize the conditions necessary for creating this new humanity based on a culture of equilibrium and on an edifying education that balances emotion, creativity, and imagination with rationality and praxis. She says, "For my own children will be blues and rose-coral hues of the New Race" (145).[98] The misovire's journal shows us how we might gain a conception of humanity beyond the limitations of a society in which positive ideas of métissage have been murdered, prematurely aborted, or convoluted into a schizoid pathology. And the key to all this, found on the journal's final page, is to proceed onward into life with a meditative and renewing outlook. Here, we are called to the imperative: "Weigh words and posits actions" (Liking 1983, 156).[99]

Liking also proposes, in her turn and in her own manner, a future world in which Black and White racial difference is not so clearly delineated, and the color of future generations is as diverse and pluriform as the beautiful shades and hues of the earth's stones

and corals. We might consider it a song of hope for all Africa to imagine this mosaic, multicolored, necessarily transversal, and egalitarian image of a potential relationship between Africa and the West. Tadjo (1990) also emphasizes this hope and this potential embodied in the twin children of a love that miraculously endows the Blind Akissi and, by extension, her progeny, with vision. With a uniquely feminine power—this cosmogonic, procreative instinct giving birth to the future in all its forms—these novelists resist a postcolonial interpenetration that spreads hate, discord, and inequality among peoples and countries. In critiquing the stereotyped relationships between Black men and White women and between White men and Black women, or any relationship involving an "Other," these women refuse to accept the limitations that their present societies impose upon them. And in the image of the child that each main character holds within her body, the work of these writers proposes a future open to many possibilities. Nonetheless, it is precisely in the power of fictional texts to posit potential futures that Afrofuturist thought provides promise and hope. Mediated through the power of the word as action, as Liking concludes, her text further constitutes an enactment of that very potential through its experimental language that congeals the unbridled potential of the verbal and embodied expressive content of the human imagination. For, as Ralph Ellison writes in *Invisible Man*, "Despite all the talk of science around me . . . there was a magic in spoken words" (1995, 381). The power to speak new worlds into existence constitutes an animating force for Afrofuturist imaginations, as glimpsed through the works of both Véronique Tadjo and Werewere Liking.

Raising a Rainbow Nation

Children are a universal symbol of hope and change. Their bodies and minds are the space in which today's dreams and desires can be cultivated to yield tomorrow's realities and, in this sense, represent the penultimate space of the politics of biopower. In this

chapter, the bodies of babies, born and unborn, in the works of five women novelists from Francophone Africa, draw particular attention to how the infant, or fetus, embodies the hybrid space created by the union of its parents, physically, culturally, and metaphorically. In these bodies, we can read allegories of colonialism as well as modes of resistance, drawing out the implications of these bodies' inscriptions for twenty-first-century African identity politics. Mariama Bâ's *Un chant écarlate* literally gives a body to the intercultural marriage that was French colonialism in Africa. A reversal of the typical tale of African alienation in a foreign Western world, one can read the love relationship between Ousmane and Mireille as an allegory of French colonization and decolonization. Their encounter is one of mutual admiration, which eventually leads to the birth of a mixed-race baby. When Ousmane recoils into the arms and bed of Ouleymatou, the neglected mother poisons her baby, stabs Ousmane, and leaves. The subtext of this extremely powerful image of an insane mother murdering her child depicts a sadly pessimistic view of international French-Senegalese relations. But rather than assigning blame to either party, the hypothetical, hybrid, open, and inclusive "civilisation de l'universel" (civilization of the universal) of which Senghor was such a proud proponent dies in infancy as a result of the insensitivity of Ousmane and Mireille's respective parents. Both parents, in their own ways, play the part of the meddling in-law to undermine the couple's intimacy.

Ken Bugul's abortion in *Le baobab fou* enacts a powerful foreshadowing of the trauma suffered by the narrator over the course of the novel. And much like the inter- and intrapersonal difficulties that Marie NDiaye's work engenders through its nuanced character development, signals yet another case of failing to give birth to a new mixed race of humanity. The dream of a rainbow nation such as the one that Liking (1983) envisions has long been an aspiration for artists and intellectuals. Véronique Tadjo, herself a métisse born of a French mother and an Ivorian father, portrays a more hopeful vision of métissage in Tadjo (1990) in

which the question of racial difference is both highlighted and placed in suspension through the creation of two categories of people: the Blind and the Others. Karim, an Other who hails from "le grand Nord," falls in love with Akissi, the daughter of the king of the Blind. When she exiles herself, Karim's mother, unlike the spiteful Yaye Khady in Bâ's novel, helps Akissi to see by letting her undergo a sacred initiation ritual. Though Karim ends up dying a martyr's death, Akissi gives birth to twins, one male and one female, symbols of hope for a future that is not divided by differences. Although an explicitly phenotypical element of métisse identity is absent in her novel, Tadjo nonetheless offers a hopeful vision of the ways in which love can unite despite difference. However, one must not forget the fundamental difference in humanity, which is its gendered and sexualized character. Hence, the central role of women as integral and fundamental elements of a future-oriented society must be fervently underscored. Reprising a statement from Ngal (1984), "We others, women, through maternity, we are artists. Our children are artistic masterpieces because we carry in us, essentially, the hopes of maternity" (58).[100] If women are the artists who create the children of the future, it is imperative to open up spaces of inclusion and support for mothers to make their aesthetic and ethical choices with regard to the future of humanity. The Orwellian aphorism "Who controls the past controls the future; who controls the present controls the past" (Orwell 1981, 204) rings loud and clear with a heavy weight of responsibility for those entrusted with the birthing and raising of Africa's children. And it is to that end that these particular writers have given their voices to the task of reinventing the past and therefore reimagining possible futures in an effort to articulate a new critical humanism[101] that celebrates difference—both racial and gendered—and invites responsible agency on the part of all for the eventual realization of its African futures.

3

Child Soldiers

Reinscribing the Human in a Culture of Perpetual War

It isn't one side or another that wins the war but war itself: the old creature that stifles all questioning and releases longing for belief and affiliation over and against that which attempts to rise up.[1]

—Jean-François Lyotard, *Soundproof Room: Malraux's Anti-Aesthetics*

Colonialism is not a thinking machine, nor a body endowed with reasoning faculties. It is violence in its natural state, and it will only yield when confronted with greater violence.[2]

—Frantz Fanon, *The Wretched of the Earth*

Writing about Joseph Conrad's *Heart of Darkness*, Edward Said states in *Culture and Imperialism* that "to represent Africa is to enter the battle over Africa, inevitably connected to later resistance, decolonization, and so forth" (1993, 68). The battle over Africa is one that takes place simultaneously in the realms of the physical and the

Child Soldiers 79

ideological, in which oppositional forces have for centuries engaged in the struggle to come to terms with the extreme violence of imperialism and its enduring legacy on global cultural forms. In fact, one might go as far as to suggest that rhetorical and representational violence are the preconditions for physical and cultural violence. On the one hand, despite a perceived democratization of knowledge, stereotypes of an impoverished, violent, diseased, and dangerous "dark continent" are continuously perpetuated by global media corporations in concert with neoimperialist political forces that concurrently create the very conditions they decry.[3] On the other hand, African writers, filmmakers, revolutionary political figureheads, and a generation of tech-savvy social media entrepreneurs have, in the face of such dominant forces, been engaged (consider the French concept of the *écrivain engagé*)[4] in a decades-long rhizomatic struggle to represent Africa both otherly and from within.

Based on literary and cinematic representations of child soldiers in Africa, I contend in this chapter that different modes of storytelling provide a nuanced understanding of the varied and sometimes contradictory intentions and effects of human rights policies pertaining to children in armed conflicts. Furthermore, the ambivalent figure of the child soldier, I argue, constitutes a representational critique of international humanitarian aid organizations in that these, much like their colonial predecessors, contribute to the vicious cycle of dependency and a climate of constant catastrophe in order to profit.[5] I begin with an analysis of the changing rules of contemporary armed conflicts wherein nonaligned armed groups (termed "war machines" by Achille Mbembe) gain power through the control of natural resources and the exploitation of local populations with little to no regard for collateral damage. One of the highly visible and tragic characteristics of these war machines' operations is the enlistment, training, and deployment of child soldiers, among other ambivalent tactical agents. Drawing out the common themes in child-soldier narratives from Africa, I will engage the child soldier's ambiguous position between victim and perpetrator as an embodiment of

the paradoxical power relations influencing the global economic policies often driving intranational armed conflicts.[6] Through discussion of the different didactic elements in these child-soldier narratives, I identify the ways in which forms of storytelling can, through their inherent critiques of human rights policies, constitute an alternative representation of Africa that may potentially exhibit positive impacts for peace building on a global scale.

Necropolitical Contexts and "War Machines"

At the heart of this representational debate regarding Africa, its peoples, and its resources is a long history of racialization and racism: this is an ideological invention that has proven resilient in helping external powers maintain a firm foothold in Africa. The continent has a long history of being claimed territorially, politically, economically, and otherwise by a number of external groups—perhaps most notably the European colonial powers in the late nineteenth century. Even after independence was obtained by most of the continent's nascent nation-states, economic and political measures put in place by the former colonial powers maintained a firm grip on the structures and institutions that were of interest to the global political economy. Consequently, Africa remains a discursive space of contradiction in which nominal independence and feigned autonomy belie an ongoing subservience and a denial of agency. Mbembe writes, "A world shackled by cruelty, violence and devastation, Africa would be the simulacrum of a blind and obscure force, enclosed in a time that is somewhat pre-ethical, indeed pre-political" (2013, 81).[7] Africa as a concept in the dominant media discourses that shape the global popular imagination constitutes an ideological chimera, a fictitious nonplace that was initially construed as a utopia by European thinkers from the Middle Ages (see Rabealais's *Pantagruel*, as one example) and later became a vacant arena for the political experiment of European colonization and its various metamorphoses over the last four centuries of the millennium.[8] Although the conceptual

Child Soldiers

space of Africa has evolved in concert with the staggered stages of Arab and European colonization, decolonization, development, modernization, and its emergence into the arena of global economics, it remains a space of paradox, conflict, and negation. Mbembe continues: "According to the philosophical horizon of our time, the term 'Africa' has come to mean nothing more than a way of naming the political question of the desiccation of the living; a way of politically interrogating the difficulty, the dryness, the roughness of life or even the visible, yet blinded and opaque forms that death has succeeded in dressing up in contemporary commerce between the living" (2013, 86).[9]

Mbembe's hypothesis is that the ambivalent construct of Africa is not only a conceptual space of suffering but also has become synonymous with a kind of mythical underworld where death resides in all of its forms, reaching across its boundaries into the world of the living. The end result of a Fanonian complex of the colonized, Africa has been relegated to an ambiguous passage where new political and humanitarian forms can be implemented, tried, and tested with relative impunity.

One example is the Malian crisis, which continues as of December 2022, following the withdrawal of French forces through ongoing terrorist attacks carried out in northern Mali as part of a conflict between Islamist and government-aligned factions. Furthermore, this conflict also has taken on an ethnic dimension like many intranational conflicts in Africa: in this case between the Peulh and Dogon populations. The Malian crisis began with a military coup d'état on March 21, 2012, in response to the government's perceived inability to support its soldiers, who were being routed by an ethnic Tuareg rebellion in the north (the Tuaregs have persistently staged many such armed rebellions since the early 1990s). The disorder spawned by this rebellion created the proper circumstances for war machines to migrate to new, fertile soil. In an article in *Time* magazine, Alex Perry identifies the influx of Islamist fighters as left over from the Algerian civil war in the 1990s as well as members of the radical Nigerian insurgent group Boko Haram (2013, 20–23). In

addition, after the fall of Libyan dictator Muammar Gaddafi, many of his former supporters who were ethnically related to the Tuaregs also moved into the perceived void, resulting in a Tuareg-Islamist alliance known as the MNLA (Nationalist Movement for the Liberation of Azawad), perhaps taking their cue from the recent successful "liberation," or separation, of North Sudan and South Sudan. What this conglomerate of insurgent groups makes abundantly clear is that regional stability in Africa cannot be conducted in a national vacuum without considering histories and sociocultural dimensions of various interrelated conflicts.

Although Islamist groups have been operating in the region for some time—AQIM (al-Qaeda in the Islamic Maghreb) has been recognized as a threat since 2007—it is worth noting that the terrorist network is not the grand mastermind behind the crisis but rather something more akin to a post hoc attribution (a notion also alluded to in the aforementioned *Time* article). A military response from France (the former colonial power) in defense of the shaky interim Malian government threatened by advancing AQIM forces toward the capital of Bamako is an ironic reversal of events from one year prior, when France militarily aided a nearly ten-year-old rebellion in northern Côte d'Ivoire in ousting the government of the then-incumbent presidential candidate Laurent Gbagbo (ultimately acquitted of crimes against humanity by the International Criminal Court in February 2019). Why the French would choose to support one rebellion and quench another through direct, unilateral military intervention raises some serious concerns regarding the precise nature of the "independence" of its former colonies.[10]

Mbembe (2013) ultimately rests upon the hypothesis that the figure of the "nègre," the dark-skinned antisubject, constitutes the catalytic force that drives modern capitalist society, noting that the colonial order rests squarely upon the notion of a humanity that is divided into species and subspecies. Furthermore, Mbembe writes, "In large part, the term 'Nègre' signals a state of minority and claustration. He is a sort of breathing island in a context of

Child Soldiers 83

racial oppression and sometimes of objective dehumanization"
(79).[11] If, as Didier Fassin contends, "political subjectivation . . . is
the production of subjects and subjectivities possessed of political
meaning within social interactions" (2012, 202), it would follow
as a consequence that the Black or African "subject" is a peculiar
political construct that has somehow been voided of its human-
ity and, by extension, its value within the context of the global
humanitarian order. Fassin remarks, "Thus within the arena of
humanitarianism itself, hierarchies of humanity were passively es-
tablished, though rarely identified for what they were—a politics of
life that, at moments of crisis, resulted in the constitution of two
groups of individuals" (240).

The transnational nature of the rebellion in northern Mali
is the result of regional destabilization, which dates back more
than twenty years: The war machines that dominated Liberia
and Sierra Leone during the 1990s (mobilized and supported in
varying degrees by Western economic interests) and that then
participated in the Ivorian civil conflict from 2002 to 2011 may
very well have been looking for the next battleground in which
to exercise their practice. This, of course, begs the question of
the long-term efficacy of France's recent military interventions.
While Côte d'Ivoire still reels from the political aftershocks of
its regime change (several high-ranking officials in the former
government were later apprehended in neighboring Ghana and
handed over to Ivorian authorities), it would be naive to assume
that the various armed rebel groups that had occupied Timbuktu
and a number of other significant patrimonial heritage sites in
the northern region had simply disappeared. Similarly, Kenya,
on the other side of the continent, was faced with the repercus-
sions of regional destabilization as extremists from neighboring
Somalia (a nation with a long history of civil, ethnic-religious,
and clan conflict even before the era depicted in the film *Black
Hawk Down*, and the more recent news stories of Somali pirates
off the Horn of Africa) began crossing the border in search of
new opportunities. Regional destabilization is commonplace

across the African continent. As the particular conflict in northern Mali continues to simmer seven years later in 2022, one must ask questions about the efficacy of international military and humanitarian interventions, not only in Malian affairs but in general because humanitarian crises only seem to increase, a condition that Mbembe characterizes as "le devinir-nègre du monde" (257; the becoming-Black of the world). Fassin points out that "'military-humanitarian' intervention has become a commonplace," and furthermore contends that "in the global development of the 'new humanitarian order,' . . . nation states in their capacity as agents of humanitarian policy, [are] often closely tied to military practices" (2012, 189). Consequently, the new political rhetoric of humanitarian crises can be construed as cause and justification for war, which would otherwise have no basis.

Mbembe's "La raison nègre" (Black reason)—the articulation of Africa as a nonspace of suspended subjectivity—and Fassin's "La raison humanitaire" (humanitarian reason), with its hierarchization of humanities, operate along the same continuum, that of a fluid and detached politicized rhetoric that reinscribes the "human" within the terms of its own rationale or "reason," shifting its dispensation of aid according to the whims of the international political economy. During the Cold War, for example, the African continent constituted the stage where the ideological battle between capitalism and communism was fought, from the assassination of Patrice Lumumba in the Democratic Republic of the Congo in 1961 to the death of Burkinabè revolutionary Thomas Sankara in 1987, among other instances. If the motivation of military-humanitarian interventions, assassinations, bombardments, and the like was purely to protect the rights and interests of human lives, then they appear to have been, historically, a sequence of total failures, often contributing to further regional destabilization in the short term, with uncertain, if any, long-term projections. The ambivalence of conflicts in Africa, from colonialism to the present humanitarian age, has been predicated on a distinction between different fabricated groups of "humanities" with disparate

Child Soldiers

levels of social and political agency. The dissociation of humanity from itself implied by Mbembe's Black reason exerts its power through the capacity to constantly produce what he terms "des objets schizophréniques" (57; schizophrenic objects). The construction of humanity and its others, oppressed and dehumanized by discursive practices that deny their fundamental right to exist, is a question of planetary importance, which has long been theorized by thinkers such as Gayatri Spivak, Trinh Minh-ha, and others.[12] In order to understand the discourses that define humanity, it is necessary to interrogate the different fictions that create it and its others. The ambivalent figure of the child soldier, I argue, constitutes a critique of international humanitarian aid organizations in that these, much like their colonial predecessors, contribute to the vicious cycle of dependency and a climate of constant catastrophe in order to profit.[13] To echo the quote in the epigraph, the only party that wins in war is war itself, as demonstrated by a new necropolitical economy of perpetually deterritorialized and reterritorialized war machines that continue to create ambiguously situated victims and perpetrators of postcolonial violence.

Examining some common characteristics of the contexts in which child soldiers are created, from abduction and integration to active participation and potential reconciliation, all within a climate of violence which Mbembe describes as "necropolitical," there is a dominant form of politics based on "the generalized instrumentalization of human existence and the material destruction of human bodies and populations" (2003, 14). Its principal form of expression is through power over life and death, and Mbembe even goes so far as to say that "politics is . . . death that lives a human life" (14–15). The ultimate consequence of this form of political economy is the systemic transformation of human beings into (necro)political capital, the inherent value of which is not determined by their life or productivity but by the ever-anticipated circumstances of their death in service to the political machine.[14] The necropolitical economy that Mbembe describes is particularly evident in the wars of the late twentieth and early twenty-first

centuries, in which rules of modern warfare between nation-states and their respective allies no longer apply. Contemporary wars, such as those in Iraq, Afghanistan, or Syria (although Mbembe cites the earlier examples of the first Gulf War and the war in Kosovo), are extremely complex and resemble nomadic (or continuously deterritorialized/reterritorialized) strategies of warfare, often with little regard for collateral damage or civilian casualties.[15] Mbembe writes, "A patchwork of overlapping and incomplete rights to rule emerges, inextricably superimposed and tangled, in which different de facto juridical instances are geographically interwoven and plural allegiances, asymmetrical suzerainties, and enclaves abound" (31).[16] Such a situation is the result of arms being actively traded on the open market, thus allowing for virtually anyone with sufficient economic power to form a private army, either in opposition or as auxiliaries to standing national armies. Once these war machines are created, there is a vested interest to continue operating because, as Mbembe notes, these war machines have features of both "a political organization and a mercantile company" (32). War machines support themselves through the creation of an environment that is favorable to perpetual war, where they can pillage resources, control populations, and hold territory, all as a means to maintain their parasitic existences.

February 12 marks the International Day of Child Soldiers, and despite over thirty years of policy and exactly twelve years of concerted efforts to halt the recruitment of children under the age of fifteen into the armed forces (those under eighteen are not supposed to engage in direct conflict), the United Nations Children's Fund (UNICEF) estimates indicate that child soldiers continue to be recruited and that children, both boys and girls (some younger than the age of ten), involved in armed conflict throughout the world number in the hundreds of thousands.[17] Despite efforts, that number has not decreased. In addition to war-torn Middle Eastern countries such as Iraq and Afghanistan whose governments were toppled by US imperialist foreign policies of the last decade, many countries where child soldiers are still actively participating

in violent conflict are on the African continent, including Chad, Sudan, Uganda, Somalia, and the Democratic Republic of the Congo, and increasingly in prominent West African nations, including Mali, Burkina Faso, and Nigeria. With the media frenzy generated by the Kony 2012 campaign, which aimed to capture one of the world's most long-standing war criminals (yet another example of an ultimately unsuccessful humanitarian campaign), it is imperative to initiate a serious, responsible, and sensitive dialogue around the issues facing child soldiers, past and present. One of the purposes of the Invisible Children's campaign, the group behind the Kony 2012 movement, was to capture Lord's Resistance Army leader Joseph Kony and thereby bring the children home. My aim here is to contribute a deeper understanding of the problems surrounding child soldiering on the African continent (which is not the only place where such practices occur). I strive not to judge the efficaciousness or lack thereof of any particular approach to the problem but rather to contextualize the issue in terms of the general political-economic conditions that precipitate the types of intra- and transnational conflicts in which children are commonly instrumentalized and used as "tactical agents."[18]

My analysis is based on geohistorical realities but only insofar as these are the contexts that inform the narratives I draw upon as my primary sources: Ishmael Beah's (2007) autobiographical novel *A Long Way Gone*; Emmanuel Dongala's (2002) novel *Johnny Mad Dog*; the accounts of Ahmadou Kourouma's (2000, 2004) fictional child-soldier narrator, p'tit Birahima, who appears in the novels *Allah n'est pas obligé* and *Quand on refuse on dit non*; and Nigerian-born director Newton Aduaka's (2007) film *Ezra*. These accounts, which are typically told in the first-person narrative voice, depict thoughts, feelings, and observations regarding the operation and consequences of war machines from the ambiguous perspective of the child soldier as simultaneously victim and participant/perpetrator. The child soldier, when understood as the embodiment of the inherent ambiguities of humanitarian and human rights discourses, can present a necessary critique of violence in

various African contexts by reinscribing the inherent but usurped humanity of those who would otherwise be reduced to "tactical agents" or necropolitical capital. Furthermore, I conclude that the child soldier constitutes a representational paradox, the deployment of which in fiction is indicative of an Afrofuturist subjectivity. The subjectivity of the child soldier is simultaneously denied and reimagined in an alternative universe—the narrative—as a means of coping with the trauma of identitary dislocations.

P'tit Birahima: Mockery of Mayhem

Kourouma's (2006) *Allah n'est pas obligé* is written from the perspective of a fictional child soldier, Birahima, a Malinké, shrewd entrepreneur, and devout Muslim who nonetheless participates in a real historical context, namely that of the decade-long conflict over territory and power that rocked the longtime American and British African nations of Liberia and Sierra Leone in the 1990s. Originally from Côte d'Ivoire, the youth (who is either twelve or thirteen years old—his actual birth date is uncertain), is uneducated, but he skillfully uses four dictionaries that he owns, Harapps, Larousse, Petit Robert, and a lexicography of sub-Saharan African Pidgin French, to accurately recount his story in French (3–4). Birahima departs into Liberia in the company of his uncle (orphaned, Birahima was raised mostly by his grandmother) in order to take advantage of the lucrative arms trade and ends up in the ranks of one opportunistic warlord after another. The insistence on language and the process of representation is key to understanding the narrator-subject's compulsion to recount his traumas in the complex socio-linguistic and cultural context of the African postcolony.

In her article on reframing peacebuilding through the fictional narrative in Kourouma's novel, Christina Lux (2010) recognizes an "acute need for dialogue between literary studies and the social sciences."[19] Lux further proposes that Kourouma's telling of the trauma of the territorial wars that plagued Liberia and Sierra

Leone in the 1990s constitutes a therapeutic trajectory that proceeds through two parallel levels of narration: the historical and the environmental (61). In the tension between these two levels of narrative, Lux identifies a site for expressing trauma through an attachment to one's environment (which is always fluid and changing), in contrast to the historical narrative in which the subject is lost in the chaos of multiple competing factions and conflicted interests. Furthermore, in her essay "Human Rights, Child-Soldier Narratives, and the Problem of Form," Maureen Moynagh (2011) elaborates on how narratives, whether fictional or factual (or a mix of the two), such as *Allah n'est pas obligé*, help to reframe human rights discourse. One way this is done is through a form of suspended temporality, which she characterizes as a "chronic temporality of the picaresque," a kind of "developmental limbo" (51). Behind this conception is a notion that digs into the problematic construct of the child soldier in terms of becoming because, as she points out, in the process of being made a soldier the child ceases to be a child, although he does not become an adult, either.[20] This in-between state is illustrated by the circularity of Birahima's interminable journey, which ends exactly where it began: with the no-longer-a-child-soldier sitting down to indulge in the compulsive retelling of his story. The insistence on the space of linguistic creation and the open temporality that it allows for exploring traumatic pasts and opening up future avenues for existence are key components of this particular text.

When one considers the context of the writing of Kourouma's two final novels, an interesting point can be made regarding Birahima's ambiguous fate. *Allah n'est pas obligé* was published in 2000. The conflict in Sierra Leone did not officially end until 2002, which means that the narrator, Birahima, is left suspended in a state of uncertainty at the end of the novel, one in which the only continuity is his quest to recount his "bla bla bla" with the help of his four dictionaries.[21] This is also the same contextual link that ties this first work to its unfinished 2004 sequel, *Quand on refuse on dit non*, which tells the beginning of the story of how "tribal war

arrived in Côte d'Ivoire" (2004, 11),[22] a nation that had exhibited one of the most peaceful and prosperous histories in West Africa (the "Ivorian Miracle") until a coup d'état in 1999. The ever-shifting context of violence in sub-Saharan Africa is the backdrop against which Birahima's "arrested development" plays out, picking up where it left off, four or six months after having left Liberia (he doesn't remember exactly) as his saga continues. One could say, echoing Birahima, "Tribal war would have it that way" (137).[23]

As the title suggests (a quotation attributed to the illustrious resister of French colonization, Samory Touré [36]), *Quand on refuse on dit non* is a refusal on several levels. First and foremost, it presents a critique of the myth of modern nationalism from the outset as Kourouma situates in parentheses, as if in a side note: "The Republic of Côte d'Ivoire ... like all the fucked up republics of this region, democratic in some ways but rotten to the core by corruption in all the others" (11).[24] Secondly, although written in French, Birahima's account ironizes the authority of the French language (in much the same way as he ironizes the authority of postcolonial despots Compaoré, Houphouët, and Eyedema, to whom he repeatedly refers as "dictators," as well as the international community and its "peace-keeping" missions)[25] by stating, "I speak French badly, very badly" (15).[26] He then underscores this statement by making reference to his "dictionnaire" to point out linguistic subtleties of certain French expressions. For example, he plays with the synonymous expressions of pedigree, or one's professional qualifications: "I will show you my pedigree (according to my dictionary, pedigree means the life of a wandering stray dog)" (13).[27] The irony of Birahima's self-deprecating humor in likening his own exploits as a child soldier to the life of a wandering stray dog is enlightening. Furthermore, Birahima's dictionary also allows him to ironically point out global inequality as he notes that a group of White people is called a "community" or a "civilization," whereas a group of Black people is an "ethnicity" or a "tribe" (16).[28] This rhetorical violence runs flush with an ongoing account of physical violence throughout the novel, after Birahima

Child Soldiers

narrowly escapes death at the hands of a group of armed FPI (Ivorian Patriotic Front) militants, a moment in which, faced with his own death, he remembers his mother, grandmother, and aunt: the bygone days of his stolen/forfeited childhood.

Like the two levels of narration that structure the text, *Allah n'est pas obligé* and its sequel, *Quand on refuse on dit non*, portray a similar environmental attachment in suspended time as Fanta (a beautiful young high school student who serves as a teacher in her local community) accompanies Birahima on a journey north out of the war-torn southern sector of the country toward the town of Bouaké, the heart of the rebel-controlled north. As they travel along roads, through forests, and past villages reeking of death and decay, the historical narration unfolds as Birahima records the history of Côte d'Ivoire as told by Fanta on a cassette recorder. Birahima intends to review this recorded history one day after he has passed his brevet and the baccalaureate exam.[29] This future-oriented dialogue as well as the punctuated flashbacks of Birahima's narrative retelling constitute modes of representing trauma. Furthermore, as Moynagh contends in "The War Marchine as Chronotope," the narrative circuity of traumatic child-soldier narratives constitutes "a vehicle for a critique of modernity as a particular time consciousness and its attendant geopolitics" (2017, 315). The dialogic narration therefore draws the reader into the conflict zone of the story, inviting us to take part in the experience of alternative temporalities that transfuse the fabric of modernity. The rediscovery of centuries of untold history, punctuated by close encounters with death, embodies the tensions of this temporality where the past and the future intersect constantly. These tensions are rendered all the more immediate through the vulgar comments from Birahima, who brags about his violent exploits in Liberia, bringing the past to light in a juvenile attempt to impress Fanta.

In the way that this text picks up where the previous one ended, yet always returning to past traumas through narrative circularity, the reader must wonder if the future Birahima envisions—"a profusion of money to buy a truck and marry Fanta"—will ever

happen (14).[30] The fact that the novel is unfinished (due to the death of the author) is a telling sign that Birahima the child soldier has no future outside of the cycle of violence that led him from Côte d'Ivoire into Liberia and Sierra Leone and then back again. One can only imagine the unwritten escapades that Birahima would have experienced in the years up until the Ivorian conflict was finally resolved in April 2011, moving between camps and exchanging loyalties: though he is a Malinké-djoula (they're "*kif-kif*" the same [17]), he fervently believes in the qualities of former president (and ethnic Bété) Laruent Gbagbo, who was, as Birahima says, "the only one to have been a real boy under Houphouët, the only one to have anything solid between his legs" (12).[31] (Perhaps one can further imagine a third work in the trilogy where Birahima continues north into Mali to participate in and "profit" from the outbreak of violence there.) With a subtle yet poignant comedic irony, Kourouma's child-soldier narrator Birahima effectively addresses both the political-economic contexts (the historical narrative) that precipitate the kinds of postmodern/postcolonial conflicts in which child soldiers are created, as well as the psychological complexities associated therewith (the environmental narrative). These narratives, according to Lux, "evoke empathy over pity" and, in so doing, contribute to an understanding of a humanitarian "reaching gesture": rather than reinforcing a framework of "possession or containment," this gesture contributes to a positive relation that does not perpetuate a cycle of violence and domination (71). It is in this fruitful space that Birahima's Afrofuturist narrative evolves through linguistic creativity as the moving mechanism for time travel and spatial reorganization in order to expel trauma and open up spaces within the temporal loop for fruitful reimagining of oneself and the world.

Memories of a Boy Soldier: Mediating Conflicting Interests

In some sense, the child soldier operates as a symbol of contemporary social ills and as such is an uncanny subject of fascination.

Child Soldiers

A cohabitation of good and evil (Moynagh refers to Kipling's "Half-devil / half child" [2011, 41]), the child soldier challenges our conception of society by personifying the nebulous gray zones of contemporary transnational political economies (la Françafrique).[32] The child soldier is perhaps the personification of Nietzsche's *Beyond Good and Evil*. In this sense, one must be cautious, as Moynagh (2011) points out, to not confuse sympathy and empathy. There are some examples in the child-soldier narrative "genre" that by separating the child from the soldier (44–45) garner the sympathy of the reader at the expense of a more nuanced, problematic, and productive undertaking vis-à-vis the conflicts and their contexts.[33] Beah's autobiographical account delicately tackles the question of the relation between the child soldier and human rights discourse. Although the author/subject is the same voice throughout, the horrors and atrocities of soldiering are contained within a form that Moynaugh describes as *"Bildung,"* in the sense that although interrupted by the "other" identity that is "forged through violence" (50), it begins by introducing a "normal" child and ends with his successful rehabilitation. In a sense, it is the representation of an extreme case of developmental angst in which the coming-of-age story is dramatically augmented through the intense violence, passion, and tragedy of war. This is indeed the case for Beah, who recounts the tragic story of his lost innocence, his violent struggle to survive, and eventually how "everything began to change in the last weeks of January 1996" (126), at which point UNICEF agents picked him up and transported him to a rehabilitation center called Benin Home.

A significant portion of the narrative thereafter is devoted to describing in detail the difficulties of rehabilitation, from overcoming the symptoms of substance withdrawal to developing coping strategies that do not involve immediately firing a bullet into whatever obstacle presents itself.[34] After seven months, he is "repatriated," a term that implies the degree to which his experience fighting in the war constituted a complete separation from society. While living with his uncle (the only living relative that

could be found) in Freetown, Beah is chosen to attend a UN conference in New York City, after which he returns to Sierra Leone to experience the infiltration of the Revolutionary United Front into the city, his uncle's death, and his flight into neighboring Guinea in 1997, at which point the story ends. The beginning of the story is set in New York City in 1998 where a conversation is taking place among school friends who are interested in the fact that Beah grew up in Sierra Leone. This scenario informs the reader at the outset that the story will have a successful outcome for the narrator/protagonist, which is not the case for many child soldiers, even after a conflict has ended. And it is a successful human rights initiative that rescues Beah from the civil war that will continue for another four years. But for each Ishmael Beah or John Bul Dau (one of the "Lost Boys of Sudan") who in turn becomes a human rights activist for his particular cause, there are countless others who remain trapped in the ongoing violence, even after the war ends. And as Birahima's case seems to indicate, there is often no better option for integration into a society that has little room for such (even "reformed") enfants terribles.[35]

Within this paradoxical context of international human rights discourses, Slaughter identifies "hegemonic linkages between the institutionalized international form of human rights law and the largely Western-canonized novelistic form and story function of socialization" (2007, 41). If one understands human rights as the freedom to create one's own narrative in life, as Slaughter does, one must inevitably ask if this "freedom" is already inscribed within the narratological limitations of human rights discourses that "have also been commodified by the nation-state as the discourse of choice for various repressive domestic practices and (neo) imperial foreign policies" (36). In sum, Slaughter proposes that the international human subjectivity—created by human rights discourses and multicultural postcolonial (globalized) adaptations of bildungsroman—is steeped in ambivalence due to the often-paradoxical agendas and political-economic interests that belie many humanitarian interventionist policies and programs.

Child Soldiers

In other words, the economic interests of developing neo- or postcolonized regions for the profit of multinational corporations and globalist financial institutions often motivate the ringleaders in an international power play to exploit the suffering of those humanities that can be recast within the framework of victims. The child soldier, as both perpetrator and victim of atrocities, thus becomes the embodiment of ambiguous human rights discourses. The ambivalence of humanitarian aid in particular, and Western interventionism in general, insofar as their functionality in Africa constitutes a response to external victimizations (e.g., ethnic conflict, political insecurity, economic instability), resides in the fact that these very same institutional practices themselves often underlie the root causes of these victimizing forces.

Ezra: The Mise-en-scène of Reconciliation

Ezra (Aduaka 2007) is a film that elaborates on the complex and long-lasting psychological impact experienced by child soldiers who attempt to reintegrate into mainstream society. Much like Beah's account, the film opens with a scene of an innocent child going about his daily routine: he is crossing a bridge on his way to school. In the classroom, a girl watches from a window. The date is July 13, 1992. The teacher is beginning a lesson on patriotism, having written on the board the phrase, "Why I love my country."[36] Suddenly, the courtyard is invaded by armed soldiers and gunfire. They abduct children and shoot a man who tries to stop them, stealing the flag before disappearing again into the surrounding landscape.

Once they return to the rendezvous point in the bush, other children are waiting, including a girl dressed in Catholic attire. When one of the boys screams, he is taken to the side and shot. The remaining children are forced to carry supplies as they march through the bush to a camp, at which point their indoctrination begins. The children are made to repeat "We are willing to die," and when one child (named Moses) asks, "What are we fighting

for?," the leader says they are fighting for justice and that this can be obtained "only through the barrel of the gun," citing the opposition rebel faction (only referred to by the fictional acronym DPRA) as "rats and thieves, only hungry for power." By contrast, he promises free education, free health care, electricity, and running water to make the nation great. Once it is established that they are fighting for a just cause, the children are told to "forget everything," including their home and family, which "no longer exist." They are "born again" children of the revolution. As they are taught to handle a weapon, they repeat "this is the gun," "this is an AK 47," "this is your security," "this is your life," "this is the bullet," and so on. They are taught to march.

This opening scene depicts the kind of indoctrination that Alcinda Honwana (2005) describes as a "ritualized process" that "appropriates and manipulates a language and set of symbols that resonate deeply with local systems of meaning in order to achieve its own objectives" (42–43); in this case, it is the type of rote memorization and repetitive exercises children are accustomed to as part of their elementary schooling. One point that Honwana stresses with regard to the practice of initiation is that there is no going back, a sentiment expressed also in the dedication of Beah's account: "to all the children of Sierra Leone who were robbed of their childhoods." Once a child takes on the identity of a killer, it is impossible to recover past childlike innocence. The only way forward is to incorporate the killer inside, to become hybrid in a sense, in order to reconcile the impossible contradictions of such paradoxical poles of existence.

The way the film produces a space for the exorcizing of past crimes in order to move forward is in the context of a Truth and Reconciliation Commission (TRC) (the goal of which, it is repeatedly stated, is restorative, not punitive). There Ezra is being looked at as a "special case." The viewer finds out through the testimony of Ezra's sister, who had her tongue removed in the same raid in which Ezra's parents were killed, that Ezra is in part responsible for the death of his own parents as well as the mutilation of his

Child Soldiers

sister. The scenes in the TRC, which are concerned primarily with the events of January 6, 1999, become increasingly tense as the film progresses, and it is clear from scenes that show Ezra leaving an artisanal class to smoke a joint, or waking up from nightmares in a wet bed, for example, that he has been traumatized. In a similar fashion to the temporal displacements in Kourouma's novels, Aduka's film deploys a similar narrative restructuring, albeit through the conciliatory work of the TRC, in which one might discern a process of psychosocial rehabilitation for existence in a new earthly (yet also alien) world.

However, amid flashbacks that relate scenes of violence in which Ezra was forced to participate, there are other scenes that remind the viewer of the lost/suppressed child beneath the callous exterior of a young soldier. There is, for example, a moment when, in celebration of his "wife" Mariam's pregnancy, the child soldier dances to reggae music ("Living in the Positive," by Nasio Fontaine) while drinking, essentially behaving like a "normal" youth.[37] In addition, when questioned again by the TRC about the events of January 6, 1999, Ezra recalls how he met Mariam, a.k.a. Black Diamond, an elite commando whom he tries to impress through his learning, despite the book he is "reading" being upside down: this is a tragicomic detail, as it reveals that this child soldier, though he has been taught to kill, is illiterate. However, Ezra mentions that Ikemefuna is his favorite character in the story, thereby indicating that the book he is holding is Chinua Achebe's much-celebrated novel *Things Fall Apart*.[38] When Ezra and Mariam strike up a conversation, she reveals that she has been fighting since the age of ten, denouncing the corrupt government that sells diamonds and puts the revenue in foreign bank accounts. When she says that she is fighting against injustice, Moses agrees, and another boy, Micha, jokingly says that he does not even know what "justice" means. Through what is again a sad revelation (they certainly have no way of possibly understanding the notion of "justice" given the circumstances in which they live), the film depicts the humanity of these terrorists/freedom fighters by way

of a casual exchange between a boy and a girl among friends.[39] The naive yet poignantly accurate observation by the young boy soldier Micha is indicative of a pervasive awareness that justice is often unequally dispensed, especially when it comes to human rights that are not universal, but often dependent on the temporalities and attendant geopolitics of modernity. As will be made clear in the next sections of this chapter, these child soldiers, although tactical agents in the perpetration of war crimes, are also the victims of the inherent oversights and blind spots of human rights and humanitarian interventions.

The film further reveals the injustices at work and the international economic motives that undergird the system that dehumanizes and instrumentalizes children by forcing them to become soldiers simply to survive. A rich Western man in a suit and a rich African in a booboo (a traditional West African garment, much like a long shirt that extends past the knees, often worn over pants) have come to do business with Rufus, the man in charge of the soldiers and the diamond mine that they control. Ezra reveals through his testimony before the TRC that they were trading amphetamine, which Rufus then injected into his soldiers before a raid. Ezra says that under the influence of such powerful drugs, "You can fight for four days. You feel nothing. You become the gun. You are not human. After not eating for two days, you see demons, hallucinations," which is of course followed by extreme fatigue and amnesia. Ezra confesses that he remembers nothing of the particulars of the raid.

Through repeated flashbacks, the viewer learns how Ezra arrived at the TRC: after being captured, he divulges the location of the mine to a group of advanced officers (four of the six are White) and is told that he is on his way to becoming captain. Once again, it is not simply a question of military treason; for in committing this act, Ezra has essentially betrayed his friends. He is, however, reunited with Mariam, who appears bald and bruised, and when the time is right, they go "home" to find Ezra's sister Onitcha. Ezra throws his gun down the well and shares a plan to

Child Soldiers

travel all the way to Lagos via Conakry by the border into Guinea. They leave on a bus as light-hearted music plays. The sun is shining. Then they are stopped by a rebel roadblock. The bus driver pleads with the young rebel ruffians, but they make everyone get off the bus and hand over their valuables. Mariam is holding on to "something for the baby." When the international coalition forces of the Economic Community of West African States Monitoring Group (ECOMOG) attack, and in the ensuing chaos, Ezra and Mariam take advantage of the fighting as a chance to flee. However, Mariam (and her unborn child) is shot and killed in the crossfire. Ezra is taken kicking and screaming by the ECOMOG soldiers as Mariam breathes her final breaths.

Back in the courtroom of the TRC, the high commissioner (played by American actor Richard Gant) expresses being torn by a dilemma: although he feels as if someone needs to be held accountable for the atrocities committed, he is grateful to not have to pass judgment for the war crimes that Ezra purportedly committed because, as he states, "These are innocent children, abused by mean and greedy men. We hope that these children can heal and live better lives." The elder Ezekiel, who has known Ezra his whole life, expresses a similar opinion, stating that there is no bad child. "Ezra did bad things because of bad influences. We have to forgive him for these reasons. We thank God that he has survived, and we pray that he finds peace. He must admit his crime before he can find peace with his ancestors and with his parents." However, Ezra cannot confess to having murdered his parents because he does not remember. He faints and is shown next in a medical office with a Black Santa in the window. We hear the health professional ask him what he is thinking. He responds by asking what she thinks Santa has in his bag, to which she replies "presents." He retorts: "I don't think so." Though his amnesia has protected him from many potentially harmful memories, it is clear from this final scene that Ezra has suffered severe psychological trauma to the point where he suspects that Santa carries something other than toys in his bag, thereby implying that his

successful reintegration or "repatriation" into society will not be an easy process but will involve a concerted effort of reeducation to break down the conditioned negative response to others that Ezra learned through his coming of age as a soldier.[40]

Johnny Chien Méchant: Seeing Double

Dongala's (2005) child-soldier narrative, bearing the name of its villain protagonist Johnny Mad Dog (a.k.a. Matiti Mabé or "poison weed," a.k.a. Lufua Liwa or "he who cheats death") also interrogates the problematic nature of the paradoxical guilt and innocence of the victim-perpetrator child soldier but in a rather unique way. The narrative is split between two points of view that retell the same sequence of events (except for a few rare instances, such as when Laokolé, the other protagonist, flees into the forest and resides for a time in a rural village). The repetition of events told from two first-person narrative voices—that of a sixteen-year-old militiaman who, before joining the war effort, recalls having worked at the age of twelve cleaning gutters in the street (23), and a sixteen-year-old girl whose father died and whose mother was crippled in a previous raid by a rebel faction—illustrates the kind of "compulsive retelling" that Lux identifies in Kourouma's narrative (Lux 2010, 60). Furthermore, the subtle differences in each account emphasize the subjectivity of the events being described in a way that undermines the notion of "objective" histories with regard to conflicts in Africa and elsewhere.[41] For example, the message given by General Giap that authorizes a forty-eight-hour period of looting as a reward for his militiamen (who have just captured the national TV and radio station) is first relayed by Laokolé, the pretext for her and her family's flight from their home. This occurs before the announcement is actually made by Giap, which is recalled specifically by Johnny Mad Dog later on when he and his battalion have finally decided on a name for themselves: "the Roaring Tigers."

One effect of this narrative nonlinearity is to again place the

reader in a kind of developmental limbo or suspended temporality, which in turn fosters an attachment to the spaces and the always doubly present environment. The first close encounter between Johnny Mad Dog and Laokolé occurs when she and her mother (whom she is pushing in a wheelbarrow) are nearly run over by Johnny's band, who have commandeered a vehicle. Laokolé remarks that they "could have been reduced to a pile of mangled metal, bone, and blood" (Dongala 2005, 49). Within the same sequence of events, retold by Johnny Mad Dog, he states, "a rollover, and we'd be nothing but a heap of bloody metal and bone" (75). Further on, once Laokolé has found refuge in a compound belonging to the High Commission for Refugees (HCR), she looks up at the moon, which she describes as "a large motherly eye watching over us, pouring out its smooth, milky light to calm our souls" (135). That same night, as Johnny urinates after feasting on the spoils of war, he looks up at the same moon, which he describes as "the eye of a spy, of a Judas, scrutinizing the world" (167).[42] This bifurcated vision of reality mirrors the psychic trauma of the child soldier's fractured world and furthermore embodies the paradox of what Fassin terms "'military-humanitarian' intervention [which] has become a commonplace of the political rhetoric" (2012, 189).

Dongala's novel stringently criticizes this paradox of humanitarianism through Western intervention in African affairs. Perhaps the most striking example of the way in which the West's "humanitarian aid" is imbalanced or even harmful is when a military convoy arrives at the headquarters of the HCR in order to rescue the "foreign nationals," in a way that is far too reminiscent of the evacuation depicted in the 2004 film *Hotel Rwanda*. The arbitrariness of human rights intervention is further exemplified when Tanisha, an American aid worker, invites Laokolé to join them in their escape only moments after Lao's friend Mélanie (who is the only one in her family to have survived the rebel attack in which her vehicle was commandeered) is crushed by a military transport. The horrific tragedy escalates to absurd proportions

when the convoy stops and reverses again over Mélanie's body in order for soldiers to rescue a little poodle at the request of a nearly hysterical woman before rolling over Mélanie's mangled corpse a final time. This particular scene serves as a prophetic fulfillment of the words of a Belgian journalist, Katelijne, who only moments earlier had interviewed Lao and Mélanie in an effort to counteract the complacency and inattention given by Western media to humanitarian catastrophes in Africa, concluding that no one "cares about Africa[.] Tantalum—okay. Oil, diamonds, hardwoods, gorillas—yes. But the people don't count. They're not whites, like us" (144–45). This particular passage speaks volumes about what Didier Fassin theorizes in terms of Foucault's biopower as "hierarchies of humanity [which] were passively established, though rarely identified" (2012, 240). Specifically, the distinctions between foreign nationals and expatriates in times of crisis mirror the same distinctions and divisions between what Albert Memmi (1965) identified in *The Colonizer and The Colonized*.[43]

Dongala's depiction of the horrific conditions of an African civil conflict and resultant responses clearly takes place in the domain of the necropolitical, in which Mbembe points out "the ultimate expression of sovereignty resides . . . in the power and capacity to dictate who may live and who must die" (2003, 11).[44] Yet, unlike the other child-soldier narratives discussed here, which tend to elicit a sympathetic response from readers/viewers, Johnny Mad Dog is depicted mostly as a foil to the young heroine Laokolé, insofar as when these two characters finally meet face to face, the readers' conscience will most likely have led them to side with the young girl. Thus they will feel a sense of vindication when she brutally murders Johnny by hitting him in the face with a Bible and then kicking him repeatedly in the genitals after he bangs the back of his neck on a corner of a table and falls to the floor (2005, 317, 320). Even though Laokolé acts in self-defense, one must raise the ethical question of whether, after this first blood, her fate will drag her down the same road to perdition that Johnny or Birahima had taken (especially considering that

she has lost everything, including her brother Fofo, her mother, and her Aunt Tamila, not to mention her best friend Mélanie). Or, like Beah, will she be saved from such brutality by the American humanitarian agent, Tanisha, who had earlier promised to take her back with her to America? The film adaptation of *Johnny Mad Dog* also does an excellent job of dramatizing the question of Laokolé's and Johnny Mad Dog's fates at the end of the film. After they meet for the last time, they engage in tense conversations much like the scene in which Johnny Mad Dog woos and makes love to Lovelita: this serves to humanize his character as an adolescent with feelings, however obscured they may be by the tragedies of war. For a brief instant, the camera shows the silhouettes of Johnny and Laokolé approaching one another as if to embrace, but at the last minute, she pushes away, at which point she beats him down with the butt of his own gun. The film ends with him on the floor begging while she aims his gun down on him, but she does not fire. Johnny asks his former commander at the end of the film: what is he, a child soldier, supposed to do once the war has ended? Director Sauvaire seems to indicate two possibilities for the future, death or love, and these hinge upon Laokolé's decision in the film's final scene. Will she shoot him for the terrible crimes that he has committed, thereby making herself a killer, or can she forgive him so that together they might forge a new future based on love rather than violent self-interest? This conundrum speaks to a broader ethical question that reverberates throughout such child-soldier narratives, a decision that Mbembe describes in no uncertain terms as a *"will to kill* as opposed to the *will to care,* a will to severe [*sic*] all relationships as opposed to the will to engage in the exacting labor of repairing the ties that have been broken" (2019, 107).

Dongala (2005) does an excellent job of identifying the ambivalence of Western intervention in African affairs in the framework of a child-soldier narrative that also in its very nature invites (if not requires) a profound interrogation of the concepts of innocence and guilt through the juxtaposition of willpowers: either to kill or

to care.[45] In particular, when it comes to humanitarian "aid," Dongala shows that the "savior" is in many ways also the devil, and vice versa.[46] This is what Moynagh refers to when she proposes that African child-soldier narratives pose a challenge to the human rights discourse of what she calls "neoliberal globalization" while at the same time representing a space that is informed and mediated by its conventions (2011, 40). In other words, the paradoxical notion of "child soldier" as simultaneously victim and perpetrator of injustice resonates in many ways with the sometimes problematic nature of Western intervention in African affairs—from colonialism to development—which is paradoxically represented as both the root cause of and a potential savior from the violence and atrocities that color the mediated landscape of the African continent.

Child Soldiers as Embodiments of Humanitarian Reason

The common themes in these child-soldier narratives are striking: drugs, violence, indoctrination, the hope of salvation, and the rare moment of genuine pleasure or enjoyment. They reveal what is certainly one of the most alarming kinds of human rights abuses because it affects future generations in wildly unpredictable ways. Formative years spent at war are not easily forgotten or overcome by these children, who are both victims and perpetrators of crimes. There are enough humanitarian agents to rescue only a small handful of child soldiers and refugees (if they even try to do so); the rest are expected to rehabilitate in a society where opportunities are few and obstacles for a child educated in the art of war are so numerous. What these child-soldier narratives accomplish—beyond the voyeuristic intrigue of the sex- and violence-charged life of a teenage gangster roaming the streets of a decaying urban metropolis with a band of merry men, looting, shooting, drinking, and fucking—is a didactic function. These narratives explain how the underlying socioeconomic conditions that engender, if not encourage, this kind of conflict in countless African (and other) nations over the years must be addressed if the

Child Soldiers

lives of the children are to improve. A subtext of these works—and it is perhaps too subtly embedded beneath the love stories, raids, and violence that animate the child-soldier narratives—is the brief, interspersed moments of pure childlike play (the only catch is that the "toys" that these children are playing with are Toyota Land Cruisers and automatic weapons). They enjoy listening to music and dancing, and they are engaged in the same kind of coming-of-age identity construction as children in any other geopolitical context, complete with the awkwardness of negotiating daily social interactions with one's peers in the ultimate *machismo* environment. Thus one can experience the humanizing effect of the narratives, which portray the figure of the child soldier in all its paradoxicality and ambivalence.

Aside from depicting the horrific conditions of an African civil conflict, which clearly takes place in the domain of the necropolitical in which the life or death of a human being is secondary to its functionality to the war machine, these narratives also implicate a larger global network of international institutions in the ultimate failure of humanity that such conflicts represent. As such, the ambivalent literary figure of the child soldier reflects the morbid political economy of a perpetual war narrative, often under the guise of humanitarian intervention. As Slaughter points out, "The banalization of human rights means that violations are often committed in the Orwellian name of human rights themselves, cloaked in the palliative rhetoric of humanitarian intervention, the chivalric defense of women and children, the liberalization of free markets, the capitalist promise of equal consumerist opportunity, the emancipatory causes of freedom and democracy, etc." (2007, 2). Echoing the rhetoric employed by Mbembe (2013), in which he illustrates the ways in which colonialism and its aftershocks have created an entire cross section of humanity that is excluded from its unalienable rights, Slaughter suggests that humanitarianism and imperialism "share enough structural features that they are, though imperfectly, homologous" (2007, 274). Accordingly, a "humanitarian reason" would be analogous to a new neocolonialism of

the twenty-first century, creating "hierarchies of humanity"[47] and contributing to the "devenir-nègre du monde" (becoming-Black of the world) through the instrumentalization of the human into "l'homme-marchandise, l'homme métal, et l'homme-monnaie" (Mbembe 2013, 257–58; man-as-merchandise, man-as-metal, and man-as-money). In the preface to the Frantz Fanon's *Les damnés de la terre*, Alice Cherki also writes of the globalization of a violent colonial reality depicted by Fanon but recast in contemporary terms: "This reality also concerns the growing inequalities in our so called 'developed' world, which inscribes the necessity of precarity and unemployment for the most disinherited, relegating him to a topical, non-utopic place, that of exclusion" (2002, 13).[48] With respect to such spaces of exclusion, Mbembe writes that "to say 'Africa' always consists in constructing figures and legends—it matters little which ones—on top of an emptiness" (2017, 52). As is done with outer space in science fiction, Mbembe depicts Africa as an enunciatory space in which fantasies, futures, and fears can be projected. Furthermore, "Africa," in the philosophical sense that Mbembe employs, has arguably become a constant of diverse global realities, such as those described by Alice Cherki.

The racialized terms of Africa and its dehumanized populations, globally speaking, constitute a nonworld, or an outer world—"l'outre-monde," according to Mbembe (2013, 95)—where humanity is negated and denied on the basis of narratives and rhetorics of exclusion. Furthermore, the process of the hierarchization of humanity takes place in a discursive space, which has yet to be decolonized. Mbembe writes, "According to this point of view, Africa as such—and one must add the 'black non-subject'—only exists on the basis of a text that constructs it as the fiction of the other. . . . In other words, Africa only exists on the basis of a colonial library that imposes and insinuates everywhere . . . to the point where . . . it becomes difficult, if not impossible to distinguish the original from its copy" (2013, 142).[49] The resultant forms by which an ontological void is layered with projected fantasies and phantasms constitute not only the contemporary condition

of Africa, but that of an increasing number of areas of the globe, including those "developed" societies, where the visceral realities of inequality can no longer go unnoticed.

Within the context of this ambivalent representational economy, the categories of real and unreal become virtually indistinguishable. The power of enunciation (*l'énoncé*) cannot be ignored, for as Fassin points out, "To speak of insecurity as a mere description of reality is to participate in bringing the feeling of insecurity into being" (2012, 33). Accordingly, the existential precarity in Africa is fundamentally a consequence of the representational and discursive practices that dictate the precise nature of the social, based ultimately on a set of arbitrary criteria either validated or denigrated by mediated interventions.

This kind of substitution of fictions, the generative discursive practices that divide humanity into its substantive parts, might be characterized as a process of social engineering in which the material world is replaced by a series of fictional representations or Baudrillardian simulacra. Accordingly, let us consider the following construction: "We are all equal when faced with the real. Yet, social engineering seeks precisely to escape from this common human condition in order to elaborate another form of life and of politics that are inegalitarian, where the phantasms of the dominant take the place of the real to become the exclusive Law of the dominated" (*Gouverner par le chaos* 2014, 68).[50]

Colonialism in its various forms and manifestations over time is a most extreme kind of social engineering that imparts a divisive ideology of inhumanity, creating discourses that expand the scope of those wretched masses of the earth whose place is only that of exclusion. The Africanization of the world that Mbembe (2013) implies underscores the ways in which violence, dehumanization, and a culture of perpetual conflict are the resultant enunciations of a European modernity inextricably linked to exploitative colonialism on a global scale. It represents a fiction created by Europe that seeks to deny the humanity of particular populations on the basis of archaic geopolitical constructs. The power to speak,

dictate, and narrate is fundamental to a conception of human agency and, when denied, the consequent representational negation leads to a zombified existence of developmental limbo or of coming into nonbeing.

The role of fiction in informing our conceptions of real social-humanitarian crises is paramount, and it further reveals an intricacy in the problem, namely that the child soldier is in fact a fictional entity. The child soldier exists only as a construction of the media depicting it (be it documentary, fiction, or autobiography). For in actuality—"living in the concrete world"[51]—the moment a child is taken, they become an instrumentalized human being, thereby forcing an abrupt termination of childhood. This childhood eventually exists only as a nostalgic memory of a lost past that may or may not be partially retrievable with extensive rehabilitation efforts.[52] A child soldier is an existential impossibility insofar as they represent a veritable tragedy. Furthermore, from an Afrofuturist standpoint, the figure of the child soldier transcends the human-object dichotomy, embodying the paradoxical cohabiting of guilt and innocence within a singular, yet multiform body/text. Therefore, an important step in addressing the social and psychic suffering caused by a divisive praxis of social engineering involves altering the perception of Africa through a new humanism, grounded in an integrated aesthetic education and directed toward a sustainable collective future.[53] This vision, which is delineated by Sarr (2016), extends beyond a mere decolonization of knowledge, invoking a plurality of approaches to reimagine the social in terms of Africa's rich cultural histories and traditions, including those spawned by colonial encounters. I propose that such an ambitious endeavor is only possible through the arts, confronting fictions with its own fictions and promoting creative approaches to reinventing the self and society against the overwhelming reductive tendencies of globalism.

4

Alienation, Estrangement, and Dreams of Departure

Emigration and the Politics of Global Inequality in (and out of) Francophone Africa

Construction of victims is viewed by humanitarian organizations as both necessary, since it identifies the target of intervention, and sufficient, in that the perspective of the populations is never required.

—Didier Fassin, *Humanitarian Reason*

I'm going, my life is too gloomy
I'm going, I left a note encrusted with dirty words
I'm going so leave me with my pain
I'm going to a world made of light and colors
. .
I'm going, for the sky is low and gray
The elders have no more wisdom, they are racist and sour
I'm going, flying toward children's laughter
I'm going even if they're mad I've suffered too much torment[1]

—Gaël Faye, "Je Pars"

To dream of elsewhere is a fundamental characteristic of the human experience. Rimbaud's words "La vraie vie est absente"

(real life is absent) from his poetic masterpiece *Une saison en enfer* ("Délires I, Vierge folle, l'époux infernal") provide us with a sense of the profound need to seek for life beyond the limits of life, to look for life in its absence. Religions rest on the solid base of an afterlife, a beyond life, an eternal life; in sum, in the words of Charles Baudelaire: "Anywhere out of this world" (2006, 220–21). Naturally, the world to or from which one hopes or dreams of escaping is typically defined by one's ordinary scope of experience, whereas that which is beyond—*l'au-delà*—may often be attributed to a place on earth, a kind of *paradis perdu* reminiscent of slave populations in the New World, after the Middle Passage. For these populations, Africa, the motherland, came to embody a kind of terrestrial heaven, and the dream of a return became an inextinguishable source of hope.[2] These fundamentally human desires are the defining qualities that undergird the futuristic imaginings of voyages to outer space, the inner earth, or the depths of the sea, as well as human migrations in search of an elsewhere that is somehow perceived as better. However, these alien landscapes can also be the sites of untold dangers and uncertainties. When it comes to sociopolitical discourses concerning migrations and population displacements, the rhetoric and the realities that it encodes are fraught with ambiguities, paradoxes, and contradictions. Didier Fassin, writing on these very ambivalences, remarks: "A dialectics of hospitality and hostility, of host and hostage: we recognize the rhetoric of immigration policies that has become widespread over the past two decades" (2012, 136). This is the same type of ambivalence that is fundamental to Albert Camus's short story "L'hôte" with regard to the agency of the other.[3] Immigration discourses oftentimes contribute to a dehumanizing narrative of immigration as a political matter, regardless of the positive or negative characterization of migrant populations.

The disjuncture between reality and rhetoric regarding humanitarian crises such as mass migrations and clandestine immigration is fundamentally construed as a problem of discursivity, to which Gayatri Spivak proposes the alternative of a planetary imaginary:

Alienation, Estrangement, and Dreams of Departure

If we imagine ourselves as planetary accidents rather than global agents, planetary creatures rather than global entities, alterity remains underived from us, it is not our dialectical negation, it contains us as much as it flings us away—and thus to think of it is already to transgress, for, in spite of our forays into what we metaphorize, differently, as outer and inner space, what is above and beyond our own reach is not continuous with us as it is not, indeed, specifically discontinuous. . . . It is only then that we will be able to think the migrant as well as the recipient of foreign aid in the species of alterity, not simply as the write person's burden. (2012, 339)

Spivak's espoused planetary vision corresponds to a fundamental respect for alterity or the "other" in terms of a common and shared relationality to the planet, which is simultaneously the host and the hostage of human arrogance. The planet is the playing field on which human interactions take place. Accordingly, a conception of human-planetary alterity changes the ways in which human interactions are conceived and construed. One can further delineate this notion of planetary thought through the term "globalectics," coined by Kenyan and Kikuyu critical theorist Ngugi wa Thiong'o as a theoretical examination of the interrelation of politics and epistemologies. Ngugi argues that "reading globalectically is a way of approaching any text from whatever times and places to allow its content and themes [to] form a free conversation with other texts of one's time and place, the better to make it yield its maximum to the human" (2012, 60). Similar to, yet more inclusive than, the theoretical construct of "littérature-monde" espoused by many Francophone writers in 2009, the primary preoccupation of globalectics is to open up theoretical and literary discourses that are inherently tied, even in their opposition, to imperialist discourses and historicism, the ultimate aim of which is to more fully emphasize the common humanistic qualities of politics, history, theory, literature, and society. Reimagining political discourses on migrations globalectically, therefore, would enable a potentially

more nuanced understanding of the various developmental practices that spawned such global human movements from a multiplicity of sociocultural perspectives; then there would be space for conversation between scientific and artistic discourses and indigenous and exogenous sources that could take place across linguistic, disciplinary, historical, and geographical boundaries.

Interestingly enough, the dream of departure figures prominently in a number of recent novels to come out of Africa and the diaspora, which represent the conflicted and often tragic plight of impoverished people living on the African continent who look northward and across the Mediterranean toward Europe as the land of perceived hope, the way out (although Sartre would stringently object that there is in fact "no exit" [*Huis-clos*]). Yet the desire for something else, something otherworldly, can be so strong as to entice people to throw their very lives into the hands of fate for the mere chance of escape. Such is also the case with all kinds of artificial paradises that occupy the various landscapes of Western materialist culture, from fast food to the newest blockbuster; the latest fashion, cancer-causing product, or portable technology; or the next best pill, capsule, or potion to make a person somehow more suitable for society. These, in some cases, constitute nothing more than a slow violence of an apparent dream product that is merely a thinly disguised gradual death sentence. Humanizing the preconditions of various forms of human migration in terms of mediated discourses of desire and alienation, absence and longing, represents an essential step in moving toward a globalectic and planetary reimagining of human life in movement across borders that divide the earth into sustained spaces of inequity and exclusion. Therefore, one must engage with the notion of alienation and its geopolitical manifestations in various migrant phenomena, theorizing the notion of alterity of the "other" to include internal and external spaces of identification and examining the ways in which African literary and cinematic voices deconstruct and demystify these spaces through humor, satire, and visual and thematic juxtapositions.[4]

Karl Marx, in his analysis of nineteenth-century capitalist societies, identified *alienation* as a primary ill of capitalist production. Unlike the struggles associated with medieval serfdom in agrarian societies, the modern working class, according to Marx, experienced a different form of dissociation from their work because they were not only stripped of the ownership of their labor but also of the purpose of their divided and mechanized efforts in the absence of a material relationship to the product of their temporal investments.[5] In the twenty-first century, this alienation has arguably reached a new threshold in what French theorist Guy Debord in 1967 termed "La société du spectacle" ("the society of the spectacle"). Since the 1960s, the spectacular nature of a hypermediated society has increased exponentially, to the point that it has become a common thread in philosophical discourses from Jean Baudrillard to Michel Serres.[6] Arguably, our society has become so consumed by a narcissistic obsession with images that our own physical existence, social interactions, and even our intellectual endeavors have become sources of anxiety and cognitive dissonance. When "reality," "fact," "truth," "self," and even "thought" are debatable in the lawless arena of democratic *médiatisation*—and by this, I am referring to the portable power, such as smart phones and social media, that each of us holds in the palm of our hand at any given moment—it is all the more essential to examine our cultural values to find that increasingly elusive common ground. Ironically, perhaps, the place that I propose we look is in the very forms of representation themselves, from oral literatures and film to the many divergent textual forms that compose the emergent discipline of the "digital humanities." In these modes of cultural production we can glimpse the universal human struggle for expression and identification.

Although the body of literature and film on immigration in the Francophone African context is significant, I focus in this chapter on select texts and films that each portray the problematic nature of the pull of emigration—emphasizing the

departure from one's country of origin as opposed to immigration to a definitive host country—while extending the discourse to a more fundamentally humanizing understanding of the phenomena of exile, alienation, and hope that characterize the migrant imaginary.[7] Analyzed through the lens of Edward Said's discourse on Orientalism, and from an existentialist philosophical perspective, select literary accounts by African writers and filmmakers reveal the complex influences and social pressures that incite generations of Senegalese youth to pursue their dreams of a better life abroad in Europe. Read against the backdrop of Cheikh Hamidou Kane's celebrated novel *L'aventure ambiguë*, Aminata Sow Fall's short story "La fête gâchée" and one of the narratives from Marie NDiaye's award-winning novel *Trois femmes puissantes* each illustrate the endogenous and exogenous pressures that precipitate the desire for departure, reproducing the cycles of poverty and unhappiness that are oftentimes catalysts for mass migrations. Secondly, I analyze Abderrahmane Sissako's (2002) film *Heremakono* in dialogue with Djibril Diop Mambety's (1973) iconic representation of the emigrant's plight in *Touki Bouki* and Amadou Saalum Seck's (1988) film *Saaraba*, which attempt to demystify—through time-suspending narrative circularity, like that discussed in the previous chapter—the dichotomous mythologies of "here" and "there" that reside at the base of migratory movements from Africa toward Europe and the West. Finally, I conclude with an analysis of Youssouf Amine Elalamy's (2011) novel *Les Clandestins* and Fatou Diome's (2003) acclaimed novel *Le ventre de l'Atlantique*, both of which depict the often-bitter consequences of buying into the illusion of finding a better life somewhere else. What will be made clear through these analyses is that the migrant's plight is one of disorientation and dislocation of a subjectivity caught in between competing experiential modes of engagement with reality, resulting in a suspension of certainties that is rich with possibilities for Afrofuturist imaginings.

The Geopolitics of Emigration:
From Samba Diallo to Aminata Sow Fall and Marie NDiaye

In Cheikh Hamidou Kane's *L'aventure ambiguë*, the main character, whose name is Samba Diallo, lives a life across two continents, between Senegal and France. The oral culture of his ancestral heritage, incarnated in the characters of "le vieux maître Thierno" (the old master) and his aunt, "La Grande Royale," contrasts with the static world of the written word that he adopts after he is taken from the hearth of his home and the traditional madrasa (Koranic school) and enrolled in the school of the Whites. He later finds himself further displaced in order to pursue advanced study in Europe.[8] The occupation of a subjectivity suspended above two distinct habitable zones is a condition which necessitates a manner of *métisse logics* as earlier depicted in the works of select African women writers in chapter 2.[9]

When faced with the inevitability of colonization of the lands of the Diallobé by the French in West Africa, *le maître* (the master) states as a matter of necessity that "the child who is not yet conceived calls out. This child must be born. This country awaits a child. But in order for him to be born, the country must give itself over" (Kane 1961, 94).[10] In this account, Samba is the incarnation of this child born of two worlds; however, neither world is the one he dreams of and longs for. He finds over the course of his "adventure" that he is alienated in his European host country, likening himself to Rainer Maria Rilke's tortured protagonist Malte Laurids Brigge, descending the Rue Saint Michel and encountering only objects: "Here one encounters objects of flesh, as well as objects of iron" (140).[11] The alien landscape of Europe is populated by objects for observation, precluding the possibility of any authentic connection. Yet he also finds that he is no longer at home in the culture of his childhood and of his traditional religious upbringing, from which he has become estranged through his Western education. What can be seen as an internal struggle between science and religion on one hand and an encounter

between Western modernity and African pastoralism on another can also be interpreted as a coming-of-age story in which the idyllic past of Africa is lost to him, much like his childhood is.[12] For, as he divulges in his conversation with the French-born "African" Adèle, he was enticed by the world of signs that was introduced to him, which allowed him to "transmit my thoughts without opening my mouth" (173).[13] However, it also interrupted his Koranic education just at the point at which he was about to be initiated into a rational understanding of what he had up until then only recited and memorized. He laments this fact, remarking how "progressively, they made me emerge from the heart of things and habituated me to taking my distance from the world" (173),[14] and he doubts ever being able to find that path again after having lost it. Clearly, in his estrangement, Samba has left an integral part of himself behind, which has been replaced by something unfamiliar (not unlike the tumultuous transition between childhood and adulthood). But this change is inevitable, and Samba realizes that he cannot go back. Although he returns to his beloved *pays des Diallobé* (land of the Diallobé) at the request of a letter from the chevalier (knight), it becomes evident that he is unable to submit to the ways of life that he has been forced to abandon as a result of his immersion, though rebellious, in Western ways of thinking, exemplified in the fact that he cannot agree to pray with le maître (187). Only then does Samba find the place where there is no ambiguity, where there is no more longing for disambiguation, in the peaceful darkness of afterlife, of "life of the instant, life without age of the lasting moment, in the flight of your wake, man creates himself indefinitely" (190).[15] This affirmation that closes Kane's novel seems to indicate that perhaps life is to be found elsewhere, at the outer rim of experience, somewhere in the encounter between the human soul and the moment of its death.[16]

With this intercultural and existential portrait in the background, I turn to Aminata Sow Fall's (2010) short story "La fête gâchée" (The spoiled party), which was published in 2010, fifty years after Kane's celebrated novel. The author here describes an

elderly woman named Soda who remains haunted by the memory of her son, Massata, ten months after his disappearance. She re-reads the letter that he left behind, in which he explains his decision as a necessity: "I am twenty-one years old. No chance for studies, no means to find a suitable job" (129).[17] Thus, he decides to take his chance at seeking his fortune, like many others before him, in Europe. Enticed by the idea of expensive villas, luxury cars, and a substantial monthly salary, Massata is determined to "assume his responsibilities" (130).[18] Soda recalls the local hysteria ten days later with the announcement that three empty pirogues (boats) had washed up on the Moroccan shore. She remembers clinging to the faint hope that her son might not be dead until three days later, when it is confirmed that 125 bodies were retrieved from the sea. In an attempt to rationalize the incomprehensible tragedy of such a loss, Soda and other inhabitants of the neighborhood and city search for someone or something to blame. The potential causes for these treacherous "pirogues de la mort" (canoes of death)[19] are put forth as such: "poverty in Africa . . . failed states . . . the image of the West—an earthly paradise—promoted by the media," and even "parents who, instead of educating their children and encouraging them to work hard like they do over there, send them to sacrifice" (132).[20] Clearly the issue is multifaceted and complex, and one might likely conclude that all of the above factors play a contributing role in the deterioration of the social fabric that leads young men and women to look elsewhere for opportunities. However, Soda hints at another underlying cause, one that is not immediately evident: namely, reliance on foreign aid that had gradually become a routine part of life.[21]

Soda describes how national and foreign aid agencies had taken the cause of "la lute contre la pauvreté" (the fight against poverty) as their primary business model, concluding with the ironic formulation that "they 'sell' poverty; it has become a job for them and a way of life" (135).[22] In this sense, the persistence of poverty is beneficial to humanitarian aid agencies that are dependent on the fight against it for their continued viability. Soda

further describes the detrimental effects of this reliance on the affected populations: "And so you will forever depend on aid. Your imagination, your ambition to realize on your own and by the grace of God your labor: annihilated!" (134).[23] The story then takes a hyperbolic turn when it is announced that a delegation of high-ranking Western authorities will come to present their condolences to the families of those who died in the failed attempt at emigration. This delegation has promised fifty million CFA for each of three respective domains: medical material for the health center, agricultural material, and basic alimentary products; this aid is naturally met with great excitement by the family members who had only just begun to grieve the loss of their children. Soda, her daughter Bineta, and a civic employee named Yérim, who had also lost his son in the unsuccessful crossing, conspire to ruin the festivities that will undoubtedly accompany such a grandiose occasion, saying: "We should not allow for this insult to the souls of our children to take place" (137).[24] With biting satire, Fall illustrates the absurdity of how the deaths of the 125 youths—who attempted a perilous journey in order to escape their perceived bleak life circumstances in exchange for a misconceived notion of European prosperity—are seen not as a horrific consequence of a problem that should be remedied but rather as an additional opportunity for Western interests to capitalize on the tragedies of suffering communities.[25] Although it is not stated explicitly, one must wonder what effect the dispensation of these goods to the families of the victims will have; certainly it will not deter anyone from attempting the perilous journey, as it acts as a kind of insurance policy. Even if the emigration attempt fails, it will still be indirectly successful by initiating the circumstances for increased "humanitarian" aid.[26] The inescapable irony of celebrating the gifts of an international community whose exclusionary and divisive economic practices have continuously contributed to the impoverishment of areas such as Senegal (where clandestine immigration is sometimes seen as the only plausible escape from endemic poverty) explains why the party in Fall's short story is sabotaged by the

Alienation, Estrangement, and Dreams of Departure

citizens who disperse charmed snakes into the crowd from beneath lion costumes. This conclusive act of defiance is enacted through a reification of the exoticized objectified stereotypical African crafted by the West, yet in a terrifyingly unpredictable fashion.

This short story by Fall illustrates in many ways the predicament of Western influence and its tragic consequences on Senegalese society, from the hopeless resignation with which Massata embarks on his fated journey to seek his fortune, to the loss suffered by those family members who are left behind, to the callous response of the international community. This response serves merely to add insult to injury by reproducing and reinforcing the same economic conditions of dependence that make migration inevitable for many youth such as Massata. Fassin explicitly elaborates on this paradox, saying, "Construction of victims is viewed by humanitarian organizations as both necessary, since it identifies the target of intervention, and sufficient, in that the perspective of the populations is never required" (232). The rhetorical and discursive processes by which segments of human populations are construed as victims of catastrophe constitute the fundamental form of dehumanization that allows for various governmental and nongovernmental organizations to profit from their exploitation. The ways in which populations become victims, through the external intervention of foreign bodies, reflect an underlying bias with respect to what Fassin terms "hierarchies of humanity." The victimization or criminalization of immigrants or refugees operates in a similar fashion by ascribing a political, or sometimes juridical, status to what would otherwise be an essentially human condition. This in turn allows interventions to further entrench the underlying inequalities that generated a particular migratory phenomenon, which could be identified as a crisis. Such humanitarian crisis responses are a principal avenue through which "the fable of 'foreign aid,'" as Mbembe (2019) states, is just that: a "fairy tale." He estimates the net amount of wealth extracted from the African continent between 1980 and 2009 to be 1,400 billion dollars (98), a notion that will be further elaborated in chapter

6. One must therefore ask this question: What makes it so easy for finances to flow from the continent, while the emigrant's flight requires overcoming astronomical odds in order to succeed?

Victimization and dehumanization—or what Mbembe refers to as "the generalized instrumentalization of human existence" (68)—can be understood as exacerbating population displacements and internments created through cycles of dependency. We will see these themes played out in the third story of NDiaye (2009), winner of the Prix Goncourt, in which Khady Demba is expelled from her in-laws' home compound following the untimely death of her husband, whom she had not had a child with during the three years of their marriage.[27] The reduction by her in-laws of Khady's person to her function of childbearing is the first example of her dehumanization. With nowhere to go, Khady is sent to board a boat at night to an unknown destination. When she cuts her leg climbing into the boat, she is helped by a young man named Lamine, whom she "*sort of* mak[es] a choice" (300; emphasis mine)[28] to follow in pursuing his ambition. Lamine had vowed that "he would arrive one day in Europe or die" (301).[29] When the convoy in which they are traveling is stopped by bandits, their money is taken, and they are forced to remain in a remote desert village, where Khady performs sex work as a way of making enough money to continue on their quest for the promised land. However, one morning she awakes to find that both Lamine and her meager savings have disappeared, and she slowly begins to waste away. One day, she manages to board a truck. She has become a stranger to herself, almost unrecognizable, yet from within she maintains the essence of her identity: "it's that I am me, Khady Demba" (326).[30] She is nursed back to health by an older man and woman with whom she shares a tent in an encampment; they spend their days building ladders for the attempted crossing of a fabled fence bordering a Spanish enclave at the edges of Moroccan territory: "a fence separating Africa from Europe" (329).[31] When their camp is attacked and destroyed by the military, they decide to attempt the crossing. They run with their ladders in the

Alienation, Estrangement, and Dreams of Departure

direction of the fence and begin to climb to the sound of gunfire. In the end, Khady falls backward to the ground and dies, another casualty in the endless pursuit of "happiness" elsewhere. Unfortunately, this is an all-too-common occurrence, exemplified by the Wolof expression *Barça ou Barseq*. In an interview, Senegalese writer, critic, and intellectual Boubacar Boris Diop explains:

> When it comes to the expression 'Barça or Barsàq'—literally: Barcelona or heaven—it comes from a different logic. Above all it testifies to the determination of young Tunisians, Senegalese, Iraqis, or Somalians and Nigerians to cross the borders of the supposed European Eldorado. . . . Still, it is difficult to comprehend why these youths in the prime of life are ready to die—and many of them in fact do—to get to Europe instead of applying that energy and determination in the struggle for change in their own countries. ("Le mariage de l'Afrique avec Molière a été un échec total," 2014)[32]

While the conundrum of mass migration from the Global South toward the Global North may be perplexing, one need look only to the way in which "otherness" is constructed and mediated through discursive practices. As Said has argued with respect to the concept of Orientalism, such otherness is less a brute reality than an invested construction of a sustained unequal power relation on the part of Europe, or the Occident more broadly: "As much as the West itself, the Orient is an idea that has a history and a tradition of thought, imagery and vocabulary that have given it reality and presence in and for the West" (1994, 132). Cameroonian filmmaker and critic Jean-Pierre Bekolo argues along similar lines, saying, "If Africa is the material production of Europe, it is also the production of its imaginary; a virtual construction that can take from in reality" (2009, 135).[33] Bekolo goes on to delineate the dynamic process by and through which the mythological, or virtual, constructions of Africa and Europe become engrained perceptions that are ultimately accepted as real. This irreality, once identified as such, may perhaps be overcome by

a counter-discursive deconstruction of these myths, such as those undertaken by the African writers and filmmakers discussed in this chapter. For example, although Khady, like so many others, dies trying to cross the barrier (which could also be interpreted as a metaphorical or purely bureaucratic impediment to emigration out of Africa and into Europe), NDiaye's (2009) work seems to indicate that all hope is not lost. As Khady's tragic terrestrial journey concludes, a bird takes flight, indicating that there is a sense in which she succeeds in attaining her objective, although on a different existential plane. This reference to liberation through death rather than through attaining some terrestrial paradise is reminiscent of the conclusion to Samba's ambiguous adventure. In this narrative transcendence, one may read a will to overcome the "wrong narratives" (Bekolo 2009, 136) of Eurocentric geopolitics through an appeal to human, planetary, and existential sensibilities.

Afrofuturistic Griots: Voicing Immigration in African Cinema

In a similar vein as Aimé Césaire's (1939) surrealist masterpiece *Cahier d'un retour au pays natal*, which poetically and viscerally congeals the feelings of angst and otherness that are associated with a deep longing for a place in a world that has become estranged, a number of African texts and films depict the narratives of displacement that constitute France's postcolonial legacy. Ivorian filmmaker Henri Duparc's (1997) *Une couleur café* dramatizes in comedic fashion the plight of the African immigrant in France, but there is nonetheless an underlying message that life "over there" is not as it is perceived to be from the other side. Mauritanian director Med Hondo's (1967) *Soleil O* more explicitly critiques the difficult experience that awaits the African immigrant upon his sojourn to the *métropole*.[34] Similarly, Flora Gomes's (2002) multilingual musical from Guinea-Bissau *Nha Fala* does an excellent job of illustrating the difficulty of success in the West while toying with existentialism and magical realism, which like Burkinabè filmmaker Pierre Yaméogo's (2003) *Moi et mon Blanc* does in fact

Alienation, Estrangement, and Dreams of Departure 123

depict the heroic return of the successful emigrant. Senegalese director Mousa Sene Absa's (2001) *Ainsi meurent les anges*, on the other hand, paints a more pessimistic portrait of the emigrant whose failure to successfully integrate into European society and whose return, marred by a perceived lack of success, leaves the protagonist stranded in between two societies, no longer belonging to either one.[35] Yet all of these narratives share the common trope of a voyage to elsewhere, a foreign land that occupies the imaginative role of another world, like the other worlds of science fiction.

In the ensuing sections, the various mechanisms of attraction, distraction, and departure that influence transnational migratory phenomena will be outlined, beginning with an analysis of Amadou Saalum Seck's (1988) film *Saaraba*. The film, whose title is derived from a Wolof word that suggests the English concept of utopia, much like Abderrahmane Sissako's (2002) *Heremakono*, ambivalently portrays difficult questions of exile, emigration, and belonging in the context of the fundamental human longing for happiness. Additionally, Djibril Diop Mambety's (2013) classic *Touki Bouki*, a symbolic and politically savvy deconstruction of French neocolonialism, ironizes the attraction of emigration through a budding romantic relationship between protagonists Mory and Anta, while also working to deconstruct the myth that the good life is to be found across the sea in Europe. Finally a reading of Fatou Diome's (2003) *Le ventre de l'Atlantique* and Youssouf Amine Elalamy's (2011) cinepoetic novel, *Les clandestins* will yield a fruitful and transnational analysis of the central role of media biases and sociocultural inequities that are central in the representation of immigrant crises, which in turn affect immigration policies and practices. Taking a transnational, multiethnic, and polycultural approach to African immigration in these works spanning over six decades, there emerges a clear vision of a common thought: namely, the power of narration to dictate possibilities in the formulation of one's hopes for the future. The extension of this inherent push toward futurity reveals an experiential relationship with a reality that can only be described as otherworldly:

an intense exile of the human spirit stuck in between competing sets of social constructs and struggling to build a conciliatory consciousness. I propose that the vision expressed in these works is rich in science-fictional tropes and themes, which provide a vision of humanity in its planetarity as a complex consciousness of constant negotiation with and between the others and selves it inhabits.

Utopic Dystopia: Seck's *Saaraba*

Illustrating the illusory pull of emigration to the West, Amadou Saalum Seck's (1988) film *Saaraba* opens with a panoramic shot of the city of Dakar, which focuses in on the international airport and a plane landing. Inside the terminal, the arrival of an Air Afrique flight from Paris to Dakar is announced, at which point the protagonist, a young man named Tamsir, is shown passing through customs. Upon arrival, he is met by his wealthy businessman uncle, who takes him to his home—a typical bourgeois house with lavish furnishings and the familiar comforts of a television set. The viewer finds out that Tamsir has been living in Europe for the past seventeen years and that he has returned home to visit his ailing father, who resides in a remote, unnamed village in Senegal.[36] The decor of the modern Senegalese home and the office where Tamsir's uncle has offered him a job contrasts with the portrayal of a typical rural setting (replete with women working on various stages of traditional food preparation) when Tamsir arrives at the village on a donkey cart (perhaps a reference to Ousmane Sembène's first film, *Borom Sarret*).

The dialogue between tradition and modernity that is alluded to in these two contrasting scenes, which has been prevalent in many Senegalese films since Sembène pioneered the genre in the 1960s, is made explicit later on in the film as Tamsir accompanies his dying father to a medical facility that they never reach. At this point, Tamsir confesses to his father that he wants neither the life of the *toubabs* (a Dioula word prevalent in much of West Africa

meaning "Whites" or "Westerners"), nor that of traditions, a salient and complex conflict that drives much of the film's action, through the romantic intrigue that develops between Tamsir and a beautiful young woman named Lissa. She has been promised in marriage by her parents to a wealthy government official, the *député* (or regional representative), whose discourse about the village is one of development, involving the construction of a salt factory as well as electric and sanitation services in response to a disastrous drought.[37] The theme of a fatherless generation born in the ambiguous space between competing notions of modern and traditional values that is first hinted at through the relational problems of Tamsir's sister Daba, whose child's father is away studying medicine in Brussels, is again echoed in Lissa's precarious position after she is left to bear the brunt of her pregnancy by Tamsir and the dishonor that she has thereby brought upon her family. Yet beyond merely condemning the disintegration of the traditional family structure, Seck humanizes the characters on both sides of the conundrum, showing the député's reluctance to pursue his promised bride despite her indiscretion, as well as Tamsir's promise to return to Lissa and the triumphal return from Europe of the respected doctor Thiam at the end of the film. It would seem that in leaving these multilayered conflicts ultimately unresolved, Seck is opening up a space for dialogue through which the complexity of human experiences can be grappled with in a way that takes into account the diverse individual and collective pressures at play in negotiating social responsibility.

It is at the député's initial address to the village populations that the spectator is introduced to the two other principal characters of the film outside of Tamsir's immediate family: a herdsman named Yoro, whose livestock is being decimated by the harsh environmental conditions, and a mechanic named Demba, trained by a White priest who bequeathed his motorcycle to him upon his departure. The cross section of modern Senegalese society portrayed by these five characters is indicative of the extreme social inequality that lies at the base of many postcolonial states, a legacy

inherited from European colonialism in which many of the structural inequalities remained intact. The leitmotif of social class disparity is brought to the fore when Tamsir, after professing a desire to return to his cultural roots, loses himself in the rebellious chaos of urban disillusionment. Tamsir loses his father and engages in a brief love affair with the beautiful Lissa who, despite her desire to remain a virgin until marriage, gives herself to Tamsir in an effort to avoid her arranged marriage to the député, whom she does not like. Tamsir then returns to Dakar, where he is influenced by the revolutionary (or "involutionary")[38] Rastafarian ideals of his cousin Sidi, ultimately spiraling into a daze of cannabis smoking and tea drinking before ending up in jail. Tamsir is initially resistant to what he sees as Sidi's aimless condemnation of modern society, referred to as "Babylon," and his self-destructive habits. However, he encounters an old friend named Massa, who has found nothing to do in the last two years after having lived abroad and returned. Massa convinces Tamsir to follow the relevant yet misguided path of many Senegalese youth. Tamsir had for a while tolerated his cousin's activist discourse, including an indictment of the Paris-Dakar rally broadcasted over the radio that cited the absurdity of an off-road motorized race playing out in front of starving populations. But he comes to a point of inebriated "conversion," which leads him to ransack his uncle's office, destroying the blueprints for the proposed salt factory. Tamsir leaves a letter imploring him to utilize his social standing for social justice rather than chasing people from their land in favor of government contracts in the interest of multinational corporations.

The ambiguous quest for survival in a society that is fraught with contradiction lies at the heart of Seck's film, embodied in Lissa's desperate attempt to escape from her arranged marriage by compromising her ideals in an attempt to find love, as well as in Tamsir's tumultuous search for his own place in a changed society that he no longer recognizes as his own. Tamsir's uncle, even in his unrelenting quest for wealth and power in complicity with the corrupt government député, is shown to have a human side as he

Alienation, Estrangement, and Dreams of Departure

bails his nephew out of jail and is even shown to hesitate for a moment in his next engagement with the député, a moment in which the viewer is led to believe that he has in fact heard Tamsir's words, although the gravity of change that would be required proves too great to outweigh the temptation put forth by the député. Similarly, Yoro's troubles with his herd of cattle, which are emblematic of rural Senegalese communities' dependence on the natural environment for subsistence, are ultimately left unresolved and therefore open to further dialogue.[39] Whereas it is clear that traditional methods may be somewhat lacking—there is a powerful scene in which Demba interrupts Yoro's attempt to sacrifice his young daughter Rugi per the advice of a local witch doctor—the modern equivalent of sacrificing one's livelihood for the promise of prosperity illustrated by the député's plans for development proves to be correspondingly problematic. Instead, a synthetic solution is hinted at when Tamsir is seen entering the library at the Université Cheikh Anta Diop in Dakar, where he finds a book on agricultural methods and begins to read, essentially alluding to the fact that modern methods of agriculture can augment traditional means of social survival without fundamentally altering the nature of rural agrarian Senegalese villages. Lastly, Demba's character, portrayed as somewhat of an eccentric, perhaps even a "fou" (crazy person) expresses his desire to depart for Saaraba, a utopic paradise that he equates with stories that he was told by the White priest of a land where machines do the work for people. Despite Tamsir's insistence to the contrary, stating from his own experience that it is the people who work for the machines, Demba is unable to shake his obsession with this paradise, which he intends to reach on his motorcycle. Only when he is shown dying at the end of the film after crashing his motorcycle does he relate to Tamsir that he is already in Saaraba. This notion could indicate—much like for Samba in Kane's *L'aventure ambiguë* or Mory in Mambety's *Touki Bouki*, as I will discuss later in this chapter—that life is to be found in the moment, in the journey, and in the appreciation

of each temporal instant and the options that they afford for freedom within one's own self.

All of the characters in Seck's film are searching for an escape, looking for their own Saaraba, whether it be intimacy in the case of Lissa, sexual conquest for the philandering député, drugs and revolutionary ideals for Sidi and Tamsir, money and power for Tamsir's uncle (and, again, the député), roots or traditions (a kind of paradise lost) in the case of Yoro, or the West, which Demba is convinced is a terrestrial paradise. Yet Seck's film is clear in its depiction that Saaraba, in all of its potential forms, is unattainable. The refrain of the song "Saaraba," played by a band in a nightclub during Tamsir's darkest moment, echoes throughout the film, almost as if to eerily remind the viewer that Saaraba is just a fleeting glimpse, always close at hand though never quite within reach.

When You're Dead and/or Gone: Sissako's *Waiting for Happiness*

Riffing on the theme of an elusive future utopia that constantly evades realization, Abderrahmane Sissako's (2002) *Heremakono* is a film that powerfully illustrates both the allure and tragedy of emigration, while dramatizing the indeterminacy of the emigrant's plight through borderlands with the linguistic differences between the protagonist's Malian language, Bambara, and the local Mauritanian language Hassaniya. The insistence on differences from a plurality of perspectives makes *Heremakono*, a concept that translates as "waiting for happiness," unique, while also sharing some similarities with Seck's *Saaraba*. The main character, Abdallah, watches the world pass by outside through a small, lowlying window in the seaside Mauritanian village of Nouadhibou. His mother expresses her concern for him and her desire that he will begin to learn the Hassanya language and embrace the local customs; however, Abdallah views his position as transitory because he is only waiting to obtain (through his rich uncle) the documents needed to facilitate his departure to Europe. As such, he makes very little concerted effort to actually live in and among

Alienation, Estrangement, and Dreams of Departure

the people who populate the streets: although he does meet Khatra, a young boy who works as an apprentice for the elder electrician Maata, hired to wire a light into Abdallah's room so that he can read. Strangely, the light that they wire from the adjacent room will not work, and they resort to carrying a light bulb, dragging the cord behind them through the desert darkness from a nearby transformer all the way to the room where Abdallah resides. As fate would have it, Maata falls and dies, handing the bulb to Khatra in a gesture that symbolizes a passing of the torch.[40]

The inexplicable refusal of the light to work is but one of the bizarre occurrences that seem to haunt Abdallah's efforts to find himself a place in Nouadhibou. Another example is when he goes to visit his rich uncle who is often away traveling. Abdallah's tailor-made ensemble matches the material of the drapes, couch cushions, and tablecloths, effectively rendering him invisible, as the television displays a French game show called *Des Chiffres et des Lettres* (Numbers and letters); this scene constitutes a striking visual image of his absent presence in the unfamiliar surroundings, while simultaneously hinting at how easily he could "blend in" or disappear.[41] Similarly, when he later goes to have tea with some of the local young women at his mother's bidding, they tease him for the meager and imperfect Hassanya vocabulary he has acquired from Khatra. As a result of his difference, Abdallah becomes a marginal member (perhaps even a casual observer) of the society he resides in. This is clearly shown on the evening of a celebration in Nouahibou. Abdallah goes outside onto his balcony and dances alone at a distance rather than fully participating in the festivities. In an effort to break out of his near total isolation, he begins a casual relationship with a neighboring prostitute named Nana, eventually sneaking out at night to go see her. After once being deterred by his mother, Abdallah makes it into Nana's room and curls up next to her where she is already asleep. This particular scene is indicative of the intense need for some kind of meaningful, compassionate human contact in a world of countless divisions. This notion is further voiced in a karaoke soliloquy sung

in Mandarin by a solitary Chinese merchant to a beautiful young woman: the woman clearly does not understand a word of what is being sung, although the intensity of the merchant's emotion translates on a purely intuitive level. The Chinese merchant's song, like the mute wanderings of the lonely Abdallah, tells a tale of exile: "When will I be able to go home again?" These two particular characters recount the difficulties of isolation and the countless barriers that divide: languages, oceans, customs, dress, dreams, and so on. The implicit message of the film is that in spite of these separations, relationships can still develop in the shared space and time that is the terrestrial passage of "heremakono."

Interestingly, Nana also has her own story of exile, loss, and longing to tell. In an effort to dissuade Abdallah from his unwavering drive to depart for Europe, she divulges a story from her past about an illegitimate daughter born to her after an encounter with a European man named Vincent. Shot in a grainy, monochromatic sepia, the flashback shows how Nana went to Europe to search for her Vincent in order to inform him of the death of their daughter, only to be quickly turned away by her former lover, who clearly retained no interest in or affection for her. The emotional coldness of this first-person account of her European adventure is emblematic of the inhospitable culture that awaits the majority of African immigrants set on finding happiness in Europe. Yet it stands in stark contrast to the bright hopes of Abdallah and other transitory characters who also populate the desolate surroundings of Nouadhibou: this includes two young men, Omar and Makan, who arrive by car and are left to await the arrival of a motorized canoe to embark on the treacherous journey up the western coast of Africa to Spain.

As they anticipate their launch to a foreign land, Omar and Makan are shown conversing about their acquaintance, a man named Michael who had embarked for Spain on that very same voyage some two weeks prior after a much-celebrated photoshoot in front of a fake Parisian backdrop complete with a replica of the Eiffel Tower. They wonder if he has arrived; after all is silent,

Alienation, Estrangement, and Dreams of Departure

a man is shown walking out of the ocean. This serves as an eerie foreshadowing of what occurs the following morning when the bloated body of a man washes up on the beach. The photos in the man's pocket indicate that it is Michael. The "mirages de Paris" (see, e.g., Christopher Miller) that entice the migratory influx toward Europe reflect an illusory dream world that exists only as a backdrop to the relatively mundane aspects of daily life, not unlike the waterlogged photograph fished from the pocket of Michael's drowned corpse. Omar decides to cancel his voyage, but he communicates to Makan that he is free to continue should he choose to do so. When they are questioned by the authorities concerning the cadaver, they fabricate stories about their intentions, stating that the large containers of petrol are used for cooking, although it is clear to everyone involved that their intended purpose is to fuel the voyage of their imminent departure.

The juxtaposition between death and departure is most clearly depicted in this scene, with the body serving as an eerie premonition of the potential danger that awaits Makan and Omar if they decide to pursue their journey. Death also becomes a part of the filmic discourse when the elder Maata explains to the young Khatra how he had once been stranded at sea in his fishing boat and had struggled to return to shore. Khatra asks if he fears death, to which Maata replies in the negative before turning away and going to sleep. In many ways, however, death and departure are shown to be synonymous in the film. Maata recalls his close friend Ethmane who had wanted them to leave together; however, Maata chose to stay behind, and for him, his friend's departure is a figurative death because Maata has not seen him nor heard from him since. The film concludes with a wave of departures that further fragment the loosely bonded members of Nouadhibou's transient population. Makan is shown departing in a taxi after deciding to abandon his journey across the sea. Maata collapses and leaves Khatra behind to carry on his legacy alone. The latter is visibly affected by his mentor's absence, shown sitting by the seaside watching the light bulb, which he had apparently thrown

into the sea, being tossed in the shallow waves before washing up again onto the beach. Khatra interprets the sea's refusal as a sign, and he takes up the rebaptized bulb and proceeds to successfully light the small room that Abdallah had recently vacated. Abdallah had been unable to wait any longer for the happiness that seems to have eluded him.

However, in parallel fashion to the sea's rejection of the discarded light bulb, Abdallah is shown struggling to walk up a sand dune before giving up and coming back down. Then another man, the feet of whom Abdallah recognizes from his hours spent staring out of the low-lying window of his room, runs up the dune and disappears. Similarly, the train arrives at the station. Khatra, amid a crowd of people shown clambering on in an effort to get away, is thrown back off and left standing as the train pulls away. He then turns and heads back across the sand. The ambiguity of this closing sequence leaves the question open as to whether Khatra and Abdallah, after their initial unsuccessful attempt to leave the confines of Nouadhibou, will stay or go. Yet the question of staying or going is in a greater sense superseded by what Sissako demonstrates through these parallel images in the film's closing sequence—namely, the pettiness of human ambition in the face of the tremendous forces of nature and of the indifferent mechanisms of civilization that refuse passage to some while seemingly arbitrarily granting it to others. And one is left to further wonder if these forces of fate (the ocean, the dunes, and the crowded train that each reject the light bulb, Abdallah, and Khatra, respectively) are not in fact a blessing in disguise because they prohibit the unhappy wanderers from blindly pursuing their own demise.[42] In a sense, Khatra and Abdallah are those whom departure—leading to, at the very least, a metaphorical death—has refused, and the viewer is left to wonder if they, like the light bulb that Khatra brings back from the sea, may now begin to shine kaleidoscopically into the once-darkened room where light had previously been impossible. Perhaps, like Makan, one can appreciate one's life waiting for happiness only after one has seriously entertained the

prospect of departure and has come to realize that happiness can only be found in the waiting. The aborted journey into the "space" represented by Europe allows them to better see and experience their terrestrial home.

Chasing the Dream: Mambety's *Touki Bouki*

The enmeshment of the characters in a web of futurity, which simultaneously animates and suspends the present, appears through an Afrofuturist leitmotif of projecting oneself into an unknown space or time. One further experiences this creative space, which Calixthe Beyala characterizes as "lunatic writing," in the romantically charged avant-gardist emigrant tale by Djibril Diop Mambety in his 1973 feature *Touki Bouki*, which translates as "The Hyena's Journey," or more correctly, as Nar Sene points out, "le voyage . . . *à l'hyène*" (2001, 80; in the fashion of a hyena). This film's circular narrative, like a hyena's errant scavenging meanderings, is enacted through the main character, Mory, a homely youth who rides around on a motorcycle affixed with the skull of a cow, in an effort to woo his lover, Anta, and pursue their dream of a romantic journey to France. Mory refers to Paris as the "gateway to Paradise," and as we see in so many of these films, Europe constitutes a destination as strangely exotic and inaccessible as the moon or distant planets. In Mambety's film, the opening images depict traditional herdsmen grazing their cattle in the West African Sahel. This idyllic scene, accompanied by tranquil flute music, is brutally interrupted by the violent sounds and images of cows being killed in a slaughterhouse, an implicit reference to the violent impact of colonialism as the transformative moment through which the animal is transformed into the hybrid machine of Mory's motorized cattle cycle. The poignant juxtaposition of life and death in these opening scenes, and the resultant embodiment of "the *living dead*" (Mbembe 2019, 92) in Mory's cattle cycle, is an additional layer of Afrofuturist postcoloniality: the mechanization or zombification of life's forms. This theme is reprised at the end of the film, when

Mory inexplicably decides to turn back just as he and Anta are aboard a ship, the *Ancerville*, and about to head for France. Instead of embarking on the voyage to the other world, he descends back into the city streets to recover the now-fractured skull that had been attached to his wrecked cattle cycle. The narrative's circularity, which is alluded to throughout the film via the travels that Mory and Anta undertake on the motorcycle (later in a taxi and finally in a stolen Roadster emblazoned with an American flag motif), is further reinforced by the final scene in the film, which reinscribes the entire journey within the context of a lovemaking act between Anta and Mory. Mory's scheme to pursue the high life in Paris follows a rather explicit lovemaking scene in which the orgasmic sounds of the young couple's embrace are accompanied by visual images of waves crashing against the rocky shore of the Dakar peninsula. The return to postcoital bliss implied by the waves again at the end of the film serves as a cautionary reminder at the end of the film to be wary of the attractions of youthful fantasies, as the viewer understands the tragic implications of a journey that has ultimately left them forever separated.

The innocent young love that exists between Mory and Anta early in the film is gradually corrupted as the pursuit of the dream slowly takes precedence over their pursuit of each other. Their devotion to one another is made explicit early in the film as the independent Anta disregards her mother's admonitions, as well as those of an old sorceress to whom Mory allegedly owes a sum of money for rice (she literally runs toward him, leaving behind everything for his warm embrace on the barren seaside rocks). Even though Anta's mother is critical of her clothes, her fascination with the university (which she describes as a "dump"), and especially the no-good Mory, Anta's strength of character is clearly illustrated when she stands up to her mother. For example, Anta refuses to let her mother sell tomatoes and peppers too cheaply to a client in the Kolobane market, which raises the question of competing cultural values, such as individualism versus communalism, that are interwoven throughout the film. Mory, in turn,

Alienation, Estrangement, and Dreams of Departure

has to stand up to a group of his peers who, after berating him for keeping Anta from coming to their meetings, tie him up and carry him off in their red truck, the color of which may indicate the political philosophy of these young student revolutionaries. Yet, in spite of the challenges that Mory and Anta do overcome in the initial stages of the film, the strength of their love does not stand up to the "pursuit of happiness" test that is the driving force of the film. Mory is left alone at the end holding half of the broken skull from his wrecked motorcycle as Anta sails off on the *Ancerville* beneath the Senegalese flag.

The imagery in the film is particularly strong, and the parallels between the young herdsmen riding on a horned bovine in the film's opening and closing sequences and the skull that adorns Mory's motorcycle indicate as much of a rupture as a continuity. If the skull is interpreted as a symbol of Mory's identity, a deadened and bleached version of the precolonial ideal implied by the young herdsmen, the fracturing of this identity at the end of the film is particularly poignant. Another example of this is the relatively late introduction of the pale (almost White) savage who takes to riding Mory's motorcycle at the very moment that Mory is transformed through theft into a wealthy aristocrat: as it happens, he has stolen clothing and an automobile from a decadent lush, Charlie, whom they had just visited and covertly burglarized, taking advantage of his naive and trusting nature. The identitary doubling at play in the film implies an interesting reification and reversal of the two competing notions that are held in tension throughout the film: namely, the values of traditional and modern societies. In this sense, if one places the nameless White savage on a parallel plane with Mory the rising aristocrat, the commonly held conceptions of "civilization" are called into question as Mory's theft and subsequent masquerade (an allusion to [neo-]colonial forms of exploitation) contrast sharply with his White double, who takes up the abandoned motorcycle journey (an allusion to the endless plight of the [neo-]colonized).[43] It is this kind of reverse colonization at play in Mory's mind as he hatches his plan

to emigrate with Anta on a boat that will be leaving the following day for France. There he intends to infiltrate and exploit the high cultural milieu by throwing around some petty cash, essentially playing the dandy, in order to actually achieve the social status and corresponding wealth that he will emulate. He justifies his quest for ill-gotten gain through a snide reference to certain "Red Cross broads who have grown fat on the drought," showing how even the seemingly benevolent acts of Western organizations serve less to benefit the victims of suffering than the relief workers themselves.

The contrasting set of values is immediately apparent in the opening scenes, when Mory's motorized voyage down the highway is juxtaposed with the perpendicular pedestrian traffic crossing over the bridge to the sprawling shantytown of Kolobane. Within this popular quartier, Anta's mother sells peppers and tomatoes next to an electronics shop that claims "dépannage de toutes marques" (repairs on any brand) as the muezzin sings praises to Allah. Again, the contrasts that exist within modern Senegalese society are at the forefront, particularly in terms of the technological, communicative, and locomotive developments that appear alongside of (yet somehow still slightly set apart from) the more mundane day-to-day aspects of life. Furthermore, when Anta is introduced, her character is seen writing at a desk in a way that brings to mind the opening scene of Sembène's (1966a) film *La noire de . . .* (Black girl), in which Sembène appears smoking a pipe and poring over some papers; this scene implicitly engages the question of two fundamental communicative modes that have been prominent in postcolonial Senegalese society—namely, writing and filmmaking. Immediately following this scene, a client arrives at Anta's mother's table and begins to complain about her son in France who does not write, suspecting that the postman may be keeping something from her; Anta's mother replies that she should never have let him go: "Nothing good comes from France." All of these opening images and dialogues serve the express purpose of setting the stage for Mory and Anta's conflicted quest to emigrate to France by alluding to the pervasive influence

Alienation, Estrangement, and Dreams of Departure 137

of France's colonial and postcolonial legacy in Senegal, which has spawned the society of contrasting modes of living, a perpetual war of the worlds, so to speak (cf. H. G. Wells), that is so clearly depicted at the outset of *Touki Bouki*.

The conflicting images of France as a place from which nothing good comes, according to Anta's mother, and as the proverbial "Gateway to Paradise" reaches a climactic point as Mory and Anta are set to board the *Ancerville*. Through their tumultuous journey, the value of African traditions has been called into question. Early on, when they discover an array of fetishes (sacred objects with protective or harmful powers) along the banks of a small river, Anta cautions that they should not touch them, mentioning a warning that she had heard from her grandmother. Mory disregards her words of caution by flippantly retorting, "Who told her?" Afterward he proceeds to take a fetish that is purported to bring good luck, which accordingly is the key to wealth. Despite this sacrilege, Mory appears to believe in the stolen fetish worn upon his left wrist. He is shown repeatedly touching it when he first gambles with a card-playing trickster for a thousand francs (which he loses), and later when he steals a strong box from a wrestling match (which does not contain the money they had hoped to find but instead a skull and other assorted items). It would initially appear that luck is not in Mory's favor. Yet he is fortunate enough to escape from the law after each attempt, first by bribing a policeman with a cigarette and later by blackmailing another with a story of observed misdeeds.[44] The ambiguity created by the combination of Mory's bad luck and good fortune further entrench the question of traditional beliefs: does the fetish work or not?[45] Mory's simultaneous respect and apparent disregard for the sacred mirrors the ambiguous image of France that Mambety portrays in the film. Anta has a taxi driver take her and the strong box from the wrestling match to an abandoned shell at the limits of the city, an ominous place where a vulture is perched and about which the taxi driver states with disdain, "This is a bad place; only Europeans could live like this." All that is destitute and

undesirable in Africa, like the carcass of a shipwreck that lies off of the coast where Mory and Anta pause to reflect on the next stage of their plan, is shown to be the result of European involvement, which provides contradictory evidence to Mory's utopic vision of his final destination of "Paris, Paris, Paris" (echoing the refrain of Josephine Baker's song that punctuates the entire film). Furthermore, as Mory proceeds to rob the unsuspecting homosexual Charlie as he showers, with repeated invitations to join him coming from the background, Charlie urges Mory to stay, saying that "France is not what it used to be," further evidence that Mory's dream may be somewhat misguided. It would, however, seem that he finally comes to his senses when he chooses to turn back at the last minute, leaving Anta aboard the *Ancerville*, but it is impossible for him to mend the fractured images that he has wrought.

There is a further commentary in the film on gender as Mory repeatedly disregards Anta's advice, stating that he is "the man," which she later learns to sardonically echo: "Whatever. You are the man." Perhaps the richest irony in the film is Mory's persistent dismissal of Anta's suggestions at critical junctures. From the outset, Anta is clearly depicted as intellectually superior to Mory; she is shown studiously working over a table while Mory rides about on his cow-skull motorcycle. When Mory refuses to acknowledge her admonishments regarding the fetishes that they find, it is the first indication of his arrogant self-assuredness. When he decides to test his good-luck charm against Anta's better judgment, he loses one thousand CFA to a card hustler, and when he is debating which case to steal at the wrestling match, he defies Anta's suggestion and picks the wrong one. Even when they decide to steal from Charlie, Mory is shown rummaging through Charlie's armoires in search of clothes, eventually emerging from the house with a bulky trunk full of exotic attire, while Anta calmly seats herself in front of a satchel from which she coolly removes a handful of cash. Anta's levelheadedness in contrast to Mory's impulsivity is what leads Sene to conclude: "In his films, women turn the decisive pages of destiny. Great social changes are the work of

Alienation, Estrangement, and Dreams of Departure

women who carry on life's adventure by themselves. They are at the center and hold the primary role of the story/history" (79).[46] Yet, in spite of Mory's poor judgment (just prior to his epiphany that they should rob Charlie, he suggests that he could fix a shipwreck lying off the coast of the Almadies if only he had tools, to which she rightly replies that it is impossible), Anta follows him up until the very end, a testament to the strength of her devotion: or perhaps evidence that she has bought into Mory's dream of contentment through material wealth.[47] Ironically, whereas Mory seems to acknowledge the error of his ways, or at least to doubt the accuracy of his vision, Anta finally refuses to follow him when he turns back. Thus, Sene remarks: "In *Touki Bouki* a poor, young girl leaves for Europe, leaving behind a boyfriend whom she holds dear" (89).[48] Not dissimilar to Sembène's *La noire de . . .*, in which Diouana leaves behind love in search of a dream (one that proves to be altogether tragic for her), Anta also turns her back on the man she loves for the dream of a better life in France. One must wonder if Mambety intentionally ended the film at this point in order to insinuate a possible parallel between Anta's fate, at least metaphorically, and Diouna's. Or perhaps his film is simply the other side of the story: that of a young man who is too afraid to commit to his dreams of love and earthly paradise, instead clinging to a fractured identity tied to a postcolonial melancholy.

The dialogue of the passengers on board the *Ancerville* seems to already foreshadow the troubles that await Anta, such as the persistence of a racist and bigoted mentality that will not allow for her (and Mory's) dream of a better life to be realized. As crates are being loaded onto the *Ancerville* for export, some White members of the neocolonial elite critique Senegal as a barren wasteland. They justify the inequality of their salary (three times that of the indigenous teachers) by saying that they eat differently and that there is nothing to buy except cheap copies of African art (a joke created by journalists);[49] as a result, they bank half of their salary, making investments abroad in the United States or in France. This brazen attitude clearly illustrates the cause of the perceived

"wasteland," and as Anta stands within earshot, they further express their disdain for the local Senegalese population by citing the nerve of their houseboy who asked for a raise. They remark on how much they have done for him and say that he is childlike, an obvious continuation of the paternalistic colonialist attitude that is still in vogue. To add insult to injury, they discuss the perceived shortcomings of the so-called revolutionary politics of the communist bloc, referencing Mao as too soft and the Italians as too extreme, saying that they challenge and incite their students with such principles to kick out the neocolonialists. Yet, clearly, especially in the wake of the failed popular revolution of 1968 in Dakar five years prior to the film's release, there is no real threat (or hope) of a change in the social hierarchy.[50] This grim vision of the future is reinforced by the recurring images of cows being slaughtered and the destruction that punctuates Mory's flight from the *Ancerville*. As Anta patiently awaits her fate and disappears below the ship's deck, Mory runs chaotically through the city as the tall white buildings whirl ominously overhead. He stumbles upon the broken body of his White savage double, who has wrecked his motorcycle. After the wreckage is cleared and the crowd dissipates, Mory leaves behind his fancy bowler hat and half of the fractured cow skull that had once adorned his motorcycle: an indication that he has not only abandoned his dream of life elsewhere in Europe but that he has also lost a part of himself that he will never be able to recover. Rather than providing him with an escape from his mundane existence, Mory's pursuit of life elsewhere has blinded him to the life and love (however small) that he had; ultimately he is left with less than when he began. Nonetheless, it would seem that there remains a resolute stoicism in the way that the film ends with the postman continuing his endless circuit through the city streets and the waves continuously crashing up against the shore.[51] In Anta's departure and Mory's forced resignation, there is a hint that life goes on and that the individual narrative, no matter how epic, is but a fleeting moment in a much greater, though perhaps incomprehensible, cosmic scheme.

Alienation, Estrangement, and Dreams of Departure

The indeterminacy of a Bhabhaian "third space" in suspension between one cultural location and another—an "other," and also between being and nonbeing, as well as reality and representations are particularly salient themes in many of these films because the geographical displacement is mirrored in the psychological space of the immigrant/emigrant who comes to embody a kind of *métis culturel*, or culturally mixed subject.[52] For example, Sissako (2002) illustrates the joy and agony of life's ambiguities through its stunning portrayal of a group of sojourners residing temporarily in the coastal town of Nouadhibou. Caught between their dreams of departure and the necessity of surviving daily reality in the confines of their temporary community, the intermingling of each individual's story as they anticipate the next stage in their journey reveals a greater metaphysical significance, one that transcends the limits of each narrative: in spite of perceived success or failure, we find our common humanity in the in-between, the uncertainty, and the waiting that when appreciated is itself a kind of happiness. Similarly, in Seck's *Saaraba*, each character is searching for an escape, whether in intimacy, sexual conquest, drugs and revolutionary ideals, money and power, indigenous roots and traditions, or the elusive promise of emigration to the West. Yet, Seck makes clear in his film that Saaraba, in all of its potential forms, is ultimately unattainable. Much like the refrain from Josephine Baker's "Paris, Paris, Paris" that echoes through Mory and Anta's journey in the manner of the hyena, the refrain of the song "Saaraba," whose title refers to a concept like utopia or the other worlds of science fiction, reverberates and reminds viewers that such places might just be purely the inventions of human imagination. It is precisely in this sense that these works of Francophone fiction embody an Afrofuturist rhetoric of alterity, which seeks to combine the contradictory or the paradoxical and to approach the limits of rationality and reason to glimpse what might lie just beyond the event horizon.

Embarking on a Journey toward Death:[53] Elalamy's *Les clandestins*

Turning to the literary, which is also strangely cinematic in the beautifully written text, *Les clandestins* (Elalamy 2011) lays bare the angst and despair that inhabit the physical and mental spaces of a small Moroccan village through a tragic retelling of a boat that capsized off the Mediterranean coast. The untimely deaths of fourteen people whose waterlogged and mutilated corpses wash up on the beach after a failed attempt to cross the strait of Gibraltar into the proverbial "promised land" that is Spain (or "Sbania" in the local pronunciation) are depicted in excruciating detail along with the varied circumstances that precipitated their departure. The novel recounts fourteen people—as well as the boat, the moon, "watching with its deadened eye," the sea, a basket of fruit, and even a worm "who embarked onboard an apple"—who depart from the seaside village of Bnidar in Morocco on the night of April 22, which is a Sunday (137).[54] The extreme attention to detail with which Elalamy tells the story constitutes an explicit attempt to ascribe value to lives and things that are all too easily ignored. The juxtaposition of the human and inhuman lives, both plant and animal, as well as the existence of inanimate terrestrial and celestial bodies constitutes an Afrofuturist critique of anthropocentric thought. With a style that demonstrates the inhumanity of a world in which tragedies are common, Elalamy first introduces the character of Omar, who discovers that "bodies had washed up kind of all over the place on the beach" (23).[55] With dramatic force, the tragedy of the situation is suspended as Omar stands in the rain[56] for twelve minutes before running at the unlucky thirteenth minute to alert the village of the dead bodies "with something like glass in his voice, several pieces of irretrievable glass, forever shattered" (37–38).[57] Omar's emotionally charged flight—which is then taken up by another local inhabitant named Moh who, on a bicycle, carries the broken-glass scream "ils se sont noyés!" (39; they've drowned!) to the village—stands in stark contrast to the official story announced on the radio that evening: "Two careless

Alienation, Estrangement, and Dreams of Departure 143

swimmers drowned near the small municipality of Bnidar" (42).[58] The multiplicity of narrative voices employed anthropomorphizes these body objects found on the beach, giving voice to each one while calling into question the veracity of the "official" take on the tragic events.

Giving voice to the nineteen body objects through Elalamy's alternating use of first- and third-person perspectives accentuates the dehumanizing ambiguity that leaves the victims in representative obscurity, a trope that is further exemplified by nineteen photographs taken of the cadavers washed up on the beach, each of which is described in detail in the nineteenth chapter of the novel (97–102). The grotesquerie of human body parts protruding from beds of sand or seaweed, accentuated in one case by a crustacean emerging from the open mouth of one of the corpses (101), illustrates in poignant fashion the disdain for human life that is (dis)embodied by the media politics of a sensationalist society. For example, Elalamy remarks on the publication of "l'un des cent trente-huit clichés" (102; one of the 138 clichés) that day, including those of the bloated and mutilated human forms, in a French weekly magazine under the title "Une si jolie petite plage!" (102; Such a pretty little beach!). The dehumanizing objectification with which the victims are described, either in purely aesthetic terms under the photographer's eye or in undifferentiated, free association with their environment—the boat, the moon, the sea, a basket of fruit, a worm, etc.—serves to highlight the vague and ephemeral distinction between life and death and between human subjects and objects. Furthermore, each character is given a name as well as a surname or nickname that serves to accentuate a distinguishing characteristic of each individual person, a sort of shorthand that becomes more developed as Elalamy meticulously unpacks the desires and motives of each one over the course of his thirty-one chapters.[59] The sustained ambiguity with which Elalamy develops his characters, vacillating between animated emotive episodes and inanimate renderings, appropriately captures the ambivalence of humanitarian discourses with respect

to human tragedies: specifically those of migrations and displacements, as well as their consequences and underlying causes.[60]

In contrast to the objective focus and strictly materialistic predisposition of the media vis-à-vis the problem of human desperation portrayed in the novel, Elalamy describes the discovery of the bodies by those who were close to them in life as well as the circumstances that precipitate the departure of each of the characters who embarked that night on the ill-fated journey. He begins with a heart-wrenching account of Louafi's mother, who finds "le corps de Louafi sans Louafi" (46; Louafi's body without Louafi). She recalls the words that he had spoken to her previously, in which he had expressed his hopelessness and his desire to leave behind his current life:

> No, mom, I refuse to be the four-legged beast with eyes on the earth that no longer feeds it. Yes, leaving to no longer await the rain that does not come, the sky that does not respond, and life that does not grow.... I think I can still live without giving over to death, live without turning my back on life.... I burn myself to see if I exist, I put fire to my hand to see if I still exist, and you know, mom, I still exist enough to leave. (47–48)[61]

The tragic explanation of a son to his mother of his need to leave in order to escape a living death exacerbates the complexity of the societal problems that Elalamy addresses in his novel. It is not a question of abandoning life for death, nor simply of trading one life for another. Rather, the problem is one of perception, which leads one to see life as a death sentence and to exchange that life for the possibility of another without recognizing that that life is itself only a different death sentence.

In many ways, Elalamy's tragic characters reveal a discomforting fact about postcolonial existence, one which Achille Mbembe characterizes as "une économie de la mort" (an economy of death), a notion introduced in his work *On the Postcolony* (Mbembe 2001) and later elaborated on in *Necropolitics* (Mbembe 2019). The fate of Moulay Abslam, also known as "le conteur" (the storyteller),

Alienation, Estrangement, and Dreams of Departure

who is able to spin beautiful stories with words "de toutes les couleurs" (92; of every color), tells a similar story of a life that has become a death sentence. His former love recalls the way in which Moulay Abslam, a man imbued with tremendous verbal power to create beauty where there was so little, lost his love for life, saying that he could no longer hear the stories that the world was telling him. She explains how he left and never came back, taking all of his words with him. She concludes by saying that his absence signals another form of death for her: "Today, I know that even without him I will continue to breathe, to drink and eat, even to sleep. But to live, never. . . . Since he died, me, at night in my bed, I die no more" (95).[62] The obvious reference to sex as "la petite mort" (the little death) raises the question of passion for life and love, obscured and overpowered by a sense of doom and gloom, which drives a person to hopeless self-denial.

Many of the characters also embody the tragic flaw of unfulfilled love, which serves as a catalyst for their demise. Ridouane, for example, a man who also is referred to as "tête-à-l'envers" (backward head), is driven mad by his wife's frigidity and by his inability to communicate his desires to her: as a result, he throws himself into the embrace of the sea. Slimane, who also goes by the name "Slim," also has love or relational problems at the base of his decision to embark on the fateful journey. He is infatuated with Lbatoul, a woman that he desires and dreams of. But upon finally meeting her one day in a café he comes to realize that she is a prostitute. He is able to ignore or deny this fact, citing his ignorance and inability to read as partial justification (133), but when he happens upon her in the company of another man in the hotel where she works, he is unable to control his passion and strikes Lbatoul's client with a kitchen knife. Upon realizing what he has done, he grabs an envelope of cash from the table, buys a basket of apples, and climbs aboard the boat to make the crossing to the other side. One final example that illustrates the societal depravity of Elalamy's characters, not only on the level of love relationships but also in terms of the complex social norms

and customs that come into play when pursuing such fulfillment, is the character of Abdou, who also goes by the name "Minuit" (Midnight). Unlike Slim, Abdou possesses his diploma, yet still he finds himself unemployed. He recounts his infatuation with a young woman whom he watches for sixty-four days and to whom he gives the name Yasmine. Unfortunately, he is too burdened by "shame, boredom, and the rest," an inadequacy resulting from having "nothing to do, [it's] not worth trying" (145).[63] Bearing the weight of his past success and the hopes of his parents, his own self-image serves only as a constant reminder of his present failures. As such, he never once engages with Yasmine but rather stands exiled to watch her from the periphery from his position in the world, which he repeatedly describes as reduced to endless waiting and the herculean task of acting as if this were not the case: "to act as if . . . [or] to pretend" (147).[64] Finally, after sixty-four days of watching, waiting, and bearing the weight of his shame, he receives word of his employment as a schoolmaster in a remote village, only to find upon arriving there that aside from a cornerstone, there is no school. His frustration is compounded as he describes the absolute absurdity of the situation of his being assigned to teach at a school that was never constructed: "Someone had forgotten that they had forgotten to build the school" (149).[65] The reader is left to infer from this that Abdou succumbs to the inevitable decision to follow the enticing image that he has seen so many times on his daily walk to and from the ministry (likely the Ministry of Labor and Professional Integration) in search of employment: "the image of that woman, on the poster in the colors of Spain" (146).[66]

Another character, Jaafar, also goes by the name "Houlioud," after the name affectionately given to the neighborhood in which he lives: Hollywood. The irony is thick because this neighborhood he hails from is a far cry from the opulence that one typically associates with that American bastion of spectacular excess.[67] Jaafar is a contributing member of society, a working-class hero of sorts who was one of the first to construct his tin shack on the outskirts

Alienation, Estrangement, and Dreams of Departure

of town in an area that would later grow into a sprawling shantytown of similar "baraques en tôle" (tin shacks). Even though he recognizes that "c'est un truc de pauvres" (108; it's a poor people thing), he takes pride in his role of pioneer, repeating twice that he was the first to settle there. This is despite the area's squalor: "They came as families to harvest misery and sickness and all of the stupidities of this city" (108).[68] Despite the hardships, there remains a sense of propriety that can only be described as the pride that comes with self-sufficiency: "It was our place" (107).[69] One day, two men in blue suits arrive in a blue car to take measurements of the area, and the next day, a group of workers begin constructing a stone wall. The inhabitants of Hollywood, who were clearly not consulted on the project, debate whether the wall is for a hospital or a cemetery. The widow Hogga makes the sardonic point that the two are in fact one and the same: "They lay you down on a bed to better see it all, to see your life take off through the window" (111).[70] Still, others argue that it is a school, a hotel, or a mosque; however, what is clear is that whatever lies on the other side of the wall is beyond the reach of the poor inhabitants of Hollywood. They are left on the outside without even the possibility of looking in. This wall symbolizes the barriers that exist in society between those who have things and those who do not. What small sense of independence and ownership that Jaafar and his neighbors glean from their destitute community is removed when their freedom (whether real or illusory) is blocked by the construction of the wall, and the reader is led to believe that this is actually the reason why Jaafar chooses to depart—to try to get beyond these imposed limitations through the pursuit of life on the other side. Clearly, this constitutes merely one more tragic instance of deception and false hope in "the story of those men and that woman who found death where they thought they would find life" (87).[71]

The remaining characters in the posthumous drama include Salah (a.k.a. "Sbania"), who spends his empty days on the beach wishing and waiting for a way across. Elalamy describes how each day Salah would bend down and drink from the sea as if hoping

one day he would be able to empty the sea into himself and thereby remove the liquid barrier that kept him from his dreamed-of elsewhere (120). Abid, "le coureur" (the runner), is also obsessed with the promise of life on the other side and driven by ambition to become a respected and admired athlete. He states: "I ran as such, carried by my illusions, the desire to go far, farther, the ambition to become someone. Over there. . . . Someone who would be paid to run, to arrive before the others, and to never get passed, who would then be applauded and covered with gold for only that" (153).[72] Abid ends up, like all the others who were with him on the boat that night, clinging to a splintered plank of wood trying to stay alive: "But I hold onto this plank, I hold onto life; I continue to run after it, with death running after me" (154).[73]

Still, others in the company such as Charaf, a.k.a. "N'joum," have more sinister, although equally compelling, motives for departure. Charaf's intention for embarking on the perilous journey is to become rich by selling drugs in Europe, and he carries his precious cargo—"de l'herbe et rien d'autre" (165; some weed and nothing else)—with him to the bottom of the Mediterranean. Momo, or "Le Gros," decides that he must leave to escape the constant ridicule inflicted on him by the neighborhood children, who constantly remind him of his girth and the shame that he associates with "his body that appeared indifferent to the lack, the need, the hunger, and the distress of others" (63).[74] Anouar, "le serveur," similarly reveals a social stigma as the catalyst for his desire to depart, although he seems to arrive at his fate in a much more haphazard fashion. He is described as an ugly young man with a harelip. His daily routine consists of working in a café where nothing ever changes; he cleans obsessively, burying his fears and anxieties in mundane tasks: "I scrub to make it all go away, and leave nothing, remove it all, women who do not see me, children who whisper behind my back, my lip in the mirror, today again and always" (158).[75] There is a man who always sits in the café and reads the same page over and over. Then one day, out of the blue, everything changes: "One day, a clock decides to stop, a man

Alienation, Estrangement, and Dreams of Departure 149

decides to turn the page, and me, to leave. That's how it is. That's all" (160).[76] The character of Zouheïr, "le muet" (the mute), is also emblematic of the extreme social alienation that can easily lend itself to the temptation of an imminent departure without the feeling of being missed by anyone. Zouheïr witnessed his father's sudden death at a young age, likely the victim of a stroke that caused him to keel over in midsentence, "as if he had swallowed a word sideways" (140).[77] Zouheïr is convinced that by speaking, he will inevitably run out of words and thus run out of life. With no escape from his prison of silence, Zouheïr sets off on a journey to elsewhere only to end up drowned, along with all of his own unspoken words, and washed up again onto the beach with his mouth open "as if he were searching to say something . . . (and) always nothing coming out of that mouth if not a small crustacean emerging silently, hesitating for a moment before the eye of the photographer and disappearing once again, mute, beneath the algae" (142).[78]

Finally, the thirteenth member of the company on board the boat that night was a beautiful young woman named Chama, also referred to as "la belle femme" and "une femme étrangement belle" (67; a strangely beautiful woman). Elalamy writes, "One must say that she was beautiful, this woman, and of this infinite beauty, no word, no perfume, no color, no music even could ever account for it" (70).[79] The reader eventually finds out that Chama is Omar's lover, the very same Omar who, following the sandy footsteps of a photographer named Alvaro, discovers the same bodies again. But for him, they are people rather than aesthetic objects, and his intense emotional reaction helps to solidify that fact. Upon seeing the corpses scattered on the beach, scorched and mutilated with empty caverns for eyes, Omar concludes in poetic, perhaps even prophetic, fashion: "Dying is to no longer see the world" (23).[80] This statement is significant because each character is shown to lose sight of the world in which he or she lives, becoming obsessed with a personal or relational flaw, social stigma, or longing for an artificial paradise that may or may not exist: these characters only see the world that *is not*, as opposed to the one that is. In some

sense, these thirteen people were already dead even before they were actually drowned in the sea, if for no other reason than that they could not see the world around them and chose to embark, as Elalamy states, "à destination de la mort" (166; on a journey toward death).

The reason that Chama gives for her fated departure is that she cannot stay in the village and bear Omar's child that she carries inside her, a boy she has named Jibril because her father disapproves: "My father says that you are strange, that you do not resemble us, that you will never be one of us" (73).[81] The intense irony lies in the fact that Omar is the ultimate outcast in the story, the orphaned son of a sixteen-year-old girl named Zaynab who, after refusing her father's attempt to arrange for her marriage, flees and is seduced by an anonymous voice "over there"—"une voix là-bas" (10)—instructing her in the ways of the world and transforming her into a prostitute for Spanish tourists and businessmen. Zaynab, upon returning to her village, dies in childbirth, leaving behind a strangely light-skinned, blue-eyed boy named Omar (17), a boy who years later would unknowingly follow in the footsteps of a father whom he had never met to find the body of his lover and unborn child, among others, washed up on the beach.[82] The functional role that Omar plays in the narrative is that of a litmus test to gauge the circumstances of the other characters; if any character has reason to leave his life behind, it would be Omar. Yet he stays, as if to show that there is no reason great enough to justify the treacherous journey toward death—one cloaked in false promises. The reader is thereby able to understand the fundamental tragedy of Elalamy's text: "To go on the journey, they paid the negotiator from Tangiers more than 20,000 dirhams each. 21,500, to be exact. As if they had worked all their life to buy their death" (26).[83] This is exploitation to the extreme: the sale of a dream, a mirage, and an escape from the difficulties of life. Yet the duped passengers find out all too late that the escape they purchased is not at all what they had hoped for. The desperation of the shipwrecked passengers is depicted in

Alienation, Estrangement, and Dreams of Departure

many poignant passages describing how each one clings to whatever flotsam lies within reach. Chama, in particular, expresses the intense angst and helplessness of the experience: "She hangs on with rage, if rage is the right word to say, not for herself but for him, the little angel asleep inside her, worriless, if he only knew, her child, her little one who does not see the surrounding night and who will undoubtedly never see the day" (81).[84] Unlike the other members aboard the ship, Jibril is the unfortunate victim of someone else's indiscretion, a child who embodies within his tiny frame all of life's potential, as of yet untainted by the kinds of troubles that drive the other characters to the brink. Jibril is an innocent victim, "a child whose color remains unknown" (138),[85] symbolizing a fundamental issue in the text: difference. The notion that one set of characteristics is more desirable than another lies at the base of each character's own discontent. Jibril, unlike the other characters, has no characteristics; he is fully human because he is unseen and invisible because he is unborn; in that way, his presence illustrates the frailty and value of human life that is often ignored by mediatic, political, and even "humanitarian" discourses that become fixated on their own agendas. Ironically, Jibril's invisibility makes him the most visible, whereas the others, even though they are captured in photographs, remain invisible victims because in being objectified, they have been stripped of their humanity: "So one could come to understand that one had looked at photographs, but had seen nothing" (106).[86]

Whether the motivation to leave is based on a dream of wealth, fame, opportunity, or merely an escape, the longing for change is constant in Elalamy's portrayal of his characters' different plights. The ever-present trope of the unborn child floating in its mother's womb as she in turn floats in the waters of the Mediterranean—waiting for her own passage out of one world and into whatever lies beyond—helps to underscore the fundamental question of estrangement inherent in all of humanity:[87] a sensation of exile and auto-differentiation that underlies any migratory phenomenon. In the preface to a collection of articles

on migrant literatures of Africa, Cameroonian philosopher Fabien Eboussi-Boulaga writes: "If exile is that which allows us to de-alienate ourselves while at the same time situating us as open relation and network, it becomes that mode of existence which assumes the end of illusory identities as stable properties, the places of happiness and paradises forever lost for the self and of the self, but prospering elsewhere where one must go in order to find them. Exile being everywhere, it becomes a voyage from which one may return happy without going back to the point of departure. Paradox?" (2011b, 26).[88]

In Eboussi-Boulaga's characterization of exile, the myths of elsewhere are dispelled as the experience of exile is universalized to encompass a constant relationality, which recalls a Glissantian "Poetics of Relation," or a way of being in the interconnectedness of the world as such, understanding the necessity of movements irrespective of particular beginning and ending points. Much like Sissako's *Heremakono*, which stages the death-life of its characters prior to departure, Elalamy's *Les Clandestins* reveals the universality of finite existence, placing human-object beings on par with other inhuman-object beings while also conflating the boundaries between being-in-life, being-in-death, and being-an-object-of-perception, either through media, memory, or other modes of representation. As a result, one can experience exile as a paradoxical space of coming and going, or *va-et-vient*, between the self as self and the self as other, always in time. The auto-determinism of geopolitical or ideological discursive boundaries becomes secondary or tertiary with respect to the boundless relational self, which is always opening to new modes of real life as always elsewhere to reprise the quote attributed to Rimbaud—"la vraie vie est absente" (real life is absent), Elalamy's humanizing portrayal of clandestine immigration emphasizes this relationality in a way that universalizes the experience of exile through a rendering of the struggles of diverse voices and the whole world that inhabits their collective consciousness. These characters all grapple with the same existential dilemma of walking the fine line between hope

Alienation, Estrangement, and Dreams of Departure 153

and despair that all too often becomes falsely associated with the fictitious constructs of "here" and "over there." As Mbembe asserts, "No longer is Europe that place over there to where we must go to find the solutions to the questions we have posed over here. It is no longer the pharmacy of the world" (2019, 188). An integral part in the process of realizing the solutions to one's problems from an endogenous perspective involves reappropriating the right of auto-representation, a task which African artists and filmmakers have urgently and passionately pursued for decades.

Demystification and Deterritorialization: Fatou Diome's *Le ventre de l'Atlantique*

One final example to conclude this chapter, Diome's (2003) novel *Le ventre de l'Atlantique* reads like an intimate dialogue between the narrator Salie (whom one might consider to be an authorial other of Diome) and her younger brother Madické. The text's message is paradoxical, or at the very least ambiguous, regarding the trip one makes from out of "the belly of the Atlantic" by which contemporary globalized Black culture has emerged in order to bridge four continents and several groups of islands between (cf. Paul Gilroy, *The Black Atlantic*). Madické's infatuation with Europe and his obsession with the soccer player Maldini fuel his intense desire to follow his sister, who has already left to pursue her life in Europe. Salie has a difficult time explaining that her situation is not what it appears; her failed marriage to the Frenchman with whom she had left Senegal and her subsequent immersion in her advanced French studies while making a meager living as a "femme de ménage" (50; house cleaner) have left her in isolation, alienated from her home and driven by the necessity of succeeding in order to avoid the harsh consequences of failure.[89] She describes herself as "absente et inutile" (51; absent and useless) to and for the daily life of her peers, yet she finds it impossible to explain her suffering because "the third world cannot see the wounds of Europe, its own have blinded it" (51).[90] Salie's life in Europe, which is seen as a

disproportionate advantage by her younger brother Madické, is in reality only a different kind of suffering. However, she recognizes the problematic nature of the persistent myth of Europe as the simultaneous source of and salvation from Africa's woes: "If the third world started to see the misery of the West, it would lose the target of its invectives" (51).[91] The myth of Europe helps to alleviate the suffering of Africa because it provides at least a mirage of a way out, as well as an ideological effigy to point to as the villain and instigator of African economic and political malaise. What Diome effectively accomplishes in her novel is to articulate Salie's alienation as equal to although different from Madiké's own alienation from himself and his present circumstances through the often-unconscious consumption of a mediated mirage.

Diome makes a number of explicit intertextual references to her literary predecessors, including Kane's *L'aventure ambiguë*, Bernard Dadié's *Un nègre à Paris* (74), and Ousmane Socé's *Mirages de Paris* (101). Furthermore, she laments the lack of progress made in Senegalese society since the dawning of the suns of independence in the 1960s, both in cultural and political terms. Salie recounts with disdain the episode of the corrupt *marabout* (a traditional healer), in which she was complicit in aiding and abetting the misguided efforts of Gnarelle to regain the affection of her husband, whose preference for his younger, third wife she could not abide. In this context, Salie's passing reference to the coming night, "extinguishing the torches that Mariama Bâ, Ousmane Sembène, and others struggled to ignite" (173),[92] is a clear indictment of the deaf collective ears onto which the forebodings of *Une si longue lettre* and *Xala* have apparently fallen.[93] The lack of cultural advancement to which Salie is referring has its political correlative in the wise words of her former schoolteacher, Monsieur Ndétare, who recognizes how "Marx's ideas are dying, and the trees of hope that we planted in 1968 have yielded very meager fruits" (205).[94]

Speaking of the misery that also exists in France, Salie and Ndétare try to dissuade the youth from their dream of departure by describing the frightful conditions of the first immigrants to

Alienation, Estrangement, and Dreams of Departure

Europe and the difficulties that their children faced with regard to "la préférence épidermique" (epidermal preference), which stands in stark contrast to the motto "Liberté, égalité, fraternité" (202; Liberty, equality, fraternity). Furthermore, Salie flips the perspective and tries to show the extreme poverty that exists in Europe: "Huddled under bridges or in the tunnels of the metro, the homeless must sometimes dream of a cabana in Africa" (204).[95] This is an ironic reversal of the typical assumptions poor Africans have in dreaming of a better life in Europe and hints at an underlying notion that is consistent throughout Diome's text: no matter the geographical location, one can always imagine a better life elsewhere. The kind of ironic reversal of stereotypical depictions of Africa and Europe is later made explicit in works of speculative fiction such as Abdourahman Waberi's (2006) novel *Aux États-Unis d'Afrique* and Sylvestre Amoussou's (2007) film *Africa Paradis,* which portray an economically vibrant, culturally sophisticated, and politically powerful African continent that is the envy of a dilapidated and impoverished Europe. Yet in Diome's account, clues of this altered perspective that aims to dismantle the mythical image of a European paradise can be more subtly glimpsed, for example, in the stories recounted by an immigrant, Monsieur Sonacotra. Monsieur Sonacotra relays exaggerated accounts of his experiences in France to a young and impressionable Madické, who is already susceptible to "la magie des médias" (183; the magic of media). Reproducing the distorted discourse that depicts France as a land teeming with millionaire soccer stars and famous figures, Diome describes the ways in which "prideful identification is the dopamine of the exiled" (188),[96] alluding specifically to the ways in which a nurse's assistant may self-identify as a doctor, or a teaching aid will claim to be a professor, in a kind of rhetorical regurgitation of common myths of success that contribute to a misconception of European reality.[97] This reality is described in stark contrast to the myth proffered by Monsieur Sonacotra, whose situation is described as such: "polyvalent worker, floating from one temp job to another, whose experience of French life is

limited to the clamor of factories, the bottoms of drainage ditches, and the amount of dog crap per meter of asphalt."[98] Depicting the darker side of life in Europe, Diome's narrative realism marks an essential step in the process of demystification in order to temper the hypertrophied imaginary of "leur tabernacle médiatique" (251; their mediatic tabernacle).

Accordingly, Diome includes examples of difficult emigrant experiences, relaying the tragic tale of Moussa over the course of an entire chapter, a tale which is intended to dissuade Salie's brother Madické from his obsession with becoming an international football (soccer) star in Europe. Moussa was recruited and offered the opportunity to join a European professional football club with the help of a man named Jean-Charles Sauveur, who arranges for his temporary visa and transportation in order to join the team. However, these promises soon prove illusory. Playing in adverse conditions, struggling to adapt to the cold and the strange European diet, and subject to the racist ridicule of his teammates, Moussa ultimately fails to flourish; according to Sauveur, "You are really not making progress. We are going to stop the fees. You owe me around a hundred thousand euros" (117).[99] Sauveur (or "savior" in English) proves to be a predator, profiting off of Moussa's naive hopes and dreams. Lacking the proper paperwork, Moussa sets to work as a laborer on a cargo ship, a condition that is reminiscent of Sembène's (1956) novel *Le docker noir*, a parallelism that seems to imply how little has changed over fifty years of Senegalese independence.[100] When Moussa disembarks from the ship on a layover in Marseille, the same city in which Sembène's novel is set, he is singled out by authorities, likely in a case of racial profiling: he soon finds himself in the custody of the French authorities. Mistreated and fed "that dejection of conscience from the country of human rights, which he called death-food" (123),[101] Moussa is expediently returned to his home country. Diome writes, "An airplane vomited him onto the tarmac of the Dakar airport" (125).[102] Moussa is unable to cope with his disgraced return. His tale stands in stark contrast to the image cast by the media and reiterated by others,

Alienation, Estrangement, and Dreams of Departure 157

such as "l'Homme de Barbès."[103] However, his story of failure, like those of countless others, is left untold, buried in the shame of regret and denial or drowned beneath the ocean waves. This is why the teacher-syndicalist Ndédtare can only advise Madické and his fellow dreamers in the past conditional mood: "You should have asked Moussa to tell you about his France. He too had followed the song of the sirens" (107).[104] The visceral language that Diome employs in this account of Moussa's detainment and extradition back to Senegal serves to underscore the dehumanizing perspective of Europe and of France in particular, vis-à-vis the immigrant body from the postcolony, marking another effort to reveal "the tricolored chimera": "France is not paradise" (131, 132).[105] The untold stories of return from Europe without the promised wealth and success portrayed by mainstream media are what make Diome's novel a remarkable representation of the intermediacy of postcolonial identification.

Trapped in the in-between space, the immigrant experiences the constant and simultaneous presence and absence of elsewhere. Salie's emergence from the ocean depths is a story of a transversal movement from the island of Niodior in Senegal to Toulouse in France. The story she tells recounts her arrival as well as a nostalgic return in a way not dissimilar from the account given by Bugul (1984), as well as the angst that she feels about being a stranger in both cultures, the ambiguous identity of the cultural *ñuluul xessul*—or the métis—so eloquently evoked by George Ngal (1984) in the character of Giambatista Viko. She states: "With roots everywhere, yet exiled all the time, I am at home where Africa and Europe lose their arrogance and are content to be added together: here on a page filled with the amalgamated combination that they have left with me" (210).[106] This dynamic process of becoming that Salie expresses through the medium of her writing can be understood in terms of the process of deterritorialization and reterritorialization, as it is theorized by Gilles Deleuze and Felix Guattari in *Mille plateaux:* "One never deterritorializes alone; there are always at least two terms, hand-use object, mouth-breast,

face-landscape. And each of the two terms reterritorializes on the other. Reterritorialization must not be confused with a return to a primitive or older territoriality: it necessarily implies a set of artifices by which one element, itself deterritorialized, serves as a new territoriality for another, which has lost its territoriality as well. Thus there is an entire system of horizontal and complementary reterritorializations, between hand and tool, mouth and breast, face and landscape" (1987, 214).[107]

Understanding the binary coupling of Africa and Europe as a continuous flux of deterritorialization and reterritorialization elucidates the discursive interdependency of the two terms in a way that recalls Edward Said's concept of Orientalism as a dependent variable of the Occident. Salie's narrative voice embodies this implicit relationality because Senegal and France must be reconceived within the reiterative space of the page as a sequence of deterritorializations and reterritorializations. The narrative constantly shifts away from her voice's point of origin and replaces each individual territoriality with a new set of artifices. In the same manner that one cannot conceive of the Orient without the Occident as a point of departure, once the Orient has been deterritorialized as such, it becomes reterritorialized within an Occidental discourse, which itself has then been deterritorialized through the investment in and interference of the other. Salie's Senegal is deterritorialized and reterritorialized as "other" as a result of her experience in France, in much the same way as she experiences a deterritorialized and reterritorialized France as a consequence of her experience in Senegal, a condition she appropriately characterizes as such: "I go back home like one goes abroad, for I have become the other for those who I continue to call my own" (190).[108]

The experience of universal exile for the immigrant begins even before departure when one's country of origin becomes initially subject to deterritorialization with respect to a conception of the potential host country that serves as the catalyst for the process. As Diome's narrator states: "I had come to understand

Alienation, Estrangement, and Dreams of Departure

that to leave would be the corollary of my existence"[109] (260) and "I grew up with a feeling of guilt, the awareness of a need to atone for a fault that is my life itself" (261).[110] Reflecting the psychological complexities of the colonized that anticolonialist thinkers such as Frantz Fanon and Albert Memmi have theorized, Salie's deterritorialization begins with a false conception that her existence is somehow contingent upon her capacity to move away, burdened by a self-inflicted sense of guilt that her life has purpose only through its eventual absence from her home. In a passage reminiscent of Adiaffi (2002), Diome describes the emigrant's plight: "To leave is to have the courage to go and give birth to oneself . . . To leave is to become a walking tomb filled with shadows, where living and dead share the same absence. To leave is to die of absence. One returns, of course, but one returns as other" (2003, 262).[111] Salie recounts her ensuing immigration experience and the anxiety of crossing the international boundary that only exists at the edge of the "arrivals" terminal at the Roissy or Charles de Gaulle Airport, where she astutely relates that the same apartheid she experiences as a Senegalese woman traveling to Europe also affects her upon her return home, where she is treated similarly as a foreigner.[112] Bekolo describes this condition of ideological slippage as the "victoire du virtuel sur le réel" (vanquishing of the real by the virtual), stating, "If 'mediatic' Africa is officially born out of Berlin, it is the mission of 'Civilization' and the duty of 'Charity' that open the door to a narrative that 'invents' Africa to the same ends" (135).[113] Any "reality" of Africa has been supplanted by a series of Orientalist fictions furthered by the West, fictions that can then be internalized and in many ways become a new experiential reality. In making explicit the ways in which the dynamic process of territorialization operates through media apparatus, anecdotal evidence, and stories, Fatou Diome's account contains a message that she writes back to the younger generation of Senegalese dream chasers. By describing the hardships experienced by emigrants whose lives can be made—but are more often destroyed—by the gamble, she reterritorializes the narrative

of France and Africa as a horizontal interplay of artifices. Diome does this in an effort to change the minds of individuals who may then be more willing to experience the exile and alienation of the human condition on their own terms instead of someone else's.

The Grass Is (Not) Greener on the Other Side

One way in which one might interpret these texts and films is to understand them as concerted attempts to make visible these invisible victims of the allure of life elsewhere whose dreams are exploited by profiteers willing to sell them death disguised as a dream of escape. At its base, the problem can be characterized as a fundamental alienation (Kristeva portrays the condition of being strangers to ourselves or "étrangers à nous-mêmes"[114]), which may be exacerbated and, in a sense, materialized through identifying some external physical place as the space in which one's alienation will be resolved. However, as the previously analyzed films and texts illustrate, there is no resolution other than death, for within the dynamic process of de- and reterritorialization, there is only the constant transience between different levels of alienation. The longing for elsewhere is exemplified in the poem by Gaël Faye in the opening epigraph of this chapter, which in many ways constitutes a reprisal of the romanticist negritude poetry of Senghor in which Africa, or a nameless tropical paradise, is painted as the place toward which one is drawn. Consequently, one might conclude that it is perhaps time for Africa to invent Europe, as these writers and filmmakers do, in a way that more accurately reflects its territoriality. It is in this rewriting process of countering fiction with another fiction, of engaging with representational politics in these fictional works, that one might identify the implicit Afrofuturist critiques, not only for the ways in which they reify notions of self and other, life and death, subject and object into a relational space of yet-to-be-realized potentialities but also for the beautifully poetic (albeit sometimes tragic) existence that they suggest as an alternative to the mindless indoctrinations of mass media machines.

Despite the geographical and historical diversity of the texts and films studied, there are common themes of existential angst, mediatic intervention, and a longing for something different. Reading these texts and films from Francophone Africa as artifacts of a globalectic human culture with our shared planetary existence allows us to further delve into the intricacies of sociocultural constructions that constitute the "narratives," as Bekolo would say (2009, 25), that ultimately create the contexts of our existences. As Arran Stibbe theorizes in his work on ecolinguistics,[115] the stories that we tell ourselves as a society exercise a tremendous influence on our particular worldview. In the case of these particular postcolonial narratives on immigration, we experience the tension of conflicted yet conflated discourses with regard to alterity, identity, and territoriality. On the one hand, there is a sense in which the Orientalist narrative that created an "Oriental" Africa as a conceptual space—a territoriality that is intrinsically linked to its "Occidental" other, Europe, through a de- and reterritorializing process—occupies the consciousnesses of the fictional individualities and collectivities depicted by these authors. However, on the other hand, one can also sense an insistence on developing alternative, perhaps transcendental, forms of negotiating existence that may not be bound by the limits of territoriality. The suspended temporality, altered perceptions, ambiguous spaces, and heteroclite voices suggest a different epistemological orientation that can navigate between, without being constrained by the weight of history and its epistemic hierarchies. Along these lines, Sarr argues in a chapter entitled "Habiter sa demeure":

> The legitimacy of this method, which consists of attempting to grasp the African real or reality [le réel Africain] through the tool we call science, has not been called into question. And yet, a certain number of reasons justify skepticism in regard to this scientific approach as the only manner by which one can elucidate the real. Other modes of apprehension for grasping

the real also exist; Western forms of knowledge do not exhaust all methods of scientific inquiry, and moreover, for the phenomenology of perception, the world exists only as an object of representation and as a discourse of a subject, located within a given moment of an individual and collective history, dependent on one way of seeing the world. (2019, 81)[116]

African, Senegalese, Lebou, Hassanya, Bambara, Francophone, Moroccan, etc.: all are categories of identification that relate to a particular cultural narrative of inherent inequality at the base of their relationality. The myth of Europe that fuels African emigration, rooted in a colonial misunderstanding (to borrow from Jean-Marie Téno's [2004] documentary film *Le malentendu colonial*), constitutes the underlying Western scientific modality of conceptualizing and demarcating the confines of existence, from and against which the deconstructive counter-narratives discussed in this chapter are conceived. As a result, the demystification of these illusions as well as the humanizing rhetorical elements that these authors employ serve the dual function of reversing the implicit cultural biases of global discourses that construe migrants as either criminal or victim while reintegrating their situation as a part of the complex web of human interactions within global existence. Whether in the form of critical humanitarianism, tragic dramatization, posttraumatic retelling, or circling around the question of what it means to leave or to belong, offering a vision of the world and of humanity as relational entities that operate between and beyond the arbitrary boundaries and frontiers—of space, time, and discourse—represents a cohesive dream for a future world to which our fragmented civilizations may aspire.

5

"We Don't Need No Education"

Alternative Pedagogies and Epistemologies in Bassek Ba Kobhio's
Sango Malo *(1990) and* Le Silence de la forêt *(2003)*

I do not want to go to their school.[1]

—Guy Tirolien, "Prière d'un petit enfant nègre"

Development is one of the West's entrepreneurial expressions, an extension of its episteme in the world by way of the dissemination of its myths and social teleologies.[2]

—Felwine Sarr, *Afrotopia*

A common link exists between the themes of the migrant and education in Francophone literature and cinema, namely that the former embodies in geographic space the psychological estrangement experienced through an alien education system. The correlation between education and development seems to indicate that the pervasiveness of educational opportunities is an influential factor in promoting economic development.[3] For example, Slaughter effectively argues that literacy is a technology of development, in terms of material or "socioeconomic advancement" in

society as well as self-actualization or "transcendental personal fulfillment through the imaginative extension of the individual into the world" (2007, 272). However, the important underlying question to consider is the precise nature of the literacy that is being promoted as a societal and personal developmental technology. Slaughter astutely notes that narrative forms of "legal and literary fictions of the person . . . define both theoretically and in practice who is obviously included and 'excluded'" from fully participating in the benefits of development instituted across the globe through international humanitarian interventions since the 1948 Universal Declaration of Human Rights (19). Slaughter even goes so far as to suggest that humanitarianism and imperialism "share enough structural features that they are, though imperfectly, homologous" (274). In the context of European colonialism on the African continent, the French humanitarian "civilizing mission" to colonize the geographic spaces of French West and Central Africa, included an inherently cultural component to colonize the minds of colonial subjects, most often through the institutions of religion and education as vehicles for transmitting the language of occupation, which explains the aphorism "the Bible and the Gun."[4] Within this paradoxical context of international human rights discourses that often serve to further entrench distinctly colonial "hierarchies of humanity,"[5] it becomes imperative to examine particular educational technologies in order to discern their efficaciousness in contributing to economic and societal development generally speaking and in serving the interests of humanity and its relationship to itself and the planetary environment.

In this chapter, the links between educational and economic development will be elaborated, not only in terms of how sociological research identifies a correlative relationship between the two but also in the manner by which educational and economic models are culturally contingent. As Sarr writes, "Although culture can be a site for the creation of values, its purposes are, as a matter of priority, symbolic; these purposes come mainly from the production of meaning and significance" (2019, 45).[6] By engaging

with the notion of cultural dissonance that results from an incongruency between the values and meanings produced through educational processes and those of a population's historical, environmental, and spiritual embeddedness, one can identify key ruptures in consciousness, like those precipitated by alien invaders in science fiction. Through the lens of Bekolo (2009) I will further argue that the economic and developmental implications of educational policies are also culturally determined, positing that indigenous knowledge systems are valuable avenues for articulating alternative economic models and developmental practices that are at once ecologically and culturally responsive and sustainable. Against a backdrop of psychic violence in the clash between cultures that was at the base of imperial conquest, like an alien invasion, an ideology of presumed moral authority, technological superiority, exploitative ideologies, and extractive developmental were subtly instilled through educative practices and policies. Examples from Bassek Ba Kobhio's films *Sango Malo* (1990) and *Le Silence de la forêt* (2003) will exemplify a theoretical approach to progress and development that is firmly rooted in African cultural histories and embodies the creative experimentality of Afrofuturist imaginings. Finally, I will conclude with a discussion of the importance of literature and the arts as educational and social tools for effectively interrogating and reinvigorating educational discourses and practices of development and in ways that prove more inclusive and sustainable for humanity's collective relationship with itself and the planet.

Mapping the Politics of Development and Education

Against a backdrop of the "two-tier world society" of a globalized economy, former Senegalese minister of education Mamadou Ndoye cogently diagnoses the fundamental problem of African development as a crisis in education, stating, "Education is almost marked out to serve both to maintain Africa in and to doom it to a state of underdevelopment" (1997, 81). By contrast, Ndoye argues for a reformulation of educational priorities in order to promote

endogenous African development, proposing that educational institutions must engage the community by linking formal and informal modes of knowledge production that promote cultural identity by mobilizing indigenous heritage and historical continuity and that operate effectively by providing access to local populations, specifically through the implementation of indigenous language instruction (82). The debates surrounding language of instruction are varied and complex, yet all must contend with the notion of cultural dissonance, defined as a "disturbing inconsistency between African students' cultures and the science curriculum that is taught in African schools" (Shizha 2011, 21). Alexie Tcheuyap (2003) remarks that the cultural disjunctures in African educational contexts occur not only through language but also through the imposition of social mores dictating comportment, as well as through the content of education; he identifies "le lien entre violence et pédagogie" (139; the link between violence and pedagogy) inherent in cultural and linguistic imperialism. Tcheuyap invokes Walter Rodney's work on African underdevelopment to characterize the sociohistorical context of colonial education, upon which postcolonial models have largely been predicated. Through a discussion of novels by Cheikh Hamidou Kane, Mongo Beti, and Bassek Ba Kobhio, Tcheuyap further delineates the paradoxical attraction of an inherently violent (post) colonialist pedagogy, remarking "school's seduction is perverse" (133).[7] It is precisely that perverse seduction of a Western education that reproduces the complexes of alienation discussed in the previous chapter on emigration, a longing for elsewhere and an internalized loathing for here, which is as much the product of media machinations as educational models that reentrench cultural codes of European superiority. For this very reason, in his book *Ecole blanche—Afrique noire*, Samba Gadjigo (1990) argues for the necessity to adapt colonial education to Africa's modern needs, which includes a literary intellectual critique of the inherent biases of colonial education which distorts reality as through "the prism of cultural superiority and racial prejudice" (Sarr 2019,

"We Don't Need No Education" 167

72).[8] While not arguing for an outright rejection of Western education or European languages, one must recognize the fundamental importance of acknowledging the underlying sociocultural values embedded in such discourses, as Sarr further argues: "The mastery of technical forms of knowledge with the goal of creating a more efficient society has become the object of consensus, even if these technical forms of knowledge are not neutral and therefore imply that their impact on society must also be understood" (2019, 71).[9] The societal implications of current scientific models, including those associated with developmental research and economic models, must be understood in their cultural contexts: as particular individual and collective behaviors are often the direct result of the values transmitted through educational systems and processes.

Shizha similarly situates the underpinnings of economic inequalities between the Global North and Global South as being fundamentally epistemological, stating, "Indigenous knowledges have become colonial captives within science education that ignores indigenous philosophies as peripheral to contemporary society" (2011, 15). According to this view, the necessity of decolonizing minds championed by such brilliant Africanist thinkers as Cheikh Anta Diop, Ngugi wa Thiong'o, Julius Nyerere, and others remains some half-century later a very real material concern for continental African populations. The cause of this delay can be attributed to the fact that postindependence development of curriculum is often undertaken at the behest of "mainly Western governments and donors" and as a result, there is the proclivity toward the Western bias of "empirical or positivist science [which] isolates African students" (16). Educational development, much like economic and infrastructural development, reflects a striking imbalance between the global social strata being served and those that continue to be exploited, in part as a result of an unbalanced educational system.[10]

Elaborating on the French critic François Partant's work in the 1980s, Edward Goldsmith explores the notion that "*Development is just a new word for what Marxists called imperialism and what we can loosely refer to as colonialism—a more familiar*

and less loaded term" (2001, 253).[11] Goldsmith further elaborates the mechanisms by which this new form of colonialism operates: firstly, establishing a cooperative indigenous elite class that operates in the interest of short-term economic gains to the detriment of the mass of the country's population; secondly, replacing the domestic, largely subsistence-based economy with an economy of resource extraction and a market for foreign products; thirdly, lending money in the form of "development aid" as a means to dictate the terms of investments; and fourthly, instilling a culture of corporatism that favors international economic profit over actual social improvement. This final aspect of Goldsmith's characterization of the neocolonial development processes accompanying international globalization efforts is particularly important, for in it resides the explicitly cultural component that is central to all other processes of maintaining dependence on the West. Shizha astutely points out the "cultural dissonance" that results from the marginalization of indigenous knowledge systems within African educational institutions insofar as "school science reinforces and reproduces Eurocentric or Western cultural capital, and conversely views indigenous science as 'mythical and mystical' despite its applicability to indigenous people's health systems, agricultural production, agroforestry, and biodiversity" (19).[12] Despite the fact that indigenous knowledge systems are specifically suited to cultural particularities—both human and ecological—and adapted in such a fashion to enable the survival of the community, they are consistently eschewed on the basis of a false narrative that valorizes abstractionism and a set of predetermined universal principals of Western scientific discourses, which are nonetheless presented as absolute "global" knowledge (19).

In order to fully decolonize the development process, epistemology must be at the forefront of the issue, for as Ndoye points out, "Africa can only succeed by mobilizing and enhancing its endogenous potential for development. And education is required to play a decisive role in mobilizing this endogenous potential" (1997, 82). In order for Africa to experience economic development from the

inside, there must be "context-based indigenous epistemology"—a shift in educational practices in which students and teachers alike "identify with the science content, while fusing indigenous perspectives" in order to correspond more closely with "African indigenous people's aspirations and their holistic life experiences" (Shizha 2011, 17). The imperative to reimagine the epistemological enterprise in Africa has a long history in African philosophical and literary production, as outlined by Valentin Mudimbé (1985); he conducts an archaeology of "Ideologies for Otherness," dating back to the early twentieth-century writings of Marcus Garvey, Senghor and Césaire, Frantz Fanon, Kwame Nkrumah, Alexis Kagame, and Cheikh Anta Diop, to name just a few (169–72). Nonetheless, it would seem that a thorough hybridization of African knowledge systems has yet to be realized either in practice or in theory. In the argument that follows, a concerted analysis of two films by Cameroonian director Bassek Ba Kobhio and related literary texts will delve into the complexities of a hybridized and adapted African educational model. Also discussed will be the alternative pedagogies and epistemologies that are essential for African societies to develop a cohesive and inclusive system of knowledge production: one that combines indigenous and exogenous ideas in a fashion that best responds to the needs of contemporary and future African populations.

Education: Between Salvation and Squalor

Twentieth-century Martinican nationalist writer Guy Cabort-Masson recalls in the autobiographical short story "Le signe du destin" his earliest memory: the first day of school, at the end of recess, when the other students line up to go back to class while he remains standing—because he has soiled his pants—beneath the bell that has just rung. He writes: "My first day at school had ended before 10. Not a trace of humiliation because the very next day, I bedazzled the class by being the only one to know how to politely present my knife. I had education, certainly. And ever since,

I ingurgitated gladly the exotic programs conceived for us in Paris because my family had prepared me well for their assimilation."[13]

Cabort-Masson is clearly critical of the French assimilation to which he was subjected on a cultural, linguistic, and political level as he saw his native Martinique undergo the transformation from an overseas territory to a department completely absorbed by the French nation-state. He nonetheless recognizes some value in his experience, as he remarks a little later on that "l'école me sauva" (53; school saved me). The tension that runs throughout much of postcolonial Francophone literature is here exemplified in Cabort-Masson's reminiscences of his education as a painful, embarrassing, and alienating experience, as well as an opportunity for personal advancement.

Cabort-Masson's story concludes with him being accepted into the prestigious military academy of Saint-Cyr. Despite the fact that his education has permitted him to definitively leave behind the insecurity of his colonized condition and enter into the camp of the *civilisés* (those who possess what he calls the *discriminant*—namely, water, electricity, and flushable toilets), he feels that at his roots, he will always be considered one of the "*damnés de la merde*" (57; *wretched of the shit*).[14] It would seem that although he has achieved considerable success as a result of his skillful maneuvering of the educational and bureaucratic institutions of French society, Cabort-Masson is acutely aware of his enduring positionality within an alternate, secondary, and supposedly "inferior" social class, a fact due very likely to his ancestral enslavement.

The question of French colonial education is fraught with contradictions, perhaps even more so on the African continent, where education was instituted and promoted—along with religion—as an instrument of ideological indoctrination and cultural assimilation intended to elevate a class of local elites divorced from indigenous populations and therefore capable of filling various roles as civil servants or administrators in the young colonies. Emmanuel Dongala explains how his father, after receiving one of the first certificates (that of "moniteur de l'enseignement") from the newly

"We Don't Need No Education" 171

founded École Supérieure Édouard-Renard in Brazzaville in 1938, was recruited into the French colonial educational system at a time when "the people didn't recognize the value of a scholarly education, even more an education at the school of the white colonizers.... No, school did not carry the future within it, it was to the contrary, socially destructive" (2001, 78–79).[15] Although Dongala clearly recognizes the negative consequences of French colonial education,[16] he describes how he was personally introduced by his father to the world of books: scientific, philosophical, and fictional. He especially loved the literary excerpts that his father would use for dictations, which awakened in him a desire to learn and understand. He says, "I wanted to know everything, I wanted to understand everything" (85–86).[17]

The trope of a desire for knowledge being awakened by the discovery of this foreign body of work has been expressed in myriad ways by colonial and postcolonial African writers since Camara Laye wrote *L'enfant noir,* since Samba Diallo wandered the streets of Europe like Malte Laurids Brigge in search of significance in Cheikh Hamidou Kane's *L'aventure ambigüe,* and since Toundi (a.k.a. Joseph) learned to emulate "la manière des blancs" (the way of the Whites) by writing his experiences and observations in his personal journal (much to his detriment) in Ferdinand Oyono's *Une vie de boy.* What these works have in common is a condition described by Kareseka Kavwahirehi in his essay on exile and the diaspora in the lives and works of postcolonial scholars Valentin Yves Mudimbé and Achille Mbembe as "notre étrangeté à nous-mêmes" (2011, 57; our estrangement from ourselves), a tacit reference to Julia Kristeva's text of the same title. Though the context of his essay is specifically African, he extrapolates a universal principle through his application of Michel de Certeau's theory of a "malheur généalogique" that all human beings share—namely, the experience of the tension of knowing (or not knowing) who one is, all the while bearing the imprint of one's identity through the name given by one's parents and society. The effect of this self-estrangement is often exacerbated by educational experiences,

which further reinforce the dominance of the socially constructed and linguistically defined self. In the context of postcolonial Africa, the stakes may be even higher due the extreme nature of the cultural, linguistic disconnect between two coexisting sets of social codes and values. In her memoir, *Unbowed*, Nobel Peace Prize winner Wangari Maathai explains how "throughout Africa, the Europeans renamed whatever they came across. This created a schism in many Africans' minds and we are still wrestling with the realities of living in this dual world" (2006, 6).[18] The alienating effect of the individual in society is compounded by the competing nature of different semantically encoded sociopolitical registers that are oftentimes contradictory and that drastically undermine the epistemological continuity of the postcolonized citizenry. Another example from Wangari Maathai's English-language education at a Catholic high school might help to further elucidate the issue. She relates her experience of the dreaded monitor, a representative symbol of shame, such as a hat or necklace, that was bestowed upon any student who dared to speak their mother tongue within the confines of school (which in her experience was also a boarding school). "While the monitor approach helped us learn English, it also instilled in us a sense that our local languages were inferior and insignificant. When [mother tongues] are maligned . . . people are robbed of a vital part of their heritage," Maathai writes (60). Maathai clearly recognizes the effectiveness of the method and has obviously benefited from its result. And though she considers herself fortunate for not having lost that connection with her native Kikuyu language and cultural identity, she is nonetheless keenly aware of the profoundly negative impact of substitutionary language learning on individual and collective identities.[19]

Entre les murs: Education and Incarceration

Cameroonian writer-thinker-filmmaker Jean-Pierre Bekolo calls for a new model of education, one that mirrors a change in media and politics toward a democratic model based on (horizontal)

"We Don't Need No Education" 173

construction, rather than (vertical) instruction (2009, 67–68).[20] Regarding the problems that he sees in the modern education system in Africa and elsewhere, Bekolo writes:

> In some countries of the third world, the colonial model saw in education the magic recipe that would transform these so-called "primitive" societies into "civilized" societies. Once independence was achieved, the school model was never questioned, nor was it revisited. Today when that school is not producing masses of chronically unemployed (chômeurs) ready to emigrate to the West in the movement known as "the brain drain" as is the case in Black Africa, it produces arms and brains in the service of foreign multi-nationals as in the case of call-centers in India. But at no moment did school enable the acquisition of knowledge with the capacity to improve the daily lives of these people. The narrative of school is made to measure to better serve the market economy. (68–69)[21]

In this statement, Bekolo is echoing the sentiment of his countryman Jean-Marie Téno in the sense that the current educational model in Cameroon, as elsewhere and like the colonial system from which it was spawned, has the primary objectives of (1) forming an elite class for exportation to benefit the empire and (2) cultivating a class of relatively unskilled indentured servants whose task is to keep turning the wheels of the economy at its most basic and inhuman level. Bekolo further expounds on his vision of an educationally impoverished world

> where life is summed up by producing, consuming, and reproducing. In a world that has decided to exploit knowledge in a utilitarian manner by a school that does not seek to form human beings who have above all a complete mastery of their being, of their thought, of their comportment, and of their environment. . . . In spite of a growing rate of education, certain problems of poverty tied to the absence of self-mastery, of one's body, of one's health, of one's environment, of culture, of

the production of wealth, of nutrition, of society, of nature, of community, persist . . . all and always in perpetual mutation.[22]

The image that Bekolo depicts of society is one in which the unfortunate bottom line has created a rift between our humanity and our society, such that the primary concern of education is not the elevation of the mind nor preparation for a fulfilling and meaningful role as a public citizen. Rather, one might contend that the principal objective of modern educational models, like the economic models that they belie, is to further what Sarr refers to as a "biais quantophrénique" (2016, 18; quantophrenic bias) in Western societies, insisting only upon that which is calculable, quantifiable, based on objective and easily evaluated criteria.[23]

Mongo Beti laments with regard to the inaccessibility (both physically and financially) of school in his village, "It's exactly what I myself lived over fifty years ago. Since that long-ago time, the condition of the village school child has not changed, it is still just as difficult and as precarious" (2006, 32–33).[24] Beti goes on to propose a number of practical solutions to the systemic problems at the core of postcolonial education in Cameroon, including a sustainable community garden, recruitment of locals to serve as instructors, and a curriculum that is dictated collectively by the parents of those attending school: "The extreme advantage of such a school would be training of men for life in their village, rather than alienating them with utopic dreams" (35).[25] Beti lucidly recognizes that such an initiative would in no way appeal to any external support, certainly not from France, for whom "the endgame is less to provide instruction than to subtract education from African children to a state of perfect disqualification and incompetence" (35).[26]

The revolutionary vision for new and more practical forms of education expressed by Beti invites us to rethink pedagogical and epistemological norms that respond to the social and intellectual needs of those being educated within the walls of institutions, rather than structures imposed from the outside. Two films by Ba Kobhio, *Sango Malo* (1990) and *Le Silence de la forêt* (2003), propose

"We Don't Need No Education" 175

their own epistemological variations and deviations from the colonial model of education that is still in vogue, with only minor alterations, in many former French African colonies.[27] Ba Kobhio (1990) depicts Marxist schoolteacher Malo, who espouses a practical, agriculturally based cooperative economics; Ba Kobhio (2003) portrays idealistic civil servant Gonaba, who has his worldview altered through an encounter with the indigenous wisdom of an ancient communitarian mystical ecology. In both instances, the intertwined educational, political, and economic values of late twentieth- and early twenty-first-century African modernity are interrogated in the light of alternative epistemological, social, and ecological modes of being that are key components of an Afrofuturist critique.

Getting Outside the Walls: Community-Based Service-Learning

The first of Ba Kobhio's films, based on his novel *Sango Malo, maître du canton* (1991; Sango Malo, the village teacher), opens with a crowded scene as university students huddle around a bulletin board where their exam scores are posted, hoping to find out whether they have passed or failed. This scene serves as the backdrop against which the rest of the film is set: a competitive, individualist system in which only a small percentage of students succeed. Fortunately, our protagonist is one of the chosen few, and upon graduation he soon leaves to assume a teaching position in the remote village of Lebamzip.

The educational status quo that serves as the background for Maître Malo's alternative pedagogical practices is further reinforced upon his arrival at Lebamzip, where students in a classroom are shown performing a series of robotic tasks before the director has them recite the poem "Jour d'hiver" (Winter day), a notably absurd task given that the notion of winter and its snowy cold would have absolutely no relevance for students in equatorial Africa. Throughout the film, the curricular elements the viewer is privy to often underscore in ironic and somewhat melodramatic fashion the inconsistencies of the enduring French colonial model of education

in contemporary African states. For instance, when the school's director intervenes in Malo's class, he chooses to give the students a recitation about the French port city of Marseille, "one of the largest ports in France. Many Africans work on the docks."[28] It is an image that seems to reinforce certain archaic notions of the grandeur of French civilization while simultaneously perpetuating the stereotype of African subservience all too reminiscent of colonial *travaux forcés* (forced labor) and slavery.[29] By contrast, once Malo has resigned from his duties—the result of collusion between the director, the village chief, and the local authorities to control someone they deem to be "un vrai subversif" (a true subversive)—Malo's successor and former classmate, Erna, chooses a more apropos subject for her recitation: "la forêt équatoriale" (the equatorial forest).[30]

Some of the educational reforms that Malo institutes, in direct contrast to the director's preferred method of "une discipline de fer" (an iron discipline)—employing "la chicotte" (the switch), or berating students with insults—include establishing a humane and cordial rapport with his students, which begins with a smile, a greeting, and a formal introduction as initial gestures of good faith. From there, he begins instituting what he refers to as "une instruction adaptée aux réalités locales" (instruction that is adapted to local realities), which includes the clearing and cultivation of a class garden plot, a collective activity with clear physical and social benefits. The director, shaped by the militaristic rigor of the colonial education system, is critical of these methods, which he sees as "corruption de la jeunesse" (corruption of the youth). The director likens Malo to the dictator and father of Guinean independence Sékou Touré, stating that his primary goal is to form savants, engineers, and doctors while reminding Malo that these students must first and foremost pass a standardized test in order to obtain their CEP (Certificat d'études primaires). While the reference to Touré is intended to be a pejorative comment on Malo's character, the informed viewer notes an ironic subtlety in the similarity between Malo's audacious pursuit of antiestablishment collective betterment and the way Touré singly defied

"We Don't Need No Education"

French imperialist practices by opting out of the French economic community and declaring Guinea's independence in 1958. Furthermore, the more brutal practices of the later dictatorial regime (arguably as much a response to France's retaliatory measures against the young and rebellious nation as anything else) are far more akin to the political-economic-educational establishment triumvirate embodied by the corrupt and self-absorbed village chief, the local shopkeeper who maintains monopolistically inflated prices on necessary goods, and the school director himself. This three-headed medusa eventually brings about Malo's demise.

The political, the economic, and the educational are all interrelated in Malo's ideology of practical utility. Clearly Malo's alternative practices of equipping the youth with skills permitting them to become self-sufficient, such as small-scale crop farming, carpentry, and construction, belie the ideological emphasis on mastering a series of fundamental tasks necessary to pass a test and receive a certificate: the tangible benefit of which is questionable at best. In addition to challenging the preconceived notion of what one might consider to be valuable education, Malo also takes an active role in community organization by encouraging the villagers to collectively found a co-op, which is ultimately implemented on the basis of a democratic vote. The practical benefits are to provide an alternative to the shopkeeper's exorbitant price-gouging, which is where the educational and economic aspects of Malo's engagements approach the political. When a representative from the Department of Agriculture visits the village and urges the inhabitants to produce one of Africa's primary cash crops, cacao (which would bring in significant government subsidies), Malo proposes the alternative of diversified, sustainable agriculture. Whereas all of the initiatives that Malo undertakes prove to be of immediate and tangible benefit to the population, the retaliatory measures of the shopkeeper, in concert with the village chief, to entice the clientele back to his original establishment (namely the transformation of said establishment into a brothel), are clearly detrimental to the social fabric of the village.

Malo's ideological battle targets the stereotype of Western success: the dream of an elsewhere where life is better, easier, more luxurious. One youth in particular asserts that "one doesn't have the right to be a farmer when one's been to school."[31] However, the "artificial paradise" that is studying in France or the United States for some, or taking a job as an airline stewardess for others, is not a realistic ambition for most; Malo, as a result, counsels those around him to invest in their local communities. Not only does Malo confront the institutional status quo on numerous levels, but he also confronts age-old traditional mores that prove to be equally alienating, including his unpopular decisions to transform the sacred forest into a plantation and to marry the young Ngo Bakang Edwidge without paying the customary dowry. This is perhaps the tipping point that undermines the social support network that was Malo's only defense against the ruses of the village chief and his co-conspirators: Malo is then arrested on unstated charges, beaten, and taken away. Although his only goal had been working for independence (in the holistic sense of the word), his expressed dream of founding a self-sustaining boarding school that would serve the community on an intellectual and agricultural level is sabotaged in the early stages of its development. Yet there is hope for the future, a point subtly underscored by the fact that Ngo Bakang appears to be pregnant with Malo's child. Erna has taken over his instructional role, and she seems to be winning over the director. Even the co-op continues to thrive under the guidance of the young Mbog, a former student who embodies the egalitarian collectivist mentality that was Malo's legacy when he emphatically states that "never again will there be a boss in this cooperative."[32]

Hope in the face of adversity is at the core of Ba Kobhio's visually striking film, which juxtaposes the ideological differences between practical sustainability and the continuation of the legacy of colonialism: as Malo and the director confront one another, the spectator can glimpse through the open doorway the Cameroonian flag blowing in the wind outside, an image that invites reflection on which path the country might take. Unfortunately, despite

"We Don't Need No Education" 179

the advent of official multiparty politics in 1992, the single-party
political system continues to persist in Cameroon, as it does in
many former French colonies in Africa.[33] As Bekolo makes abun-
dantly clear, the education system (and the economic system that
it undergirds) has yet to undergo any significant transformation
since the colonial era. In the words of Charles Ngandé's poem
"Indépendance," which figures prominently in the film's climactic
moment: "We cried all night. / The phase was long. / The par-
tridge sang timidly / in a morning of fog. / Fields illuminated by
cataracts of hope. / Hope for a dawn with balafon teeth. / And
the partridge fell silent / because his song was extinguished in the
throat / of a python."[34]

The notion of aborted independence is not an uncommon
theme among postcolonial writers and critics, as the residual co-
lonial order gradually revealed its persistence in nascent nations'
political, educational, and economic institutions. Consequently, the
struggle for liberation is ongoing, as Sarr identifies the importance
of controlling one's own future: "The capacity to reappropriate
one's future, to invent one's own teleologies, to organize one's val-
ues, to find a harmonious equilibrium between different dimen-
sions of existence, will depend on the capacity of African cultures
to conceive of themselves as projects encompassing the present
and the future and having as a goal the promotion of freedom in
all its expressions" (2019, 61).[35]

In order to reimagine African social orders, one must ad-
dress the epistemological barriers that have been institutionally
erected in order to systematically undermine communal efforts to
collectively establish an autonomous and liberated future heavily
steeped in indigenous cultural values. One must necessarily con-
sider the central role of educational activities in forming the future
societies, which leads Sarr to point out, "Beyond the simple neces-
sity for quality education for the masses, there is a fundamental
question concerning the nature of the various forms of knowl-
edge that need to be promoted and transmitted" (2019, 71).[36] This
statement, reminiscent of the epigraph from Guy Tirolien (who

did not wish to attend "their" school), underscores the importance of implementing educational models that correspond to the lived experiences of the populations that these schools claim to serve.

Doors in the Wall: More Than Words Can Say

The more recent of Ba Kobhio's films, *Le Silence de la forêt* (the English-language title is *The Forest*), in many ways constitutes a reprise of the themes expressed in Dongala's "L'enfant de l'insti-tuteur," when he recalls his father's interest in bringing "universal education" to the Pygmies (feudal servants of the larger and polit-ically dominant Bantous) despite their feared and revered esoteric knowledge of the deep forests (2001, 82).[37] Dongala writes, "Now when I think about it, I am stunned by my father's bizarre idea to force the Pygmies to speak French, as if turning us into the descendants of Gaul ancestors wasn't enough!" (84).[38]

This film is set in the Central African Republic—formerly Oubangui-Shari, named for the confluence of two major rivers—and opens with the return of the French-educated Gonaba, who shares with the ferryman taking him across the river his idealistic hopes of helping to change the country. This opening scene is eerily reminiscent of the ancient Greek mythical crossing of the River Styx from the land of the living into the land of the dead,[39] and the cynical laughter of the ferryman only reinforces the hint that there is no hope for the damned in this country, based on what Mbembe terms "une économie de la mort" (2000, 160; an economy of death).[40] Ten years pass, and the ferryman's knowing laughter seems to haunt Gonaba; in spite of his nominal success and the prestigious title of regional inspector of schools, he is dis-appointed with the state of his country and quite possibly himself for not having succeeded in his youthful ambitions.

The materialistic culture of pomp and style—"le spectacle et le paraître" according to Gonaba—that so pervades postcolonial societies upsets him, and as a sign of resistance, he refuses to dress in his fine suit to attend the day's political fanfare organized on

"We Don't Need No Education" 181

behalf of the local governing prefect. Gonaba's houseboy, Paul, whom he has taught to read and write, expresses his disdain for Gonaba's poor taste, saying that he does not want to be considered a small houseboy because his boss is not a big boss.[41] This sentiment is echoed by a group of chauffeurs disputing whether theirs is the "worst job in the world." When they witness Gonaba acting out, one candidly states that he would not like to have a boss like that. Gonaba's internal rebellion increases as he finds himself feeling somewhat responsible for the decadence and destitution bred from corruption that underlie the shining, opulent superficiality to which he is privy. Sipping whiskey in the presence of society's elite, Gonaba uninhibitedly joins the Pygmies who have been conscripted to dance and entertain. When he is deterred, he rails against the abuse and exploitation of the Pygmies, who are treated like animals. He then leaves, seeking solace in drink and in the company of a fine young woman named Simone, who owns a relatively upscale bar called Paris.

The next day, Simone accompanies Gonaba on an inspection of a village school where Gonaba's patience is tried by the manner of complaints brought before him, having to do mostly with "des affairs de fesse" (stories of teachers sleeping with students) rather than real pedagogical issues. His passion is ignited by an exchange with Manga, the Pygmy indentured servant of the village chief, and Gonaba decides to accompany Manga back to his village, where Gonaba anticipates staying for one or two weeks. When he emerges from the forest at the end of the film, he wonders how long he has been away: one or two years, possibly? The fact that he has lost track of time is significant because his experience is ultimately less about what he is able to teach the Pygmies about the modern world than about what they end up teaching him. Numerous instances of what Gonaba calls a "useful education" are juxtaposed with the intuitive and immediately applicable knowledge of even the youngest member of the Pygmy village. At one point, he is trying to teach the letter "A," and a boy says that he smells rain. Indignant, Gonaba pursues his agenda, only to be

interrupted moments later by a torrential downpour. Gonaba also learns the art of spear hunting, as well as the joy of love, marriage, and fatherhood as he marries Kali, the sister of Touka, who found Gonaba caught in a trap after getting lost in the forest when his guide Manga initially abandoned him.[42] Gonaba learns, or perhaps unlearns, that language, writing, and time are structures by and through which we experience our environment, and that these structures are as subject to variation as the almost infinite number of environments that make up—past, present, and future—the entirety of the contemporary world.

To illustrate the variations of epistemological hierarchies, the Pygmies, or the Biaka in this specific instance,[43] function in many ways as a double for the colonial African subject who was in many ways treated inhumanely and used for the purposes of entertainment, manual labor, and domestic service. Gonaba's "mission to civilize" them through the Western model of education (which previously transformed French African colonial subjects into "descendants of Gaul ancestry") holds up an inverted mirror to the civilizing mission that was conducted a century earlier by French colonialist explorers, educators, and exploiters.[44] The epistemological bias that Gonaba exudes (which arguably is the product of a postcolonial political culture of corruption and pandering to the West sometimes referred to as "Françafrique") thus exemplifies a continuation, if not a perpetuation, of the colonial mentality of intellectual superiority that discredited and destroyed indigenous forms of knowledge and knowledge production. As Sarr writes, "The legitimacy of this method, which consists of attempting to grasp the African real or reality [*le réel Africain*] through the tool we call science, has not been called into question" (2019, 81).[45] If one begins to question the primacy and preordained limitations of scientific discourses as the defining order of knowledge, new spaces of knowledge can begin to emerge.

As is the case in Ba Kobhio's first film, there is a hint of optimism that positive changes can be made, if only on an individual level. As Gonaba pursues his noble objective of educating the

"We Don't Need No Education" 183

Pygmies, he is confronted with their alternative framework for interpreting the world, events, and relationships. For example, he is dumbfounded to find that the Pygmies are dancing one evening for no reason other than that the hunt was good and the people well fed. In another instance, he is outraged when he finds that the Pygmies are using the pages from his precious books to smoke an herb from the forest, possibly akin to the herbal mixture that Kali administered to him on his road back to health. Later on, Gonaba is upset that his pupils are drawing pictures instead of learning the alphabet, but Kali tells him that he should be happy that they know how to draw. A fourth example is the story of how gorillas lost their tails. This story echoes throughout much of the film and is first told in part by Manga on the first night that they spend in the forest. This is in response to Gonaba's invocation of Barthélémy Boganda (described as "the father of Independence") and Jean-Jacques Rousseau (characterized as "a white guy who thought a lot") to explain that all men are equal. The juxtaposition of two different origin myths in their conversation reveals how arbitrary stories can come to define the nature of experiential reality and the human condition. In this context, European sociopolitical philosophy and its various democratic embodiments around the globe are portrayed as no less mythical than the story of how the gorilla lost its tail. This Pygmie origin myth is referenced again in the film later on when Kali continues it, explaining that the original Pygmy was exiled and a gorilla took pity on him. The story being told in three distinct phases over the course of the film could represent the gradual assimilation of the Pygmies' indigenous knowledge, as it is Gonaba himself who finally finishes narrating the story for the film's audience, telling a group of children how the gorilla gave the Pygmy fire and burned its tail, but the Pygmy mastered fire and henceforth he and the gorilla became friends. Similar to the Greek myth of Prometheus—though the god figure is of the natural planetary order rather than an anthropomorphic one—the added emphasis on friendship, rather than enmity, in spite of differences further contributes to an articulation of the indigenous worldview

in which mutual relationally ensured survival is a fundamental element. These instances reveal much about the different set of social values that are embraced in this particular Pygmy village: namely, a distinct focus on communal well-being and survival rather than the individual acquisition of material or mental objects.

Ultimately, Gonaba's arrogance and self-assuredness are his downfall. When the village patriarch tells Gonaba of his troubled sleep and urges him to make offerings and sacrifices to the ancestors, he replies that he does not believe in such things. His initiation hunt is later rained on, indicating that the gods refused his initiation; when the party returns, they find that a very large tree branch has fallen on Gonaba's house (a large, rectangular house with good ventilation, intended to serve as a model to the Pygmies and built in an unauthorized location), killing his wife Kali. He is left with only his daughter Lema, whom he wants to take with him back to the city. When the Pygmies refuse to let him take her, he returns alone. As he reaches a road, and the sounds of gasoline engines and sirens engulf the silence of the forest that he has left behind, the spectator is led to question two very different visions of human existence and to reconsider the primacy that Western values have accorded to logic, text, and verbal intellect over other forms of relating to environments. One can liken this alternative epistemology to what Gayatri Spivak terms "planet-thought": "Planet-thought opens up to embrace an inexhaustible taxonomy of such names including but not identical with animism as well as the spectral White mythology of post-rational science" (2012, 339). Thinking being in relation to the planetary systems as opposed to human systems, categorizations, and hierarchies of knowledge allows for a more holistic conception of human experience and its myriad forms of knowing the world in which it finds its being. One of the key components of such an endeavor begins with language as a principal vehicle for the transmission of culturally contingent values and meanings. For one can also interpret the film's title, *Le Silence de la forêt* (silence of the forest), in a more ominous way, which is the subtle implication that the forest and its polyphonic

"We Don't Need No Education" 185

voices are in fact being silenced by the developmental procedures of a dominant epistemological paradigm. Echoing the viewpoint espoused by Jean-Marie Adiaffi regarding the value of indigenous African languages, and quoted in the first chapter of this book, Sarr proposes that "African languages are privileged entry points into taking care of and managing the cultures in question as well as their contents in terms of thought and forms of knowledge" (2019, 76).[46] A diversity of linguistic apparatuses can only contribute a greater breadth of understanding of the complexity of the human cultural experiences in the world, which cannot be oversimplified by the calculable reductions of positivist science and its abstractions.

A Case for Communal Arts in Global Development

Congolese novelist, dramaturge, and poet Sony Labou Tansi (2005) provides a further indication of the disjuncture between competing notions of education from his personal experience. He states that "had it not been for my grandmother, I would have gone to school for nothing. What would I have learned? Nothing" (64).[47] Recalling his early education as a struggle, he talks about walking three kilometers to learn calculus and catechism and later having to cross a river to attend Protestant primary school at Soundi Loutete, where "after scholarly work in the morning, the afternoons were filled with manual labor because it was we who built the buildings, we who repaired, we who did it all" (48).[48] He later switched to a Catholic school in the French Congo thirteen kilometers from his mother's village because his prior schooling in what is now the Democratic Republic of the Congo (where his father was from) was conducted in the local language and therefore perceived to be inadequate. But he struggled again because, as he states, "I wrote phonetically" before moving on to a boarding school seventy-five kilometers away. Despite these apparent difficulties, he recalls how "every evening, I returned to my maternal grandmother" (49).[49] Clearly in this anecdote we detect a moral fortitude that was imparted to him from his

grandmother, an alternative form of knowing that enabled him to adapt to the strangeness of his formal colonial education.[50] This informal education is essential in grounding a community in its past in order to build a future in its own best interest. Bekolo therefore proposes an alternative vision of education that might better serve the needs of local populations: "It consists of envisioning a society where everything is school. An open school set up in the heart of each community where all are at the same time teachers and students. . . . A school where everything is intellectual knowledge (*savoir*), beginning with the practical knowledge (*connaissances*) needed to improve our daily life. . . . A school that 'builds' in permanent fashion a culture of anticipation, of prevention, of speculation, and of organization for all in the bosom of each community" (2009, 160).[51]

Essentially, Bekolo argues for a school and an education which, unlike the one the young narrator experienced in Cabort-Masson's short story, actually allows its students hope for the future—a school of practice, application, sensitivity, and relevance. Both of Ba Kobhio's films portray two very different social and educational modes of knowledge production and transmission, each of which contrasts sharply with the dominant global capitalist model that has been the subject of criticism since the earliest African intellectuals began espousing the inherent values of African cultures. Nevertheless, both have one trait in common: an educational system that is the property and product of local populations embedded within their environment, responding to local needs and designed for the betterment of all.

At the outset of this chapter, the importance of indigenous scientific knowledge was foregrounded as an asset for the global community.[52] However, in accordance with the analysis of Ba Kobhio's films, one must also consider the central importance of the aesthetic—one might even include the esoteric—in the type of holistic educational enterprise depicted here. The arts have always constituted a central aspect of indigenous African societies, incorporating oral performance into aspects of political and communal

life in which rituals and societal rhythms reflect the broader cosmic cycles that inscribe humanity's spatiotemporal consciousness and being. In fact, referencing Aimé Césaire's (1939) surrealist prose poem *Cahier d'un retour au pays natal*, Sarr remarks on the imperative to "put oneself in step and in rhythm with the world," going so far as to posit "*poïesis* (creativity) ... [as] the generic function of the human as creator" (2019, 97).[53] According to this view, the essential function of human beings is to create and poetically engage with the universe—not fall prey to the trap of fixed forms and static structures of an absolutist worldview. This insistence on the importance of the aesthetic process recalls the expressive and performative orality of indigenous African cultures in sharp contrast with the rule of reason, which has tended to define and dominate Western epistemologies. Therefore, in order to effectively conceive of and implement novel models of education for African futures, the arts as reflective of human cultures must be taught in tandem with the sciences, including indigenous sciences and arts of particular communities.

Handel Kashope Wright argues precisely that, saying, "Certain African-centered advances in the fields of development studies, reappraisals of the place of indigenous African education, and literature studies reconceptualized as cultural studies can, in combination, create a discursive environment in which it is possible for literature studies as cultural studies to contribute significantly to the development process in Africa" (2004, 131). Employing the creative arts in African educational models and correlative development discourses therefore fulfills the dual function of effectively engaging with developmental concerns affecting Africa in a global context, while simultaneously embodying an endogenous epistemological practice rooted in African cultural specificities. Accordingly, Sarr (2019) reconceptualizes development as a constantly unfinished process, arguing that "a well understood political modernity is always carried by an endogenous dynamic in accordance with universal exigencies of human liberty and dignity."[54] A self-sustaining social order is dependent on its ability

to grow itself from within, which may require eschewing certain extant biases with regard to knowledge and progress.

Bassek Ba Kobhio (1990) himself candidly states, "It is education which can form a new people. It is hard to think about changing African society without envisioning an appropriate form of education." Embracing the *practical* and the *esoteric* forms of knowledge that Kobhio outlines in his two films is a way to enrich education in order to surpass the limitations of an educational system that otherwise does little more than create more bricks for the proverbial wall.[55] The question of the utility of education on a global scale must therefore be continuously recast in the following terms: Utility for whom? Are societies being given tools to enhance their own individual and collective agency in accordance with planetary specificities, or are societies merely being made into tools to serve as support for the agency of other "humanitarian" interests? It would appear that the answer depends on the ability to realize the creative visions of those artists and critics who invent their future societies through poetic, literary, and cinematic expressions of what the world can potentially be. Or as Sarr states: "The conception of the universe that manifests itself within the diverse forms of African knowledge and practice is that of a cosmos considered as a great living being (*grand vivant*)" (2019, 83).[56] If the baseline for human being shifts away from a relationality with civilizational monuments and archives and toward a relationality with a living universe, the field of human experience becomes exponentially enriched. Planetary being, or the "imperative to re-imagine the planet," as Gayatri Chakravorty Spivak (2012) argues, necessarily involves identifying indigenous knowledges as fundaments to an aesthetic education. She writes: "Learning the Aboriginal way of living as custodian of the planet . . . is daily being compromised by the Development lobby's drive to patent not only so-called indigenous knowledge but the very DNA or life-inscription of the autochthone most separated from the cultures of imperialism" (343).[57] The drive to resist quantification, fixation, and ultimately death resides in the ability to constantly reimagine and rearticulate new forms of understanding

the human-planet or human-cosmos relation in ways that cannot be reduced to the knowledge paradigms of science but embrace the mysterious voyage of constant discovery that defines the human condition. By suggesting that reality can be enhanced or augmented through an inherently creative and inquisitive process of multilingual and experiential engagement with human planetarity, the Afrofuturist currents in the works discussed in this chapter become exceedingly clear. Regarding the relationship between the material world and the psychic world, which through education becomes both its filter and its mirror, Sarr states, "Cosmogonies and ontomythologies reveal a worldview and starting from there, African societies' relation to the real or reality [*le réel*] as well as the role and function assigned to humankind within the cosmos" (2019, 85).[58] By embracing the tensions between mythologies and reality, between the language that structures experience and experience itself, one might more broadly ascertain the full range of human conscious capacities through nurturing modes of cosmological being that are at once material and mystical, existential and ephemeral. In adopting an Afrofuturist perspective that validates other forms of knowledge, like the esoteric as well as the practical, the education of humanity can proceed to explore and value the undetermined potentialities of human experiences. As Huxley writes, "Even in this age of technology the verbal humanities are honored. The non-verbal humanities, the arts of being directly aware of the given facts of our existence, are almost completely ignored" (1990, 76). These other communicative potentialities resist quantification and escape from the calculable scrutinizing measures of a finite model of civilization that demands acquiescence to fixed forms and predetermined formulaic articulations. The implications of a more inclusive and imaginative pedagogy nurtured by local languages, customs, histories, and their implicit relationality to the planetary environment can have a fundamental impact on fostering participatory and sustainable models of economic development for the betterment of the whole of humanity, a notion that will be further elucidated in the next chapter.

6

Paradis Artificiels

The Lottery of Global Economies in Djibril Diop Mambety's Le Franc, *Imunga Ivanga's* Dôlè, *and Fadika Kramo-Lanciné's* Wariko

That humanity at large will ever be able to dispense with Artificial Paradises seems very unlikely. Most men and women lead lives at the worst so painful, at the best so monotonous, poor and limited that the urge to escape, the longing to transcend themselves if only for a few moments, is and has always been one of the principal appetites of the soul.

—Aldous Huxley, *The Doors of Perception*

In aspiring ceaselessly to rekindle his hopes and to lift himself toward the infinite, he revealed in all places and at all times, a frenetic taste for all substances, even dangerous ones which, in exalting his personality, could conjure up in an instant before his eyes, this fleeting paradise, object of all his desires, and finally his hazardous spirit, without even knowing it, is pushed all the way to hell, thereby testifying to his original grandeur.[1]

—Baudelaire, *Paradis Artificiels*

For the love of money is a root of all kinds of evil. Some people, eager for money, have wandered from the faith and pierced themselves with many griefs.[2]

—I Timothy 6:10, NIV

Paradis Artificiels

To be human: Is it to search for the unknown, to seek enlightenment, to love? Is it identification with another, or creative expression, as some might propose? In accordance with Foucault's analysis of *The History of Sexuality*, and the notion of biopower, which "brought life and its mechanisms into the realm of explicit calculations and made knowledge-power an agent of transformation of human life" (1990, 143), one might propose that humanity has become a function of economic advancement insofar as, in the twenty-first-century global political economy, the one law that arguably supersedes all others is the all-encompassing law of the marketplace. Human life thereby becomes a consequence, a product of economic calculations, and it is subject to the epistemological discourses that define reality by ascribing arbitrary value to given actions. Sarr explains the dominant economic knowledge-power and its effect on the potential futures of the African continent, stating: "Key words such as *development, economic emergence, growth*, and *struggles against poverty* are, for some, the principal concepts of the dominant episteme of the era" (2019, xiii).[3] In a fundamentally capitalist, profit-based society, one might propose that money, insofar as it is perceived as that which can provide an escape from the mundane realities of corporeal being in the twenty-first century, may be considered the artificial paradise of the day. Understood as an illusory escape from the limitations of everyday, corporeal existence, often in the context of the mind-altering effects of various intoxicants (cf. Baudelaire), the notion of an "artificial paradise" is rich in implications for theories of liberation. In particular, the idea of individual emancipation through the accumulation of enormous quantities of wealth, a hallmark of many a corrupt political and financial elite throughout the years, has come to dominate the collective psyche. To this end, Sarr, who links the economy to a set of cultural processes, has proposed the following: "Therefore it appears that the dominant economic thought conveys a culture, a unique view of the world and of man (*homo economicus*)" (2019, 85).[4] According to this characterization, the function of humanity is defined by each

individual's contribution to the economy; one's biopower or life value is wholly dependent upon one's ability to participate in the economic reality as it is narrowly defined by the episteme of a given epoch. However, one might further consider that one's ability to participate in the economy may be unequally skewed based on a variety of mediating circumstances, including (but certainly not limited to) the institutional economic inequalities forged by Western colonialism and imperialist expansionism.[5] This condition explains Sarr's supposition that the African subject is at least partially excluded from this order, as he states, "*Homo africanus* is not a *homo economicus* in a strict sense" (2019, 53).[6] He goes on to explain precisely that which differentiates the African subject from its purely economically "human" counterpart—namely the residual influence of indigenous and alternative informal economies, which is a direct result of the economic alienation imposed by the former colonial powers of Western Europe.

In his analysis of nineteenth-century capitalist societies, Karl Marx identified *alienation* as a primary ill of capitalist production. Unlike the struggles associated with medieval serfdom in agrarian societies, the modern working class, according to Marx, experienced a different form of dissociation from their work: they had not only no ownership of their labor but no material relationship to the product of their temporal investments.[7] If religion was the nineteenth-century opiate of the masses, then one can argue that purchasing power is the religion of the twenty-first. However, when the myth of the global economy and the particular version of the "human" that it has engendered is perceived for its illusory false promise—that of an "artificial paradise," which can appear like a brief hallucination when the subject is engaged in its daily dose of consumerism but that ultimately leads to further alienation—one can look beyond or before it for alternative iterations of human life irreducible to its mere biopower. Achille Mbembe refers to this extreme condition of alienation through an Afrofuturist rereading of the contemporary condition, arguing that "it will be necessary to do so based on the assemblages of *objects-humans* and

Paradis Artificiels

of *humans-objects* of which, since the advent of modern times, the Negro is the prototype or prefiguration" (2019, 164). Accordingly, Mbembe identifies how since slavery, "these fundamentally *human* beings constituted reserves of value in the eyes of their owners" (166). Thus, the human becomes objectified and instrumentalized through the rhetoric of dehumanization that marks the incipit moment of colonial capitalist models of extractive development practices, converting life into exchange value. An Afrofuturist perspective embraces the paradoxical constructions of the animal or machinic dimensions of instrumentalized human existence as capital and then converts these into sites of resistance and sources of power in relation and in opposition to the discursive practices that generated such conditions of such *"life in suspension"* (167).

Cameroonian-born writer-thinker-filmmaker Jean-Pierre Be-kolo writes about the predominantly economic *narrative*[8] of modernity, stating, "It seeks to distract, but with the mercantile goal, so making a distraction, not in search of a narrative of life, but the narrative of money, the recipe that will bring in the most. A kind of exploitation of our misfortunes" (2009, 25).[9] Essentially, Bekolo describes the ways in which life (and, one might also add, liberty) is ultimately equated to money and the relentless pursuit and accumulation thereof. He continues his critique of global capitalist society with the metaphor of a needle that one seeks in order to make a hole ("la perceuse et le trou"). Confusing the ends and the means, due to the narrative conflation of money (the needle) and life (the hole), the economic subject fails to realize that one in fact desires a hole and not a needle and, furthermore, that there may be many alternative ways to make the desired hole without a needle, if imagined. In effect, one spends one's time and energy on the pursuit of the metaphorical "needle" to make the hole without ever entertaining the possibility that there may be other ways of achieving the desired result.

Building upon the basic premise that in modern societies the pursuit of happiness is reduced to the pursuit of money (with which one can presumably buy happiness), Bekolo continues: "It is

this *reductive narrative* that money makes life which is in question. Money is the needle, the magic formula par excellence, purported to open the doors, except perhaps for the main one" (72).[10] Here Bekolo alludes to the fact that although money can buy many things, it cannot fuel the human soul. Sarr aptly characterizes this condition as an inversion of humanity by the dominant economic narrative, stating, "In adopting this economic viewpoint along with its statistical abstractions, certain Africans seem to adhere more and more to the mandate of quantity over quality, of having over being; they are content to have their presence in the world be evaluated by nothing more than the statistical data of their GDP or their leverage on the international marketplace" (2019, xi).[11] To echo Winston in George Orwell's *1984*, "Sanity is not statistical" (1981, 179). Accordingly, one might propose that the capitalist system that mediates modernity through the commoditization of daily life creates a cultural climate in which transformation of every gesture into some form of exchange pervades, such that each and every action and interaction ultimately becomes fundamentally economic in nature. Sarr explores the fundamentally discursive practice of economics, arguing that "in this context, economic discourse functions as a language that ensures the establishment of a common symbolic code through which the group's ability to name, think, and experience the real develops" (49).[12] In other words, reality translates into a monolingual semantic signification of the economy and, consequently, the diversity of basic human needs beyond economic functionality are left unmet.

Interactions, pursuits, and achievements are all mediated by the pervasive influence of the economic system, such that every advancement of human capital is converted and reduced to its direct or indirect economic significance. For example, education, entertainment, and religion have become business. Crime is big business. Health care and civic welfare are just businesses. One might even suggest that relationships (in the age of constant telecommunication) have become a particular kind of business as well. It follows that the highest of all possible rewards, measured

Paradis Artificiels

in the terms that society most values, is the mass accumulation of money. This illusory knowledge-power that is finance within the capitalist system reduces the human to a mere formula for producing wealth (Sarr's *homo economicus*), creating revenue, or providing savings or investments for the capitalist system. The value of human life need not be equated to its net worth; nor can life be reducible to its mere biopower. For this reason, Bekolo declares that "money makes us poor! We devote to money a cult of idols much like the pagans of antiquity" (72).[13] Three films by Francophone African directors present a harsh critique of this global economic order through their staging of the lottery, not as the pinnacle of personal happiness but rather as an inextinguishable source of individual and collective misery. What better dream to chase, what better "artificial paradise" to imbibe on a daily basis, than the chance of instantly striking it rich through the mere act of purchasing a ticket?

In the following sections, a focused reading of films and related texts from Senegal, Mali, Gabon, Kenya, and Côte d'Ivoire will serve to further explore the trope of the lottery as a paradigmatic form of exploitative economics that impoverishes people through an illusory (and false) liberation, while explicating the subtleties of Africa's ambivalent economic position in the global economy.[14] Beginning with the critiques of global finance depicted by Ngugi wa Thiong'o (1980) in *Devil on a Cross* and Abderrahmane Sissako (2006) in his film *Bamako*, we will underscore the inequitable and unsustainable processes of global finance before proceeding to a critique of the multiple and derivative cultural and linguistic impediments to economic "success" in Ousmane Socé's (1937) *Mirages de Paris* and Ousmane Sembène's (1966b) novella *Le mandat*. From there we will proceed to analyze three postcolonial films that call into question the ways in which the projections of a potential lottery win may in fact constitute a debt trap for the protagonists in Djibril Diop Mambety's (1994) short film *Le Franc*, Fadika Kramo-Lanciné's (1994) grossly understudied film *Wariko*, and Gabonese director Imunga Ivanga's (2001) *Dôlè*. The

texts and films depict, albeit in different ways, the consequences of the lottery, its irresistible allure, and its destructive impact on the individual and society. At the same time, the Afrofuturist critiques of the language of economics that these works tacitly offer reveal new avenues and directions for development, as economies conceived of in different terms open up new spaces for humanity to fulfill its multiple, relational, and creative purposes.

<div align="center">

The Criminality of Global Finance:
From Ngugi wa Thiong'o and Abderrahmane Sissako

</div>

Abderrahmane Sissako is a film director from Mauritania, though he spent much of his early life in neighboring Mali, his father's country of origin. In the 1980s, he studied film in the Soviet Union, and in 1990, he settled in France. He made three short films before his first feature film, *Rostov-Luanda*, in 1997. His next two films, *Life on Earth* (1998) and *Waiting for Happiness* (2002), won special mention and first prize, respectively, at FESPACO, the biennial Festival Panafrican du Cinéma et de la télévision de Ouagadougou (Pan African festival of cinema and television). And his 2006 film, *Bamako*, which takes its name from the capital city of the current West African nation of Mali, won him widespread critical acclaim.[15]

In *Bamako*, there is an international trial of the African people versus the World Bank and the International Monetary Fund. Those two international financial institutions are accused of crimes against humanity for their complicit role in the systematic impoverishment of African nations through privatization, political influence, and the unjust and impossible requirements upon governments to repay the colonial debt—the price to pay for nominal independence.[16] The testimony of one of the many witnesses called upon by the prosecution, an educated Burkinabè woman who states her profession as a writer, makes explicit the distinction between "poverty" and "pauperization," implying an active process of producing impoverishment. Indeed, Stiglitz has

Paradis Artificiels

demonstrated the ways in which the objectives of the International Monetary Fund have gradually evolved to "serving the interests of global finance" (2002, 207), and the policies deployed to attain these objectives "almost surely contributed to global instability" (211). Additionally, because of the oft-conflicting objectives within such global institutions as the International Monetary Fund or the World Bank, Stiglitz points out that certain policies have in fact often served paradoxically to exacerbate the same problems they were intended to address, thereby tacitly enabling the continuation of a vicious cycle. The confusion of objectives and shifting policies that fail to account for the human condition is precisely what Sissako alludes to in the mockumentary *Bamako*.

For example, the defense for the global financial institutions accused of crimes against humanity, which has no witnesses, resorts to ad hominem attacks to discredit the witnesses: all the while deflecting responsibility and demanding concrete proof of the corruption that is allegedly responsible for the "pauperization" of African communities. This evidence, as of a May 2016 article in *New African,* has now come into the public view as evidenced by Khadija Sharife's thorough examination of the Panama Papers, which implicate the extortion of $150 billion annually from the African continent through offshore tax havens, or what Verschave (2004) terms *"les paradis fiscaux"* (fiscal paradises). The divide between the lives of ordinary people and the existence of global economic and legal institutions is emphasized in this film. The testimonies presented by the prosecution's witnesses, in French, in Bambara, sometimes in song, and sometimes even in complete silence, repeatedly run up against the eloquent arguments of the defense attorneys who repeatedly defer culpability through technical rhetorical maneuvers.

The wedge that Sissako drives in his film between the ways in which the world is experienced by human beings living their everyday lives and the ways in which its systems are structured by multinational corporate and legislative bodies invites the spectator to consider the arguments of the case and to then act as judge

and jury in the absence of a clear and definitive verdict. Sissako's technique is subtle yet powerful, as he captures moments that reflect the slow pace of daily life in the intervening moments of the trial: a sick child, a wedding procession, Muslim and Christian religious practices, a dying man, artisans weaving cloths, and a gate guard studying Hebrew with the dream of working for the Israeli embassy—all this along with the quotidian activities of communal life, such as food preparation, washing, cleaning, and children playing.[17] These moments overlap with the events of the trial in a poetic fashion, juxtaposing two levels of reality: the human and the juridical. Interestingly, the juxtaposition of these interwoven yet seemingly contradictory realities is represented spatially through the conflation of the courtroom and the courtyard. This rendering of the institutional power structures, divested at least in part of their baroque facade (the attorneys and presiding judges still wear robes and wigs, although the bench is located in a humble courtyard beneath the shade of a tree), alludes to the absolute necessity to reconsider the dominant discursive registry and to reconsider the entrenched inequalities of the global political, economic, and litigious systems in terms of the diversity of human experiences.[18]

The indictment of modern capitalism and its globalist financial mechanisms is by no means a new argument for African critics. For example, Ngugui wa Thiongo's (1982) satire *Devil on the Cross* represents a commentary on Kenya's position in the burgeoning global political economy of the late 1970s, and it clearly illustrates the economic conundrum plaguing those whom the narrative defines as poor. Following the fated journey of a group of strangers who all attend a great competition of "Modern Theft and Robbery," the novel portrays the aid-dependent model of development in which populations are duped into believing in the myth of prosperity. One character on the journey named Mwireri wa Mukiraai describes the dire facts of this reality: "The question is: who are the modern heroes? We are—the people with money. It's we who have proved that we can beat foreign thieves and robbers when it comes to grabbing money and property. Our eyes are

Paradis Artificiels199

now open, and we are able to see clearly that theft and robbery are the true foundation of modern progress and development" (80).

Further, the leader of the foreign delegation of thieves and robbers explicitly states that "the barons of finance houses are the governing voices in the world today. Money rules the world! ... Money is the heart that beats to keep the Western world on the move. If you want to build a great civilization like ours then kneel down before the god of money" (89). Ngugi wa Thiong'o's satirical logic depicts modern robbery as the fashionable modus operandi for businessmen and statesmen and is akin to a lottery in that it is a kind of thievery: it essentially robs the poor by giving them the false hope of attaining the kind of financial success that is merely an illusory projection of the thieves themselves.

<div style="text-align:center">

Lustrous Allure and Loss:
Socé's *Mirages de Paris* and Sembène's *Mandabi*

</div>

Ousmane Socé's (1937) novel *Mirages de Paris,* as the title suggests, unfolds a number of mirages, illusions, and artificial paradises through the life of Fara, an African immigrant who finds himself infatuated with metropolitan France. Although primarily an account of Fara's enchantment with Paris and its personification in the character of the lovely, blond Jacqueline, money is a prominent subtheme in the narrative.[19] Fara initially starts a business and pays off his debts accrued through living a life of self-indulgence but later takes to gambling with his friend Ambrousse. Socé describes the dizzying—one might even qualify it as hallucinatory—atmosphere of these casinos that are capable of dispossessing an individual not only of their money but also of their very conscience: "To see in the halls that crowd of men and women intermingling in every direction, chasing after money and emotions, to see bank notes whirling about, punctuated by the flat toothmarks of the ticket puncher and by the raucous voice of the salesman, Ambrousse could no longer control himself" (129–30).[20]

Like a whirlwind, the frenetic atmosphere of the gambling enterprise incites a dissociation from oneself and one's rational decision-making process through an emotive appeal that destabilizes the self with the allure of wealth. However, much like the twisting imagery evoked in the above quoted passage, it would prove nearly impossible for Ambrousse to grasp those very banknotes that seemed to be spinning all around him. Socé goes on to describe the vicious cycle in which Fara became embroiled: "He played, won, lost, as long as he had money. . . . He had managed such shortfalls until good fortune got him back on track; he had mistaken his new chance and had let it go for another illusion" (130).[21] First, we witness the highly addictive nature of the gambling enterprise: as long as Fara has money, he gambles with it, alternately winning and losing but playing regardless. Furthermore, he notes in a regretful tone how despite his initial material difficulties and subsequent efforts to alleviate them, he had discarded his second chance for the illusion of big winnings. The novel's conclusion is one of complete disillusionment, not only with Paris, the shining city once described as an "El Dorado" (15), but also with his love affair with Jacqueline (pregnant with his child) and finally with his dream of financial success and living the high life, so to speak. Incapable of reconciling his perceived reality with that of his dreams and illusions, Fara ultimately takes his own life by throwing himself into the Seine. This tragic end to a tale of alienation is subsequently echoed by numerous African writers and filmmakers, depicting the many difficulties that ultimately foil the plights of immigrants.[22]

Ousmane Sembène's (1968) film *Mandabi*, based on his 1966 novella *Le mandat*, similarly portrays the disjuncture between competing value systems. Ibrahima Dieng is the recipient of a *mandat*, or money order, for the amount of 25,000 CFA, which at the time was the equivalent of 500 French francs, a considerable sum of money in the postindependence Senegal of the 1960s (1966, 115). Ibrahima is instructed by his nephew Abdou, the originator of the money order, to give 3,000 of the 25,000 to

Abdou's mother, to take 2,000 for himself, and to put the remaining 20,000 in savings for Abdou (119). Ibrahima's troubles begin with his wives, Aram and Mety, whose impatience prompts them to go to Mbarka's "boutique," or general store, and purchase a kilo of rice on credit, at which time they have Mbaye read the letter that accompanied the money order. Thus, the news of Ibrahima's newly acquired resources begins to seep into the fabric of a highly relational society. Almost immediately, a pesky neighbor, Maïssa Fall, described as a "franc tapeur" (122; money grabber), comes to Ibrahima and offers to accompany him to have the money order cashed. Gradually, Ibrahima's money begins to trickle away as he first gives 50 francs to Mbarka to pay his transportation costs for the rice (122) and then an additional 50 francs to the writer for reading the letter (127). Ibrahima's troubles are compounded when he finds that he cannot cash the money order without an official, state-issued identity card, which he does not possess, to prove that he is in fact the recipient of the money order. This requires that he have a photograph, a stamp, and a birth certificate (133). These items, which can be fabricated with the help of his acquaintance Madiagne Diange, will cost him an additional 5,000 francs (135). Thus, the illusory gains of the money order vaporize in the effort to navigate the bureaucracies of a system designed exclusively to turn a profit from the hardships of others.

In these two narratives, one can read the characters of Fara and Ibrahima as embodiments of the colonial and postcolonial subjects, respectively, living on the hope for independence or for a more significant form of liberation and emancipation from persistent neocolonialist interference. The lottery in both of these narratives functions as a false promise that ultimately foils the protagonists' attempts at bettering their conditions. In the analysis that follows, Senegalese, Ivorian, and Gabonese directors represent the tragicomic consequences of the kind of casino capitalism that dominates the global political landscape, while infusing their narratives with the intricacies unique to former French colonies and the "cooperative" policies that have come to be known

as Françafrique.[23] In Mambety (1994), for example, the protagonist is driven mad in his efforts to cash the winning ticket, and it is only when he drops the ticket into the ocean (symbolizing the objective pettiness of the modern economy in the context of the immense natural forces at play in existence) that he feels truly liberated—his unbridled laughter seems to indicate a strange sort of insane lucidity.[24] Similarly, in Kramo-Lanciné (1994), Ali and his family are entranced by the idea of instant wealth, though the winning ticket has been momentarily misplaced. An unfortunate sequence of events ultimately leaves the family more impoverished than before, echoing the refrain that opens the film: "Money has ruined the world today."[25] Ivanga (2001) recounts how a group of young friends are driven to the extreme act of robbing the lottery booth when their efforts to win the lottery prove unsuccessful: it seems like the only way they can attain their individual and collective dreams, and it is a decision with tragic consequences. The purported "liberation" from financial woes that the lottery represents in these three films constitutes an artificial paradise par excellence, proving that there is no way around the laws of free-market economics, no matter how "lawless" these may be. Furthermore, these cinematic narratives of the lottery serve as a poignant critique of foreign aid, whether in the form of the colonial debt that is the subject of Sissako's docudrama (2005) or through the development and humanitarian aid policies instituted by multinational nongovernmental entities. Consequently, one can read within these narratives an economic counter-narrative that favors sustainable internal development as opposed to opportunistic influxes of financial stimuli from outside, which, much like the stimulants and substances of artificial paradises, provide only short-term gains while perpetuating an ongoing cycle of dependency.

Artificial Paradises: Buying the Ticket and Taking the Trip

When Baudelaire speaks of hashish or the experience of the opium eater, his description is one of extended relative euphoria, a

Paradis Artificiels

generalized fascination with one's most immediate surroundings—"a kind of angelic excitement, a reminder of a form of complimentary order" (1860, 5)[26]—that can instantly shift to a proportionally horrific intensity (as also noted in Huxley [1990]). In an imitation of a quasi-manic state, "the solitary and somber passerby" (3) or "those who knew, like Hoffmann, how to construct their spiritual barometer" (4)[27] undergo a transformation of the mind, a renewal or regeneration of consciousness in line with a momentary cosmic reordering of things, only to be left at the end of it all with hunger pangs for something more lasting and substantial. For this reason, Orwell's 1984 identifies the mechanism for maintaining a docile and subservient population, stating, "Films, football, beer, and, above all, gambling filled up the horizon of their minds" (1981, 61–62). The experience of the lottery player is analogous to that of the user of intoxicants in that the anticipation of the next potential "high" conditions the user or player to forgo concerted efforts at achieving long-term comfort in exchange for the fleeting fancy of unimaginable wealth and prosperity. However, even when the high of winning is attained, it is only a passing moment before the gambler proceeds to then embark on the next quest for more. The intermittent high of winning or the low of repeatedly losing precipitates more of the same: to keep playing. There is no way out of the cycle except in realizing the brute reality that the momentary rush or the recurring letdown are merely the twin facets of a singular escapist trip afforded by this artificial paradise. The visible illusion of individual opportunity often obscures its hidden counterpart of protracted collective suffering and inequality. In this way, cycles of physical and psychological addiction function similarly as cycles of economic dependency perpetuated by the aid-debt cycle, which attains its extreme form in inegalitarian practices like the lottery and its institutionalized forms, the stock market.

Only upon realizing the illusory nature of the aforementioned sentiments is it possible for the player, the flaneur in Baudelaire's world, to enjoy the effects of self-indulgence. In the case of the hash smoker or opium eater, the self-indulgence is often repeated

(hence the belief in the habit-forming nature of such drugs) because the dreamlike state that is thereby induced provides sufficient incentive to deny the brute reality of its fleeting and clandestine essential qualities in order to revel momentarily in its effects. The lottery player, or gambler, lives by the same set of rules, enraptured by the pleasure (or pain) afforded by the play, regardless of the ultimate consequences. The exhilaration of the win is actually of no more consequence than the extreme agony of loss: all the gambler values is the moment in which the game is played. That is the moment of unlimited potential in which dreams of unbridled wealth and limitless happiness supplant the player's rationality and feed into the illusory dream-state of constantly chasing the next high. This type of economic dependency plays out in the international economic arena as the distribution of aid short circuits long-term sustainable growth and a coherent vision of a prosperous future in favor of a continuous struggle for temporary relief. The ecological implications, which will be explored further in the next chapter, are similarly narrowly focused on short-term solutions to perceived problems at the expense of the longevity of various exploited environments, both natural and human.

Taking as an example Mambety (1994), as the title *Le Franc* suggests, the film's primary concern is with money, specifically the Franc CFA (Communauté Financière Africaine). The CFA franc, which was initially tied to the French franc at a fixed exchange rate of fifty to one, was devalued in 1994 to a fixed ratio of one hundred to one, essentially reducing the buying power of France's former colonies by half (the CFA is now tied to the euro at the same fixed rate).[28] And although the Economic Community of West African States has long attempted to initiate an independent currency (such as the eco, initially proposed in 2003), any substantial changes in the fiscal and economic policies in the region have yet to materialize. Mambety's short film opens with typical scenes of Senegalese social life, appropriately punctuated by the crashing waves and the equally continuous calls to prayer made by the muezzin (Muslim holy man). Focusing on the city of Dakar,

Paradis Artificiels

the contrasting rhythms of daily life are immediately apparent, from the "cars rapides" (local public transport) circulating around the transportation hub, or "gare routière," to the women preparing food and the "talibé" children reciting verses from the Qur'an as part of their traditional Islamic education in a madrassa. Against this backdrop of bustling urban life, the film's protagonist, a man who goes by the name Marigot (which means "creek" or "stream" in the context of Francophone Africa), sleeps beneath a poster of Yaadikoone, a renowned Senegalese resister to French colonization who has the reputation of a hero, not unlike the Serigne of Touba who purportedly walked on water after jumping from a French prison vessel.[29]

Although Marigot finds himself evicted for not paying rent, he appears to meander, as his name would suggest, like flowing water through the barren landscapes. In the scene immediately following his confrontation with his landlady, he is shown merrily leading a group of children in the fashion of a pied piper to the sound of his congoma, a stringed boxlike instrument, before becoming a sort of baroque-romantic "promeneur solitaire" walking across desert dunes, throwing sand up into the wind, an image rich in symbolism regarding the passage of time and the transient nature of existence. It is at this point that the viewer is introduced to Langouste, a very small man who sells tickets for Lonase (Lottérie nationale sénégalaise). While he exchanges bills for tickets at his kiosk with a man who just got off the train at the Dakar station, the radio plays music in French (in contrast to the Wolof spoken by the characters). The topic of the radio broadcast turns to the global economy with references to the dollar as well as to the French franc, and the West African Franc CFA (a move that instinctively recalls the multidirectional, historical triangular *traversées* of the "Black Atlantic" between Europe, Africa, and the New World).[30] A passerby nonchalantly drops a banknote, which Marigot picks up from the ground before being immediately confronted by Langouste, who invites him to a restaurant, having noticed his financial good fortune. At the restaurant, a radio program

plays, relaying the message of devaluation in Wolof. Framed by an oblique, low-angle shot from a streetside camera, Langouste explains the importance of consuming locally sourced African products to minimize the negative impact of France's unilateral economic actions. Marigot tells Langouste how his congoma was confiscated by his antagonistic landlady because he owed rent, and Langouste counsels him to buy a lottery ticket to alleviate his stress. He points out a man in a tattered red boubou who is carrying his door down the street, telling the story of how the man had been driven mad by a "sure winner" lottery ticket that he gave to his grandmother for safe keeping. She died before the drawing, and so he lost it (although he never truly had it). The viewer who has already seen the film will recognize that this is an auto-reflexive foreshadowing of the film itself, in which Marigot embarks on a bizarre adventure through the city (not unlike his traversal of the desert wasteland in the opening scenes) in order to cash in his winning lotto ticket, which he has pasted to his door beneath the poster of the heroic rebel Yaadikoone. In an atmosphere of subversive complicity, Langouste then sells him "a winning lottery ticket" with the number 555.[31] These initial scenes not only suggest the nature of global economic inequalities through the juxtaposition of multiple economic and linguistic registers but also subtly depict the inherent dishonesty and corruption in modern economics, from the ill-gotten banknote to the fortuitous lunch arrangement and finally to the conspiratorial sale of the winning ticket. Furthermore, through the foreshadowing of how a "sure winner" is not necessarily a foregone conclusion, Mambety's film hints at the illusory nature of fast money, which is often little more than an empty promise. In so doing, the film mounts a poignant critique of the neocolonialist policies of former colonial powers and global financial institutions behind the devaluation of the CFA franc.

It comes as no surprise then that Marigot struggles to actually redeem the ticket for cash (in much the same way as one might struggle to redeem currency for "happiness"). He finds himself confronted with bureaucratic red tape because his decision to glue

the ticket on his door for safekeeping has rendered it unredeemable and leads to the absurd image of a man wandering the streets carrying a door, showing how his winning ticket has become a very real burden. The absurdity of the entire enterprise comes to a head when Marigot, in seeming despair, comes to the ocean shore and laughs hysterically as the ocean waves wash over him and his "winning ticket," which has finally come unglued and is now floating about in the shallows. As the film closes, the spectator is left to wonder if Marigot will redeem his ticket, but the imagery of the crashing waves and the sound of his laughter imply his realization that the "paradise" he has been chasing is false and that there is more to life than money. Mambety comments on his final films, stating: "You see, in this trilogy, alas, money is fundamental. There was a time, there certainly was a time when the terms of exchange between men were other than just that. That definitely did once exist. But it had to be that some wanted to be richer than others. That is in the very origins of humanity. Where the very concept of sharing was ruptured so thoroughly that we created the poor, there we also created the rich. That's the burden of man. You see the birds? They do not need money."[32]

This sentiment seems to echo the biblical imagery of Matthew 6:26, when Jesus instructs his followers not to worry, stating that although birds do not reap or sow or store up food, they are cared for by God, implying that the same is true for human beings, who are God's children. By contrast, the human society that has been constructed on the basis of money is depicted as an unnecessary burden born of greed and inequality upon the ruins of a prior system of exchange: that of sharing or *le partage*. Interestingly, Sarr identifies the cultural contexts of African economies along similar lines: "The economies of traditional African societies were marked by the fact that production, distribution, and possession of goods was regulated by a social ethics, the goal of which was to guarantee everyone's livelihood through the redistribution of resources and the right of each member of the community to receive help from the whole society if the need arose" (2019, 55).[33]

This vision of an alternative economic model to that proposed by global capitalism is precisely what undergirds Mambety's cinematic project to valorize the lives of everyday people trying to cope with the tremendous societal pressures of globalization, which he attempts to portray as illusory pretense. The psychology of the lottery is an extreme example of the ways in which the logics of capitalism have infused societal behaviors, as Sarr observes, "Saving, investment, and earning behaviors, as well as the logics and rationalities that preside over certain patterns of consumption, are culturally determined" (2019, 46).[34] According to this understanding, the motivations that maintain the lottery—essentially funneling the funds of a large portion of the population into the hands of a single individual, the lucky winner—are illustrative of culturally determined behaviors that impoverish, divide, and incite jealousy rather than foster a sense of communal engagement toward developing common interests.

Artificial Paradises and the Perpetual Pursuit of Happiness: Fadika's *Wariko*

Turning then to a second example of the lottery in African cinema, Fadika Kramo-Lanciné's (1994) *Wariko* (the Dioula word for "lots of money"—"le gros lot" in French) is an Ivorian film released around the time of devaluation, which also deals with the notion of the lottery as a duplicitous trope in modern economics. The film is a comedy in which an Abidjanais police officer named Ali falls upon the winning lottery ticket as a fortuitous result of his wife's minor inconvenience. Awa, Ali's wife, sells traditional cloths or *pagnes* in the upscale business district of Plateau, and in a desperate attempt to make change for her wealthy client whose French-speaking spouse pays in big bills, purchases a lottery ticket, which she then bequeaths to her husband. This expository scene occurs against the backdrop of the opening credits, in which scenes of everyday economic transactions are portrayed while the talking drum (tam-tam parleur) relays the following message:

Paradis Artificiels

"L'argent a gâté le monde" (or "Money has ruined the world"). The camera follows a suitcase (which one assumes contains money or some other medium of exchange) that proceeds to change hands from a man in a boubou to one in a suit coat and then to a woman, symbolizing the transcultural nature of global finance: a nature that does not discriminate based on gender or religion—only socioeconomic status counts. Next, shots showing hands scratching lotto tickets are juxtaposed with the outstretched hand of a beggar before a pickpocket is shown disappearing into the fray as a crowd forms in pursuit chanting "*Voleur! Voleur!*" (Thief! Thief!). One can read this opening sequence of images in numerous ways: mere scenes depicting the multiple ways in which money moves, or perhaps the lottery is being likened to mendacity, theft, or some unspecified grand financial racket, as suggested by Ngugi (1982) as previously mentioned. The message of the talking drum, however, is clearly stated—namely, that money, the pursuit and exchange thereof, and its manipulation have taken over the world in irreversible, even ominous ways.

After hearing the news of Ali's winning lotto ticket, although it has promptly and ironically been misplaced, each of his family members begins to entertain a dream of becoming "nouveaux riches." As news spreads, neighbors and extended family members also begin to encroach on Ali, asking for financial assistance for myriad real or imagined problems. Ali, however, is driven into a downward spiral by his failed attempts to find the missing ticket. He nearly loses his job, almost pays fifty-thousand CFA (one-eighth of his potential winnings) to a marabou for supernatural assistance, and finally he falls ill after walking in the rain in disillusionment, at which point the refrain of the talking tam-tam returns: "L'argent a gâté le monde." Only when he has reached the very bottom does Ali serendipitously stumble upon the winning ticket stuck between two pages in his young son's school notebook. However, this too will be only a momentary reprieve, for when he takes it to the imposing vertical skyscraper of an office building to claim his winnings, a large man convinces Ali to give

him the ticket, which he gives to someone else to "check for authenticity" before dazzling him with the lights and camera shots "for publicity." Ali realizes all too late that he will never again see his winning lotto ticket nor the three million CFA francs that it was supposed to guarantee.

One immediately picks up on the tragicomic irony of Kramo-Lanciné's film in that Ali, the protagonist who wins the enormous sum of three million CFA francs, encounters more hardship than happiness as a result of his winnings. The film's message is summed up by the parable that Ali's father shares with him about a man who thinks he has found a diamond, and after alienating all of his friends, he realizes the diamond is not real: he is essentially left with less than what he had in the beginning. This cautionary tale issued from the wisdom of a previous generation represents a different form of riches—namely, the wealth of participating in a concerned community. The Ivorian economy, like those of other nations in Francophone Africa suffered significantly as a result of devaluation, which exacerbated the effects of harmfully unsustainable neocolonialist economic policies over previous decades. Kramo-Lanciné's film can therefore also be considered a commentary on the initial years of Ivorian independence, when the "Ivorian Miracle" exhibited all of the positive signs of having "won the lottery": an artificial paradise that only further impoverished the land and the people subject to the whims of global market forces.[35]

Mambety (1994) critiques the devaluation through an absurdist lens, which implies that money is ultimately meaningless in relation to the oceanic forces of existence and the genuine humanity exhibited by Marigot in the initial segments of the film (prior to his becoming a "lucky winner") and restored at the end in his insane laughter ("le fou rire"). Kramo-Lanciné (1994) however, exploits the comic irony in the problems wrought by Ali's fictitious "winnings" that are lost and then found before finally being stolen in order to illustrate the cyclical and illusory nature of the economic system. While *Le Franc* astutely demonstrates the terrifyingly dictatorial hold that money has on the life of

Paradis Artificiels

this humanity (in both the individual and the global sense of the word), *Wariko* represents the harmful consequences of money's liquidity as it flows through every corner of society, eroding social bonds and flooding communities with greed and envy. Just as the sun rises and sets above the earth (or at least that is how it would appear from our limited human perspective), money comes and goes in Mambety's and Kramo-Lanciné's films without ever really coming and going. The promissory note of the lottery ticket does not translate into actual financial independence, which implies that the entire financial system may be predicated on pure illusionism, and that one who chases after it becomes like Sisyphus endlessly "rolling the rock." In both of these instances, the crux of the critique is on the individualist nature of modern economics and the dream of escape that it promotes through the promise of financial independence. In a way that seemingly echoes the aforementioned parable of the diamond, Sarr explains: "A relational economy seems to be the most powerful determinant of trade and of the framework of the material economy" (2019, 58).[36] Consequently, one can infer that a material economy structured around a solid base of communal relations such as that of the traditional African societies depicted by Sarr will be robust in its capacity to accommodate the needs of the society as a whole. However, if the relational economy is rooted in avarice, greed, cheating, exploitation, and self-serving practices—what Mbembe characterizes as a "society of enmity" (2019, 42)—the material economy will be subject to the kinds of pitfalls and inequalities portrayed in these African films focused on the lottery.

Dôlè: A Dream Deferred Explodes

As a final look at the myth of striking it rich in African cinema, Gabonese director Imunga Ivanga's (2001) *Dôlè* recounts the story of a handsome youth who goes by the name of Mougler. His rivalry with the *métis* Jean-Robert over the affection of the beautiful Ada prefaces the tragedy that ultimately serves as the catalyst in Mougler's

transformation (a modern-day rite of passage) into adulthood and independence, which can also be read as a national allegory.[37] The death of his mother, whom he is unable to rescue in time with the prescribed medications from the pharmacy, leaves Mougler orphaned, having already been abandoned by a father whom he does not remember. While caring for his ailing mother, Mougler pursues his adolescent passion for the opposite sex—in this case, Ada—and seeks to establish himself in a viable occupation (which turns out to be petty theft, mostly auto parts for resale but also the occasional boom box). Charlie acts as a sort of surrogate father for Mougler, guiding him along the way and furnishing him with a piece of advice at a very critical moment in the film: he must "choose between the two kinds of men: those who undergo and those who decide." Naturally, he chooses to be one who decides, exercising his postcolonial agency in the void left by his absent parents.

Amid this tragic and tumultuous individual narrative, Mougler also participates in a collective narrative with his friends, a small-time gangster who goes by the name of Baby Lee and two others named Akson and Joker, who together are swept up in the grand global capitalist illusion of winning the big jackpot—in this case, *dôlè* (money). They play with their ill-gotten meager means and they lose, but their dreams live on. In their everyday lives, they are academically disinterested expressions of a global popular culture (which might also be "Black culture," or "une culture de negritude") as they spend their afternoons spray painting an abandoned building while listening to iconic American rappers Tupac and Notorious B. I. G. on the boom box before freestyling a pithy, marginal existence within the material confines of Omar Bongo's Gabon.[38]

The myth of getting rich is the only way that one can possibly envision participating in the lavish world that appears in mass media advertisements, especially if one is underage, underprivileged, unemployed, and failing out of school. For youth and adults of every generation who are raised to believe in the notion that there is a way out of the everyday—be it through a kind of individualist, Protestant work ethic or some sense of communal

Paradis Artificiels

213

responsibility and belonging (i.e., nationalism)—there eventually comes a moment of realization that whatever form of happiness is being pursued is wholly illusory and that the base experience of corporeal existence remains the only certainty (or so Descartes would have us believe). Unable to envision any other way to achieve the dreams of wealth and success promoted by the media images that they consume, the youth hatch a plan to rob the lotto booth and make their dreams come true. Baby Lee is wounded and believed dead after the guard hits him in the head with the butt of his gun. However, the film's final scene shows the group together on Charlie's boat, and Baby Lee emerges from underneath with the boom box as if to insinuate that music or art more broadly is capable of transcending the death world in which they live. In a final act of defiance, the lottery tickets that they had stolen from the booth are thrown overboard as if to reiterate the theme that money is not important to the lives they have together. Baby Lee's "death" and "resurrection" are a clear indication that even in "winning" the lottery, the impoverishment brought about by instant, unmerited wealth often proves to be worse than the previous state of the lotto player. The rejection of the material in favor of the relational again juxtaposes two disparate visions of economic success in a way that seems to suggest the primacy of everyday communal life over the unending quest for individual wealth.

Choosing Something Else for Planetary Being

Humanity will always look elsewhere for joy and satisfaction. In the modern era, that elsewhere is money. What these African filmmakers, novelists, and critics express through their creative and intellectual works is that money should not be the ultimate goal. This, in turn, leads one to inquire about the alternatives, be it awe in the face of nature's power, contentment with one's lot in life, or a sense of community and expression of identity. The spectator is invited to imagine other ways of making a hole without needing to acquire a needle, as Bekolo points out: a notion that is

rich in implications for today's climate of economic crisis. Rather than trying to sustain an impossible model, perhaps it is time to globally reenvision the ways in which humanity functions on a global scale. It is, after all, only money. In the twenty-first century, the alienation of humanity that was first brought into the domain of public discourse by Marx in his analysis of capitalist economics has once again reached a new threshold in what French theorist Guy Debord in 1967 termed "La société du spectacle" (the society of the spectacle). Since the 1960s, the spectacular nature of a hypermediated society has increased exponentially, to the point that it has become a common thread in philosophical discourses from Jean Baudrillard to Michel Serres.[39] When "reality," "fact," "truth," "self," and even "thought" are debatable in the lawless arena of democratic *médiatisation*—the reality-building power of each individual's contribution to the digital narrative of humanity—it may be difficult to discern the artificial paradises of the global economy and other symbolic economies when confronted by them. Arguably, society has become so consumed by a narcissistic obsession with images, representations, and illusions that one's own physical existence, social interactions, and even intellectual endeavors have become sources of anxiety and cognitive dissonance. Within the context of this ambivalent representational economy, and as Fassin points out: "The idea that social conditions such as poverty, exclusion, marginalization, and even social position, in the sense of the gap between expectations and reality, tensions between goals and limitations, should be sources of frustration, humiliation, distress, or torment has become familiar—in short, natural—to us. . . . The 'social'—a vague essentialization of inequality, violence, and deviance—makes people suffer, and that suffering must be heard" (2012, 41).

If Fassin is correct in asserting that the social is a principal cause of psychic suffering, then it is all the more essential to examine the cultural values and, by extension, the economic transactionality of our human race in an effort to find that increasingly elusive common ground.[40] This common ground can

Paradis Artificiels 215

be represented in art as an alternative vision, with a powerful message that contrasts modern methods of violence fueled by fear of difference with ancient African wisdom and commonality, embodied in the philosophy of *ubuntu*. Sarr also employs the term *ubuntu* to depict an alternative economic model for an emergent African economy that is relational as opposed to materially based, grounded in communal well-being as opposed to the hoarding of individual wealth: "The Ubuntu philosophy 'I am because we are,' being based on the social essence of the individual, privileges the common good and respect for the humanity of the other" (2019, 68).[41] The rhetorical inversion of Enlightenment individualist egoism, distilled in the Cartesian formulation cogito, ergo sum, or "I think, therefore I am," signals a radical shift in consciousness, which sees self as other and vice versa.

Such a radical shift requires an altogether different conception of the place of socioeconomic status within a broader existential sphere, as Sarr recognizes: "The economic order tends to become hegemonic, overflowing its natural space and attempting to impose its meanings and logic on all dimension of human existence" (2019, 44).[42] It remains to be seen whether the world will be able to dispense with its illusions and reconceptualize the economy as embedded within social structures that emphasize the overall well-being of a society and the individuals that compose it, or as Sarr states: "The economy was inserted into the society" (32).[43] Rather than an ever-expanding and alienating economic system that constantly erupts within the foundational fabrics of societies by inciting ever more action and reaction to continue expanding, the economy must be thought of in its original supporting role, as a means to an end, merely a needle (among many alternative options) that can be used to make the desired hole. If society can reconceive if its relationship to the economy, not as subservient to an immutable and scientifically determined model that projects infinite growth and places value on exploitation and excess, then it may become possible to explore alternative forms of relationships, not only between individuals in society but also between nations

in the global economic order. As Sarr cogently argues, "To truly take advantage of the market of globalization, there must be a radical disruption of the guiding principles of this very market or some sort of renegotiation with Africa's relations with it by reconfiguring modalities of insertion within the process of globalization that are specifically advantageous for the local African economies" (2019, 94).[44] The essential element to change is choice itself. Allowing individuals and nations to discover and produce their own standards of contributing to and profiting from exchanges. The same Afrofuturist critique of humanism that Mbembe (2019) outlines, therefore applies equally to an Afrofuturist critique of the economic order. He writes, "Capitalism is establishing itself in the modality of an animist religion, as yesteryear's flesh-and-bones human yields to a new digital-flux human, infiltrated from everywhere by all sorts of synthetic organs and artificial prostheses" (178). The same mystical forces that animate the environment with spiritual significance in many animist religions appear strikingly similar to the seemingly arbitrary valuation of everyday objects imbued with additional monetary value that is nonetheless subjected to the whims of divine market forces. Extending the metaphor even further, the ability to relate to these market forces through engaged economic practices is therefore akin to the ability to consult the ancestral spirits through mediated exchange: so when access to the medium is denied through financial devaluations, structural adjustment programs, weaponized debt, and the like, one is no longer able to fully participate in the spiritual life of that society (i.e., its transactional economy). In order to adapt to the changes of the twenty-first century, it is necessary to envision modes of human being that marshal technologies that allow access to the universe of exchange value and imbue it with new forms or value production that depend primarily upon the relational as a prerequisite of the material. This will allow communities to grow together rather than be torn apart by avarice precipitated by unbridled individualism in constant pursuit of more ways to purchase happiness.

7

Arguing against the Shame of the State

Sony Labou Tansi's Ecocritical Womanism and Gaiacene Planetarity

In these times of crisis for meaning within a technical civilization, Africa can offer different perspectives concerning social life, emanating from other mythological universes, thereby continuing to support, promote, and be an exemplary instance of the shared notion for the common dream of balanced and harmonious life imbued with meaning.[1]

—Felwine Sarr, *Afrotopia*

Today, we are still waiting for the propositions of an Africa that should either join with the world or propose an alternative to the world.[2]

—Bekolo, *Africa for the Future*

Where do discourses of sustainable development intersect with the humanities? In the previous two chapters, I have advanced arguments proposing that thinking in terms of sustainable development on a global (perhaps even cosmic) scale is central to the future of our planetary civilizations.[3] In 2004, Cameroonian

political economist Achille Mbembe and Sarah Nuttall called for "new critical pedagogies" to understand Africa in a global context, arguing that literary analysis needed to be given full consideration alongside sociological discourses in an effort to deconstruct the Western bias of many "scientific" theories. These "new *critical pedagogies . . .* of writing, talking, seeing, walking, telling, hearing, drawing, making" express a profound need to rethink the way Africa is conceptualized and constructed in order to fully account for the experience of *being* as African (352). This new scholarship which continually reshapes the forms of African life (as much as they do life in any other area of the globe) requires a mixing of registers—popular, scientific, theoretical, aesthetic—in order to account for the "worldliness of African life in general and of the African metropolis as a compositional process that is displacable and reversible by the act of reading and deciphering" (352). Handel Kashope Wright aptly points out that "if we reconceptualize development as more than a process of economic growth, then we can begin to see how orature contributes to development by creating the space to put forward ideas about how, why, and in what direction social change should take place" (2004, 133). Stressing the importance of dialogue, oration, and communicative performance, which compose the base of many indigenous African social structures, Wright argues for alternative models of social discourse that are firmly grounded in the expressive humanities as vehicles for new forms of knowledge production that coincide with the diverse material, ecological, and cultural contexts of global populations. Wright further explains: "Despite interventions and very gradual mutation, dominant development discourse was and is always already liberal, capitalist, economistic, modernist, male-centered and colonialist and/ or imperialist. It has therefore drawn criticism from feminists, anti-colonialists, postcolonialists, and anti-imperialists, leftists, nationalists, traditionalists, post-modernists, environmentalists, and critics who subscribe to various combinations of these political standpoints" (138).

Arguing against the Shame of the State

Because development problematics are often aligned with particular global political and financial interests and therefore subject to a degree of bias in their "objective" representation, works of art may escape from these implicit or inherent prejudices while still presenting a realistic interpretation of a particular set of developmental issues. As Albert Memmi posits: "Fifty novels from a given time period provide a richer source of insight than tons of newsprint published during the reign of a dictator" (2006, 36). Therefore, looking to literature and the arts plays a key role in mounting poignant critiques and identifying plausible solutions for societal issues in the twenty-first century, ranging from efficacious educational models to sustainable economic and ecological measures. Essentially, Wright's argument is that studying literature is studying culture, and that through studying culture one can envision methods and processes of development that benefit the planet and its populations rather than its corporations. This process, however, involves a radical shift in thinking toward a collaborative and inclusive pluralist philosophy.

Spivak (2012) makes a similar argument regarding the importance of an aesthetic education for humanity that imparts a sense of responsibility, not only for individuals to themselves and their immediate communities but also to the planet as an *other* requiring equal, if not paramount, consideration. She outlines just such an "Imperative to Re-imagine the Planet" in terms of a diversity of cultural perspectives, all of which take the planet as a starting point. Spivak writes: "Re-constellating the responsibility-thinking of precapitalist societies into the abstractions of the democratic structures of civil society, to use the planetary—if such a thing can be used!—to control globalization interruptively, to locate the imperative in the indefinite radical alterity of the other space of a planet to deflect the rational imperative of capitalist globalization: to displace dialogics into this set of contradictions" (348).

Essentially, Spivak argues for collapsing the typical epistemological binaries that have created societal divisions between rich and poor, Black and White, colonizer and colonized, and

dominant and subaltern in an effort to reach a commonality based not on a responsibility to a particular geography or even religion but on a mutual responsibility to the planet as a whole, which necessitates a radical alterity through what she terms "diversified social tact" (348). The diversification of the social, opening itself up to difference in light of a shared relationship with the planet-other, engenders a world in which multiple worlds can simultaneously coexist.

Sarr envisions a similar notion of multiple concurrent worlds as a fundamental aspect of contemporary African societies, stating: "As the cultural values of a society are constantly being redefined, the African societies in mutation are symptomatic of this permanent renegotiation of their cultural references and this contemporaneousness (transversality) of several worlds" (2019, 22).[4] He goes on to further define the concept of "Afrocontemporaneousness" in terms of its temporal continuity. Sarr's formulations embody an indigenous epistemological perspective that is outlined by Jean-Godefroy Bidima in his work *La philosophie négro-africaine*, expressing the inherent plurality of Africa as a concept, both spatially and temporally: "The multiple scansions[5] of African philosophies must be understood or evaluated not as an excess but as the spot or place of absence, a germinating flower that, in its exuberances, dictions, and inscriptions expresses itself as the field where every 'possible' is in turn tried, provoked, nullified, and started over" (1995, 3–4).[6]

The baroque imagery of exuberant proliferation from a void, the life cycle of African philosophies that perpetually reproduce multiple cultures, histories, epistemologies, and diasporas engender a relational and inclusive model of theorizing that concerns itself with movement—Bidima employs the word *traversée*—allowing the diverse pasts to illuminate the present tenses with an open stance toward the future. This particular vision of becoming through plurality is echoed by Sarr in terms of a future-oriented vision of Africa: "This Africa that *exists* and that is becoming is protean. Its reason is plural" (2019, 23).[7] Not only is Sarr's vision

of an "Afrotopia" consistent with the inherent pluralities of indigenous knowledge systems, but it also operates in a specific temporality that reflects the sacred Ashanti concept *sankofa*, which Sarr defines concisely as "nourish[ing] oneself off of the past in order to better move forward" (2019, 109).[8] Consequently, one imagines a heterogenous society in a state of constant flux but with the capacity to recall and reproduce past stages of the developmental process according to its own assessment of its unique time and place in the grand cosmic revolutions of life.

From the theoretical perspective of multiplicities, this chapter engages with the natural environment in terms of its physical and metaphysical characteristics as a means of theorizing alternative conceptions of human societies and their interconnected relationships to the visible and invisible animating forces of the planet and the cosmos. Anne Frémaux (2011) expresses that many "environmentalist" discourses are inadequate in actually addressing the problems of the environment. She argues instead for a radical ecology, which includes the notion of *décroissance*, or "de-growth," as a foundational principle. In the spirit of contributing to this vision, this chapter identifies elements in African cultural creation that can aid in conceptualizing a world that takes human, spiritual, and environmental interconnectedness as primary. In such a context, the notion of economic, civilizational, or even individual "de-growth" is recast from being seen as a purely negative phenomenon in relation to a biased notion of unbounded growth as fundamentally positive. In an interview conducted by Denis Lafay, French philosopher Michel Serres (2014) defines "progress" as such: "Evaluating progress supposes that time is linear. Rather it is disparate, it is like a landscape, varied, where flowery valleys—progress—meets deserts—regression. Sometimes the same object can contain both extremes. Television, for example, is a considerable technological progress but also a motif of human sacrifice and regression, if I were to judge it by the majority of its programs in which cadavers fill the screen and death is the most frequently used word."[9]

Consequently, one must understand progress as only one pole in a relational dynamic with regress, much in the same way that Bidima describes the ebbs and flows of African philosophies. Continuing along this paradoxical line of binary couplings, Minh-ha argues that power is always inscribed within language as a form of knowing and that consequently the "most 'realistic' work will not be the one which 'paints' reality, but one which, using the world as content, will explore as profoundly as possible the unreal reality of language" (1989, 62). Understanding the implicit others of relational power dynamics at work within language and the epistemic forms that language encodes constitutes the "unreal reality of language." The linguistic construction of the world is a principal preoccupation of the emergent field of ecolinguistics. Stibbe qualifies the rhetorical preconditions of reality: "The stories are important because they influence how individuals think, and if they are spread widely across a culture then they can become stories-we-live-by and influence prevailing modes of thought in the whole society" (2015, 16). The stories of society differ from the stories of existence in that notions such as "progress" and "development" are decoupled from their alternates. Why would a civilization arrogantly presume that it is somehow immune to the laws of equilibrium that govern the universe? Although the scientific laws of thermodynamics are generally understood as defining principles of the physical universe, global society operates as if infinite growth were possible. Writing about this "victoire du virtuel sur le réel" (victory of the virtual over the real) in relation to the mediatic creation of "Africa" as a European production, Bekolo states that "Africa is also a production of the European imaginary; a virtual construction which can take form in reality" (2009, 135).[10] Humans first create the stories to explain perceptions of reality, which over time begin to assume fixed conscious and material forms. Without calling these stories into question, modifying them, or creating alternative narratives, society begins to stagnate. In the ensuing sections, an analysis of Kahiu's short film *Pumzi* (2011) and the novels of Congolese poet, dramaturge,

and author Sony Labou Tansi reveals an Afrofuturist, womanist, and environmentalist vision of planetary being that embraces the cyclical and paradoxical complexities of life and death, progress and regress, and nature and society. The virtual realities depicted by these artists encourage a fundamental reimagining of the nature of human relationships within the planetary and cosmic ecosystems and propose alternative visions of a sustainable humanity that can slowly begin to take form, first in the mind, followed by reality.

Seeding a New World: Wanuri Kahiu's *Pumzi*

Kenyan director Wanuri Kahiu's (2009) short film *Pumzi*, its title derived from the Kiswahili word for "breath," depicts a bleak and dystopian vision of the future. The film's young feminine protagonist, Asha, works in a laboratory analyzing soil samples from the radioactive landscape outside the sealed compound for signs of habitability. When the viewer is introduced to Asha, she appears to be asleep at her desk in the midst of a lucid dream of a tree, another artifact of a forgotten past. Much like the setting of Aldous Huxley's *Brave New World*, humanity in *Pumzi* is hierarchically organized and systematized in order to maintain the inner workings of an enclave. The ensuing intrigue represents a world in which humans are reduced to mechanistic functions to ensure the continued persistence of the artificial biosphere, including generating electricity through physical exercise and harvesting water from sweat and urine. However, when Asha discovers a soil sample that is not radioactive and is therefore capable of supporting life, and she reveals her findings via a technologically mediated communication interface, the authorities assume that she is suffering from an ailment and needs to take her medication. Although Asha may have discovered the key to the future via the regeneration of a viable biosphere, she is ordered to take her dream suppressant. Reminiscent of the soma administered to the occupants of Huxley's dystopia, it would seem that the dream suppressants are intended to lull the inhabitants of the artificially

constructed society into a state of complacency in the interest of preserving the status quo.

The intertextual complexity of Kahiu's film is foregrounded in the opening sequence, in which clips from what appears to be a museum space retell planet Earth's history through fragmented snapshots of preapocalyptic human civilization. Preserved remains of various life-forms as well as framed print newspaper headlines heralding the advent of a global ecological catastrophe indicate that the film is indeed set in a "brave new world" context. The existence of this museum space within a closed system—an artificial biosphere in the middle of an uninhabitable radioactive desert—serves to illustrate the isolationism and narratological limitations of humanity in this postapocalyptic landscape.[11] Furthermore, the film opens with a linguistic puzzle that inscribes the predominant silence of its opening sequence within linguistic parameters that emphasize the power of language and text. In contrast to the European English language in which the newspaper headlines record the catastrophic end of the world as it has been known (the film is set thirty-five years after an imagined World War III), the camera focuses on a jar labeled "MAITU (mother) seed." The etymological breakdown of the Kikuyu word *Maitu* into its composite syllables, "Maa" and "itu" (meaning "our truth") is also included on the label. By emphasizing the abstract, sometimes arbitrary nature of signification through manifold linguistic layering, this initial sequence functions as an intertextual space that links notions of femininity, ecology, fertility, life, breath, and truth within a complex web of meaning to enhance the symbolic depth of the film's intrigue.

In addition to foreshadowing the film's conclusion, the hallucinatory dream tree that prompts the administering of Asha's dream suppressant embodies the ambiguous space between conscious and unconscious perception in which actual and potential realities can simultaneously appear. A poignant contrast with and departure from the film's setting of a world that reduces humans to their ability to preserve the life of the colony, Asha's mind space operates as an interior doubling of the earth, a fertile cerebral

Arguing against the Shame of the State 225

domain capable of supporting the thought life of a future planet. When Asha rebels against the persistent attempts to suppress the dream seed that has been planted in her mind, the dream slowly begins to unravel within the material sphere after she discovers the uncontaminated soil sample indicating the possibility of a life-supporting world outside. Although the council dissuades her from pursuing her findings, her dream reveals itself to be resistant to suppression. She rebels and steals the fertile soil sample from the lab, along with the "mother seed" that has sprouted, and escapes into the endless arid expanse of the uninhabitable desert beyond the closed borders of the enclave. This moment marks the approximate midpoint of the twenty-minute short film. In the desert, she nurtures the seed with her limited water reserves and then, upon dropping her compass, makes her way toward a tree in the distance which proves to be a mere mirage—she encounters only dead wood. Undeterred, she digs a hole in the sand and plants her sprouted "mother seed," the *Maitu*, or "our collective truth." Wiping every last drop of sweat from her body, Asha waters the sprout and then lies down over it to shade it from the sun. The camera zooms skyward as the tree slowly grows to cover Asha's immobile body, and the sounds of thunder and rain are heard as the word *pumzi* (breath) reappears on the screen. Before the end credits begin to roll, and as the camera continues to zoom out, a lush forest appears within the cutout letters of the word *pumzi*, beyond the borders of the desert, an expanded perspective that gives hope for the growth and regeneration of a barren landscape.

Thought influencing action, dreams becoming reality, the power of language, and the self-sacrificial act of giving life outside of oneself constitute the principal themes of Kahiu's short film, which bears some resemblance to Octavia Butler's novel *Imago* in the otherworldly nature of its aesthetics, its rebellious ethos and brash individualism, and its culmination in the final act of planting a seed to mark a new beginning. The tree itself is a rich symbol in the context of many African cultures, both in terms of the natural environment and that of human societies. "L'arbre à palabres,"

or the "tree of debate," constitutes a central tenet of many indigenous African social structures, serving heteroclite functions of a communal gathering spot; a celebratory, didactic, or conciliatory space; or even simply a place of rest. Within the field of ecocriticism, the tree also stands as a fundamental element of the natural environment, offering food, shelter, and resources to a variety of life-forms and practices. In the shading protection of this natural guardian, disputes are resolved and indigenous communities succeed in working together for their own advancement. One must therefore consider, as I contend in this chapter, that the presence of the tree—a quintessential representation of nature that manifests first in Asha's dream and later as a transformational life force on a deserted planet—also invites the spectator to rest in its shady embrace and assume the collective responsibility of maintaining a balance between all earthly inhabitants, human or otherwise.

The Tree That Grows Out of the Pages

A central preoccupation in the literary corpus of one of the twentieth century's most creative and prolific Francophone writers, the Congolese poet, dramaturge, and novelist Sony Labou Tansi, is that of the equatorial, the exotic, the other side of things. Many scholars have debated the notion of the tropical, the corporeal, the sexual, and the natural environments in Tansi's oeuvre, yet few have argued, as I propose, that an Afrofuturistic and ecocritical interpretation of specific characters, themes, and plot details in his early novels *La vie et demie* (1979) and *L'anté-peuple* (1983) defines the parameters of an ideal society beneath the overwhelming pessimism and tragedy of Tansi's extremely dark and violent magical realism. Suberchicot remarks that "a preoccupation with ethical questions is a common trait of literary works concerning ecological and environmental questions" (2012, 11).[12] The moral preoccupation of these environmentally minded authors is, in another sense, a concern for criticism of societal structures dangerous to humanity because of their disdain for nature in favor of profit and

Arguing against the Shame of the State

economic "development." Suberchicot explains that "the underlying issue of all ecological discourse is that of development" (14).[13] It is therefore reasonable that a certain differentiating quality should be imputed to the literature of subjugated countries; in particular, the literary output of the African continent represents a fertile realm of rhetoric where discussions of development, ecology, and humanitarianism intermingle. Suberchicot observes additionally that "in this pursuit, an author takes notice of the tenacity with which the civilized world—our world—attempts to destroy its spring of life without the faintest feeling of remorse" (83).[14] Tansi aligns himself firmly with those who criticize the civilized world by revealing its manifestations of violence when he describes a world in which humankind is bent on "killing life" or "tuer la vie" (1979, 9). Writing in this manner, Tansi chooses a side in the moral struggle to rejoin human philosophy with planet Earth, with its physical state, and with life itself—even a life and a half.

Examining the writing of Tansi from the perspective of ecocriticism while simultaneously emphasizing the spiritual quality that the author's words lend to the natural realm, specifically considering the numinous characteristics of the sacred forest, there emerges a vision of the planet as an oppositional life space within a broader environmental context of death and decay. The particular conception of spirituality or divine Nature that inflects Tansi's work also marks a fundamental element of societal structures, influencing interaction among human beings while also relating such beings directly to the greater system of natural life or, what one might call (to echo Spivak) an ethos of planetary being. From a futuristic frame of reference informed by Serres's social and political philosophy, one can theorize the estrangement of humanity from the natural realm as a central characteristic of the modern postcolonial state described by Tansi as *honteux* (shameful).[15] In the context of a counterculture of writing literature in countries dominated by former colonial powers, concepts of development and civilization that stem from traditionally Western, even neocolonial, patterns of thought are scrutinized and critiqued.

Consequently, one can trace an alter-globalist (*alter-mondialiste*) discourse based upon the egalitarian environmentalism in Tansi's work. This ideal reflects Afrofuturist elements through combining "science-fiction, historical fiction, speculative fiction, fantasy, Afrocentricity, and magic realism with non-Western beliefs" (Womack 2013, 9). Thus, the worldview that Tansi suggests from the equatorial forests of the Congolese Basin offers a poignant critical observation of a protean process of unsustainable globalization, the shadowy "Françafrique" representing but one of its manifold manifestations. In response to this shameful state of affairs, the morality that Tansi proposes by dint of his aesthetic style and thematic approach encompasses dimensions that are both spiritualist and womanist, embodying the inclusive values of complementary relationships between men and women—all of which unfold within the interwoven fabric of our greater shared environment.[16]

Love and the Sacred Forest: Integral Sources of Life

The "sacred forest" is a common theme in African literature and an integral part of several of the continent's indigenous cultures: Bassek Ba Kobhio's (1990) film *Sango Malo*[17] is an example of this trend. This film critiques the political, economic, and educational systems that have perpetuated exploitation of both human beings and the environment in newly independent central African countries. In the film, the instructor Malo attempts to restructure his school, desiring that the students have a better education. Special attention is given to the practice of planting and tending crops, with the aim of participating in a local agricultural cooperative. Initially, the film appears to advocate for agricultural diversification instead of government-imposed monoculture. However, this environmental critique proves problematic when Malo selects a sacred wood as the site of his next planned area of cultivation. Police arrest the instructor, and his teaching career meets an abrupt end. The film casts attention on the egotism of Malo, whose

Arguing against the Shame of the State

socialist ideology has obscured the ideas of his cultural forebears. Furthermore, the film suggests that sustainable development must not impose on nature, emphasizing a pristine and fragile value found in preserving certain natural spaces that are sacred due to their freedom from human intervention.[18]

The sanctity of nature as the source of life originated in the mythologies of ancient cultures. The knowledge of indigenous African peoples, embodied in the sacred forest, traveled via orally communicated tales and stories that also describe the strange mystique of the natural world. The presence of this mystique is visible not only in the anthropomorphism of the animal characters, the animal totems of the clans, and the idea that human beings are simply *les bouts de bois de dieu* (God's bits of wood) but also in the animist beliefs that each element of nature possesses a soul and is a single part of the greater unity of life.[19] The sacred pervades nature; this includes human beings. Sarr remarks that "tradition is the site where we see the configuration of the fundamental spiritual values that give life meaning" (2019, 15).[20] Life is a product of the natural realm and of the sacred, while death or hell (*l'enfer*) is the direct consequence of a shameful and destructive civilization. In her study on Afrofuturism, Ytasha L. Womack states: "Humankind has lost a connection to nature, to the stars, to a cosmic sense of self. . . . Valuing the divine feminine is one way that Afrofuturism differs from sci-fi and the futurist movements in the past. In Afrofuturism, technological achievement alone is not enough to create a free-thinking future. A well-crafted relationship with nature is intrinsic to a balanced future too" (2013, 103–4).

For Tansi, equally, the world has stagnated. However, the forest is the place and ideal femininity is the way of being allowing us to escape this stagnation and retake control of a directionless life. Tansi's poetic style evokes "the double dimension of love, at once spiritual and sensual" (Dérive 2003, 135).[21] Two of Tansi's novels, *L'anté-peuple* (1983) and *La vie et demie* (1979), form a sort of parentheses around his second novel, *L'état honteux* (1981), and represent nature as the antithesis of modernization. Calling to

mind the work of Gilles Deleuze, the natural realm becomes a sort of line of flight (*ligne de fuite*) by which the heroes, particularly the feminine protagonists, rediscover the meaning of earthly life, as well as a new, holy existence founded upon the sacred.[22] The ecological themes found in these texts (e.g., the equatorial forest, the river, the Pygmies, a powerful femininity) enrich their environmental criticisms by linking them to the divine, to the esoteric, and to ancestral beliefs. This expanded significance attributed to the mystical natural environment is a central aspect of Tansi's literary ecocriticism that simultaneously aligns itself with the philosophy of Afrofuturism.

Viewing Tomorrow through the Lens of Today

According to the philosophy of Serres, environmental degradation on a global scale is a direct consequence of the epoch in which we live, the so-called Anthropocene: an era in which human civilization has mastered all its procedures and activities to such a degree that it finds itself drastically cut off from the ecosystem that was the foundation of its very existence.[23] Tansi describes this homocentric, narcissistic logic as shameful because it rationalizes a certain carelessness toward the natural realm on behalf of humanity. Once established, this shameful indifference toward nature transforms one's experience of the life and beauty that is the natural world into a foreign landscape, unrecognizable to a race of beings stumbling through a fog of illusion. This corrupted worldview is described by Serres as a mediated construction: "Assisted by their internal relationships with one another, media networks construct another reality, another society, a new ideology, another education, another political agenda, and so on, another way of being and of truth. . . . Ignoring the task of describing a reality that already exists, the media conglomerates attempt to invent their own" (2001, 212).[24]

The representative, digitized forms of virtual reality in which humanity has become enmeshed, and the proliferation of

Arguing against the Shame of the State

a corresponding worldview in which data is constantly quantified and manipulated in order to construct a society in which insincerity and excess border on obscenity, become the standard story we live by. As a result, life begins to resemble less and less the soul of a living subject in the concrete world, a concept which Mbembe dubs "le temps vécu" (2000, 20; lived experience). In this way, humanity has become an alien to itself, forgetting its participatory role in the fragile balance of our planet's ecosystem. Appreciation of the natural realm disappears in the wake of a constantly evolving global economy that is merely a facet of a propped-up simulacrum existence, a product of human imagination.[25] In this regard, Sarr describes a "biais quantophrénique," or "quantophrenic bias," of Western epistemological orientations as "the obsession to count everything, to evaluate, to quantify, and to place everything into equations" (2019, 1).[26] Meanwhile, "the nature of cultural, relational, and spiritual life, and so forth[,] everything that makes up existence, . . . pass[es] right through measurement systems like fish through nets too large to catch them" (2019, 2).[27] The shameful negligence of the modern world is parodied in Tansi's hyperbolic use of exaggerated numbers, as we will see, which reproduces the sensation of dissociation from the natural realm and the relational temporality of lived reality in a shared biosphere.

Serres invites us to consider the human condition, as well as the foundations upon which our ideals of global civilization have arisen: "The time is coming when philosophy will abandon the subject for all the other things, the Cartesian ego forgotten in the face of flowers and of wax, of wax and flame beheld in mysterious conversation" (1972, 97).[28] The necessity of rediscovering the essential qualities of our relationship with the environment seems to be a sacred task during certain privileged moments felt while communing with nature. This new logic aims to transform our homocentric epistemology into a biotic egalitarianism; this would require us to "gérer ces illusions" (manage one's illusions) by "la maîtrise de la maîtrise" (the mastery of mastery) (Serres

2003, 199).[29] For Serres just as much as for Tansi, it is a matter of returning to a spiritual yet fundamentally human naturalism that does not attempt to meet the grandiose expectations of political and economic systems of power. The paradox is interesting because it presents an alternative to modernist illusionism that is often the shameful state that Tansi describes: "The regression of man to beast, the incapacity to continue living. Mankind in culture shock in its own skin" (qtd. in Riesz 2000, 113).[30] Naturally, Tansi wages his struggle against "la déshumanisation générale des humains" (40; the general dehumanization of humankind) by dedicating his writing to the environment and attempting to re-create certain mystic aspects of the Congolese worldview that depict his vision of a stable future for Africa and for the world at large. Tansi's ecocriticism finds inspiration in age-old traditions that uphold the natural realm and the spirit of femininity, yet his work also envisions an "African modernity [that] remains to be invented, that is must be thought of as a graft that will succeed in being accepted by way of a selective incorporation of practices and institutions that are initially foreign to it" (Sarr 2019, 16).[31] This incorporation of the internalized or externalized other to embody the hybrid human-animal or human-machine constitutes a hallmark of Afrofuturist thought.

There is a clear relation between these concepts and the (eco) logical philosophy of Serres, who is discomforted by rapidly expanding media networks that threaten to replace the fabric of "real life" with a virtual reality that is absolute and detached from awareness of the natural realm. Furthermore, the great contrast between the soul of a civilization on the brink of collapse and the choice to adopt a new biotic eco-logic finds support from Suberchicot when he remarks "that to write of ecology is to write of the apocalypse" (2012, 13).[32] This characteristic is imputable to Tansi's invented nation, Katamalanasie, where "même la forme humaine avait fui" (even the human form had vanished), a land where there remains only "simulacres sociaux" (a sham society) and "simulacres d'amour" (mockeries of love) (1979, 37). This moral crisis compels

Arguing against the Shame of the State

us to restabilize our human nature, as well as the condition of our natural habitat. A futuristic sentiment is present in the anticipation (one might call it "foreboding") of the future that gives this novel life. In the book's beginning pages, a section titled "Warning," Tansi writes that *Life and a Half* becomes a fable that views tomorrow through the lens of today" (10).[33] Since the work's publication, the degradation of the natural realm has accelerated just as Tansi had feared. Similarly, at the end of the novel, the natural realm has utterly disappeared from the story's world, leaving the protagonists to wander a postapocalyptic urban wasteland of filth and ruin.

This point is well illustrated by a passage near the end of *La vie et demie* describing the doctor Granicheta's inner thoughts: "All the weight of Africa—mysterious, unpredictable, wild, resilient in spite of everything—all this was hung from his heart in the silence" (Tansi 1979, 164).[34] Even though the world is spiraling out of control, devoid of reason and substance as the threat of apocalyptic war between Katamalanasie and Darmellia looms, an anchoring force remains that connects human beings to the earth and to their peers. The doctor continues: "It was not men that he could love . . . but the void that men placed between him and themselves; an elegant void, resplendent with intoxicating wonder: the void introduced to us by others" (164).[35] Despite all of civilization's reassurances, and despite his training in science and reasoning, in his heart of hearts the doctor feels the occult and mystical influence—firmly rooted in the earth of the African continent—of an absence that becomes overpowering in between encounters with others. In his written ecocriticism, Tansi attempts to accentuate the spiritual aspects that pervade the natural and human environment in which we live. While emphasizing the spiritual (even mystical) nature of the relationship human beings share with their planet, Tansi reaffirms the importance of ecocriticism and sustainability, suggesting that we apply these concepts to our view of today's world and its inhabitants in order to protect our global cultural heritage from oblivion.

Morbidity and Modern Shame

The modern shame outlined in Tansi's written work exists principally in society's illusions of progress that systematically dismantle and destroy other modes of human being, as well as nonhuman life-forms viewed as marginal in relation to humanity. This view on the impoverishment of life-worlds is voiced by the Savage, the embodiment of the outsider in Aldous Huxley's *Brave New World:* "Yes, that's just like you. Getting rid of everything unpleasant instead of learning to put up with it" (1946, 162). The nations of the modern world tacitly support this systematic destruction in support of a global system that wastes the planet's resources, displaces entire populations, and allows abusive governments to remain in power, ignoring humanity's best interests in favor of increased economic advancement. To quote the infamous *avertissement* (warning) of *La vie et demie*, this is "an age where mankind is bent more than ever upon killing life" (9).[36] In other words, our societies have lost their most basic connection with the earth, denying their life's wellspring while celebrating contributions to what Mbembe names "une économie de la mort" (2000, 160; an economy of death), which opens up spaces for perverse pleasure in the very manner by which death is produced. Viewed through an Afrofuturist lens, the destruction of life, or the dispensation of death that routinely occurs on a planetary level as an inevitable consequence of global development practices, constitutes a moment of pleasure for those profiteers and beneficiaries for whom that death signals an opportunity for gain. In other words, the base quantification of existence is predicated on dispensing death. The inevitable consequence of participating in these death-worlds is a profound suppressed shame of a discontinuous and dissociated mode of existence that cannot be called "life" proper: shame for country, for fellow citizens, for oneself, and, most tragically, for the planet. It is necessary to view Tansi's ecocriticism in contrast with our shameful modernity in order to understand this pattern, both material and spiritual, that exalts humankind above all other

Arguing against the Shame of the State

life.[37] In the words of Sarr, we must simply "imagine and invent conceptions of life, of what is livable, and viable, in a mode other than one based merely on quantity and greed" (2019, xiii).[38]

In Tansi's third novel, *L'anté-peuple*, the teacher Dadou falls in love with a young woman, Yaeldara, but their forbidden love forces them to flee from their homes. They find shelter among a group of bush resistance fighters living in nature on the edges of the "civilized" world. In the words of the narrator, it is a society "où le cadavre déborde" (overflowing with cadavers) where men and women are reduced to a state of "peut-être vivants" (maybe-alive beings) (Tansi 1983, 172). Yaeldara, Dadou's lover and the book's main character, describes the situation: "We live on the outskirts of life" (172).[39] The alienation of men and women from the natural realm and from life leads to an absence of vitality, love, spirit, and nature—a situation similar to that found in Katamalanasie in *La vie et demie*.[40] This shameful world is explicitly present in the portrayal of the leader of the rebel band that Dadou encounters.[41] While society is depicted as nothing but pestilential ruin, the natural realm represents life in all its fullness, equally physical and spiritual. The forest is the cradle of humanity, preserving the wisdom of the ancestors: open, welcoming, outside, and on a different plane than that of purely material limitations.

An integral part of this nonlife, the antithesis of the forest, is the absence of human contact: relationships become nothing more than dull economic transactions. In such a world driven mad by a system of commodification, living beings (along with everything else) become products. Anyone and anything can be represented as a number, a symbol, a card, or, more recently, a digital footprint. Amando, an old fisherman whom Yaeldara encounters at the riverbank, explains that "this world is mad. Only information is left to reason, to think, to breathe. Men, all men, are blocked up. All hearts. All minds. All blood. The only blood that remains to flow is that of information" (147).[42] The gravest consequence of this inhumanity enshrined in paperwork, this digitized inhumanity of our time, is the absence of love. Yealdara remarks how "the city's

inhabitants became consumers of sex" (147).[43] The fact that love has dwindled to a mere medium of exchange—bought, sold, and consumed—represents a failure for human relations. Tansi characterizes this social condition differently in an interview: "There is no such thing as love that goes further than sex. It's terrible, it's horrible!" (2005, 64).[44] It is necessary to question whether the absence of love of the self derives from the absence of a being's relationship with the natural environment. A dead nature and a dead life give way to a dead love. By contrast, a vibrant natural realm represents the basic conditions necessary for a life and love of equal spirit.

In a study on love in *L'anté-peuple*, Ivorian poet, novelist, and critic Tanella Boni observes that love "is then a way of being the one to question this constricting virtue. In this manner, human love is the salvation of our once-spontaneous, natural life; it is an element of our healthful and joyous existence" (2003, 204).[45] Thus, at the novel's end, it is initially love that inspires Dadou to flee his ignominious existence, leading him through a series of vital experiences linked closely with the natural realm and with the forest in particular: "Only the forest could help those who had sacrificed their standing in that bastard mess" (Tansi 1983, 187).[46] This element of the novel is an explicit return to several themes that are also made plain in *La vie et demie*. Firstly, the two novels employ a vocabulary in which the very act of dying is central. As seen in the previous quotation, one must sacrifice their standing in "le bordel de la bâtardise" (that bastard mess) in much the same way that revolutionaries of Katamalanasie resign themselves to the fate of Martial, the living-dead half-bodied protagonist and father of Chaïdana in *La vie et demie*, as a way of resisting the dictates of the providential leader. Secondly, as the following section will further explain, Tansi views the forest as a place where one can escape the deception of a society living a simulation and rediscover a deeper sense of self, of the sacred, and of what links all of the planet's inhabitants. This sacred or divine element is central to humanity's relationship with the natural realm. As the

Arguing against the Shame of the State

rebel character Assabrou puts it, "If life ceases to be sacred, matter, all matter will be nothing more than a deaf lunacy" (Tansi 1983, 189).[47] If this divine element is retained, the individual and, consequently, society at large may expel their shame and realize a new way of life together with the world, one that is in harmony with the natural realm and the spiritualism it embodies.

Writing of Life between Forest and Femininity

Portrayals of the violent encounter of worlds unleashing the inhuman madness of our civilization's shameful state are present in the text of Tansi's written works. For example, Tansi (1979) displays at the textual level an image of fragmentation, of alienation, even of a mise-en-abyme of the senses. The words no longer form a text, just as beings no longer form a real world, only one held together by the assorted images of a lofty spectacle. In this sense, Tansi's novels appear all the more innovative in that they explicitly attempt to incorporate words with embodiment, thereby imparting corporeality to his texts.[48] For Tansi, the act of writing in "chair-mots-de-passe" (9; passwords-of-flesh) represents an active struggle to draw abstract philosophy down into concrete things, to draw writing down into a body, and to draw critical discourse down to the plane of ecology. For this reason, the novel concludes with the phrase "mon corps se souvient" (192; my body remembers). As such, *La vie et demie* is an embodied tale recounting the apocalypse that arises from a power struggle in the wake of a series of shameful, offensive "providential" leaders in a way that can be felt immediately by the nonverbal body that Tansi has added to his words. By means of textual acts that incarnate the ambiguities of the world they illustrate, Tansi's ecocriticism is thus arrayed within the setting of an apocalyptic world, a future that is merely an extension of today's chaotic, shameful global crisis. In this crumbling, senseless world, it is a feminine protagonist, Chaïdana, who, escaping to the shelter of a vast primordial forest, will personify the divine powers of ancient mythologies and of

a spirituality in harmony with nature. In her character and its multiple reincarnations throughout the story, one comes to discover a powerful means of escaping the catastrophe of a reckless globalization.

The critic Xavier Garnier examines the idea of an apocalyptic media obsession. Garnier introduces the idea of a simulacrum or nonplace that has replaced the natural realm and what we knew as the "real" world: "The simulacrum has occupied all spaces, the non-place has devoured all places" (2015, 163).[49] In this context of nonbeing, of a world filled with dead souls, "Sony Labou Tansi invites us to embrace an ecology of reality," as well as the hope "of a new human ecosystem" (175).[50] In *La vie et demie*, just as in *L'anté-peuple*, this invitation finds expression in the presence of the tropical rainforest. In *La vie et demie*, the children of Martial and his daughter Chaïdana's incestuous relationship flee from the evils of society, undergoing a spiritual rebirth among a Pygmy community inhabiting a mysterious clearing at the forest's heart. Likened to the form of mythological gods, it is the power of the natural realm and the Pygmies' knowledge of this power that facilitate both Chaïdana's physical and spiritual rebirth and the death of her twin brother.[51]

Garnier focuses on a psychoanalytical dimension (181), identifying the forest as a place of extreme solitude and a site for the questioning of identity. However, the mythical quality of the environment (i.e., the ancient knowledge retained by the thirty-nine Pygmy civilizations) plays an equally necessary role in the regeneration of Chaïdana's body and spirit.[52] Whether one views her as in a true ecological space or as suspended in a mythological hallucination, Chaïdana, aided by a Pygmy named Kapahacheu, successfully internalizes the forest's mystic power. This power, both natural and verbal, bears a striking resemblance to the verbal, corporeal logic of Tansi's writing: "The sap you put in your eyes to see very far or to see at night. The sap you put in your nostrils to smell an animal or another man at a distance. The sap that makes you sleep or that keeps you from falling asleep. The

sap that creates a mirage or the effects of wine. The whole range of [poisons (*sic*).] The whole range of drugs. The words that provoke tears. The words that bring good luck. The words that kill" (2011, 67).[53] Again, one might remark on the way that verbal and non-verbal are enmeshed in the words and saps that each imbue those who use them with certain properties.

The natural and the spiritual intertwine. The forest contains within itself all that is necessary for life and for much more; by contrast, outside of this Garden of Eden awaits "l'enfer" (hell), a word not found in the Pygmy language. Attempting to explain the concept of hell to her Pygmy partner, Chaïdana remarks, "It's something that eats you alive" (Tansi 1979, 95).[54] Hell is thus portrayed as a sickness that eats at beings from the inside, the effect of a decayed, corrupted society like that of Katamalanasie. Hell is the equivalent of the shameful state: dehumanization by the denigration of the power of words and of nature.

An infernal civilization surrounds the rainforest, interrupting its status as a sacrosanct place and inverting the center and periphery of the world. This is a fundamental aspect of Tansi's ecocriticism. This hell reaches even the Pygmy population when civilization begins to encroach on the primordial tranquility of the forest: "The asphalt street named Fraternity, which lay not far from the Catholic mission in Darmellia, a city with many attractions, including two hundred and twelve ultramodern villas, a construction site for a three-thousand-bed hospital, next door to a private school that could house fifty professors and six thousand students" (2011, 70).[55] One must note the parodic inclusion of quantities as illustrative of the implicit biases of modern progress and economic development, as well as the emphasis on education and life management systems (e.g., schools and hospitals) as integral parts of the project.

Although this development seems positive on the surface, it undeniably resembles certain aspects of the French colonization of Africa and of the initiative's "civilizing mission." It represents the replacement of one way of life with another, and this process

comes with negative consequences for the natural environment, particularly in relation to the lives of the forest's inhabitants. Where the lifeblood of the trees and esoteric wisdom of the forest once furnished life's essentials, the hospitals and the schools take control. With these shifts, the reader witnesses the extermination of a people: "The hunting after Pygmies for their integration reached its climactic moment" (1979, 102).[56] This hyperbolic example of forced assimilation represents a critique of all violence imposed upon populations subjugated by an external alien civilization. This ecocriticism thus targets the vicious cycle of a war waged perpetually against the world and its inhabitants by the forces of order. The Pygmies are but one of the many examples useful in a critique of the different forms of postcolonial domination that destroy the cultural environments that support them.[57] This forced integration of a marginalized population is essentially the destruction of their social structures. The two worlds cannot cohabitate; symbolizing this is the image of the "Darmellia bridge that separated those of the forest from those of Jesus Christ" (1979, 105).[58] This is a fundamental aspect of this text's ecocriticism: the advancement of a "civilization" that does not wish to recognize any frontier and insists on a dualistic logic that merely divides, conquers, and colonizes. The heroine Chaïdana is the glimmer of hope found in this text, mastering life and death by means of her relation to the divine natural realm: "It was the forest of time, the forest of life, incarnate in the forest of her beautiful body."[59] Therefore, a clear link exists between nature, divinity, and femininity in the Afrofuturist ecocriticism expressed in *La vie et demie*, which aims to illustrate a less infernal world for the future.

For an Ecocriticism of "Françafrique"

The growing divide between sacred love and nature, on the one hand, and the shameful modern state, on the other, is even more apparent in the two conclusions of Tansi's twice-released theater piece, *Une vie en arbres et chars . . . bonds* (1995) or *Monologue*

Arguing against the Shame of the State

d'or et noces d'argent (1996), one of the last works to have seen completion before the death of this playwright, poet, novelist, and philosopher.[60] Garnier (2015) explains that a certain tree is found in this play, about which a "village planétaire" (165–66; planetary village) forms. The parallelisms with "l'arbre à palabres," or the tree of debate, are remarkable. In the first version of the play, the tree becomes a world heritage site, a sort of cultural commodification; this launches a series of political negotiations that inflate the value of this resource, which is ultimately transported to California. Could this be an example of the "Hollywoodizing" or "Disneyfication" of nature, an ill-advised appropriation, or perhaps the realization of a society of spectacle completely devoid of any concrete terrestrial base? In any case, the message is clear: the world makes a mockery out of what this tree once was. However, in the conclusion of the play's second version, the tree remains intact in its original location, while around it arises a new nation under a king driven mad by his passionate love for a woman (167–69). The difference is important because this second representation of a new human race contains all the aspects central to an effective ecocriticism. Firstly, there is recognition of the sanctity and the divinity of nature; this element has evolved from certain older African traditions. At the same time, the work underscores the importance of a love that is beyond rationality, logic, and the purely physical realm. The sacred courses throughout both the human and natural realms, in a manner that permanently interweaves the three.

An eco-logic of community is thus discernible in Tansi's novels. This eco-logic mounts a critique of our destructive and shameful modernity and valorizes a new societal form that resides in harmony with nature and that reinvents itself in the feminine aspects of being. Regard for femininity and of the sacred natural realm are the foundations of human life and the composing elements of Tansi's ecocriticism. However, Tansi's vision transcends feminism by aligning itself instead with the concept of African womanism: "But it is not in terms of feminism, because that too was a

catastrophe. It castrated all the men. It's not any better to castrate the men or to castrate the women. It's not that, not in those terms, but I believe that we are complementary" (2005, 64).[61] The ideal of complementarity expressed in African womanism is central to Tansi's ecocriticism, not only in the complementary relationships of men and women but also in the relationships between living beings and the natural environment. This lends sacred meaning to a life otherwise devoid of substance. Of course, it is the ensemble of men and women living in mutual and complementary respect, as well as their harmony with nature, that furnishes life's sacred qualities. Love, therefore, is a form of power unto itself, as we see in Orwell's description of the love affair between Winston and Julia in 1984: "Their embrace had been a battle, the climax a victory. It was a blow struck against the Party. It was a political act" (1981, 105). Accordingly, this ecocriticism targets the inner soul of human beings, their interpersonal relationships, and their relation to the environment: all within the comprehensive spiritualistic exterior. This holistic vision of humanity marks a form of resistance to the shameful impoverishment of life through the orchestrated simulacra of state and party politics.

To establish the fundamental axes of Tansi's feminine ecocriticism, consider this frank saying from the writer: "Our planet is poorly managed. We pay engineers to fuck around with nature when we don't even pay women who raise children. That's tragic, it really is! It's tragic!" (2005, 63).[62] His words clearly express the imbalance in our society's values. The highways, bridges, mines, and urban expansion of the aforementioned engineers contribute to economic development and to the ever-inflating numbers behind its processes, while less profitable concerns like human and environmental diversity, children and their upbringing, relationships with others, and the future are largely ignored. Sarr defines this singular trajectory of development according to the Western episteme as "an entanglement of ideas that ended up concealing reality by justifying a different praxis and order of the real" (2019, 7).[63] The world is operating as a simulacrum of itself,

Arguing against the Shame of the State 243

dominated by the language and logic of development, which is at times completely antithetical to anything remotely resembling real life. Tansi has much to say himself about the place of the African continent within this destructive economic system, remarking that "all of these countries that were fabricated in Berlin are going to fall apart since they will have no basis for life! So, for sure, we have no country. And if we want to give independence, we should start by giving it to the oil. We need to start saying: 'This oil is independent!' At that instant, the whole world will be independent, and we will begin to make real prices, real exchanges, the fundamental things" (2005, 67).[64] In this quotation, it is clear that questions of agency and autonomy are no longer linked to the nation-state, but rather to the resources that corporate entities exploit through fiscal wizardry and influence on the legal apparatuses of supposedly sovereign political entities. Granting independence first to the environment is the essential step in reestablishing a *real* relation between things outside of their prescribed value as commodities for use or exchange in order to overcome the rigidities of systematic for-profit exploitation and the instrumentalization of life.

Tansi would also certainly be correct in pointing out the artificial qualities of African countries that were drawn up in Berlin during 1884 and 1885, with the sole interest being the exploitation of the continent's resources for European profit. After nominal independences in the decades following the Second World War, this exploitation persists even today in the economic and political dealings of corrupt leaders. Named "Françafrique" by François-Xavier Verschave (1998), this system has perpetuated human and environmental damage in Africa ever since the exploitative practices of Jacques Foccart and others systematically challenged the independence that these countries had received from Charles De Gaulle (15).[65] Real independence will only come when societies cease to value profit and extraction of the planet's resources above populations and the ecosystem. Life must be valued above all; our resources must be used in service of life. A final quotation

from Tansi is in order here: "At last, I hope beyond Coca-Cola and McDonald's. I believe that life has such a flavor, a force. . . . Something fundamental. Life is fundamental, but we do not want it to be so. And we reduce everything because we want to master or manage it all. We cannot master life, and that's fine. Life is an explosion. Let's leave it like that. Why would we want to master it, organize it, chop it up chop it up, program it? Why?" (2005, 68).[66] This vision of life as a powerful expanding force within the laws of the universe stands in stark opposition to the quantification of existence within the laws of the market. This passage hearkens once more to the thinking of Serres and his calls to manage the illusions of modernity and to become masters of mastery. Therefore, there exist two critical goals. We must first learn to recognize the extension of the media's distortion of reality, and then create new social forms that will allow us to live in greater harmony with our planet. And secondly, we must rediscover love of ourselves and of others: this will aid us in comprehending and valuing the world's vast array of eco-cultures and ways of life.

Tansi's written body of work is a paradigmatic example of the ecocritical literature of subjugated countries, as well as of the world at large. Its alter-globalism, at once ecological and humanistic and Afrofuturist, thus invites us to reconsider the importance of natural spaces where life and love are begotten. As mythology and futurism collide, a reconstitution of ancient wisdom and indigenous experience occurs in the setting of an apocalyptic science fiction, restoring equilibrium to the mystic, spiritual dimension of nature and human beings. It is more important than ever to open oneself to others, to study their cultures and their artistic expressions, if we do not wish to lose the precious heritage of our ancestors and our planet. Rather than our human community losing itself in an anthropocentric egoism, an ill-advised narcissism based on the certainty that our civilization represents the apex of human development, perhaps it is time that we reunite around *un arbre-livre à palabres* (a book-tree of debate). We must rid ourselves of the shame of our current state, building a new path to our collective future.

Arguing against the Shame of the State 245

Gaiacene Spaces for Planetary Humanity

Recognizing and dispensing with false narratives is a fundamental element in Bekolo's project, *Africa for the Future*, for "how can we negotiate our freedom in a world where we feel increasingly confronted by 'infected' formulaic narratives, all more or less suspect in their intention to take away a strand of our liberty or a corner of our consciousness" (175).[67] The answer, of course, is in the book's subtitle, "Sortir un nouveau monde du cinema" (To make a new world out of cinema), which entails the marshaling of one's imaginative faculties in order to propose new speculative narratives and to project different future visions of the world, countering dominant "stories we live by" with a plurality of other stories we might also live by (and perhaps more fully). As Sarr argues, it involves a collective effort to "construct the voice for all of Africa's men and women," further suggesting that "Africa must complete its decolonization by way of a fruitful encounter with itself" (Sarr 2019, 113, 115).[68] In a similar fashion, humanity must reencounter itself in its planetarity in order to redefine the parameters of its existence beyond the auto-imposed limitations of an Anthropocene technocracy.

The work of Sony Labou Tansi outlines a worldview embedded in African cultural values and indigenous knowledge systems, which propose alternative approaches to understanding societal development on a planetary scale. This process necessarily involves incorporating a multiplicity of perspectives and opening spaces for dialogue between different worldviews in order to arrive at a fuller conception of ecological and psychological diversity. Rethinking humanity in terms of a diverse unity rather than a fragmented heterogeneity affords a basis for common understanding. The keys to this are an awareness of the role of biodiversity and cultural diversity within the context of shared experiences. Humankind must find a way forward through the forest of thought, recognizing the potential richness of the unknown, the undiscovered, and the unforeseen in relation to the human environment and all of its social complexities—but most importantly in relation to the

natural environment. To be clear, Tansi's environmental critique is not antidevelopmental. The notion of "de-growth," or sustainable development, when understood in the context of an ecologically embedded humanity, represents new potentialities for capitalizing on and profiting from the natural cycles of the cosmic order. Rather than simplifying, reducing, and homogenizing human and planetary nature to fit into a particular neoliberal framework of a global political and cultural economy, it is helpful to conceptualize a collaborative and iterative process of globalization that does not impose a monolithic agenda at all costs. Instead, if humanity can be viewed in its liminality and in the full temporality of past and future civilizations, as Afrofuturist thinking encourages, then it becomes possible to valorize loss as well as gain, to monetize de-growth as much as growth, and to embrace the ebbs and flows of time through a holistic understanding of the real, which encompasses not only that which *is* but also that which *is not.* Therein lies the potential of realizing dreams such as Asha's in Wanuri Kahiu's *Pumzi*, in which the mind seed sprouts and produces effects in the concrete world. The capacity and desire to nurture that which may potentially become, beyond a mere practice of relabeling the same concepts and constructs that define and restrict human-planetary interactions, constitutes the locus at which one might position a new form of reality building that imagines, envisions, and implements new models of socialization grounded in respect for both self and others. Such a process requires a decentering of humanity as the dominant life-form in an Anthropocene epoch and recentering the planet within a new Gaiacene epoch in which planetary primacy marks the precondition of collective existential becoming.

Conclusion

Toward an Afrofuturist Ecohumanist Philosophy of Experience

> Forces
> Forces of forces
> Without beginning nor end.
> The others came after.[1]
>
> —Makombo Bamboté

According to American philosopher and social psychologist William James, reality is often determined by subjective impressions, or what he calls "inner significance." In a collection of essays published near the turn of the twentieth century entitled *On Some of Life's Ideals*, he writes, echoing Emerson, of intense individual sensory experiences that are almost revelatory in nature, asserting that "there is a depth in those moments that constrains us to ascribe more reality to them than to all other experiences" (1899, 20). Such a subjective inwardness to recall Kierkegaard's axiom on truth and subjectivity is the mindset through which external impulses are processed, resulting in the particular interpretation of "reality" that for the individual in that instance is rendered "true." What is considered real is often subject to mitigating factors impacting the intensity of a nearly infinite set of potential experiences, the composite of which ultimately results in the formation of an

individual's identity based on the narrative of interactions between the inward and the outward, subjective and objective forces. Individual and collective identities therefore naturally evolve over time as external influences continue making withdrawals and deposits into the memory bank of the identity narrative through experiential intensity. These perceived realities are not objective in nature, as I have tried to demonstrate through the deployment of fictional texts as engines of alternative world-making. As indicated in the epigraph to this concluding chapter, there exists a unique and primordial animating force which is fundamental to humanity, after which all other constructions emanate. The world that we inhabit is the object of our creation, which therefore affords tremendous opportunity to anyone courageous enough to question, alter, and reimagine that creation in order to adapt one's relationship with it to the demands and exigencies of a new time. The Afrofuturist visions, themes, and languages of the texts and films discussed and analyzed in this book reveal a vested interest in giving voice to the extraneous temporality of existence through the creative act of imagination. The language of these texts is paramount as they generally constitute a point of entry into the social-scientific universes of African imaginaries. And although the Western forms of French or English literary norms and the globalized nature of personal and material relationships underscore the contemporaneous nature of postcolonial African thought, there resides beneath these fixed forms a unique animated energy. This energy speaks of a future that is under careful development within the minds of human beings who are willing to tell unique stories about living in the world. Such stories form the bases of our relationship with the world, which must be one of dis-alienation, which seeks to creatively combine and multiply rather than instinctively divide, separate, and codify conceptions of the real.

In an article in the journal *Green Letters: Studies in Ecocriticism,* Keith Moser (2018) proposes a rewriting of the cosmic narrative in a way that considers humanity as a species, not as the singular, dominant life-form exceeding all others in importance,

but as one among many participating members of a biotic community that extends beyond the finite terrestrial to the infinite possibilities within the expansive cosmic time and space of the universe. In "Decentering and Rewriting the Universal Story of Humanity: The Cosmic Historiography of J. M. G. Le Clézio and Michel Serres," Moser interweaves the poststructuralist position of Michel Serres's resistant sociopolitical philosophy with a mystical naturalism in Le Clézio's literary oeuvre in order to effectively argue for an ecology of space and time that transcends the Anthropocene.[2] By invoking the concept of the biotic in such a way that it no longer asserts the human as the dominant life-form, the consequences of this position entail an emancipatory counter-discourse to the global conception of the human as defined by its biopower in the context of a technologically mediated sociopolitical economy. From an Afrofuturist vantage point, as Sarr argues, "A civilization is not only based on material and technical values; it is complemented by the moral (and aesthetic) values that orient it" (2019, 117–18).[3] The crisis in values, which appears to be driven primarily by an overinsistence on economic primacy over the human, marks a moment of rupture in human history. The point at which colonialist mentalities began the practice of partitioning humanity on the basis of racial categorizations has left a lasting impact on the structures of human civilization, which has theretofore been oriented by logics of extraction, competition, and domination. The resultant postcolonial condition is one of multiple schisms that emerge in relation to reconciling the entrenched hierarchies of humanity that colonialism spawned.

In the works of African women writers engaging with the weight of motherhood in the context of a society that discriminates based on race, the notion of *métissage* becomes a salient site of critique, and through their Afrofuturist imaginings of future societies (utopian or dystopian), the creative writing of Were-were Liking, Véronique Tadjo, and Ken Bugul offer glimpses into a future civilization that is struggling to be born. This struggle against the barriers of an entrenched and enduring neocolonial

order that has been institutionalized through macro-political apparatuses embodies what Fassin describes as "the contemporary tendency to produce victims and victim discourses" (2012, 27). The culture of perpetual war that animates this necropolitical society depends on maintaining a divisive distinction between guilt and innocence, which follows an all-too-familiar rhetoric of heroes and villains, which of course are historically and culturally contingent: yesterday's revolutionaries become today's despots. The figure of the child soldier poses a challenge to this distinction through the ambivalent trait of cohabiting good and evil in a singular embodiment. The paradoxes of international humanitarian interventionism staged through the emblematic and mediated figure of a Johnny Mad Dog in Dongala's work or Kourouma's Petit Birahima, enmesh the multiple possibilities of renegotiating the psychic space of suffering[4] through a narrativizing process that supersedes the limitations of binary logic, thereby demonstrating the promise of Afrofuturist reorientations of the possible as processes and products of the human mind and its numerous operating languages. The evolution of a new episteme then enables human consciousness to essentially bypass the cloistering effects of a hypermediated individualistic global techno-economy through a fundamentally aesthetic and continuous reimagining of the relationship between the human and reality. In so doing, the reality of various societal structures is reified in order to produce a more concordant or harmonious symbiosis between the human and the other, which involves above all an insistence on the aesthetic relationality of creative being as a fundamental component.

Spivak remarks on this essential relationality, writing, "The planet is in the species of alterity, belonging to another system; and yet we inhabit it, indeed are it" (2012, 338). In relating to the planet as a shared space that we as humans simultaneously inhabit and comprise, one can begin to rehumanize the dehumanized other. The process of truth and reconciliation for the child soldier mirrors the relational process of "reterritorialization" that is essential to the migrant's journey, whether at home or abroad,

Conclusion

as both have been altered through the process of exile. Exuding the same impulses that prompt writers to recount the potential dangers and possibilities of exploring new worlds, the monumental assemblage of African voices, both literary and cinematic, engage with the ambiguous in-betweenness of the migrant figure in ways that demystify the myths of Eurocentric exceptionalism. By exposing what Fassin calls "a dialectics of hospitality and hostility, of host and hostage [in which] we recognize the rhetoric of immigration policies that has become widespread over the past two decades" (2012, 136), writers such as Marie NDiaye, Fatou Diome, and Aminata Sow Fall and filmmakers like Sissako, Mambety, and many others have been able to voice the migrant's plight in viscerally human terms. Part of the implication of "the routinization of exception and its justification on humanitarian grounds" (Fassin 2012, 183) is to offer alternative modes of existence that can resist the exclusionary impulses of extreme nationalism. In order to transcend such political divisions, one must reimagine borders as potential sites of negotiation, inviting equitable exchanges rather than a closure that devalues the whole of humanity. Spivak's concept of planetary provides an insight: "If we imagine ourselves as planetary accidents rather than global agents, planetary creatures rather than global entities, alterity remains underived from us. . . . It is only then that we will be able to think the migrant as well as the recipient of foreign aid in the species of alterity, not simply as the white person's burden" (2012, 339). The humanizing impulse of planetary consciousness, in which we are all mere accidents through relational becoming, lies at the core of an Afrofuturist reorientation of subjectivity. Rather than falling prey to the reductive tendencies to view ourselves through the social constructs that either grant or revoke one's humanity on a seemingly arbitrary basis—immigrant, outlaw, clandestine, criminal, marginal, other, etc.—the planetary embeddedness of all people becomes the impetus for promoting acceptance and understanding and the productive exchange of information on equitable terms.

The central role of education in altering our perceptions and constructions of reality cannot be overstated. Unfortunately, much of education is narrowly focused on a particular kind of social performativity, which is to recognize and accept one's position within a predetermined social hierarchy. As evidenced by Bassek Ba Kobhio's cinematic masterpieces, there are alternative epistemologies that can obtain from registers other than the officially produced and politically motivated policies and practices of public education, with its emphasis on order, control, and cataloging knowledge. This is what leads Spivak to propose "the training of the imagination for epistemological performance of a different kind, called an aesthetic education when institutionalized" (2012, 345). An aesthetic education can therefore be defined as the process of cultivating critical sensibilities and imaginative capacities in order to more fully engage in the experience of being human on the planet, which is a fundamentally beautiful and awe-inspiring experience. Sony Labou Tansi's *La vie et demie* contains an implicit critique of logocentric rationalism through the imaginative stylistics that suggest how much more life can be had in the sometimes surreal, sometimes baroque, yet thoroughly Afrofuturist depictions of the planet: Tansi suggests different ways of engaging life's mysteries beyond the confines of a violent technocracy bent on destruction embodied by the providential guides. When the third incarnation of the protagonist "Chaïdana-aux-gros-cheveux" (Chaïdana with big hair)[5] agrees to marry the guide, Jean-Coeur-de-Père (John heart of a father), he inflicts on her "huit gifles intérieurs" (eight internal slaps) on the 322nd day of his reign, and after fifteen months she gives birth (1979, 128). As if to demonstrate the arbitrary nature of numbers—there are only two articles in this guide's newly drafted constitution, which gives him absolute power, and by contrast there are 228 holidays in the calendar year (128–29)—Tansi calls into question the foundational principles of mathematics and natural biology in order to allow for alternative conceptual spaces to open up. These spaces assume the form of poetic knowledge, embodied knowledge,

Conclusion

ancient indigenous mythology, as well as Afrofuturist technical advancement—all conceived through a planetary lens that reaches beyond the borders of Katamalanasie.

Artistic projects such as those discussed and analyzed in this book illustrate the nature of planetary education, which Spivak describes: "This is where educating into the planetary imperative—assuming and thus effacing an absolute and discontinuous alterity comfortable with an inexhaustible diversity of epistemes—takes its place" (2012, 346). The diversity of epistemes that Spivak alludes to here consists of the multiple forms of knowledge and wisdom that have sustained societies through millennia. These knowledge forms afford opportunities for enhancing relationships with the planetary other through various agricultural and horticultural practices, as well as reinvigorating relationships with ourselves through cultural and developmental processes such as storytelling, rituals, and ceremonies to mark the passage of time and open dialogues about how to progress, understood as an inherently cyclical dynamic. As such, Spivak proposes that "planet-thought opens up to embrace an inexhaustible taxonomy of such names including but not identical with animism as well as the spectral white mythology of post-rational science" (2012, 339). By embracing multiple modes of understanding and relating to one's planetary being, the vast field of scientific disciplines becomes greatly enriched and expanded. No longer bound by the limitations of observable and reproducible facts, planetary being allows for iteration and experimentation in the constant production and reproduction of new or recycled facts that are not immutable but adaptable to specific social and human ends. For, as Sarr proposes, "The intelligence of a civilization resides in its capacity to form a synthesis of the complementary worlds that offer themselves up to it so as to integrate them into a *telos*" (2019, 112–13).[6] The articulation of collective goals is fundamental to society, and the capacity to define and redefine those goals based on the exigencies of incorporating content from multiple worldviews that make up the existential plane is the hallmark of civilizational

intelligence. The error of colonial and postcolonial educational models has been in denigrating particular ways and means of knowing and acknowledging the validity of experience in favor of an absolute standardization of knowledge for a centralized and often alienating directive issued from outside of a community itself.

The same basic mathematical and scientific principles that undergird educational dynamics are also at the core of the particular economic discourse that structures societal engagements and interactions. Engaging with an alien education system or an alien economic system constitutes a common representational trope in Afrofuturist imaginings. While the films of Fadika Kramo-Lanciné or Imunga Ivanga are couched in the sociocultural context of late twentieth-century global capitalism, their engagement with questions of wealth and power and private property through the trope of the lottery is particularly revelatory. First of all, the juxtaposition of decadence and poverty that the lottery embodies serves to exacerbate social inequalities while undermining the specific relational economies that are the fundamental processes governing the parameters of material exchanges. Secondly, the lottery's function as an artificial influx of unmerited, unregulated capital reflects a fundamental problem in international development, namely the debt-aid cycle that reinforces dependency and sabotages efforts to create endogenous and sustainable economic practices. The alien world of capital finance, with its inexhaustible quantifications that spiral into ever-expanding numbers, becomes increasingly disconnected from any practical economic implications for human subjects. If a scientific discourse, like the one that inscribes global economic activity, operates in a fashion that obfuscates reality (rather than clarifying it), this invites reflection on the need to alter that discourse to make it more responsive to the integral needs of population groups. Sarr notes that "infinite economic growth within a finite world is a myth" (2019, 117).[7] And yet, the current model has not been subject to recalibration. Imagining alternative forms of value production based on social

Conclusion

benefit or ecological responsibility are just two of the potentially myriad suggestions that an Afrofuturist framework can conjure into being.

The consequences of unbridled consumerism have had a devastating environmental impact, which has only been exacerbated in recent times; this is why Tansi's ecofeminine criticism proves so valuable. It would seem naive, if not utterly contradictory, to presume that the same positivist scientific discourse that precipitated the human and ecological crises of the twenty-first century would suddenly and without alteration prescribe viable solutions to those crises. The postcolonial condition necessitates the generation of new forms of knowledge that defy the destructive logics of ecological catastrophe. One can perceive an illustration of this attitude persisting in the work of another Congolese novelist, In Koli Jean Bofane, whose work *Congo Inc.* recounts the psychic alienation of a Pygmy youth named Isookanga, who wants nothing more than to abandon the forest of his ancestors and engage fully in the practice of globalization, which he understands only through playing an online video game called *Raging Trade* (2014, 18). He has in effect become entrenched in the virtual narrative of globalization, which operates through the fabrication of exchange value based on environmental and human exploitation. When asked about certain "technologies ancéstrales" (ancestral technologies) related to the secrets of the equatorial forest by a former rebel commander (now in charge of administering the Salonga National Park), his reply illustrates the conflicting priorities between the overall planetary well-being of his ancestral homeland and the win-at-all-costs economic globalization seen through the virtual realm of his online *Raging Trade* interactions: "Man, if I could help you get rid of all those trees, I would do it. Even I have not been taught how to break that ecosystem. I was initiated as a future chief, but my instruction was not complete. If at least they had taught me to find oil, diamonds, or cassiterite (tin-oxide), then I would have felt like a real powerful potentate turned toward the future" (177).[8] Aside from the obvious corruption involved in the extraction of

resources from a supposedly protected national park, his response reveals not only a disregard for the natural environment—where trees are seen as obstacles to progress—but also an internalized depreciation of his ancestors and their deeply embedded historical knowledge of being within their forest home for generations. Drawn by the allure that invites youth to pursue emigration or win the lottery, Isookanga has been indoctrinated by a system that is fundamentally antihuman, a system that values only what can be quantified and exchanged and converted into profit. At the end of the novel, after Isookanga's exploits in the nefarious world of globalization, he has internalized the inhuman logic of economism: "It becomes imperious to balance the accounts by first pushing aside, through losses and profits, the human" (289).[9] This transformation in consciousness reveals the ecolinguistic biases of a society steeped in the languages and logics of a culture of profit against a culture of peace.[10]

Again, the question of linguistic and cultural contingency of the reality that one ascribes to appears central, and the ecoliterate language of Afrofuturist writers and thinkers proposes novel dimensions to explore the conceptual spaces of alternate historical universes, future projections, and the remnants of ancient traditions. René Maran's (1988) novel, *Batouala*, marks a pivotal moment in French literary history. Originally published in 1921, and generally considered to be the first novel written by a Black Frenchman, *Batouala* embodies the ambiguities of the colonial paradigm in which the Antillean administrator serves as an intermediary between colonizer and colonized, sharing particular affinities with both sides. Reading the ambiguities of Maran's text, which vacillates between cultural anthropology, aesthetic exoticism, societal critique, and engaged ethnography, one becomes acutely aware of the dialogic cultural relation taking place. One particularly interesting example stems from the distinction often made between science and magic. Marna writes, "'doctorro'—that's the name that whites give to the one who, in their country is in the magic business" (31). The implication is that a cultural and linguistic divide is all that

Conclusion

separates the former from the latter, since their societal function is determined to be roughly equivalent. His text seems to suggest that the attribution of value to the work of a doctor versus the primitivist dismissal of a magician's practice is merely a question of cultural dominance. He writes later on toward the end of the novel: "The whites have their doctors; the blacks their sorcerers. Rest assured that they are alike and that the latter are worth as much as the former. There are good doctors and bad sorcerers. There are good sorcerers and bad doctors" (145). Maran's text negotiates the subtleties of intercultural exchange in a way that elucidates the arbitrary nature of established systems of symbolic value.

As a final example of the essential function of language in the establishment or subversion of dominant orders in society, Algerian writer Boualem Sansal's (2015) dystopic novel, *2084, La fin du monde*, stages these problems in a parodic rendering of George Orwell's totalitarian, futurist hellscape, which takes place under the authoritarian theocracy of Abistan.[11] From their seat of government located within an enormous pyramid, the agents of Abigouv direct the country, scrupulously enforcing the sacred book of Gkabul and the laws transmitted to Abi, the faithful servant of Yölah. The populace of this country, consisting of inhuman, docile, zombie-like beings, lives in terror of the incessant surveillance of the "Apparatus." This text depicts the extreme end of social engineering, where human beings regress to "shameful manifestations of human mechanics," where "everything was well regulated and finely filtered, nothing could happen without the expressed will of the Apparatus."[12] Sansal describes the constant business of the regulated lives of the citizenry as a procession of life-simulating processes, the ultimate purpose of which remains forever hidden: "The system, overflowing with restrictions and interdictions, propaganda, preaching, cultural obligations, the rapid succession of ceremonies, personal initiatives to undertake that would count toward ranking and earning privileges, all added together, this had created a particular mindset among the Abistani, perpetually busying about in service of a cause about which they

did not understand a single letter" (29).[13] In such a state of meaninglessness, "History does not exist,"[14] and "la Guerre sainte," or perpetual Holy War, holds the same objective as the "périlleux pèlerinages" (perilous pilgrimages): that of "transforming useless and miserable believers into glorious and profitable martyrs" (29).[15] In this context of total repression, an economy of death dictated by an irreproachable and omnipotent autocrat, the protagonist Ati awakens and begins to wonder what might exist beyond these prescribed limitations.

Despite what the fanatical religious rhetoric of the Abistani Apparatus might imply, Sansal's unique take on Orwell's Big Brother implicitly incites a critique of any absolutist discourse—be it political, economic, social, or even cultural—which demands total adherence to a specific set of principles that require a particular series of actions, without being able to question the rationale behind the principles. The fundamental mechanism by which such systems function is through the control of symbolic language. In Orwell's novel, it is "newspeak," and for Sansal, it is "Abilang, which at its artificial conception was a militaristic language, designed to inculcate rigidity, contrition, obedience, and the love of death" (29).[16] As was the case for Giambatista Viko, and also in Mélédouman's plight in *La carte d'identité*, surpassing the limitations of an imposed dominant discourse often involves an innovation in thought-language, which can bring about a change in one's perception. Thus, when Ati befriends a former professor of Abilang named Koa, and together they discover these ghettos that shelter a latent resistance led by a figure referred to as Balis, the linguistic ingenuity of liberation is foregrounded. In contrast to the senseless frenzy of social existence as dictated by the Apparatus, Ati and Koa discover some liminal zones that are resistant to its authoritarian gaze, namely: "the devastated suburbs where a small amount of impoverished liberty still reigned, too little to be effective, but one needs very much to avail oneself against the secrets on which unshakable empires are founded" (119).[17] In these marginal and excluded zones of defiance, words prove the ultimate

Conclusion

power in furthering the cause of freedom, as one hears the rebel slogan *Mort à Bigaye* (Death to Bigaye). Bigaye (pronounced "big eye") is the name given to Abi and his system by those who tacitly oppose it. The expression "Abi = Bia," the term for a plague-bearing rodent, functions similarly to *verlan*, the language of the French banlieues, characterized by words formed from the reversal of their usual syllabic order (132–33). Their encounter with the last remaining dregs of a humanity that has nearly been lost to the homogenizing activities of the Abistani Apparatus reveals new alternative modes of communication and knowledge production.

Ati longs to fully experience the freedom that he can only glimpse lurking in the shadows of seedy ghettos. He begins asking himself: "What is the frontier, good grief, what is there on the other side?" (45).[18] After a lengthy search undertaken with his friend Koa, who mysteriously disappears along the way, Ati—like many wayward wanderers who stray too far—eventually concludes that "this life in this world is finished for me, I want, I hope to begin another on the other side" (313).[19] This epiphany occurs after Toz's reassurances of the Frontier's nonexistence: "There is only Abistan on this earth" (Sansal 310).[20] Here one clearly sees the functionality of the Apparatus, admitting only the existence of the reality which it constantly creates using its control of methods of communication. Just as there is no vocabulary other than Abilang, there is no land other than Abistan: nothing to say and nowhere to go except for within the Apparatus itself. In terms of Derrida's theory of the archive, which implies that one can only decipher the future from an anterior glance after that future has had a chance at actualization, Ati finds himself faced with humanity's archive in Toz's museum of nostalgia. Here Toz reveals that he has preserved an array of twentieth-century artifacts, which shed light upon the forgotten habits and practices of bygone days. Toz has objects and furnishings of a lifestyle that no one recognizes anymore—images imbued with the secrets of yesteryear. The closest that Ati ever comes to the coveted experience of human freedom outside of the oppressive Abistani dictatorship is his tour of Toz's museum of

nostalgia, which allows him to postulate the essential question: "Who were we? . . . The Gkabul having colonized the present for everyone for all the centuries to come, it's in the past, before its inception that one could escape it" (300–301).[21] Suggesting that humanity's meaning can only be understood in the past tense, this is the archival experience par excellence: the experience of being in time, grappling with the present predicament and future uncertainties through inevitable repeated returns to past memories from which to project one's hopes for the future.

In conclusion, the expressive forms of Afrofuturist thought in Francophone fiction contain within themselves the seeds for creating alternative future societies unbounded by the logics of linguistic or cultural imperialism that have since colonialism assumed numerous and varied forms, including the logic of humanitarian reason. Imagining the universe in its totality and one's individual existence in its planetarity, it becomes possible to transcend the imposed limits that attempt to distinguish between victims and perpetrators, inclusion and exclusion, and human and inhuman by hierarchizing the matter of human experiences according to multiple constructs of identity politics. In opening up spaces for orature within the literary and cinematic fields, African artists can suggest pluriform alternatives to these binary logics that dictate the functioning of political, economic, educational, and environmental practices. An Afrofuturist imaginary is animated by the spiritual and scientific forces that constitute the relational frameworks for existence from a transtemporal and cosmic perspective. In decentering dominant discursive modalities through creative literary interventions, artists can imagine new ways of understanding the common human condition that has been obscured by divisive discourses that seek to remove the human as a factor in civilization. Almost like an extraterrestrial invasive force, civilization seems to proceed according to its own singular economic directives, following a predetermined course toward ecological and cultural catastrophe. However, recognizing that this is the result of human constructions and not divinely ordained and immutable

Conclusion

systems, one can then begin to deconstruct its science fictions that have come to be taken as fact in order to reconstruct new science fictions that respond more readily to the needs of humanity and its rich and diverse cultural environments. This process of deterritorialization and reterritorialization takes place on multiple levels through the poetic language of reflection that holds up a magic mirror to society, through which one not only perceives the inverted image but also perhaps the new images of potential future societies lurking just beyond the looking glass, waiting to be articulated in order to enter into the ever-expanding and constantly evolving project of the real, which is always and already a product of human imagination.

Notes

Introduction

1. "En ces temps de crise de sens d'une civilisation technicienne, offrir une perspective différente de la vie sociale, émanant d'autres univers mythologiques et empruntant au rêve commun de vie, d'équilibre, d'harmonie, de sens"; I have included the original French quotes from Sarr 2016 throughout.

2. "On attend toujours aujourd'hui ces propositions pour une Afrique qui devrait soit rejoindre le monde, soit proposer une alternative au monde"; unless otherwise noted, all translations from French are my own.

3. In a series of interviews conducted in 1985 with Swiss journalist Jean-Philippe Rapp titled "Dare to Invent the Future," revolutionary Burkinabe leader Thomas Sankara outlines his basic vision of social and economic policies for national self-sufficiency and equality for all citizens. Sankara states, "You cannot carry out fundamental change without a certain amount of madness. In this case, it comes from nonconformity, the courage to turn your back on the old formulas, the courage to invent the future" (1988, 144).

4. On inadequate health infrastructures, water scarcity, and socioeconomic conditions, see Okoi and Bwawa (2020).

5. Title of his talk given at Duke University on April 2, 2019.

6. "Le développement est l'une des expressions de l'entreprise occidentale d'extension de son épistémè dans le monde" (2016, 21).

7. "Les maîtres-mots que sont développement, émergence économique, croissance, lutte contre la pauvreté pour certains, sont ces concepts clefs de l'épistémè dominante de l'époque" (Sarr 2016, 13); "Key words such as *development, economic emergence, growth,* and *struggles against poverty* are, for some, the principal concepts of the dominant episteme of the era" (Sarr 2019, xiii).

8. "Cette perspective inversée de l'humain, qui consacre le primat de la quantité sur la qualité, de l'avoir sur l'être" (11).

9. "Leur biais quantophrénique: cette obsession de tout dénombrer, évaluer, quantifier, mettre en équations" (18).

10. See, for example, Moss (2011), or more recently, McMahon and Decker (2020).

11. This is the argument that Achille Mbembe proposes, writing: "The colony is not external to democracy and is not necessarily located outside its walls. Democracy bears the colony within it, just as colonialism bears democracy, often in the guise of a mask" (2019, 27).

12. See, for example, Stibbe (2015).

13. See McBride et al. (2013, 67).

14. For example, the anthology edited by Ivor Hartmann, *AfroSF: Science Fiction by African Writers* (n.p.: A StoryTime Publication, 2012).

15. Nnedi Okorafor, "Africanfuturism Defined," *Nnedi's Wahala Zone Blog*, October 19, 2019, http://nnedi.blogspot.com/2019/10/africanfuturism -defined.html.

16. The Latin root *scientia* literally translates as "experience" in English. Also, the word *expérience* in French means both "experience" and "experiment."

17. Beyala states, "Life in the bidonville [I would also add banlieue] denies the present because one lives on hope. Everyone thinks that they're in transit to a better tomorrow. . . . So you conjugate verbs in the future tense. And it's in that space between the present and the future that lunatic writing develops" (Beyala qtd. in Jules-Rosette 1998, 204–5).

18. "Donne-moi la main, et désormais tu seras moi . . . mon histoire naîtra dans tes veines."

19. One can cite, for example, this significant passage of *Tu t'appelleras Tanga*: "J'irai trouver la folle. Je fermerai mon parapluie sous la pluie et l'ouvrirai dans le désert. J'irai trouver l'enfant verrouillé dans l'innocence. Il voyagera dans ma mémoire" (Beyala 1988, 9; I will go to find the crazy woman. I will close my umbrella in the rain and open it in the desert. I will go to find the child locked in innocence. He will travel in my memory).

20. The notion of inegalitarian economic systems will be further analyzed in the sixth chapter of this book, which analyzes the mechanisms of neoliberal global capitalist exploitation through the trope of the lottery in African films.

21. "Mais on s'accroche à la guerre. La guerre c'est notre tic. Avant quand c'était la guerre de la paix, on se battait comme des hommes; maintenant qu'on est entré dans la guerre pour la guerre, on se bat comme des bêtes sauvages. On se bat comme des choses." This dehumanization in the postcolonial context can be directly related to the way in which, in his *Discourse on Colonialism*, Aimé Césaire describes colonialism as "thingification."

22. Tansi's novel will be discussed further in chapter 7, which outlines an ecofeminine criticism against the shamefulness of state politics.

Notes to Pages 14–20 265

23. In this regard, see Diop (1954), in which he extolls the historic virtues of Black civilizations.

24. "L'auteur de *Aux Etats-Unis d'Afrique* nous présente une histoire (un énoncé) où l'Afrique émerge comme le lieu légitime et aisé de l'énoncé. En plaçant cette histoire fabuleuse comme une inversion des rapports réels d'autorité, l'auteur dépasse l'ironie pessimiste . . . pour suggérer la contingence non seulement des 'faits', mais aussi de l'enjeu du pouvoir dans l'acte de l'énonciation qui résulte de ces faits."

25. "Ne savent-ils pas qu'ils doivent leur santé et leur prospérité aux silhouettes grises habillées de loques qui traversent la Méditerranée pour se vendre aux industiels du Transvaal ou à la marine marchande de Nouakchott?"

26. These disjointed economic strategies are the primary subject of analysis in the sixth chapter of this book, which is on the lottery.

27. This notion is explored further in the context of the economy in chapter 6.

28. "Ce sont les autres qui sont la prevue de notre existence."

29. "Je suis car nous sommes" (96).

30. "L'école africaine était adaptée à la société africaine."

31. "C'est pour le bien futur de l'Afrique."

32. "Si nous enterrons nos langues, dans le même cercueil, nous enfouissons à jamais nos valeurs culturelles."

33. "Purée de caca et de boue noire."

34. There is a very interesting juxtaposition in the text through the image of the bulldozer intent on destroying the world under the guise of purported progress. Mélédouman laments: "Cette belle harmonie de la nature et des hommes, cette belle harmonie va être enterrée sous les dents monstrueuses de la monstrueuse machine" (Adiaffi 102; This beautiful harmony between nature and humans, this beautiful harmony will be interred beneath the monstrous teeth of the monstrous machine). At the end of the chapter, Mélédouman, in desiring to be what he is, embodies this harmony between the natural and the human through the image of a tree in all its parts: roots, sap, and the tree itself. Mélédouman desires to be his own roots, his own sap, his own tree (116). I will further elaborate on the notion of the ecocritical in chapter 7.

35. According to Wright, "Certain African-centered advances in the fields of development studies, reappraisals of the place of indigenous African education, and literature studies re-conceptualized as cultural studies can, in combination, create a discursive environment in which it is possible for literature studies as cultural studies to contribute significantly to the development process in Africa" (131).

36. Ewout Frankema and Marlous van Waijenburg (2018) theorize about the emergence of regional, labor-intensive, industrialized economic developments in Africa, noting that the likelihood of eradicating poverty through

such developments over the next decade is minimal at best. They make it clear that the "development" issues facing the African continent are indeed systemic.

37. To this point, Rodney points out: "Uneven development has always insured that societies have come into contact when they were at different levels—for example, one that was communal and one that was capitalist" (2011, 11).

38. In addition to these works and Nkrumah (1966), one of the most significant texts was published by the Surrealist Group in Paris in 1932, titled "Murderous Humanitarianism," critiquing the hypocrisy of colonialism, "snivelling capitalism," and what they term a "counterfeit liberalism" that allows for the exploitation and decimation of both human and environmental cultures (1970, 352).

39. See, for example, Rocheleau et al. (1996).

40. This notion is discussed in Barry and Grady (2019, 182–86).

41. I will be referring specifically to the chapter in Spivak (2012) entitled "Imperative to Reimagine the Planet," 335–50.

42. It is precisely this interplay of the political, the socioeconomic, and the aesthetic that leads Wright to propose the imperative that "literature studies in Africa must become part of African cultural studies" (2004, 136).

Chapter 1: Afrofuturist Ecolinguistics

1. "La légitimité de la démarche qui consiste à tenter de saisir le reel africain par cet outil que l'on nomme la *science* ne fut pas interrogée.... D'autres manières d'appréhender celui-ci existent, les savoirs occidentaux ne les épuisent pas toutes."

2. This is not dissimilar to the methodological approach that I employed in my doctoral dissertation, which analyzed a baroque aesthetic in African fictions, an art historical concept to be applied in an effort to explicate the cultural and political upheavals that African writers were encoding in their fictions during the late twentieth century.

3. Building on Keto's work and that of thinkers such as Archi Mafeje and Molefe Kete Asante, Nontyatyambo Dastile (2013) argues that for African writers, intellectuals, and purveyors of African thought to play a larger role in "knowledge generation that is responsive to human needs and existential problems" (93).

4. "La multiplicité des scansions des philosophies africaines."

5. The *"incompossible"* worlds of Gilles Deleuze incorporate all possible worlds that inherently contradict one another (the sky is blue, or it may well be red) and are thus incapable of occupying the same spatial-temporal plane, hence their "incompossibility."

Notes to Pages 32–36

6. "De ce point de vue, l'outre-Monde est l'équivalent d'une zone hors l'humanité, hors de l'espace où s'exerce le droit des hommes."

7. See, for example, the text *The Empire Writes Back*, which draws its title from that of the second film of George Lucas's Star Wars trilogy. The introduction Mudimbe (1988) identifies numerous seminal works dating from the decades immediately following the Second World War, in which cultures, philosophies, and indigenous knowledge systems are reclaimed by African intellectuals, including Cheikh Anta Diop, J. B. Danquah, and Kagame, among others (170–71).

8. "L'avenir est ce lieu qui n'existe pas encore, mais que l'on configure dans un espace mental. Pour les sociétés, il doit faire l'objet d'une pensé prospective. Aussi œuvre-t-on dans le temps pour le faire advenir. L'Afrotopos, est l'atopos de l'Afrique: ce lieu non encore habité par cette Afrique qui vient" (2016, 133).

9. "Le refus de la cadence imposée de l'extérieur . . . prendre le temps de trier d'expérimenter, de cueillir soigneusement des fleurs provenant de différents jardins, d'en humer les fragrances et de construire sereinement son bouquet par son art de l'arrangement floral" (45).

10. This notion of cultural intermixing in Francophone novels will be further examined in chapter 1 on métissage dedicated to the works of Ousmane Socé, Mariama Bâ, Véronique Tadjo, Werewere Liking, Ken Bugul, Gaël Faye, Cheikh Hamidou Kane, and many others.

11. This pluralization implicitly references Henri Lopes's novel *Chercheurs d'Afriques*.

12. "Investir la science, en commençant par les sciences humaines et sociales, et de saisir les tensions, de réanalyser pour notre compte les appuis contingents et les lieux d'énonciation, de savoir" (qtd. in Sarr 2016, 102).

13. "*Un discours scientifique qui serait l'émanation de la vie matérielle de leurs contextes sociopolitiques*" (2016, 105).

14. "En effet, si l'on considère la science non dans sa méthode, mais dans ses résultats, elle a dépassé l'imagination la plus folle du magicien; la science dans ses résultats est plus magique que la magie: une magie qui prouve, une magie à preuves, voici la grande différence."

15. "La magie, nous dit Van der Leeuw, est une tentative de transformation de la nature en culture, ou, pour nous exprimer de façon moins moderne, c'est un effort visant à faire du monde donné un monde à soi, à dominer le monde. L'attitude magique est donc une condition essentielle à toute culture."

16. Here, I use the term "human" in quotation marks to suggest that this civilization may perhaps be less properly human than technocratic.

17. Working in a transnational hip-hop aesthetic, Rollefson draws his "Robot Voodoo Power" thesis from the musical works of Sun Ra,

268 Notes to Pages 36–38

Parliament-Funkadelic, and Kool Keith, explaining: "The tension produced by collapsing the fantasies/fallacies of black superstition and white science fiction one onto the other creates a powerful weapon with which to reflect the deformed irrationality of these visions back onto the rationalized 'universalist' society that created them" (104).

18. Mbembe defines Afrofuturism as such: "Afrofuturism attempts to rewrite this Negro experience of the world in terms of more or less continuous metamorphoses, of multiple inversions, of plasticity, including anatomical, and of corporeality, if required, machinic" (2019, 164).

19. Spivak cautions against a reductivist understanding of culture: "Otherwise, multiculturalist policy reduces itself to allowing unreasonable cultural practices as a sign of freedom, to the institutionalization of the interval between 'colonial' and 'pre-colonial' time, the negotiation of which ensured survival under imperialism proper" (340).

20. "Cette fécondation du roman par l'oralité."

21. "Un texte hétérogène."

22. "Je m'indigne et m'élève contre cette prétention de vouloir ériger aujourd'hui les mythes, les legends, les contes africains en discours scientifiques."

23. "Une pratique scientifique proprement africain."

24. "C'est alors qu'une certaine forme de rationalité s'installera bon gré mal gré. Dialectique du succès et de l'insuccès ou de l'échec de la maintenance à tout prix de telle ou telle coutume dégradante. Il se réalisera ce qu'on pourrait appeler 'une coupure épistémologique' qui fera voir aux Africains le réel avec un regard neuf; leur fera traiter le temps et l'espace—maîtres mots—de manière prospective. Travail souterrain, patient, de la taupe."

25. The experiences of (post)colonial Africa make plain the way of progression to a more equitable future where, to draw once more from Sarr's philosophy, "Elle [l'Afrique] doit surtout participer à l'œuvre d'édification de l'humanité en bâtissant une civilisation plus responsable, plus soucieuse de l'environnement, de l'équilibre entre les différents ordres, des générations à venir, du bien commun, de la dignité humaine: une civilisation poétique" (153). (Above all, Africa must participate in the work of the edification of humanity by building a more responsible civilization, one more concerned about the environment, about a harmony and balance between different orders, of the generations to come, of the common good, and of human dignity. Africa must once again become a poetic civilization [116].)

26. One may also consider Diop (1981), often described as "politique-fiction," in which a researcher in the year 2063 attempts to reconstruct the events of the previous century, including the 1968 Dakar demonstrations, a fictive popular uprising of May 24, 1998, which is followed by a socialist revolution in 2015 that seems to have established a new, free country supervised by a government devoted to transparency and fairness (60).

Notes to Pages 38–43

27. See the 2019 special issue of *Oeuvres & Critiques* "La science-fiction en langue française," edited by Paul Scott and Antje Ziethen.

28. This notion coincides with Spivak's (2012) conception of the notion of "planet-thought." Emphasizing hybridity and multiplicity, she writes: "Planet-thought opens up to embrace an inexhaustible taxonomy of such names including but not identical with animism as well as the spectral white mythology of post-rational science" (339).

29. "*La vie et demie* devient cette fable qui voit demain avec des yeux d'aujourd'hui."

30. While scholars have analyzed Sony Labou Tansi's literary work in terms of magical realism and even the baroque, stemming from transatlantic discourses of postcolonial Latin America, considering it as Afrofuturist science fiction affords the opportunity to once again critique the hegemonic discourse of Western science over non-Western magic and superstition.

31. In Blane Harvey's study "Development Cooperation and Learning from Power in Senegal," he calls for more-equitable practices in the cooperative spaces of development, allowing for "institutions and collectives in the South . . . to 'speak back' to the development process" (187). This illuminates the irony of contemporary agro-alimentary development practices in Senegal in that "farmers opting into organic agriculture find themselves essentially forced to re-learn more traditional approaches to their trade, now re-presented through the scientific/managerial technologies of formally-educated agricultural specialists" (194). See Harvey (2011, 187–205).

32. A handful of seminal works that are critical of contemporary humanitarian and developmental discourses in the context of globalization include Bonny Ibhawo's *Imperialism and Human Rights: Colonial Discourses of Rights and Liberties in African History* (2007), Slaughter (2007), Fassin (2012), Barnett's *Empire of Humanity: A History of Humanitarianism* (2011), and Joseph Stiglitz's *Globalization and Its Discontents* (2017).

33. Mbembe elaborates on this in terms of necropower, or "the subjugation of life to the power of death," stating that "in our contemporary world, weapons are deployed in the interest of maximally destroying persons and creating *death-worlds,* that is, new and unique forms of social existence in which vast populations are subjected to living conditions that confer upon them the status of the *living dead*" (2019, 92).

34. "C'est la vie . . . la carte d'identité c'est plus que la vie."

35. "Conflit de deux mondes, de deux puissances, de deux pouvoirs."

36. "La question n'est pas de croire ou de ne pas croire. MAIS DE RESPECT OU DE MÉPRIS."

37. "La culture de l'inégalité ne concerne pas que le domaine économique. Elle touche aussi à la configuration du champ perceptif. . . . Illusionnisme et prestidigitation appliqués à tout le champ social, de sorte à construire un

espace de vie en trompe-l'oeil, une réalité truquée dont les règles véritables ont été intentionnellement camouflées"; the author goes on to delineate some of the mechanisms of this social control, which include, among other things, "le marketing, le management, la robotique, le cognitivisme, la psychlogie sociale et behaviouriste (comportementale), la programmation neurologique (PNL), le storytelling, le Social Learning, le reality-building" (33; marketing, management, robotics, cognitivism, social and behavioral psychology, neurological programming, storytelling, social learning, and reality-building).

38. Emmanuel Dongala's short story "Jazz et vin de palme" (1982), one of the rare Francophone African works of science fiction in the traditional sense, depicts this very encounter when a race of blue aliens lands in the Congo basin and ultimately upsets the entire order of human civilization, eventually coming to terms with the earthlings through a shared experience of drinking palm wine and listening to the jazz records of John Coltrane.

39. "Une maison qui marche et qui fuit à l'horizon comme l'horizon."

40. "Les autres vivent-ils dans son monde qu'il pense réel et vivant, ou vivent-ils dans un autre monde qu'il ne sait plus baptiser, nommer?"

41. Sarr refers to this process as "se défaire de l'odeur persistante du père" (2016, 103; Ridding oneself of the lingering stench of the father [2019, 74]).

42. "Nous avons toujours soutenu durant notre lute que le mot développement est un mot piégé, un mot miné, un attrape-nigaud. Chaque peuple suit la logique interne de son développement."

43. "Oui, le développement est devenu un mythe vidé de son contenu historique. En son nom, on fait trop de choses qui n'ont avec lui qu'un rapport lointain: massacres, viols, vols, pillages, détournements de deniers publics, et les dictatures de tyranneaux, présidentelets minables! Non, ça suffit le camouflage!"

44. "[Une] économie relationnelle [qui] semble être le determinant le plus puissant des échanges et la charpente de l'économie matérielle."

45. "Semons le Nil future."

46. "Puisque j'inaugure un temps nouveau, un nouveau calendrier. Le calendrier de mon identité. Le temps sacré de ma mémoire. Le temps sacré de mon identité perdue, volée, violée, durant mon sommeil. Le long sommeil de l'oubli, le long sommeil mortel!"

47. "Ce faisant, vous introduisez de la subversion dans l'oralité et dans le discours occidental" (89).

48. In this context, "science" carries the epistemological connotation of "conscience" (i.e., knowledge). For more, see chapter 5 on education and alternative epistemologies.

49. For example, consider the stakes of the political fiction of Diop (*Le Temps de Tamango*) or Waberi (*Aux États-Unis d'Afrique*), the intertwining of

Notes to Pages 47–51

subjectivities of Beyala (*Tu t'appelleras Tanga*) or Liking (*Elle sera de jaspe et de corail*), or even the mystic universe of Jean-Marie Adiaffi (*La Carte d'identité*) or Tansi (*La vie et demie*). In each of these cases, elements of science fiction are visible in the fantastical qualities of the plot. The innovations of certain narrative forms, such as Liking's ritual theater or Adiaffi's "*n'zasa*" (genre without genre), are further fields of comparison.

50. "Je veux faire ce que fait le cinéma qui est à la fois un support et une sémantique pour nos utopies, je veux créer cet endroit dans lequel on pourra géographiquement situer cette société exemplaire."

Chapter 2: Birthing the Future

1. Unless otherwise noted, all translations from French are my own.

2. "Nous savons cependant qu'il n'existe pas de civilisation pure, qu'elles sont toutes hybrides. L'hybridité des civilisations n'est pas dérivée, elle est originelle" (Sarr 2016, 112).

3. In *Mille plateaux* (1979), Gilles Deleuze and Félix Guattari theorize the pervasive global reality of deterritorialization, in which identification becomes a constant iterative process of reterritorialization within a complex web of shifting relations and appurtenances.

4. In her introduction, "*Logiques métisses*: Cultural Appropriation and Postcolonial Representations," Lionnet proposes the following: "Understood as a dynamic model of relationality, I argue, métissage is 'universal' even if, in each specific context, power relations produce widely varying configurations, hierarchies, dissymmetries, and contradictions" (4). Furthermore, she writes: "Women writing in postcolonial contexts show us precisely how the subject is 'multiply organized' across cultural boundaries, since this subject speaks several different languages (male and female, colonial and indigenous, global and local, among others). The postcolonial subject thus becomes quite adept at braiding all the traditions at its disposal, using the fragments that constitute it in order to participate fully in a dynamic process of transformation" (5).

5. Lionnet provides the following example: "French is appropriated, made into a vehicle for expressing a hybrid, heteroglot universe. This creative act of 'taking possession' of language gives rise to the kind of linguistic métissage visible in many contemporary Francophone and Anglophone works" (13).

6. "L'Afrocontemporanéité est ce temps présent, ce continuum psychologique du vécu des Africains, incorporant son passé et gros de son futur, qu'il s'agit de penser" (2016, 40).

7. "Dans les mythes de fondation des régions, des villes, c'est souvent une femme qui détermine le choix de l'emplacement de la future cité, comme si la femme 'génitrice' des enfants de la société devait aussi donner vie à

leur environnement. . . . L'autorité de la femme au sein des systèmes de commandements africains est réelle et sa participation à l'action du gouvernement effective dans diverses sociétés."

8. See Succab-Goldman (1995).

9. See Disney (2009).

10. "Et si la femme africaine est symbole de vie, elle souhaite la vie à toutes les institutions importantes de la société moderne africaine."

11. "C'est en adoptant au départ une démarche de marginalisation de leurs personnages, d'exploration audacieuse de zones interdites, telles la sexualité, le désir, la passion, l'amour, mais aussi la relation mère-fille, la mise en question de la reproduction et de la maternité obligatoire comme consécration de la femme, qu'elles sont parvenues à s'inscrire au centre, s'assurant ainsi l'appropriation de zones de langage jusqu'ici considérées comme la prérogative des hommes."

12. "Toutefois, c'est la femme qui est porteuse du futur, elle est la condition qui fait naître."

13. Here I am invoking Gayatri Chakravorty Spivak's notion of the subaltern, particularly with regard to semiotic or textual insurrection, which takes the place of the utterance and marks the subaltern point of view: "When we come to the concomitant question of the consciousness of the subaltern, the notion of what the work cannot say becomes important. In the semioses of the social text, elaborations of insurgency stand in the place of 'the utterance'" (28). Accordingly, the thematic, stylistic, and rhetorical choices of the authors that I study here, their "insurrections," do reveal a kind of métisse logic (Cazenave) in what is said, but also in what is perhaps merely implied or suggested.

14. "Les écrivains femmes ont amorcé le développement d'un nouveau roman politique, plus visionnaire dans la qualité du message délivré, porteur potentiel de changements prometteurs."

15. "Refus de l'assimilation à la race blanche."

16. "L'angoisse liée à la narration de l'identité métisse."

17. One can also cite the example of George Ngal's novel, *Giambatista Viko ou le viol du discours africain,* for the ways in which his textual innovations create a kind of métis or hybrid text that negotiates the ambiguous spaces between orality and textuality.

18. "Personnifie 'le problème métis.'"

19. "Les details qui [lui] différencient des autres gamins du village ne sont pas des signes de malediction mais la marque du sacré."

20. I analyze elsewhere the identity politics in Oyono's *Une vie de boy* and Laye's *L'enfant noir.* See Joslin, "Baroque and Post/colonial Sub-Saharan Francophone Africa: The Aesthetic Embodiment of Unreason" (PhD diss., University of Minnesota, 2010), 141–55.

Notes to Pages 54–57

21. See the opening chapter of Frantz Fanon's *Les damnés de la terre*, in which he outlines the particularities of this kind of geographical violence.

22. "Une voie entre négritude et race blanche."

23. The concept is theorized by Martin Deming Lewis in his article, "One Hundred Million Frenchmen: The 'Assimilation' Theory in French Colonial Policy," *Comparative Studies in Society and History* 4, no. 2 (January 1962): 129–53.

24. See Joseph Paré's analysis of Ngal's novel in terms of its "métadiscursivisation," namely the novel's attempt at elaborating new aesthetic forms that yield a pluralist and heterogenous, interactive textual experience (1997, 121–26). See also, my article on Ken Bugul's innovative writing style: Joslin, "L'écriture Ken Bugul: Pour un 'genre' de roman cinématographique africain," *Nouvelles Études Francophones* 28, no. 1 (Spring 2014): 162–75.

25. "Se guérir du mal qui l'étouffe et l'affaiblit."

26. "*Le métis sera l'homme de l'avenir.*"

27. The second chapter of Miller's book, titled "Hallucinations of France and Africa," examines this issue, proposing that "*métissage* is thus compromised by two kinds of problems: one is the political inequality governing relations; the other is the fog of illusions within which exchanges take place" (88), and further on, "What Ousmane Socé critiques are the terms of inequality and the delusions that can ruin a project of *métissage*" (89). The notion of the "incompossible" to which I refer appears in Deleuze's *Le Pli* (Paris: Éditions de minuit, 1988), 79.

28. The French-language portmanteau *Françafrique* is also used to describe this union. With regard to the linguistic, cultural, and political implications, see my interview with Boubacar Boris Diop, "Le marriage de l'Afrique avec Molière a été un échec total," Africultures.com, 2014.

29. "Assimilation critique, active et réciproque."

30. Through the use of this French portmanteau: *femme* (woman) + *féministe* (feminist), I am alluding to the domain of "womanist" theory, which differentiates itself from feminist theory in that it accounts for the particularities of female life in Third World countries. Clenora Hudson-Weems popularized this term in the 1980s and since then, there have appeared several critical studies on the subject, including Mary Ebun Modupe Kolawole's *Womanism and African Consciousness* (1997) and Chandra Talpade Mohanty's *Feminism without Borders* (2003).

31. In her essay "Urban Spaces, Women's Places," Obioma Nnaemeka discusses the thematic similarity between Bâ's first novel, *Une si longue lettre*, and her second, *Un chant écarlate*, which is visible, she writes, in the nature of polygamy's negative influence in modern African societies—what she calls a sign of "hémorragie culturelle" (1997, 187; cultural hemorrhage). When Ousmane takes a second wife without consulting his first wife, and

when he unequally manages the two relationships, he behaves contrary to both Senegalese tradition and Islamic law.

32. "Lamine était un homme ouvert [qui] épousait la manière de vivre des Occidentaux [et] continuait plus allègrement à tourner le dos à certaines exigences sociales qui n'avaient pas à ses yeux de signification essentielle."

33. "La vie conjugale est plutôt humaine approche et tolérance"; "C'est la sagesse africaine qui le conseille."

34. This is not dissimilar to the practice of modern polygamy which, in the words of Nnaemeka, benefits only men (186).

35. See Fanon (2012), in particular the section entitled "Mésaventures de la conscience nationale," in which he writes: "La conscience nationale au lieu d'être la cristallisation coordonnée des aspirations les plus intimes de l'ensemble du people, au lieu d'être le produit immédiat le plus palpable de la mobilisation populaire, ne sera en tout état de cause qu'une forme sans contenu, fragile, grossière" (145; National consciousness, rather than the coordinated crystallization of the most intimate aspirations of the whole of the populace, rather than the immediate and most palpable product of popular mobilizations, will be for all intents and purposes nothing more than an empty form, fragile, and vulgar).

36. "Ousmane Guèye se moquait visiblement des efforts d'adaptation de son épouse."

37. "Tu essaies de donner à l'esclavage de tes sens un contenu culturel."

38. "L'Africain s'était imposé et faisait valoir ses origines."

39. "Son cœur et son corps ne contenaient plus qu'Ousmane. Et Ousmane n'avait rien voulu sacrifier. Mieux, il se débarrassait d'elle, chaque jour un peu plus."

40. "Placé à la lisière de deux mondes appelés à ne jamais se confondre."

41. Wolof phrase meaning "neither dark nor light," referring to the mixed-race child.

42. "[Il] n'a pas de place dans ce monde. Monde de salauds! Monde de menteurs!"

43. This notion is implied by the authors of *Gouverner par le chaos: Ingénierie sociale et mondialisation*, in which they describe a symbolic society of spectacle, which exercises: "un contrôle social reposant sur la programmation comportementale des masses au moyen de la manipulation des émotions et la contrainte physique" (29; a social control resting upon a behavioral programming of the masses by means of emotional manipulations and physical constraints).

44. See E. Nicole Meyer's (1999) "Silencing the Noise, Voicing the Self: Ken Bugul's Textual Journey Towards Embodiment" (197).

45. See Fanon's (1952) theorization of the White-man/Black-woman relationship.

Notes to Pages 61–63 275

46. "Je détestai Louis jusqu'à la nausée."

47. "Je le détestais jusqu'à sa peau, cette peau qui me fascinait là-bas dans le village."

48. See Walker's essay (1999, 176) on Bugul titled "Blossoming of the Undefined Self" in *Countermodernism*. Achille Mbembe also notes with regard to the concept of race: "sa capacité de produire sans cesse des objets schizophréniques" (2013, 57; its capacity to constantly produce schizophrenic objects).

49. In fact, she wins "tous les grands prix" (137; all the big awards) at school, thus receiving the scholarship, which enables her travel to Belgium.

50. "Génération façonnée par l'école française [qui] entra dans la solitude, face à la famille traditionnelle."

51. "Ce que je représentais pour les autres, et ce que je ressentais en moi, c'était comme le jour et la nuit"; "au village je passais pour une 'toubab.'"

52. "Deux réalités . . . contraditcoire[s]."

53. "Imitation néo-coloniale [qui] fauchait 'l'élite' comme une mangue verte cueillie avec sa sève encore âpre."

54. She describes this emotion: "Ah que je fus longtemps mal et seule dans ma peau!" (163; Ah, long was I unhappy and alone in my skin!).

55. "Oui, j'étais une Noire, une étrangère."

56. Gaël Faye (2013) employs the image of a confluence in the refrain of his song "Métis," which proceeds: "Quand deux fleuves se rencontrent ils n'en forment plus qu'un et par fusion nos cultures deviennent indistinctes; elles s'imbriquent et s'encastrent pour ne former qu'un bloc d'humanité debout sur un socle." (When two rivers merge, they form only one, and through fusion our cultures become indistinct; they interweave and overlay to form just one bloc of humanity upright on a pedestal.)

57. "Moi qui n'avais jamais connu de milieu, de famille, issue d'une génération condamnée, moi qui n'avais aucun repère, comment pourrais-je m'aliéner? Or l'ambiguïté *établie*, *l'impossibilité* de l'aliénation en était peut-être déjà une."

58. "J'avais travesti la conscience." Daouda Loum (2008) brings up a similar case of Abdoulaye Sadji's protagonist, Nini, mulâtresse du Sénégal, who performs her métis identity in conflicting ways, which is the result of her self-projection into the collective unconscious mythology of Black inferiority: "Nini a une double personnalité. Son comportement varie suivant qu'elle est en face d'un Européen ou d'un Sénégalais" (89; Nini has a double personality. Her behavior changes based on whether she is facing a European or a Senegalese person).

59. The author's pseudonym, Ken Bugul, is a Wolof phrase meaning "nobody wants." Keith Walker emphasizes the optimism in the potential vanquishing of cultural schizophrenia, because this will allow the individual to

276 Notes to Pages 64–68

participate deliberately and subjectively in both of the worlds that they occupy (1995, 195). One must ask ourselves if the two métis children could have escaped this lamentable outcome if they had experienced a life in such a Manichean society.

60. "Des démons qui s'étaient assis sur leur ventre quand elle avait huit ans et Sony cinq."

61. "'Accablé, submergé d'inutiles et mortifiantes femelles pas même jolies,' se disait tranquillement Norah en pensant à elle-même et à sa sœur qui avaient toujours eu, pour leur père, le défaut rédhibitoire d'être trop typées, c'est-à-dire de lui rassembler davantage qu'à leur mère, témoignant ainsi fâcheusement de l'inanité de son mariage avec une Française—car, cette histoire, qu'aurait-elle pu lui apporter de bon sinon des enfants presque blancs et des fils de bonne facture?"

62. "Méprisant . . . sa propre fille et tout l'Occident avachi et féminisé."

63. "Un étranger au front blanc . . . à la mèche blonde."

64. The graphic novel, *Tintin au Congo*, by the Belgian cartoonist Hergé, was released serially from May 1930 until June 1931 in the newspaper *Le Vingtième Siècle*. It is often subject to critique for the ways in which it reinforces colonialist mentalities and racist attitudes with respect to the African continent and its peoples.

65. "Bon petit dieu de Mama, père compatissant . . ."

66. "Mon Dieu, brave petit père, bon et brave petit dieu de maman."

67. "Cette certitude qu'il l'avait trompée en l'attirant ici."

68. "Tu peux retourner d'où tu viens."

69. "Et, à son exemple, l'enfant habitait la maison en petit esprit indécis, effleurant le carrelage de ses pieds légers, semblant même parfois flotter au-dessus du sol comme s'il redoutait le contact avec la maison de son père."

70. "L'enfant avait peur de Rudy et Rudy aussi, en un sens, avait peur de l'enfant, car l'enfant, son propre fils, ne l'aimait pas, même si, en son jeune cœur, il l'ignorait, et il n'aimait pas sa maison, la maison de son père."

71. "Il démarra, roula jusqu'à sortir du village. Il se gara sur un chemin de terre entre deux champs de maïs et, sans même descendre de voiture, se mit à dévorer le pain et le jambon, mordant alternativement dans l'un et dans l'autre."

72. "*La pensée du métissage*, de la valeur tremblante non pas seulement des métissages culturels mais, plus avant, des cultures de métissage, qui nous préservent peut-être des limites ou des intolérances qui nous guettent, et nous ouvriront de nouveaux espaces de relation."

73. In this story, a race of blue aliens descends upon the cities of Brazzaville and Kinshasa, eventually expanding their presence as far as Tenkodogo and Timbuktu. In this time of crisis, the world comes together in unity around drinking palm wine and listening to jazz music—particularly

Notes to Pages 68–72

John Coltrane's saxophone playing—which causes the disappearance of the aliens, bringing peace to all humanity (Dongala 1982, 116–25).

74. One might read this allegory also as a premonition of the xenophobia and of the refractory concept of "Ivorian-ness" that influenced the events of the violent conflict in Côte d'Ivoire during the past decade, in which a generical division (based on political, economic, ethnic, and religious factors, among others) grew up among the differing populations in the north and south of the country. Rather prophetically, Karim's two proposed solutions, "ou le royaume se régénère ou il brûle" (58–59; either the kingdom regenerates itself or it burns), seem to have predicted this imminent catastrophe ready to burst under the pressure of long-standing inequalities.

75. "Ces bêtes se multipliaient à un rythme incontrôlé. Elles colonisaient ainsi tous les arbres de la ville et chassaient les moineaux qui fuyaient petit à petit vers le Nord."

76. "[Ils] étaient les seuls à parcourir la ville à pied, [ils] toussaient, crachaient étouffaient."

77. "De fuir les taudis, de tout laisser derrière eux pour aller vivre parmi les Aveugles."

78. "Royaume où ne régneraient ni palais ni taudis." The problem of social inequality represents a theme (if more lightly present in this case) of Marguerite Abouet's graphic novel *Aya* (2007), in which the young girl Adjoua, a member of a working-class family residing in Yopougon, becomes pregnant with the child of Moussa, the son of the CEO of the Solibra company. In the story that follows, the couple's resultant marriage represents just as much of a success for Adjoua as it represents a failure for Moussa's family.

79. "Le fils de la poussière et du sol rouge, le protégé des génies du vent sec."

80. "Que l'expérience du palais."

81. "Un regard perçant et une raison lucide."

82. "Karim avait planté la vie en elle. De cette vie naîtrait peut-être l'espoir" (136; Karim had planted life in her. From this life, maybe, hope would be born).

83. "Entre les quatre murs de sa prison dorée."

84. Irène d'Almeida (1996) notes Liking's ability to bring stereotypes of negritude into play in her writing. Liking's approach is ambiguous, utilizing the physical and psychological traits of each character, including their masculine virility and their rationality (271).

85. "Éternelle Mère [qui] Manifeste encore ici et maintenant / La prochaine humanité."

86. "Pour un nouveau langage. . . . Une Race au nouveau souffle de vie de parole de Verbe."

87. In addition to the works of George Ngal, Ken Bugul, Ahmadou Kourouma, and other linguistic and narrative innovators, one can also note

278 Notes to Pages 72–77

Ngugi wa Thiong'o (1986), which outlines in detail the ways in which language of expression, in both literature and society, becomes a key concern for a successful decolonization process.

88. "Capable de nous secouer secouer secouer jusqu'à l'évacuation totale des croûtes d'ignorance d'indifférence de limitations et de complexes inoculés par deux siècles d'inactivité obligatoire des périodes de non-créativité des temps sevrés d'originalité."

89. "L'articulation d'un projet social africain qui a pour but d'achever sa mutation économique, sociale, et cuturelle . . . dans les lieux d'où s'énoncent les discours que l'Afrique produit sur elle-même: le culturel, le religieux, l'artistique, le démographique, l'urbanité, le politique" (2016, 42).

90. "La critique d'une culture par des hommes cultivés."

91. "Prendre le temps de trier, d'expérimenter, de cueillir soigneusement des fleurs provenant de différents jardins, d'en humer les fragrances et de construire sereinement son bouquet par son art de l'arrangement floral" (2016, 45).

92. "Le regard de la pause qui pose / Et voit et distingue."

93. Spivak cautions against a reductivist understanding of culture: "Otherwise, multiculturalist policy reduces itself to allowing unreasonable cultural practices as a sign of freedom, to the institutionalization of the interval between 'colonial' and 'pre-colonial' time, the negotiation of which ensured survival under imperialism proper" (340).

94. "Le voyage triomphal au bout de soi-même / Et de l'autre."

95. "Un plan d'évolution harmonieuse qui passera automatiquement par l'éducation."

96. "D'une véritable éducation répondant aux aspirations d'une âme humaine en quête d'évolution et résolvant les problèmes d'équilibre que suscite nécessairement la reproduction des corps susceptibles d'être choisis pour une orientation consciente."

97. "Pleine d'expérience d'émotions enrichissantes de sources d'inspiration d'exaltation de possibilités d'actions créatrices."

98. "Car mes enfants à moi seront bleus et rose-corail de la Nouvelle Race."

99. "Pèse les mots et pose les actes." This is a ritual transformation, which Adams (1993) highlights.

100. "Nous autres les femmes, de par la maternité, nous sommes des artistes. Nos enfants sont des chefs-d'œuvre d'art, parce que nous portons en nous essentiellement l'espérance de la maternité."

101. This is a reference to the notion of "A Critical Humanism," as depicted by Achille Mbmebe and Deborah Posel, which "breaks with essentialized notions of difference and builds on a philosophy of critical cosmopolitanism. . . . It also refuses the new imperialism which has taken on the mantle of international human rights in the war on terror" (2005, 283–84).

Notes to Pages 78–81 279

Chapter 3: Child Soldiers

1. "Ce qui gagne la guerre n'est jamais un parti, c'est la guerre, la vieille bête qui asphyxie toute mise en question et déchaîne l'avidité de croire et d'adhérer contre ce qui essaie de s'élever."

2. "Le colonialisme n'est pas une machine à penser, n'est pas un corps doué de raison. Il est la violence à l'état de nature et ne peut pas s'incliner que devant une plus grande violence."

3. It is no secret that Africa's rank in the global societal order is the direct result of international fiscal and political policies. See, for example, Walter Rodney's *How Europe Underdeveloped Africa* (1972); François-Xavier Verschave's *De la Françafrique à la mafiafrique* (2004); Kwame Nkrumah's *Neo-colonialism, the Last Stage of Imperialism* (1966); or the recent phenomenon of "Afri-leaks."

4. *Écrivain engagé*, or "engaged writer," is a term to describe authors whose work embodies a particular social and/or political agenda, with which they are intimately involved.

5. The Surrealist Group's manifesto, "Murderous Humanitarianism," continues to ring true in spite of the various movements for decolonization and independence that have taken place since its original publication in 1932. This is primarily because development aid operates along the same exploitative lines as the colonial enterprise on a global scale, reinforcing inequalities and profiting from human suffering (see Walter Rodney, Jerry Mander and Edward Goldsmith, and Dambisa Moyo).

6. See the article that reinscribes this manifesto in the context of the international coalition-led ouster of Muammar Gaddafi of Libya in 2011, https://criticismetc.com/2011/03/20/murderous-humanitarianism-1932-and-2011/.

7. Unless otherwise noted, all translations from French are my own. "Monde accablé de dureté, de violence et de dévastation, l'Afrique serait le simulacre d'une force obscure et aveugle, murée dans un temps en quelque sorte pré-éthique, voire prépolitique."

8. See the chapter in Ali Mazrui's book *The Africans: A Triple Heritage* (Little, Brown, 1986) titled "Where Is Africa?" in which he cites the uncertain etymological origins of the term "Africa." Whether Greek or Latin, or an Arabization of one or the other, Africa ironically finds its conceptual origins in Europe.

9. "Dans l'horizon philosophique de notre temps, le terme 'Afrique' ne signifierait donc rien d'autre que cette manière de nommer la question politique de la dessiccation du vivant; une manière d'interroger politiquement la dureté, la sécheresse et la rugosité de la vie ou encore les formes visibles, mais opaques et aveugles que la mort a fini par revêtir dans le commerce contemporain entre les vivants."

280 Notes to Pages 82–87

10. Verschave (1998) illustrates countless cases of French complicity in ethnic conflicts (including the Rwandan genocide), "ethnic" conflicts that always have an underlying political agenda, despite the rhetoric of enduring ethnic tensions presented by Western media organizations. Verschave (2005) makes the further argument that many Western powers are complicit in the international political economy of African affairs, likening the international corporatist networks to a kind of mafia. And today, one must also add Chinese aid policies to the discussion surrounding the "development" of African nations.

11. "Dans une large mesure, le terme 'Nègre' fait signe à cet état de minorisation et de claustration. Il est une sorte d'îlot de respiration dans un contexte d'oppression raciale et parfois de déshumanisation objective."

12. In addition to the seminal Spivak (1988), Minh-ha (1989) also theorizes the notion of alterity through a radical theorization of otherness. Mbembe also notes that the "experience of the Other, or the *problem of the 'I' of others and of human beings we perceive as foreign to us*, has almost always posed virtually insurmountable difficulties to Western philosophical and political tradition" (2001, 2).

13. See, for example, Loewenstein (2015), in which he identifies the paradoxically profitable function of catastrophic events for corporate interests often operating under the umbrella of a humanitarian enterprise.

14. Mbembe's discussion, which builds upon Deleuze and Guattari's (1980) conception of the "war machine," is not limited to postcolonial Africa but rather is grounded in a broad geohistorical analysis of sovereignty and power.

15. For an interesting theorization of the concept of nomadic *errance,* see Glissant (1997, 26–28).

16. One can look at the aftermath of the coup d'état on March 26, 2012, in Mali as a concrete example of just such a situation where the legitimate government has been replaced by a rogue military faction and where the country is further divided by an armed ethnic rebellion (the Touaregs, though politically divided between the MNLA and FNLA) in the north, as well as an armed Islamic militant group Ansar Dine (affiliated with al-Qaeda in the Islamic Maghreb), and a number of local militias.

17. According to an article published by Radio France Internationale titled "La lutte contre le recrutement d'enfants soldats progresse lentement," http://www.rfi.fr/general/20120211-il-y-environ-300-000-enfants-enfants-soldats-le-monde-selon-unicef. These numbers have remained relatively stable as of 2020, despite years of efforts to curb recruitment and facilitate the liberation of child soldiers,

18. Alcinda Honwana defines the "tactical agency," the kind of agency deployed by the child soldier, as "a specific type of agency that is devised to

Notes to Pages 88–91 281

cope with the concrete, immediate conditions of their lives in order to maximize the circumstances created by their military and violent environment. Their actions, however, come from a position of weakness" (49).

19. Novels such as Kourouma's (Lux provides numerous other examples) not only present a counter-discourse to images of conflict in sub-Saharan Africa that are filtered through Western media but also influence the way that future wars but also peacemaking initiatives can be reimagined (Lux 2010, 58–59). Achille Mbembe, similarly advocates for new "critical pedagogies" for studying Africa, which necessarily involve a consideration of arts and humanities within social science discourses. See Mbembe and Nuttall (2004, 347–72).

20. Honwana also discusses the "construction of a warlike persona" as an interruption of childhood, which is already a "process of becoming rather than being" (2005, 34). She argues that this is due not only to the intense initiation into violence designed to "cut off their links with society" (41) but also because the savagery of postmodern and postcolonial warfare extends to all levels of society and essentially erodes the social codes and structures that would permit a child to enter (or be initiated) into adulthood.

21. See N'Diaye (2006, 77–96).

22. "La guerre tribale avait atterri en Côte-d'Ivoire."

23. "Ça, c'est la guerre tribale qui veut ça."

24. "(La République de Côte-d'Ivoire . . . comme toutes les républiques foutues de cette zone, démocratique dans quelques domaines mais pourrie jusqu'aux os par la corruption dans tous les autres)."

25. Kourouma notes the opinion of Sierra Leonean rebel leader Foday Sanko regarding said international peacekeeping efforts: "The vast machinery of the UN always serves the interests of European colonial *toubab* colonists and never the interests of the poor Black Nigger Native savages" (2006, 161).

26. "Je parle mal, très mal le français."

27. "Je vais vous présenter mon pedigrée (d'après mon dictionnaire, pedigrée signifie vie de chien errant sans collier)."

28. With biting irony, Kourouma further identifies the rhetorical racism of international discourse: "Ce qui arrive en Côte-d'Ivoire est appelé conflit tribal parce que c'est un affrontement entre des nègres indigènes barbares d'Afrique. Quand les Européens se combattent, ça s'appelle une guerre, une guerre de civilisations" (2004, 42; What is happening in Côte-d'Ivoire is called a tribal conflict because it's a struggle between Black indigenous African barbarians. When Europeans fight, it's called a war, a war of civilizations).

29. A future-oriented narration is a coping strategy for dealing with difficulty, as Calixthe Beyala stated in an interview: "Life in the bidonville denies the

present because one lives on hope. Everyone thinks that they're in transit to a better tomorrow. . . . So you conjugate verbs in the future tense" (Beyala qtd. in Jules-Rosette 1998, 204–5).

30. "L'argent à profusion pour acheter un gbaga et marier Fanta."

31. "Le seul à avoir été un vrai garçon sous Houphouët, le seul à avoir du solide entre les jambes."

32. This is the kind of complicity that Mbembe identifies as a fundamental characteristic of the African postcolony's power structure in his work *On the Postcolony*, in which the dichotomy of oppressors and oppressed breaks down in the baroque spectacle of politics where everyone is an actor. See Joslin, "Baroque Practices in Postcolonial African Literature and Theory: From Achille Mbembe's *On the Postcolony*," *International Journal of Francophone Studies* 12, no. 4 (December 2009): 639–54.

33. In particular, she is referring to the types of narrative reconstructions by an outside "humanitarian" agent/writer, who "speaks on behalf of the suffering child soldier," a move that does not enact the kind of positive relation envisioned by Christina Lux but, quite to the contrary, further "[entrenches] global inequalities" (Moynagh 2011, 43).

34. Interestingly, music, which figures prominently throughout the narrative (rap in particular) is instrumental in helping Beah through his personal struggles.

35. Moynagh points out a particularly troubling incongruity in human rights practices in terms of NGO-run refugee camps in Kenya that in 2001 refused to accept children who were believed to have served as child soldiers.

36. Though the film reproduces events in the context of Sierra Leone's civil conflict, it is quite plausible that Aduaka's sensitivity was piqued by his experiences as a child growing up in Nigeria during the Biafran civil war.

37. Similar scenes of temporary relief are depicted in the Hollywood film set in the context of the Sierra Leonean crisis, *Blood Diamond* (Zwick 2007), as well as in the narratives of Birahima (Captain Kid's funeral), Beah (they take drugs and watch war movies to relax and celebrate), and Dongala's *Johnny Mad Dog*.

38. Ikemefuna is the adopted son of the protagonist Okonkwo who has been given as a peace offering by a neighboring clan and who is ultimately sacrificed as recompense for perceived trespasses.

39. Honwana also describes instances when child soldiers in a rare moment of levity are able to revert, in a sense, to the kind of carefree playfulness characteristic of normal childhood.

40. In "Coming of Age with an AK-47," John Walsh also remarks on the way that Kourouma's narrative "deforms" the African bildungsroman by drawing out comparisons with Camara Laye's *L'Enfant Noir* (1953).

Notes to Pages 100–106 283

41. The novel was adapted into the French-Liberian film *Johnny Mad Dog* (Sauvaire 2008), which, although less detailed in its account, portrays with horrific, visceral imagery the terrifying violence of modern African conflicts. In its own way, the film punctuates the two narrative perspectives by cutting back and forth from one to the other, accelerating the pace of the cuts as the two characters approach one another.

42. I have argued elsewhere that the schizoid structure of a narrative is indicative of the kind of madness one perceives in postcolonial societies wherein the lives of ordinary people are constantly threatened by the insane dictates of an omnipotent despot. See Joslin, "L'écriture Ken Bugul: Pour un 'genre' de roman cinématographique africain," *Nouvelles Études Francophones* 28, no. 1 (Spring 2014): 162–75.

43. See Memmi (1965) in which he outlines the hierarchical inequalities established under the colonial order.

44. Johnny Mad Dog recognizes that he has "life-or-death power" (72) in much the same way as the warlords in Kourouma's novel did: "Colonel Papa le bon had the power of life and death over everyone who lived in Zorzor" (Kourouma 2006, 66); and "General Barclay had the power of life and death over everyone in Sanniquellie" (104).

45. Mégret expertly describes the ways in which he examines the exclusionary language of international humanitarian law, which "has always had an 'other'—an 'other' that is both a figure excluded from the various categories of protection, and an elaborate metaphor of what the laws of war do not want to be" (2009, 266).

46. Dongala thereby places an ounce of evil in the generally "good" character of Laokolé, in much the same way he also puts a small amount of good in the arrogant imbecile Johnny Mad Dog, whose pure criminality is occasionally penetrated to reveal an underlying (and somewhat disturbed) humanity as, for example, in the relationship that he has with his girlfriend, Lovelita. Only when she dies, like with the pregnant Miriam in *Ezra*, is Johnny's humanity, usually hidden behind his façade of false confidence, perceptible (263–64).

47. Fassin describes such "hierarchies of humanity," likening humanitarian ventures to the exploits of colonial administrators (2012, 238–39).

48. "Elle [cette réalité] concerne également l'accroissement des inégalités dans notre monde dit développé, qui inscrit la nécessité de la précarité et du chômage pour les plus déshérités, quitte à lui donner une place topique et non pas utopique: cette place est celle de l'exclusion."

49. "Selon ce point de vue, l'Afrique en tant que telle—et l'on devrait ajouter le Nègre—n'existe qu'à partir du texte qui la construit comme la fiction de l'autre . . . En d'autres termes, l'Afrique n'existe qu'à partir d'une bibliothèque coloniale qui s'immisce et s'insinue partout . . . au point où . . . il

284 Notes to Pages 107–113

est sinon impossible du moins difficile de distinguer l'original de sa copie, voire de son simulacre."

50. "Nous sommes tous égaux face au réel. Or, l'ingénierie sociale vise justement à échapper à cette commune condition humaine pour élaborer une forme de vie et de politique inégalitaire, où le fantasme du dominant prendrait la place du réel pour devenir la Loi exclusive du dominé."

51. This notion is theorized by Mbembe as the existential space in which the African subject emerges in and through experience of being/having a Black body in a world of ideological entanglements (2001, 17).

52. As Honwana puts it, "War became all they knew of life" (2005, 49); and in the words of Johnny Mad Dog, "After a while those explosions became our normal environment" (Dongala 2005, 223); and echoing Ezra, Johnny Mad Dog also states in his defense: "I'm not a murderer, for your information! I fight wars! In war, you kill, you burn buildings, you rape women. That's *normal*. That's what war is all about—killing is *natural*" (313; emphasis is mine).

53. See *Gouverner par le chaos*, 68; Spivak (2012).

Chapter 4: Alienation, Estrangement, and Dreams of Departure

1. Unless otherwise noted, all translations from French are my own.

Je pars, ma vie est trop maussade
Je pars j'ai laissé une feuille incrustée de mots sales
Je pars laissez-moi donc ma douleur
Je pars pour un monde fait de lumière et de couleurs
. .
Je pars car le ciel est bas et gris
Les vieux n'ont plus d'sagesse, ils sont racistes et aigris
Je pars, je m'envole vers le rire des enfants
Je pars même s'ils m'en veulent j'ai trop souffert dans mes tourments

2. Cf. Marcus Garvey and Pan-Africanism.

3. In this short story from the collection *L'exil et le royaume* (1947), Camus presents the conflict in existential terms as a schoolteacher, Daru, is forced to choose whether to fulfill his political duty with regard to his nameless Arab prisoner, who is at once hostage and host to the colonial French presence in Algeria.

4. Many of these aesthetic and cinematographic strategies constitute an evolution of the "cinéma engagé" pioneered by Ousmane Sembène and other early African directors discussed by Kenneth Harrow.

5. Walter Benjamin proposed a similar critique of artistic creation becoming devalued in the age of mechanical reproduction.

6. My doctoral research on a baroque aesthetic in Francophone African literatures (2010) similarly explored the complexities of representation in the art and politics of colonial, anticolonial, and postcolonial discourses.

Notes to Pages 114–117

7. Francophone African literary texts that have transnationalism and immigration as primary thematic preoccupations are a growing trend in an increasingly globalized and transient world (Mongo-Mboussa 2002b, 67).

8. Two Ivorian writers who were contemporaries of Kane present their own accounts of the alienation that is experienced when cultures are stacked one upon the other: Bernard Dadié recounts with cool detachment his estrangement in *Un nègre à Paris* (1959), while Aké Loba depicts the difficulties of a student turned factory worker who becomes involved with labor union and party politics and experiences loss and a nostalgic longing for the Africa that he has left behind with the story of *Kocoumbo: L'étudiant noir* (1960).

9. This concept is also theorized in terms of Chicana identity by Gloria Anzaldúa in *Borderlands/La frontera: The New Mestiza* (San Francisco: Aunt Lute Books, 1999).

10. "L'enfant qui n'est pas encore conçu appelle. Il faut bien que l'enfant naisse. Ce pays attend un enfant. Mais, pour que l'enfant naisse, il faut que le pays se donne."

11. "On y rencontre des objets de chair, ainsi que des objets de fer."

12. Samba Diallo himself is averse to this dichotomous sort of reasoning, stating: "Je ne suis pas un pays Diallobé distinct, face à un Occident distinct... Je suis devenu les deux. Il n'y a pas une tête lucide entre deux termes d'un choix. Il y a une nature étrange, en détresse de n'être pas deux" (165; I am not of a distinct Diallobé country, facing a distinct West.... I have become both. There is no lucid mind between two terms of one choice. There is an estranged nature, in distress for not being two).

13. "Transmettre ma pensée sans ouvrir la bouche."

14. "Progressivement, ils me firent émerger du coeur des choses et m'habituèrent à prendre mes distances du monde."

15. "Vie de l'instant, vie sans âge de l'instant qui dure, dans l'envolée de ton élan indéfiniment l'homme se crée"; at the end of the invitation to prayer, the "fou" draws his weapon and Samba is plunged into darkness (187), which one can interpret as the moment of his death. It is unknown whether his body actually dies, or whether the near-death experience allows him to reawaken, renewed, into a new existential plane. Therein lies the greatest ambiguity of Samba's life adventure.

16. An entire volume has been dedicated to the question of the experience of exile and the migrant phenomenon in Francophone African literature. See Fandio and Tchumkam (2011).

17. "J'ai vingt-et-un ans. Pas de chance pour les études, pas les moyens de trouver un boulot convenable."

18. "Prendre [s]es résponsabilités."

19. Touré (2012) dramatizes the fatal journey across the Mediterranean toward the perceived paradise of Europe. Similarly, the rap song "Sur les

pirogues de la mort" by Negus (2010) from his album *À l'ombre de la lune* identifies the dangers associated with the thinly veiled nightmare of clandestine emigration.

20. "La pauvreté en Afrique . . . l'échec des gouvernements . . . l'image d'un Occident—paradis terrestre—véhiculée par les medias . . . [les] parents qui, au lieu d'éduquer leurs enfants et les encourager à travailler dur comme font ceux de là-bas, les envoient au sacrifice."

21. Sembène (1992) succinctly illustrates the problematic nature of foreign aid in its nefarious perpetuation of cycles of dependence and poverty, a notion that can be read in conjunction with François-Xavier Verschave's analysis of the occult political-economic networks, which he characterizes metaphorically as an iceberg, only the tip of which is visible, designating them under the term "Françafrique." These networks range from the scandalous dealings of the ELF petroleum corporation in Central Africa to the massive fraudulent enterprise of the French government's "aide publique au développement" (aid for public development), the vast majority of which ultimately serves to enrich private-sector companies and their political enablers with only 1 percent to 3 percent actually serving to combat poverty and other social ills (73).

22. "Ils 'vendent' la pauvreté; c'est devenu un métier qui les fait vire."

23. "Et [tu] dépendras éternellement de l'aide. Ton imagination, ton ambition de te réaliser toute seule grâce à Dieu et à ton travail: anéanties!"

24. "Nous ne devrions pas laisser passer cette insulte à l'âme de nos enfants."

25. This is one of the primary arguments advanced by Anthony Loewenstein in his 2015 book *Disaster Capitalism: Making a Killing out of Catastrophe*.

26. Fall consistently employs the term "humanitaire" in quotation marks as if to signal the ironic and fundamentally nonhumanitarian nature of the effects that such aid has on the populations upon which the "aid" is being dispensed. Jean-Pierre Bekolo describes this very phenomenon as "recolonisation positive" (positive recolonization), stating that "ce que font les ONG et institutions internationales de ces États-Gâteaux organisés par des élites autour d'une mangeoire avec des gouvernements aux effectifs pléthoriques et aux privilèges indécents au vu du niveau véritable du pays, répétant un discours rodé sur la pauvreté, l'aide international et parlant avec des bailleurs de fonds au nom d'un peuple qui sert de prétexte pour justifier l'existence de ce no man's land à la merci des prédateurs du libéralisme" (2019, 153–54; NGOs and international institutions function in these Cake-States organized by elites around a feeding trough along with governments dispensing endless means and obscene privileges compared to the actual condition of the country, repeating a discourse focused on poverty and international aid while in

Notes to Pages 120–125 287

dialogue with their silent backers, all in the name of a population who only serves as a pretext to justify the existence of such a no man's land at the mercy of liberalist predators).

27. Khady is similar in many ways to the main character in the medieval fairy tale of Cinderella, which also bears a striking resemblance to a West African folktale recorded by Bernard Dadié titled "Le pagne noir."

28. "Elle faisait, *en quelque sorte*, un choix."

29. "Il arriverait un jour en Europe ou mourrait."

30. "C'est que je suis moi, Khady Demba."

31. "Un grillage séparant l'Afrique de l'Europe."

32. "Quant au fameux 'Barça ou Barsàq,'—littéralement: Barcelone ou l'au-delà—il relève d'une autre logique. Il témoigne surtout de la détermination des jeunes Tunisiens, Sénégalais, Irakiens ou Somaliens et Nigerians à franchir les frontières du supposé Eldorado européen. . . . Il n'en reste pas moins qu'il est difficile de comprendre pourquoi des jeunes dans la force de l'âge sont prêts a mourir—et beaucoup meurent effectivement—pour entrer en Europe au lieu de mettre cette énergie et cette détermination dans la lutte pour le changement dans leur propre pays."

33. "Si l'Afrique est la production matérielle de l'Europe, elle est aussi la production de son imaginaire; une construction virtuelle qui peut prendre forme dans le réel."

34. This is a principal theme in a number of early African novels, including Socé (1937), Sembène (1956), and Kane (1960).

35. More recently, Burkinabè Eléonore Yaméogo's (2011) documentary *Paris mon paradis* explores in lurid detail the many difficulties faced by illegal immigrants ("sans-papiers") struggling to live and work in France. Nathalie Étoké's 2012 documentary *Afro-Diasporic French Identities* further explores the psychological tensions associated with multiple registers of individual and collective identification.

36. Absa (2001) also depicts the return of a Senegalese man to his home on Gorée Island after a failed attempt at establishing himself in Europe. His inability to procure stable and satisfying employment (a reference to the implicit racism and cultural prejudice of European society) eventually undermines his marriage to a French woman with whom he has two children. His return home is met with disappointment at the fact that he has not returned triumphant and laden with European wealth, in spite of his attempts to explain the difficulties associated with the correspondingly high cost of living in a developed nation.

37. Many of Sembène's later films, including *Faat Kiné* (2000) and *Moolaadé* (2004), engage with the topic of female liberation from an intensely patriarchal societal organization. See also chapter 1.

288 Notes to Pages 126–137

38. See Miller (1998) on early African fiction and its ambiguous relation to metropolitan France, in particular, chapter 1, entitled "Involution and Revolution, African Paris in the 1920s" (9–54).

39. The notion of agricultural subsistence in the face of modern challenges is a primary theme of Faye (1975), as well as Sembène (1992).

40. This notion of following in the footsteps of his fallen mentor is further alluded to in the way that Khatra finds a miniature pair of coveralls in a market stall that serve to identify him with his chosen trade. He also digs up Maata's tobacco pouch, which he had buried in the sand in front of the entrance to Abdallah's abode, before he proceeds to light the bulb that had been resisting their best efforts.

41. The concept of playing with visibility and invisibility through a character's identity and becoming is also a prominent theme in Ralph Ellison's *Invisible Man*.

42. In Sissako (2005), there is a striking visual portrayal of a tragic desert crossing when a member of the group is left behind to die after succumbing to the elements. The scene then cuts away to the rinsing of blood-red dye from cloths in the courtyard where the IMF is being put on trial by the people of Bamako in Mali.

43. Thomas's (2011) article on Mambety characterizes this character as "a young Tarzan type from Europe who wants to go native," citing him as an example of Europe's fetishization of Africa and describing his ride on Mory's "wild beast" of a motorcycle as a symbolic act of bestiality, another instance of Europe's raping and ravaging of a "savage" continent (11). With respect to the doubling effect, Sene further acknowledges that Mambety's cinema "s'occupe de multiplication des idées" (69; occupies itself with multiplying ideas), presenting the viewer with a multilayered and baroque palimpsest that affords multiple opportunities for interpretation of the complex (neo)colonial relationship between France and Senegal.

44. These scenes, which hint at the profound corruption characteristic of modern Senegalese society, also serve to illustrate a fundamental element of Mambety's cinematic project: "Discréditer le pouvoir politique, défier l'autorité à ses risques et périls avec les armes dont il dispose et qui ont pour nom audace courage et intelligence" (Sene 2001, 67; To discredit political power, defy authority at his own risk and peril with the weapons that he had, which were namely audacity, courage, and intelligence).

45. In his work on Mambety, Sene (2001) notes that Lebou folklore, the ethnicity of fishermen from which Mambéty hails, is particularly strong, yet he elaborates that these folkloric elements "sont des repères esthétiques qu'il faut savoir trouver dans les films de Djibril, parce qu'ils y existent, non en images nécessairement, mais en sensations, en tressaillements, en sensibilité perceptive. Il sauvegarde la quintessence de sa culture autochtone,

Notes to Pages 139–141 289

tout en en parlant avec distance" (34; are aesthetic signposts that one must know how to find in Djibri's films, because they exist, not necessarily in images, but in sensations and subtle movements, in perceptive sensitivity. He preserves the quintessential elements of his autochthonous culture, all the while talking about it from a distance).

46. "Dans son cinéma, c'est la femme qui tourne la page décesive de destins. Les grandes mutations sociales sont le fait des femmes qui seules, continuent l'aventure de la vie. C'est elles qui sont au centre et tiennent le rôle principal de l'histoire."

47. It would seem that this dream is tainted by a bad omen because the first time Anta indulges in a reverie of their soon-to-be-acquired wealth, her daydream is interrupted by the opening of the stolen chest, which reveals a skull, inciting the screaming flight of the taxi driver. Nevertheless, they persist, and in the scene in which a decadently dressed Mory and Anta enter Dakar atop Charlie's stolen Roadster, as well as later on when they purchase their passage at the travel agency (playing the role of big shots), it seems they have become enamored with their new self-image. In pursuing their dream at all costs, their love becomes distorted and transformed into a commodity, a notion that is clearly depicted at Charlie's mansion as he makes turns around his swimming pool in his paddleboat while bored women lounge around him.

48. "Dans *Touki Bouki* c'est une jeune fille pauvre qui part en Europe laissant derrière elle un copain qu'elle a dans la peau."

49. This remark highlights the role of various media outlets in perpetuating exoticized stereotypes of Africa primarily for Western consumption.

50. The events of 1968 are recounted in fictional form by Boubacar Boris Diop (1981) in his novel *Le temps de Tamango*; also see Ibrahima Diop's (2005) *La rue publique de mai 68*. The actual events are recorded by Abdoulaye Bathily (1992) in his work *Mai 68 à Dakar ou la révolte universitaire et la démocratie*.

51. Sene characterizes Mory's flight thusly: "la musique des pas de Mory galopant, non pour échapper aux flics ou à son destin, mais pour réfléchir en mouvement. Le gars est serein. Il pense à la suite immédiate au lendemain situé au bout de sa course en rythmant son allure sur les blues de son âme brisée" (80; the music of Mory's galloping footsteps, not to escape from the cops or his destiny, but to reflect while in motion. The guy is serene. He thinks of the next moment, of the tomorrow that sits at the end of his course while matching his own allure to the blues of his broken heart).

52. The solo album of Franco-Rwandan jazz/hip-hop artist Gaël Faye, titled *Pili-pili sur un croissant au beurre*, poetically exemplifies the identification struggles of a "métis," occupying ambiguous spaces of exile and asylum between France and Africa.

Notes to Pages 142–146

53. An implicit reference to the Heideggerian existential notion of "being-toward-death," a way of being there (*Dasein*) that accounts for the inevitable terminus of existence, elaborated upon in his treatise *Being and Time*.

54. "Qui observe de son oeil mort"; "qui embarque à bord une pomme."

55. "Un peu partout des corps avaient échoué sur la plage."

56. "Quand le ciel est entièrement bleu, quand il a la couleur de tes yeux, et qu'il se met à pleuvoir quand même, comme ça, sans prévenir, ce n'est pas *pleuvoir* qu'il faut dire, c'est *pleurer*" (35; When the sky is entirely blue, when it is the color of your eyes and yet it begins to rain anyway, just like that, without warning, it is not *raining* that one should say, but *crying*).

57. "Avec comme du verre dans la voix, plusieurs morceaux de verre, ir-récupérables, brisés à jamais."

58. "Deux baigneurs imprudent se sont noyés près de la petite localité de Bnidar."

59. The identities of the thirteen individuals, their associated aliases, and their identities are summarized in chapter 14 (65–67).

60. Bates (2016) elaborates on the complexities of media discourses about migrant phenomena and the contextual constructions of identities and subjectivities.

61. "Non maman, je refuse d'être cette bête à quatre pattes, les yeux sur la terre qui a cessé de la nourir. Oui, partir pour ne plus espérer la pluie qui ne vient pas, le ciel qui ne répond pas, la vie qui ne pousse pas, ... je crois pouvoir encore vivre sans donner la mort, vivre sans tourner le dos à la vie, ... je me brûle pour voir si j'existe, je mets le feu à ma main pour vérifier si j'existe encore et, tu sais, maman j'existe suffisamment encore pour partir."

62. "Aujourd'hui, je sais que même sans lui je continuerai à respirer, à boire et à manger, à dormir même. Mais à vivre, jamais. ... Depuis qu'il est mort, moi, la nuit, dans mon lit, je ne meurs plus."

63. "Rien à faire, pas la peine d'essayer—, la honte, l'ennui et le reste."

64. "Pour faire comme si ... [ou] pour faire semblant ..."

65. "Quelqu'un avait oublié qu'on avait oublié de construire l'école."

66. "L'image de cette femme, sur une affiche aux couleurs de l'Espagne."

67. Elalamy's novel is an indirect commentary on the biased media politics that dominate contemporary global society, from the contrast between the radio report of the two wayward swimmers who drowned and the gruesome reality of the thirteen corpses that were found washed up on the beach, to the stringent desensitization depicted in the photographs taken of the corpses, which are passed over in favor of a clean-looking image selected for the purpose of touristic attraction. Furthermore, Ealamy indicates an awareness that his work is markedly not the kind of story that will translate into the dominant media forms of the day. He reminds

readers in the final chapter: "Et c'est là qu'on réalise qu'on est dans un livre et pas au cinema" (And it's there that one realizes that one is in a book and not at the movies), invoking the much more intimate and personal experience of a text and the subtle power of words: "il va falloir se contenter de mots tells que *embarquer à destination de la mort*" (173; one must be content with words such as *embarking on a journey toward death*). Elalamy is very insistent on this point and the finality of the written sentence, a disambiguation that contrasts starkly with the eerie descriptions in which the bodies on the beach take on a purely aesthetic quality ("un point de vue *purement esthétique*" [101]). He states, "C'est écrit noir sur blanc qu'il est mort, parce que le noir c'est tout de même mieux pour announcer ces choses-là" (172; It is written black on white that he is dead, because black, after all, is better to announce those kinds of things). He closes the novel with a reiteration that is itself a colloquial double entendre that serves to reinforce the severity and the brute realism of the situation he has just described: "C'est pas du cinema" (175; It is not a movie).

68. "Ils venaient en famille récolter la misère et la maladie et toutes les saloperies de cette ville."

69. "C'était chez nous."

70. "On t'allonge sur un lit pour mieux voir tout ça, voir ta vie foutre le camp par la fenêtre."

71. "[L]histoire de ces hommes et de cette femme qui ont trouvé la mort, là où ils croyaient trouver la vie."

72. "Je courais ainsi, porté par mes illusions, l'envie d'aller loin, plus loin, l'ambition de devenir quelqu'un. Là-bas . . . Quelqu'on que l'on paierait pour courir, pour arriver avant les autres et ne jamaiis se laisser dépasser, que l'on applaudirait ensuite et que l'on couvrirait d'or rien que pour ça"; Young Africans' dreams of athletic success in Europe is one of the principal themes of Fatou Diome's (2003) novel *Le ventre de l'Atlantique*, which I discuss next in this chapter's closing section.

73. "Mais je m'accroche à cette planche, je m'accroche à la vie; je continue à lui courir derrière, avec la mort qui me court après."

74. "Ce corps indifferent au manqué, au besoin, à la faim, à la détresse des autres."

75. "Je frotte pour faire partir tout ça, et ne rien laisser, tout enlever, les femmes qui ne me voient pas, les enfants qui se passent le mot derrière mon dos, ma lèvre dans le miroir, aujourd'hui encore et pour toujours."

76. "Un jour, une horloge choisit de s'arrêter, un homme décide de tourner la page, et moi de partir. C'est comme ça. C'est tout."

77. "Comme s'il avait avalé un mot de travers."

78. "Comme s'il cherchait à dire quelque chose . . . [et] toujours rien qui sort de cette bouche si ce n'est ce petit crustacé qui émerge sans bruit, hésite un

moment devant l'oeil du photographe et disparaît encore sous les algues, muet."

79. "Il faut dire qu'elle était belle, cette femme et, de cette beauté infinie, aucun mot, aucun parfum, aucune couleur, aucune musique même ne pourra jamais rendre compte."

80. "Mourir c'est ne plus voir le monde."

81. "Mon père dit que tu es étrange, que tu ne nous ressembles pas, que tu ne seras jamais des nôtres."

82. Elalamy's gradual unveiling of the implicit relationship between the European photographer, Alvaro, and his unknown son, Omar, who each discover and react to the victims' bodies in their own way—detached curiosity or traumatic shock, respectively—serves as a metaphorical bridge linking (post)colonizer and (post)colonized through the trope of a prostituted relationality. In so doing, Elalamy highlights the interconnected nature of a singular humanity that is only divided by arbitrary geographical, political, historical, cultural, and phenotypical distinctions.

83. "Pour être du voyage, ils ont payé à ce négociant de Tanger plus de vingt mille dirhams chacun. Vingt et un mille cinq cents, exactement. Comme s'ils avaient travaillé toute leur vie pour acheter leur mort."

84. "Elle s'accroche avec rage, si c'est rage qu'il faut dire, non pas pour elle mais pour lui, le petit ange qui dort en elle, insouciant, s'il savait, son enfant, son petit, qui ne voit pas la nuit tout autour, et ne verra sans doute jamais le jour."

85. "Un enfant dont on ignore encore la couleur."

86. "Alors parviendrait-on peut-être à comprendre qu'on a regardé des photos, mais qu'on n'a rien vu."

87. Here, I am referring to the psychoanalytic conception of alienation discussed in Kristeva (1988) which theorizes the phenomenon of the foreigner from the perspective that each individual is a foreigner to themselves in terms of the temporality of their own becoming.

88. "Si l'exil est ce qui nous permet de nous désaliéner tout en nous instituant come relation ouverte et réseau, il devient le mode d'existence qui assume la fin des illusions identitaires come propriété stable, des lieux de bonheurs des paradis à jamais perdus chez soi et pour soi mais prospérant ailleurs où il faut se rendre pour les retrouver. L'exil étant partout, il devient voyage dont on peut revenir heureux sans retour au point de départ. Paradoxe?"

89. She says, "Il me fallait 'réussir' afin d'assumer la fonction assignée à tout enfant de chez nous: servir de sécurité sociale aux siens" (51; I needed to 'succeed' in order to assume the function assigned to every child where we are from: to serve as social security for one's family). The inclusion of quotation marks around the word "réussir" ("to succeed") implies an ambiguity vis-à-vis the notion of what "success" really is. Certainly, there is

Notes to Pages 153–156 293

a sense in which financial success is the ultimate obligation, yet the quotation marks seem to call into question this emphasis on financial success, suggesting that this conception of success is limited and often comes at a high personal or collective price. See also the satirical Rigouste (2005), published just months prior to the October 2005 riots sparked by the accidental deaths of two immigrant youths, Bouna Traoré and Zyed Benna.

90. "Le tiers-monde ne peut voir les plaies de l'Europe, les siennes l'aveuglent."

91. "Si le tiers-monde se mettait à voir la misère de l'Occident, il perdrait la cible de ses invectives."

92. "Éteignant les flambeaux que Mariama Bâ, Ousmane Sembène et d'autres se sont évertués à allumer."

93. These two works by Bâ and Sembène, respectively, deal explicitly with the problems associated with the outdated practice of polygamy, which no longer serves a beneficial function in modern Senegalese society.

94. "Les idées de Marx se meurent, et les arbres d'espoir que nous avons plantés en 68 n'ont donné que de bien maigres fruits"; Bathily (1992) recounts the events of May 1968 in Dakar, which mirrored in many ways the simultaneous civil unrest in Paris. Diop (1981) also represents the events of 1968, although from the perspective of speculative fiction set in the year 2063.

95. "Blottis sous les ponts ou dans les dédales du métro, les SDF doivent parfois rêver d'une cabane en Afrique."

96. "L'orgueil identitaire est la dopamine des exilés."

97. This is the case in Henri Duparc's (1997) comedy *Une couleur café*, in which the protagonist goes by the name "Docteur" while visiting his native Côte d'Ivoire, although it is later revealed that he is in fact a janitor in a hospital. He occupies a basement apartment in the Parisian neighborhood of Montreuil, which is also affectionately referred to as "Bamako-sous-bois" to underscore its high concentration of African immigrants.

98. "Ouvrier polyvalent, volant d'intérim en intérim, ne connaissait de la vie française que le fracas des usines, le fond des égouts, et la quantité de crottes de chien au mètre de bitume" (183).

99. "Tu ne progresses vraiment pas. On va arrêter les frais. Tu me dois environ cent mille balles."

100. An additional reference to Oyono (1956) further entrenches Diome's (2003) postcolonial critique with regard to her literary predecessors. Her passing remark on Monsieur Sonacotra, who "passa de maître chien à chien du maître" (103; went from master-dog to dog of the master), constitutes a satirical reversal of Toundi-Joseph's arrogant assertion upon becoming the houseboy for the colonial commandant that "le chien du roi est le roi des chiens" (32; the dog of the king is the king of dogs).

101. "Cette déjection de la conscience du pays des Droits de l'homme, qu'il appelait *mouriture*"; the French word "nourrir," meaning to feed or nourish,

294 Notes to Pages 156–159

rhymes with "mourir," meaning to die; the resultant neologism "mouriture," while sounding like "nourriture" or nourishment, in fact implies the very opposite: that Moussa is literally being fed death. This singular italicized word congeals the entire emigrant plight in the sense that what may look or sound like salvation in the form of emigration to Europe is merely a thinly disguised death sentence.

102. "Un avion le vomit sur le tarmac de l'aéroport de Dakar."

103. This is a man described as "l'emblème de l'émigration réussie" (38; the emblem of successful emigration), and who, "respectable et notable au village, n'était pas avare en récits merveilleux de son odyssée" (93; respected and noteworthy in the village, was not stingy in telling stories of his marvelous odyssey).

104. "Vous auriez dû demander à Moussa de vous raconteur sa France à lui. Lui aussi avait suivi le chant des sirens"; it is worth noting that Moussa's lifeless body is discovered on the beach on a Saturday after having become tangled up in fishermen's nets. Moussa is unable to face the despair and hopelessness of his shattered dream, coupled with the alienation from his peers. His corpse represents another casualty in the seemingly endless search for a life elsewhere.

105. "La chimère tricolore"; "La France, ce n'est pas le paradis."

106. "Enracinée partout, exilée tout le temps, je suis chez moi là où l'Afrique et l'Europe perdent leur orgueil et se contentent de s'additionner: sur une page, pleine de l'alliage qu'elles m'ont légué."

107. "On ne se déterritorialise jamais tout seul, mais à deux termes au moins, main-objet d'usage, bouche-sein, visage-paysage. Et chacun des deux termes se reterritorialise sur l'autre. Si bien qu'il ne faut pas confondre la reterritorialisation avec le retour à une territorialité primitive ou plus ancienne: elle implique forcément un ensemble d'artifices par lesquels un élément, lui-même déterritorialisé, sert de territorialité nouvelle à l'autre qui n'a pas moins perdu la sienne. D'où tout un système de reterritorialisations horizontales et complémentaires, entre la main et l'outil, la bouche et le sein, le visage et le paysage" (Deleuze and Guattari 1980, 214).

108. "Je vais chez moi comme on va à l'étranger, car je suis devenue l'autre pour ceux que je continue à appeler les miens."

109. "J'avais compris que partir serait le corollaire de mon existence."

110. "J'ai grandi avec un sentiment de culpabilité, la conscience de devoir expier une faute qui est ma vie même."

111. "Partir, c'est avoir tous les courages pour aller accoucher de soi-même. . . . Partir c'est devenir un tombeau ambulant rempli d'ombres, où les vivants et les morts ont l'absence en partage. Partir, c'est mourir d'absence. On revient, certes, mais on revient autre."

Notes to Pages 159–167

112. "Étrangère en France, j'étais accueillie comme telle dans mon propre pays" (Diome 2003, 228; A foreigner in France, I was treated as such in my own country).

113. "Si de Berlin naît officiellement l'Afrique 'médiatique', c'est la mission de 'Civilisation' et le devoir de 'Charité' qui ouvrent la porte à une *narrative* qui 'invente' l'Afrique par la même occasion."

114. See Kristeva (1988).

115. "No longer is the object of study—whether the mind, the human, society, culture or religion—seen in isolation, but as an inextricable and integral part of a larger physical and living world" (Stibbe 2015, 7).

116. "La légitimité de la démarche qui consiste à tenter de saisir le reel africain par cet outil que l'on nomme la *science* ne fut pas interrogée. Or un certain nombre raisons peuvent justifier un scepticisme quant à la capacité de la démarche scientifique, seule à élucider le reel. D'autres manières d'appréhender celui-ci existent, les savoirs occidentaux ne les épuisent pas toutes et, par ailleurs, le monde n'existe que comme objet de representation et de discours d'un sujet situé à un moment donné d'une histoire individuelle et collective et tributaire d'une manière de voir le monde" (2016 112).

Chapter 5: "We Don't Need No Education"

1. "Je ne veux pas aller à leur école." Unless otherwise noted, all English translations of French are my own.

2. "Le développement est l'une des expressions de l'entreprise occidentale d'extension de son épistémè dans le monde, à travers la dissémination de ses mythes et de ses téléologies sociales."

3. Kwabena Gyimah-Brempong, "Education and Economic Development in Africa," *African Development Review* 23, no. 2 (2011): 219–36.

4. The title of Basil Davidson's 1984 docuseries on Africa; also the title of a novel by Maurice Bandaman, *La Bible et le fusil* (Abidjan: CEDA, 1996).

5. Fassin (2012) describes such "hierarchies of humanity," likening humanitarian ventures to the exploits of colonial administrators (238–39).

6. "Bien qu'elle [la culture] puisse être un lieu de création de valeurs, ses finalités sont prioritairement symboiques, ells relèvent principalement de la production de sens et de significations" (Sarr 2016, 67).

7. "L'école séductrice est perverse."

8. "Le prisme de la spériorité Culturelle et du préjugé raciste" (Sarr 2016, 101).

9. "La maîtrise de savoirs techniques visant une organization sociale plus efficiente fait l'objet d'un consensus, même si ces derniers ne sont pas neutres et que leurs impacts sociétaux doivent être appréhendés" (2016, 100).

10. Shizha discusses how "the colonisation of African knowledge spaces in African educational institutions is highly problematic" (18), and also

296 Notes to Pages 168–171

addresses the linguistic question in postcolonial African educational systems, arguing, "The fact that science teaching and schooling in general is conducted in English, a 'global' language, or any other foreign language, makes the discussion on implementing indigenous sciences in African schools sound like cosmetic romanticisation" (27).

11. Goldsmith's original emphasis. Then president of Ghana Kwame Nkrumah published *Neo-colonialism: The Last Stage of Imperialism* (a tacit reference to Lenin), in which he critiques, among other things, the Balkanization of the African continent that resulted from French "aid" to its former colonies, whereby economic dependence on French investment was guaranteed to the detriment of self-sustaining, trans-African exchange (1966, 16–17).

12. Harvey calls for more equitable practices in the cooperative spaces of development, allowing for "institutions and collectives in the South . . . to 'speak back' to the development process" (2011, 187). This illuminates the irony of contemporary agro-alimentary development practices in Senegal in that "farmers opting into organic agriculture find themselves essentially forced to re-learn more traditional approaches to their trade, now re-presented through the scientific/managerial technologies of formally-educated agricultural specialists" (194).

13. "Ma première journée à l'école s'était achevée avant dix heures. Nulle trace d'humiliation parce que, dès le lendemain, j'émerveillai la classe en étant le seul à savoir présenter poliment mon couteau. J'avais de l'éducation, sûrement. Depuis, j'ingurgitai avec bonheur les programmes exotiques conçus pour nous à Paris, puisque ma famille m'avait bien préparé à leur assimilation" (Cabort-Masson 2001, 52).

14. "*Damnés de la merde*" is a clear reference to Frantz Fanon's (1961) seminal text on decolonization, *Les damnés de la terre* (1961), which shares its title with the words of Haitian poet Jacques Roumain's "Sales nègres" from his 1945 collection titled *Bois d'ébène*, as well as with the opening lines from the nineteenth-century leftist anthem "L'internationale," by Eugène Pottier; McClintock (1995) analyzes in detail the links between sanitation and civilization in colonial discourses.

15. "La population ne reconnaissait pas la valeur d'une éducation scolaire, et en plus une éducation à l'école des colons blancs. . . . Non, l'école ne portrait pas en elle l'avenir, elle était au contraire destructrice des sociétés."

16. Alessandri (2004) recognizes the vast differences in educational systems following the independence of France's West and Equatorial African colonies in 1960. But she underscores the experience, employing the term "éloignement," in its geographical and more symbolic (i.e., cultural, spiritual, and identity-based) dimensions, to characterize the impact of imposing a new system of values upon African citizens (48).

Notes to Pages 171–174

17. "Je voulais tout savoir, je voulais tout connaître."

18. The example that Maathai gives is that of Mount Kenya, which, as a result of miscommunication between German explorers and the local inhabitants, was named after the Kikuyu word for gourd, *kii-nyaa*. Similar stories exist for the naming of Cameroon after a Portuguese word for shrimp found in abundance near the mouth of the river that empties into the Gulf of Guinea. Additionally, the name of Senegal may have resulted from a similar misunderstanding when European explorers were told by local fisherman "su nu ngaal," meaning "this is our boat" in Wolof.

19. See Thiong'o (1986).

20. The heading references the 2008 film *Entre les murs* by Laurent Cantet, which chronicles the difficulties of a group of middle-school students in one of France's multiethnic districts in which the socially disenfranchised students find themselves constrained within the limitations of an inadequate educational system.

21. Bekolo's use of the concept of narrative is unique and insightful: narratives are the primary content of the universal language of human and social consciousness, which he terms "le mentalais" (25); "Dans des pays du tiers-monde, le modèle colonial voyait en l'école la recette magique qui allait transformer ces sociétés dites 'primitives' en des sociétés 'civilisées'. Une fois les indépendances acquises, le modèle de l'école n'a jamais été ni remis en question, ni revisité. Aujourd'hui quand cette école ne produit pas des masses de chômeurs prêts à émigrer en Occident dans ce mouvement qu'on a appelé 'la fuite des cerveaux' comme c'est le cas en Afrique noire, elle produit des bras et des cerveaux au service de multinationales étrangères comme c'est le cas des call-centers en Inde. Mais à aucun moment, l'école n'a permis d'acquérir des connaissances capables d'améliorer le quotidien de ces peuples. La narrative de l'école est taillée sur mesure pour mieux la mettre au service de l'économie de marché."

22. "Où la vie se résume en produire, consommer, se reproduire. Dans un monde qui a décidé d'exploiter la connaissance de manière utilitariste à travers une école qui ne cherche pas à former des êtres humains ayant avant tout une entière maîtrise de leur être, de leur pensée, de leur comportement et de leur environnement. . . . Malgré une scolarisation grandissante, persistent des problèmes de pauvreté liés à l'absence de maîtrise de soi, de son corps, de sa santé, de son environnement, de la culture, de la production des richesses, de l'alimentation, de la société, de la nature, de la communauté . . . tous toujours en perpétuelle mutation" (2009, 173–74); Dead Prez (2000) expresses a similar dissatisfaction with an education system depicted in the chorus of their song "They Schools" as "They schools ain't teachin us, what we need to know to survive. / They schools don't educate, all they teach the people is lies."

Notes to Pages 174–179

23. Caplan (2018) makes the astounding argument that the vast majority of educational activity consists of "signaling," whereby the accumulation of accolades, grades, and degrees merely serves to signal the productive potential of individuals for prospective employers.

24. "C'est très exactemet ce que j'ai vécu moi-même il y a plus de cinquante ans. Depuis cette époque si lointaine, la condition de l'écolier villageois n'a pas changé, elle est toujours aussi dure, aussi précaire."

25. "Et, avantage supreme, cette école-là du moins destinerait l'homme ainsi formé à la vie au village, au lieu de l'aliéner dans des rêves utopiques."

26. "L'enjeu final [est] précisément moins de distribuer de l'instruction que de soustraire l'éducation des enfants africains à un État parfaitement disqualifié et d'ailleurs incompetent."

27. In similar fashion, Kobhio (1995) recounts the exploits of German missionary and doctor Albert Schweitzer (1875–1965) in the Gabonese rainforests from an African perspective that is critical of Western medicine and religion while illustrating the value of the often-intertwined medicinal and spiritual practices of indigenous communities.

28. "L'un des plus grands ports de France. De nombreux Africains y travaillent comme dockers."

29. Sembène (1966a) is also a commentary on the postcolonial incarnation of continued indentured servitude, both on an individual and on a national-allegorical level.

30. In an interview presented by Bernard Magnier, Sony Labou Tansi recalls his experience as a middle-school teacher "par sanction" following the demise of Massemba-Débat's regime and how he engaged in similar projects. "Les mercredis et vendredis après-midi, tous les élèves devaient faire quelque chose, du sport, de la culture, de la production, de l'art ménager, tout ça. Et ça a été beaucoup plus subversif encore!" (2005, 53; Every Wednesday and Friday afternoon, all the students had to do something, sport, culture, production, domestic arts, all of that. And that was even more subversive!). In the late 1970s, it would appear that Tansi was engaged in service-learning projects decades before it was in vogue in today's Western universities.

31. "On n'a pas le droit d'être paysan quand on a été à l'école."

32. "Plus jamais de chef dans cette cooperative."

33. A few notable examples include Togo, Gabon, and Congo.

34. "Nous avons pleuré toute la nuit. / L'étape a été longue. / La perdrix a chanté timidement / dans un matin de brouillard. / Champs illuminé de cataractes d'espérances. / Espérance d'une aurore aux dents de balafon. / Et la perdrix s'est tue / car son chant s'est éteint dans la gorge / d'un python."

35. "La capacité à se réapproprier son futur et à inventer ses propres téléologies, à ordonner ses valeurs, à trouver un équilibre harmonieux entre les

Notes to Pages 179–186

differentes dimensions de l'existence, dépendra de la capacité des cultures africaines à concevoir comme des projets assumant le présent et l'avenir et ayant pour but de promouvoir la liberté dans toutes ses expressions" (2016, 87).

36. "Cependant, au-delà de la nécessité d'une éducation de masse de qualité, se pose la question fondamentale de la nature des savoirs à promouvoir et à transmettre" (2016, 100).

37. In Tansi (1979), the Pygmies are represented as superhuman, almost divine beings.

38. "Maintenant quand j'y pense, je m'étonne de l'idée saugrenue de mon père d'obliger les Pygmées à parler la langue française, comme si faire de nous les descendants d'ancêtres gaulois ne suffisait pas!"

39. Similarly, in the ancient Central African mythologies of the Mvet, there is a corresponding fluidity between the two worlds of the dead and the living.

40. For more on Mbembe's notion of an economy of death and the society of baroque spectacle that pervades postcolonial African political culture, see Joslin 2009.

41. This particular scene can be considered a homage to the protagonist in Ferdinand Oyono's *Houseboy*, who refers to himself in the service of his White colonial master, the Commandant, in these words: "Le chien du roi est le roi des chiens" (1956, 32; The dog of the king is the king of dogs).

42. Manga reveals to Gonaba that he cannot return to his village until he has become a soldier, which is the dream that he has set out to achieve, and so he leaves Gonaba in the jungle, slipping away in the night while he is asleep.

43. According to the DVD jacket, this is the specific ethnicity that is represented in the film.

44. See Conklin 1997.

45. "La légitimité de la démarche qui consiste à tenter de saisir le réel africain par cet outil que l'on nomme la *science* ne fut pas interrogée" (2016, 112).

46. "Les langues africaines sont les voies d'accès privilégiées permettant la prise en charge des cultures concernées, ainsi que leurs contenus en termes de pensée et de savoirs" (2016, 106).

47. "Si je n'avais pas eu ma grand-mère, je serais parti à l'école pour rien. Qu'est-ce que j'aurais appris? Rien."

48. "Après le travail scolaire pendant la matinée, les après-midi, c'était le travail manuel, parce que c'est nous qui construisions les bâtiments, c'est nous qui réparions, c'est nous qui faisions tout."

49. "J'écrivais phonétiquement"; "tous les soirs, je retrouvais ma grand-mère maternelle."

50. Bekolo similarly describes "la vieille de mon village" (the old woman of my village), whose words and actions not only ground him in the genealogy

and territoriality of his ancestors but whose very existence also constitutes a critique of the mediatic intervention and technological functionalism of global society, providing a glimpse into a different mode of being with others in the world (2009, 13–19).

51. "Il s'agit d'envisager une société où tout est école. Une école ouverte installée au cœur de chaque communauté où tous sont à la fois enseignants et élèves. . . . Une école où tout est savoir, à commencer par les connaissances dont nous avons besoin pour améliorer notre vie quotidienne. . . . Une école qui 'construit' de manière permanente une culture de l'anticipation, de la prévention, de la spéculation et de l'organisation pour tous au sein de chaque communauté"; this is similar to the vision expressed by Liking as "d'une véritable éducation répondant aux aspirations d'une âme humaine en quête d'évolution et résolvant les problèmes d'équilibre que suscite nécessairement la reproduction des corps susceptibles d'être choisis pour une orientation consciente" (1983, 144; a veritable education that responds to the aspirations of a human soul on an evolutionary quest and that resolves problems of equilibrium that necessarily arise from the reproduction of bodies susceptible to be chosen for a conscious orientation).

52. For example, Shizha comments on the ways in which Guinea's traditional healers were instrumental in identifying plant species that were considered effective in the treatment of diabetes mellitus (23).

53. "Se mettre au pas et au rythme de ce monde"; "la *poiésis* (créativité), la fonction générique de l'homme" (2016, 130).

54. "Une modernité politique bien comprise est toujours portée par une dynamique endogène qui saura s'accorder avec les exigences universelles de liberté et de dignité humaines" (2016, 131).

55. Aldous Huxley wrote: "In a world where education is predominantly verbal, highly educated people find it all but impossible to pay serious attention to anything but words and notions. There is always money for, there are always doctorates in, the learned foolery of research into what, for scholars, is the all-important problem: Who influenced whom to say what when? Even in this age of technology the verbal humanities are honored. The non-verbal humanities, the arts of being directly aware of the given facts of our existence, are almost completely ignored" (1954, 76).

56. "La conception de l'univers qui transparaît dans divers saviors et pratiques africains est celle d'un cosmos considéré comme un grand vivant" (2016, 115).

57. In "The Language of Nativism," Trinh Minh-ha (1989) describes how scientific discourses, including that of anthropology, have been constructed in ways that privilege the particular forms of dominant discourses, namely the insistence upon systems, methods, and absolute certainty. She writes: "'Complete,' 'systematic,' 'methodical,' 'scientifically trained,' 'really relevant,'

Notes to Pages 189–194 301

'aims,' 'real importance'—so much of the scientific mind condensed in such a repetitively short statement. Common sense, turns out to be the kingdom of the mute, the unreal, and the 'illiterate.'" She continues: "Science is Truth, and what anthropology seeks first and foremost through its noble defense of the native's cause (whose cause? you may ask) is its own elevation to the rank of Science" (57).

58. "Les cosmogonies et le ontomythologies révèlent une vision du monde et, partant de là, le rapport au réel des sociétés africaines ainsi que le rôle et la fonction assignés à l'homme dans le cosmos" (2016, 117).

Chapter 6: Paradis Artificiels

1. "[A]spirant sans cesse à réchauffer ses espérances et à s'élever vers l'infini, il montrait, dans tous les pays et dans tous les temps, un goût frénétique pour toutes les substances, même dangereuses, qui, en exaltant sa personnalité, pouvaient susciter un instant à ses yeux ce paradis d'occasion, objet de tous ses désirs, et enfin que cet esprit hasardeux, poussant, sans le savoir, jusqu'à l'enfer, témoignait ainsi de sa grandeur originelle"; unless otherwise noted, all translations from French are my own.

2. "Car l'amour de l'argent est une racine de tous les maux; et quelques-uns, en étant possédés, se sont égarés loin de la foi, et se sont jetés eux-mêmes dans bien des tourments."

3. "Les maîtres-mots que sont développement, émergence économique, croissance, lutte contre la pauvreté pour certains, sont ces concepts clefs de l'épistémè dominante de l'époque" (Sarr 2016, 13).

4. "La pensé économique dominante véhicule une culture, une vision du monde et de l'homme particulière (*homo economicus*)" (Sarr 2016, 71).

5. See, for example, Rodney (2011), who argues that "African development is possible only on the basis of a radical break with the international capitalist system, which has been the principal agency of underdevelopment of Africa over the last five centuries" (vii).

6. "*L'Homo africanus* n'est pas un *homo economicus* au sens strict" (2016, 76).

7. Walter Benjamin proposed a similar critique of artistic creation becoming devalued in the age of mechanical reproduction.

8. Bekolo's use of the concept of narrative (again) is unique and insightful: narratives are the primary content of the universal language of human and social consciousness, which he terms "le mentalais" (25).

9. "[Elle] veut divertir dans un but mercantile, donc faire diversion en cherchant non pas la narrative de vie, mais la narrative de l'argent, la recette qui rapporterait le plus. Une espèce d'exploitation de nos malheurs."

10. "C'est cette *narrative réductrice* que génère l'argent à la vie qui est en question. L'argent c'est la perceuse, la formule magique par excellence censée ouvrir les portes, sauf peut-être la principale."

11. "Cette terminologie empreinte d'économisme et d'abstraction statistique, … cette perspective inverse de l'humain, qui consacre le primat de la quantité sur la qualité, de l'avoir sur l'être; leur présence au monde n'étant évaluée qu'en points du PIB ou en poids dans le commerce international" (2016, 11).

12. "Dans ce context, le discours économique fonctionne comme un langage qui assure l'établissement du code symbolique commun à travers lequel la manière de dire, de penser, de faire l'expérience du réel du groupe s'élabore" (71–72).

13. "L'argent nous rend pauvres! On voue à l'argent un culte des idoles comme les païens de l'antiquité."

14. A BBC News article from January 24, 2019, by Christopher Giles and Jack Goodman entitled "Reality Check: Does the CFA Franc Keep Some African Countries Poor?" explores the ways in which the imbalanced economic policies between France and its former colonies in Africa hinders their economic development, suggesting that this may in turn contribute to the migrant crisis affecting countries on the Mediterranean Sea.

15. Sissako's 2014 release, *Timbuktu*, was received with similar success. It portrays conflicting human narratives in the struggles of citizens under the oppressive rule of Islamic militants in the ancient northern city of Timbuktu.

16. Verschave builds upon his extensive research into the political, economic, and military mechanisms of the transnational neocolonialist exploitative networks that he terms Françafrique, implicating "la mondialisation de la criminalité financière" (2004, 7). He concisely outlines the ways in which corruption consistently keeps "l'aide au développement publique" from actually reaching the public (it instead develops only the financial interests of concerned parties) and further delineates the ways in which "la dette du tiers monde" constitutes a fundamental mechanism for this kind of criminal profiteering (16–18). Moyo (2009) further critiques the international aid model for its inefficaciousness. Finally, Sharife (2016) explicitly describes the ways in which international tax havens such as Switzerland or the Cayman Islands have for decades enabled the expropriation of approximately $150 billion annually.

17. In much the same fashion Mambety (1994), which will be discussed later in this chapter, and *La petite vendeuse de Soleil* (1999) depict the lives of ordinary people in their repetitive mobilities, constantly moving through the same spaces in a way that resembles the movements in his earlier film, *Touki Bouki*, journeying in the manner of a hyena.

18. Williams (2017) further delineates the ways in which Sissako's representation of human narratives in the film contrasts and critiques the institutional languages of neoliberalism. This analysis reflects the critical analysis of Slaughter (2007), which underscores the parallels between the legal discourse of international human rights and the literary discourse of

Notes to Pages 199–206

the global, postcolonial novel, in that they both serve to inscribe agency within a narrative form that inherently valorizes the Western biases of individualism within a particular social order.

19. Fara's love letter to Jacqueline aptly illustrates this progression: "Il me faut, désormais, Vous et Paris, Paris dans Vous et Vous dans Paris" (72–73). As a means for him to possess these two loves, Fara discovers the absolute necessity of money.

20. "À voir, dans les couloirs, cette foule d'hommes et de femmes qui s'entrecroisaient dans tous les sens, courant après l'argent et les émotions, à voir tourbillonner les billets de banque, tourbillon scandé par le coup de dent mat des machines à poinçonner les tickets et par la voix rauque de l'homme des 'côtes', Ambrousse ne se possédait plus."

21. "Il jouait, gagnait, perdait, tant qu'il avait de l'argent … il avait supporté ces privations jusqu'à ce que la bonne fortune le remît à flot; il s'était moqué de sa nouvelle chance et l'avait lâchée pour un autre illusion."

22. See the examples discussed previously in chapter 4.

23. Cf. Verschave (2004); for more on the notion of casino capitalism, see Strange's (2016) critical analysis of free markets, originally published in 1986 and rereleased by Manchester University Press in 2016.

24. For more on the notion of "la folie sage," see my interview with Professor Papa Gueye of the UCAD, which appears in the appendices of Joslin, "Baroque and Post/colonial Sub-Saharan Francophone Africa" (PhD diss., University of Minnesota, 2010).

25. "L'argent a gâté le monde aujourd'hui."

26. "Une espèce d'excitation angélique, un rappel à l'ordre sous une forme complimenteuse."

27. "Promeneur sombre et solitaire"; "ceux-là qui ont su, comme Hoffmann, construire leur baromètre spirituel."

28. Working papers of the IMF, such as the one published in 2005, "Ten Years after the CFA Franc Devaluation: Progress toward Regional Integration in the WAEMU," detail the issues and outcomes associated with this policy. See https://www.imf.org/en/Publications/WP/Issues/2016/12/31/Ten-Years-After-the-CFA-Franc-Devaluation-Progress-Toward-Regional-Integration-in-the-WAEMU-18382.

29. One may also note the baay-fall, a subgroup of the sufi, mouride brotherhood (established in 1883 by Amadou Bamba) who follow the teachings of one of Bamba's disciples, Ibra Fall (photograph). A reference to these figures is made by Mambety in his early short film, *Contras' City* (1968).

30. Cf. Gilroy (1993).

31. Subversive complicity, which I analyze in my dissertation on the baroque in African cultural contexts, is the concept of baroque cultural practice that Mbembe (2000) discusses.

304 Notes to Pages 207–212

32. "Voyez-vous, dans cette trilogie, hélas, ce qu'il y a de fondamental c'est l'argent. Il était un temps, il fut un temps certainement où les termes de l'échange entre les hommes étaient autre choses que cela. Certainement ça a existé. Mais il a fallu que certains veuillent être plus riches que d'autres. Ça c'est à l'origine même de l'humanité. Où le terme même du partage s'est cassé si bien qu'on a créé des pauvres, là on a créé des riches. Eh ben, c'est ça la croix de l'homme. Voyez-vous les oiseaux? Ils n'ont pas besoin d'argent." This quote is taken from an interview included with his two films, *Le Franc* and *La petite vendeuse de soleil.* The latter also stages a monetary problem in that the protagonist, Sili, is unable to repay the money that she stole from her grandmother because she has already broken the banknote to buy newspapers; she must sell the papers if she hopes to pay back the amount of the original banknote.

33. "Les économies des sociétés traditionnelles africaines étaient caractérisées par le fait que la production, la distribution et la possession des biens étaient régies par une éthique sociale qui avait pour but de garantir la subsistance de tous, grâce à une répartition des ressources et au droit de chaque membre de la communauté de recevoir une aide de la société entière en cas de besoin" (2016, 79).

34. "Comportements d'épargne, d'investissement, d'accumulation, ainsi que les logiques ou rationalités qui président à ccertains modes de comsommation sont culturellement déterminés" (2016, 68).

35. First President Félix Houphouët Boigny is often credited with coining the term "Françafrique" in his efforts to appease the French colonial power in his bid for national independence (1960). Boigny favored a cooperative economic policy with France in direct conflict with the efforts of his contemporary leaders in Mali and Senegal, Modibo Keita and Léopold Sédar Senghor, who were striving with other decolonization activists to create the Mali Federation of independent West African States. Kramo-Lanciné's film can therefore also be read as a critique of Houphouët's policies of independent national wealth to the detriment of the larger community of postcolonial West African nations, which has yet to fully realize economic independence.

36. "Une économie relationnelle semble être le déterminant le plus puissant des échanges et la charpente de l'économie matérielle" (2016, 83).

37. In the absence of the colonial father, Mougler's dying mother represents the slow decay of indigenous traditions, leaving the postcolonial orphan suspended in a no man's land of conflicting ideals.

38. In addition to Verschave's revelations of the inner workings of Françafrique, Békolo (2010), using documentary footage, interviews, and commentary, depicts the complicity of early African leaders in furthering the "cooperative" economic policies of French neocolonialist interventionism, including Houphouët Boigny and Omar Bongo.

Notes to Pages 214–220 305

39. My doctoral research on the baroque aesthetic in Francophone African literatures similarly explored the complexities of representation in the art and politics of colonial, anticolonial, and postcolonial discourses.
40. See Hedges (2009).
41. "L'ubuntu 'je suis parce que nous sommes' se fondant sur l'essence sociale de l'individu, privilégie le bien commun et le respect de l'humanité de l'autre" (2016, 96).
42. "L'ordre économique tend à devenir hégémonique, déborde son espace naturel et tente d'imposer ses significations et ses logiques à toutes les dimension de l'existence humaine" (2016, 65).
43. "L'économie est enchâssée dans la société" (2016, 52).
44. "Pour en tirer avantage, il faudrait un bouleversement radical de ses principes ou une renégociation des rapports que l'on entretient avec lui [le marché], en choisissant parmi les modalités d'insertion dans ce processus, celles qui leur sont avantageuses" (2016, 126).

Chapter 7: Arguing against the Shame of the State

1. "En ces temps de crise de sens d'une civilisation technicienne, offrir une perspective différente de la vie sociale, émanant d'autres univers mythologiques et empruntant au rêve commun de vie, d'équilibre, d'harmonie, de sens" (Sarr 2016, xiv). Unless otherwise noted, all translations from the French are my own.
2. "On attend toujours aujourd'hui ces propositions pour une Afrique qui devrait soit rejoindre le monde, soit proposer une alternative au monde."
3. In this article, Moser interweaves the poststructuralist position of Michel Serres's resistant sociopolitical philosophy with a mystical naturalism in Le Clezio's literary oeuvre in order to effectively argue for an ecology of space and time that transcends the Anthropocene. By invoking the concept of the biotic in such a way that it no longer asserts the human as the dominant life form, the consequences of this position entail an emancipatory counter-discourse to the global conception of the human as defined by its biopower in a technologically mediated social and political economy.
4. "Les valeurs culturelles d'une société étant en constante redéfinition, les sociétés africaines en mutation sont symptomatiques de cette renégociation permanente de leurs références culturelles et de cette contemporanéité (transversalité) de plusieurs mondes" (2016, 41).
5. Note the use of the poetic term for rhythmic analysis, implying an embodied poetics as philosophy, a notion further espoused by Sarr: "Les formes achevées qu'il ne s'agirait que de reprendre et de répliquer en politique, en édification des villes, en pratiques sociales, juridiques, économiques, attesteraient l'idée que les choses auraient pris leurs formes définitives et ultimes. Que le monde serait achevé . . . Un tel mimétisme est anesthésiant

et mortifère. Il signe la fin de la *poiésis* (créativité). C'est une amputation de la fonction générique de l'homme qui est de créer" (2016, 130). (The completed forms that we continue to see being re-created and reapplied within politics, within the construction of cities, within social, juridical, and economic practices, would attest to the idea that things have already taken on their definitive and final forms. That the world has been completed . . . this kind of mimicry is anesthetizing and deadly. It marks the end of *poiesis* [creativity]. It's a veritable amputation of the generic function of human as creator [2019, 97].)

6. "La multiplicité des scansions des philosophies africaines doit être évaluée non comme un excès, mais comme le lieu du manque, fleuron en germination qui, dans ses exuberances, dictions, et scriptions se veut le champ où tous les possibles s'essayent tour à tour, se provoquent, s'annulent et recommencent."

7. "Cette Afrique qui *est* et qui advient est protéiforme. Sa raison est plurielle" (2016, 41).

8. "Se nourir du passé pour mieux aller de l'avant" (2016, 145).

9. "Évaluer le progrès supposerait du temps qu'il soit linéaire. Or il est disparate, il est comme un paysage, très varié, où se croisent des vallées fleuries–le progrès–et d'autres désertiques–la régression. Parfois un même objet peut contenir les deux extrêmes. La télévision, par exemple. Elle constitue un progrès technologique considérable, mais aussi un motif de sacrifice humain et de régression si j'en juge par la plupart des programmes dont les cadavres capturent l'image et au sein desquels la mort est le mot le plus répandu."

10. "Elle est aussi la production de son imaginaire; une construction virtuelle qui peut prendre forme dans le réel."

11. The theme of a museum for humanity is also iterated in Boualem Sansal's novel *2084, la fin du monde*, in which the character Toz is revealed to be the sole curator of a "museum of nostalgia" that depicts the everyday use-objects of human societies prior to the advent of the timeless totalitarian regime of Abistan, which encompasses the novel's diegetic space.

12. "Souci d'éthique: voilà un trait dominant de la littérature proche des questions d'écologie et d'environnement"; Chamoiseau makes the same observation in his critical work *Écrire en pays dominé* concerning the range of linguistic, socio-cultural, and ecological problems extant in former colonies.

13. "L'enjeu sous-jacent de tout discours écologique est celui du développement."

14. "L'écrivain note ainsi l'acharnement avec lequel le monde de la civilisation, le nôtre, engage volontiers à détruire le vivant sans le moindre sentiment de culpabilité."

Notes to Pages 227–230

15. See the title of Tansi's second novel, *L'État honteux* (1981), in which the illegitimacy of corrupt political, societal, and cultural structures is clearly delineated.

16. C. Tsehloane Keto elaborates this notion in *The Africa Centered Perspective of History and Social Sciences*, writing: "Further, if an Africa centered perspective draws its inspiration from the instructive anvil of early history, it should be imbued with sensitivity towards the complementary roles of gender for continuing the biological security and survival of society" (1989, 16–17).

17. This filmmaker's work is discussed in further detail in chapter 5.

18. In another of Kobhio's films, *Le Silence de la forêt* (2003), the intrinsic value and mystic spiritual importance of the forest are more explicitly shown when another teacher, Gonaba, attempts to educate a Pygmy population residing there. Rather than convincing them to adopt Western ways of thinking, Gonaba undergoes a transformation during his experience and his initiation into the Pygmy community. He is conscious of their esoteric worldview based on an intimate relationship with the forest, the source of all that is necessary for their survival and well-being.

19. *Les bouts de bois de Dieu* (*Banty Mam Yall* in Wolof) is the title of Ousmane Sembène's novel concerning a rural population's extreme dedication to resisting pressure from large railway firms in 1947. Moreover, in the "Anan Kissié" (Holy Monday) section of Jean-Marie Adé Adiaffi's novel *La Carte d'identité*, the author offers a dialectic critique of religion while demonstrating that certain animistic beliefs survive in nearly all the world's largest religions, which allows for a conception of the sacred free from any spectrum of "good and evil." In the same way, one may reference the poetry of Birago Diop (1960), who demands in his well-known poem "Souffles" (Breaths), "Écoute plus souvent / Les Choses que les Êtres" (64–66; Listen more often / To Things than to Beings), because knowledge and sacredness exist throughout the world, especially in the natural realm.

20. "La tradition est le lieu où se configurent les valeurs spirituelles fondamentales qui donnent sens à la vie" (2016, 32).

21. "La double dimension spirituelle et sensuelle de l'amour."

22. Martin-Granel makes a different observation, identifying the political nature of Tansi's first novels while placing the theme of feminine love at the heart of Tansi's last novels, beginning with *Les Sept Solitudes de Lorsa Lopes*. However, I propose that this theme of femininity is equally significant in Tansi's early work, albeit in a less explicit form. This form is a part of a naturalistic and humane ecology, a concept that will be clarified in the following analysis.

23. Moser (2018) completed a scholarly analysis of Serres's philosophical writings, introducing a sharp critique of modernity and the media-fueled

narcissism that interweaves the fabric of global society in the absence of attention to humanity's common interests.

24. "Par leur dynamique interne, ces réseaux [médiatiques] construisent donc un autre réel, une autre société, une nouvelle idéologie, une autre éducation, une autre politique et ainsi de suite, un autre mode d'être et de vérité. . . . Délaissant le rôle de représenter un réel déjà là, ils prennent celui de créer le leur propre."

25. The words of Debord are applicable at this juncture: "Toute la vie des sociétés dans lesquelles règnent les conditions modernes de production s'annonce comme une immense accumulation de spectacles. Tout ce qui était directement vécu s'est éloigné dans une représentation" (3; In societies where modern conditions of production are in place, all of life is expressed as an immense accumulation of sights and spectacle. Anything that might be directly lived or experienced is distanced from the beholder, reduced to a mere representation).

26. "Cette obsession de tout dénombrer, évaluer, quantifier, mettre en équations" (2016, 18).

27. "La nature de la vie relationnelle, culturelle, spirituelle, etc., tout ce qui fait l'existence . . . passent à travers les mailles de leurs filets trop larges" (2016, 18–19).

28. "Voici venir le temps où la Philosophie doit descendre du sujet dans les choses, de l'égo cartésien dans les fleurs et la cire, la cire et la flamme, qui se mettent à entretenir un étrange dialogue."

29. Moser has explicitly identified the idea of the divine permeating the natural realm in Serres's environmentally conscious writing (2018, 90–91).

30. "L'ensauvagement de l'humain, l'incapacité de rester vivant. L'homme en dépaysement sous sa propre peau."

31. "La modernité africaine reste à inventer, [qui] doit être pensée comme une greffe à réussir par l'incorporation sélective de pratiques et d'institutions qui lui sont initialement étrangères" (2016, 33–34).

32. "Que la littérature de l'écologie est une littérature de fin du monde."

33. "*La Vie et demie* devient cette fable qui voit demain avec des yeux d'aujourd'hui."

34. "Un silence qui pesa dans le cœur du docteur le poids de cette Afrique, mystérieuse, imprévisible, fauve, enracinante malgré tout."

35. "Ce n'était pas les hommes qu'il pouvait aimer . . . mais le vide que ces hommes mettaient entre lui et eux. Un vide exquis, rempli de vertiges: ce vide qui nous vient des autres."

36. "Une époque où l'homme est plus que jamais résolu à tuer la vie."

37. Devésa has already noted this tendency in Tansi's written work, as discussed in his essay titled "Sony Labou Tansi: écrivain de la honte de des rives magiques du Kongo."

Notes to Pages 235–238

38. "Concevoir la vie, le vivable, le viable autrement que sous le mode de la quantité et de l'avidité" (2016, 13).
39. "On habite l'extérieur de la vie."
40. Riesz points out the paradoxical manner in which shame plays into Tansi's work, describing this shame as invading yet simultaneously occupying a void, negative space: "'Shame' seems only to express a void, the black hole of a dictatorial regime with no legitimacy" (2000, 121).
41. The leader says, "Nous sommes des morts" (We are dead) and, by contrast, "La forêt: Les arbres, tous les arbres me semblèrent des ancêtres. Ils m'ont ouvert leurs bras" (Tansi 1983, 183; The forest: The trees, all the trees appeared to be ancestors. They opened their arms to me).
42. "Ce monde-ci est fou. Il n'y a plus que les papiers qui raisonnent, qui pensent, qui respirent. Les hommes, tous les hommes sont bouchés. Tous les cœurs. Toutes les têtes. Tous les sangs. Le seul sang qui circule, c'est celui des papiers."
43. "Les gens de la ville consommaient bien le sexe."
44. "Il n'y a pas d'amour qui aille plus loin que le sexe. C'est terrible, ça, c'est horrible!"
45. "Est donc une manière d'être qui questionne la vertu trop rigide. Ici, l'amour humain tend à sauver la vie naturelle, spontanée, il est du côté de la vie saine et heureuse."
46. "La forêt seule pouvait aider ceux qui avaient tué leur place dans le bordel de la bâtardise."
47. "Si la vie cesse d'être sacrée, la matière, toute la matière ne sera qu'une sourde folie."
48. Caroline Giguère and Christiane Ndiaye have separately characterized Tansi's stylistic technique of allowing his writing to take shape in textual acts. In the most pertinent passage of Giguère's article, "La Vie et demie ou les corps chaotiques des mots et des êtres," she discusses the idea of "Ajouter de la chair aux mots" (101). She also discusses certain textual tendencies, such as the equivalence of blood and ink along with other corporeal metaphors saturating the text, drawing the conclusion that "le corps parle alors de lui-même, de sa condition incertaine . . . liée à la langue qui le dit" (104; in these moments, the body speaks of itself, of its uncertain condition . . . linked to the very tongue that describes it).
49. "Le simulacre a pris toute la place, le non-lieu a dévoré tous les lieux."
50. "Sony Labou Tansi nous invite à une écologie du réel"; "d'un nouvel éco-système humain."
51. It is important to note that in L'anté-peuple, the protagonist Dadou also finds assistance from "un pêcheur pygmée au village [qui] connaît beaucoup de plantes" (Tansi 1983, 137; a Pygmy fisherman from the village who knows many plants).

310 Notes to Pages 238–243

52. The fact that Chaïdana survives while her twin brother Martial dies an agonizing death implicitly suggests the importance of femininity in Tansi's ecocriticism.

53. "Les sèves qu'on met dans les yeux pour voir très loin ou pour voir dans la nuit. Les sèves qu'on met dans les narines pour respirer l'animal ou l'homme à distance. Les sèves qui font dormir ou qui empêchent de dormir. Les sèves qui provoquent les mirages ou les effets du vin. La gamme de poisons. La gamme de drogues. Les mots aussi. Les mots qui guérissent. Les mots qui font pleuvoir. Les mots qui donnent la chance. Ceux qui la tuent" (1979, 98).

54. "C'est quelque chose qui vous bouffe."

55. "Le bitumage de la route dite de la Fraternité, l'installation non loin de la mission catholique de Darmellia d'un village d'attraction, comptant deux cent douze villas ultra-modernes, la construction d'un hôpital de trois mille lits à côté d'un collège capable d'héberger cinquante professeurs et six mille élèves" (1979, 102).

56. "La chasse au Pygmées pour leur intégration atteignit son paroxysme."

57. Sarr describes the economies of precolonial African civilizations as being "*enchâssée[s] dans la société*" with the goal "d'assurer la subsistance des individus" rather than "un progrès continu des sociétés" (2016, 52), a model that is unsustainable over the long term. ("The economy was inserted into the society [and] aimed at ensuring individual subsistence," rather than "the possibility of continuous progress in societies" [2019, 32], a model that is unsustainable over the long term.)

58. "Pont Darmellia qui séparait ceux de la forêt de ceux de Jésus-Christ."

59. "C'était la forêt du temps, la forêt de la vie, dans la forêt de son beau corps" (1979, 101).

60. The very title of this play presents a striking contrast, comparing a life sheltered among trees to the combination of *chars* (tanks) and *bonds* (leaps forward) that forms the word *charbon* (charcoal), an image of destruction and of the death of trees: this constitutes the principal tension of Tansi's ecocriticism.

61. "Mais ce n'est pas en termes de féminisme, parce que ça aussi, c'était une catastrophe. Ça castrait tous les hommes. Ça n'est pas mieux de castrer les hommes ou de castrer les femmes. Ce n'est pas ça, ce n'est pas en ces termes-là, mais je crois que nous sommes complémentaires."

62. "Notre planète est mal gérée. On paie les ingénieurs pour qu'ils foutent des conneries dans la nature, et on ne paie pas les femmes qui élèvent des enfants. C'est tragique, quand même, ça! C'est tragique!"

63. "Un entrelacs d'idées qui, au lieu d'éclaircir la réalité, la voile, en justifiant une praxis et un ordre différents du réel" (2016, 23).

64. "Tous ces pays qui ont été fabriqués à Berlin vont s'écrouler parce qu'ils n'auront aucune base de vie! Donc, c'est sûr, on n'a pas de pays. Et puis si on

Notes to Pages 243–252

veut donner l'indépendance, il faut commencer par la donner au pétrole. Il faut commencer à dire: 'Ce pétrole est indépendant!' À ce moment-là, tout le monde sera indépendant, et puis on commencera à faire les vrais prix, les vrais échanges, les choses fondamentales."

65. For his part, Sarr emphasizes the importance that Africa rid itself of this kind of toxic development strategies, which he describes as, "les économies d'enclaves et d'extraction . . . [qui] n'entraînent pas de développement intégré des pays, créent des problèmes environnementaux et sociétaux, entretiennent la corruption" (2016, 61). (In the long term, such economies do not help to bring about a comprehensive development of countries; rather, they create environmental and social problems and corruption [2019, 40].)

66. "Enfin, j'espère, plus loin que le Coca-Cola et le McDonald [sic]. Je crois que la vie a une telle saveur, une force. . . . Quelque chose de fondamental. Elle est fondamentale, la vie, mais on ne veut pas qu'elle soit fondamentale. Et puis on réduit tout parce qu'on veut maîtriser, on veut gérer. On ne peut pas maîtriser la vie, c'est tant mieux. La vie, c'est une explosion. Laissons-la comme ça! Pourquoi vouloir la maîtriser, l'organiser, la saucissonner, la programmer? Pourquoi?"

67. "Comment allons-nous négocier notre liberté dans un monde où nous nous sentons de plus en plus envahis par des *narratives* 'infectées' de formules, toutes plus où moins suspectes dans leur intention de nous arracher un brin de notre liberté ou un coin de notre cerveau."

68. "Édifier sa voix [e]"; "Il lui faut achiever sa décolonisation par une reoncontre féconde avec elle-même" (2016, 149, 152); also see Sarr (2019, 113, 115). Note the nuance in the original French between *voix* (voice) and *voie* (way), which implies that voicing is the integral process of making one's way in the world.

Conclusion

1. "Les forces / les forces des forces / sans commencement ni fin / Les autres sont venues après"; unless otherwise noted, all translations from French are my own.

2. See my article "La poétique de Sony Labou Tansi: Pour une écocritique équatoriale égalitaire," *Nouvelles Études Francophonees* 33, no. 1 (Spring 2018): 210–25.

3. "Une civilization n'est pas seulement matérielle et technique, elle est complétée par des valeurs morales (et esthétiques) qui l'orientent" (2016, 154).

4. Fassin writes, "Psychic suffering has become the most prominent symptom of precarious lives" (2012, 27).

5. Her grandmother, Chaïdana, also had adopted ninety-three different identities before marrying a previous providential guide (1979, 53).

6. "L'intelligence d'une civilisation réside dans sa capacité à faire la synthèse des mondes complémentaires qui s'offrent à elle et à les intégrer dans un *telos*" (2016, 149).
7. "Une croissance économique infinie dans un monde fini est un mythe" (2016, 154).
8. "Vieux, si je pouvais t'aider à nous débarrasser de tous ces arbres, je le ferais. Même à moi, ils ne m'ont pas appris comment casser cet écosystème. J'ai été initié en tant que future chef mais ma formation n'a pas été complete. Si au moins on m'avait enseigné à repérer le pétrole, le diamant, la cassitérite, là je me serais senti comme un véritable potentat, puissant, tourné vers l'avenir."
9. "Il deviant impérieux d'équilibrer les comptes en faisant passer, par pertes et profits, l'humain d'abord."
10. Arran Stibbe writes of ecolinguistics, "The stories are important because they influence how individuals think, and if they are spread widely across a culture then they can become stories-we-live-by and influence prevailing modes of thought in the whole society" (2015, 16).
11. Explicit reference is made to Orwell's text on p. 137, and again on p. 290.
12. "Manifestations honteuses de la mécanique humaine" (16); "tout était bien réglé et finement filtré, il ne pouvait rien advenir hors la volonté expresse de l'Appareil" (17).
13. "Le système touffu des restrictions et des interdits, la propagande, les prêches, les obligations culturelles, l'enchaînement rapide des cérémonies, les initiatives personnelles à déployer qui comptaient tant dans la notation et l'octroi des privilèges, tout cela additionné avait créé un esprit particulier chez les Abistani, perpétuellement affairés autour d'une cause dont ils ne savaient pas la première lettre."
14. An example of the obliteration of history is told of an abandoned village discovered by pilgrims lost on their way; the site is subsumed into the system, anointed publicly as holy ground (2015, 148–49).
15. "L'Histoire n'existe pas"; "transformer d'inutiles et misérables croyants en glorieux et profitables martyrs." In this passage, it is important to recognize the echoes of Achille Mbembe's (2000) characterization of the postcolonial economy in Africa: an economy of death, as discussed in the previous chapter, in which the spectacle of power exercised upon helpless, nameless citizens through the arbitrary dispensation of death constitutes the method par excellence of auto-ratification of the mechanisms of power. Such a death-world is described in the words of Martial: "Je ne veux pas mourir cette mort" (Tansi 1979, 13; I do not want to die this death).
16. "L'abilang, qui à sa naissance artificielle se voulait une langue militaire, conçue pour inculquer la rigidité, la concision, l'obéissance et l'amour de la mort."

Notes to Pages 258–260

17. "Les banlieues dévastées où régnait encore un peu de pauvre liberté, trop petite pour être efficace, or il en faut beaucoup pour s'attaquer à des secrets sur lesquels reposent des empires inébranlables."
18. "Qu'est-ce que la frontière, bon sang, qu'y a-t-il de l'autre côté?"
19. "Cette vie dans ce monde est finie pour moi, je veux, j'espère en commencer une autre de l'autre côté."
20. "Il n'y a que l'Abistan sur terre."
21. "Qui étions-nous? . . . Le Gkabul ayant colonisé le présent pour tous les siècles à venir, c'est dans le passé, avant son avènement, qu'on pouvait lui échapper."

References

Abouet, Marguerite, and Clément Oubrerie. 2007. *Aya*. Translated by Helge Dascher. Montreal: Drawn & Quarterly.

Absa, Mousa Sene, dir. 2001. *Ainsi meurent les anges*. San Francisco: California Newsreel.

Adams, Anne. 1993. "To Write in a New Language: Werewere Liking's Adaptation of Ritual to the Novel." *Callaloo* 16 (1): 153–68.

Adiaffi, Jean-Marie. 1992. *Silence on développe*. Abidjan: CEDA.

———. 2002. *La carte d'identité*. Paris: Hatier International.

Aduaka, Newton, dir. 2007. *Ezra*. Amsterdam: Filmfreak Distributie.

Alessandri, Brigitte. 2005. *L'école dans le roman africain*. Paris: L'Harmattan.

Amoussou, Sylvestre, dir. 2007. *Africa Paradis*. Paris: Metis Productions.

Anderson, Reynaldo. 2016. "Afrofuturism 2.0 and the Black Speculative Art Movement." *Obsidian* 42 (1–2): 230–38.

Anzaldúa, Gloria. 1999. *Borderlands / La frontera: The New Mestiza*. San Francisco: Aunt Lute Books.

Ashcroft, Bill, Gareth Griffiths, and Helen Tiffin. 1989. *The Empire Writes Back: Theory and Practice in Postcolonial Literature*. London: Routledge.

Bâ, Mariama. 2005. *Un chant écarlate*. Dakar: Nouvelles Éditions Africaines.

Bamboté, Makombo. 1998. *Que ferons-nous après la guerre ou Eloge de l'animisme, Poèmes à diverses dimensions*. Brossard, Quebec: Humanitas.

Bandaman, Maurice. 1996. *La Bible et le fusil*. Abidjan: CEDA.

Barry, Fatoumata Binta, and Sue C. Grady. 2019. "Africana Womanism as an Extension of Feminism in Political Ecology (of Health) Research." *Geoforum* 103: 182–86.

Bates, Severine. 2016. "Homo Mediaticus: Immigrants, Identity, and (Tele) Visual Media in Contemporary Francophone Literature." PhD diss., University of Minnesota.

Bathily, Abdoulaye. 1992. *Mai 1968 à Dakar ou la révolte universitaire et la démocratie*. Paris: Éditions Chaka.

Baudelaire, Charles. 1860. *Les paradis artificiels: Opium et Haschisch*. Paris: Poulet-Malassis et de Broise.

———. 2006. *Le Spleen de Paris: Petits poèmes en prose*. Paris: Gallimard.

Beah, Ishmael. 2007. *A Long Way Gone*. New York: Sarah Crichton.

Bekolo, Jean-Pierre. 2009. *Africa for the Future: Sortir un nouveau monde du cinéma*. Yaoundé: Dagan & Medya.

———, dir. 2010. *Les Pieds nickelés à l'Élysée*. Yaoundé: Ecrans Noirs.

———, dir. 2017. *Les Saignantes*. San Francisco: Immeuble Bekolo.

Beti, Mongo. 2006. *La France contre l'Afrique*. Paris: Éditions la découverte.

Beyala, Calixthe. 1988. *Tu t'appelleras Tanga*. Paris: Éditions Stock.

Bidima, Jean-Godefroy. 1995. *Que sais-je? La philosophie négro-africaine*. Paris: Presses Universitaires de France.

Blake, Cecil. 2005. "An African Nationalist Ideology Framed in Diaspora and the Development Quagmire: Any Hope for a Renaissance?" *Journal of Black Studies* 35: 573–96.

Bofane, In Koli Jean. 2014. *Congo Inc. Le testament de Bismarck*. Paris: Actes Sud.

Boni, Tanella. 2003. "L'amour dans L'anté-peuple de Sony Labou Tansi." *Sony Labou Tansi: Témoin de son temps*, edited by D. Gérard Lezou and Pierre N'Da, 199–212. Limoges, France: Presses Universitaires de Limoges.

Boto, Eza. 1954. *Ville cruelle*. Paris: Présence Africaine.

Bugul, Ken. 1984. *Le Baobab fou*. Dakar: Nouvelles Éditions Africaines.

Butler, Octavia. 1989. *Imago*. New York: Popular Library.

———. 2005. "Positive Obsession." In *Blood Child and Other Stories*. By Octavia Butler, 225–136. New York: Seven Stories.

Cabort-Masson, Guy. 2001. "Le signe du destin." *Une enfance outre-mer*, edited by Leïla Sebbar, 49–57. Paris: Éditions du Seuil.

Camus, Albert. 1947. *L'exil et le royaume*. Paris: Gallimard.

Caplan, Bryan. 2018. *The Case against Education: Why the Education System Is a Waste of Time and Money*. Princeton, NJ: Princeton University Press.

Carrington, André. 2016. *Speculative Blackness: The Future of Race in Science Fiction*. Minneapolis: University of Minnesota Press.

Cazenave, Odile. 1996. *Femmes rebelles: Naissance d'un nouveau roman africain au féminin*. Paris: L'Harmattan.

Césaire, Aimé. 2000. *Cahier d'un retour au pays natal*. Paris: Présence Africaine.

Chamoiseau, Patrick. 1997. *Écrire en pays dominé*. Paris: Gallimard.

Cherki, Alice. 2002. Preface to *Les damnés de la terre*. By Franz Fanon, 5–15. Paris: Éditions la Découverte.

Cissé, Souleyemane, dir. 2016. *Yeelen*. San Francisco: Kanopy Streaming.

Clarke, Arthur C. 1973. *Profiles of the Future: An Inquiry into the Limits of the Possible*. New York: Harper & Row.

Conklin, Alice. 1997. *A Mission to Civilize: The Republican Idea of Empire in France and West Africa 1895–1930*. Stanford, CA: Stanford University Press.

Dadié, Bernard. 1955. *Le pagne noir: Contes africains*. Paris: Présence Africaine.

———. 1959. *Un Nègre à Paris*. Paris: Présence Africaine.

References

D'Almeida, Irène Assiba. 1996. "The Intertext: Werewere Liking's Tool for Transformation and Renewal." *Postcolonial Subjects: Francophone Women Writers,* edited by Mary Jean Green, Karen Gould, and Micheline Rice-Maximin, 265–84. Minneapolis: University of Minnesota Press.

Dastile, Nontyatyambo. 2013. "Beyond Euro-Western Dominance: An African-Centered Decolonial Paradigm." *Africanus* 43 (2): 93–104.

Dead Prez. 2000. *Let's Get Free.* New York: Columbia Records.

Debord, Guy. 1992. *La Société du spectacle.* Paris: Gallimard.

Deleuze, Gilles, and Félix Guattari. 1980. *Mille plateaux: Capitalisme et schizophrénie.* Paris: Éditions de Minuit.

———. 1987. *A Thousand Plateaus.* Translated by Brian Massumi. Minneapolis: University of Minnesota Press.

Dérive, Jean. 2003. "Sony Labou Tansi, poète de l'amour." *Sony Labou Tansi: Témoin de son temps,* edited by D. Gérard Lezou and Pierre N'Da, 129–39. Limoges, France: Presses Universitaires de Limoges.

Derrida, Jacques. 1995. *Mal d'archive.* Paris: Éditions Galilée.

Devésa, Jean-Michel. 1996. *Sony Labou Tansi: Écrivain de la honte et des rives magiques du Kongo.* Paris: L'Harmattan.

Diome, Fatou. 2003. *Le ventre de l'Atlantique.* Paris: Éditions Anne Carrière.

Diop, Birago. 1960. *Leurres et lueurs.* Paris: Présence africaine.

Diop, Boubacar Boris. 1981. *Le Temps de Tamango.* Paris: Éditions L'Harmattan.

Diop, Cheikh Anta. 1954. *Nations nègres et culture.* Paris: Présence Africaine.

Diop, Ibrahima. 2005. *La rue publique de mai 68.* Dakar: Éditions Maguilen.

Disney, Abigail, dir. 2009. *Pray the Devil Back to Hell.* Warren, NJ: Passion River Films.

Dongala, Emmanuel. 1982. "Jazz et vin de palme." *Jazz et vin de palme et autres nouvelles.* Paris: Hatier.

———. 2001. "L'enfant de l'instituteur." *Une enfance outre-mer,* edited by Leila Sebbar, 73–86. Paris: Éditions du Seuil.

———. 2005. *Johnny Mad Dog.* Translated by Maria Louise Ascher. New York: Farrar, Straus and Giroux.

Duparc, Henri, dir. 1997. *Une couleur café.* Paris: Médiathèque des Trois Moindes.

Eboussi-Boulaga, Fabien. 2011a. *L'Affaire de la philosophie africaine.* Yaoundé et Paris: Éditions Terroirs et Karthala.

———. 2011b. "Préface: Le topos de l'exil et son poème." *Exils et migrations postcoloniales: De l'urgence du départ à la nécessité du retour,* edited by Pierre Fandio and Hervé Tchumkam, 9–27. Yaoundé: Éditions Ifrikiya.

Elalamy, Youssouf Amine. 2011. *Les clandestins.* Vauvert, France: Éditions au diable vauvert.

Ellison, Ralph. 1995. *Invisible Man.* New York: Vintage International.

Étoké, Nathalie, dir. 2012. *Afro-Diasporic French Identities.* New London, CT: Movimiento.

Fall, Aminata Sow. 2010. "La fête gâchée." *Nouvelles du Sénégal*, edited by Pierre Astier, 129–40. Paris: Magellan & Cie.

Fandio, Pierre, and Hervé Tchumkam, eds. 2011. *Exils et migrations postcolniales: De l'urgence du depart à la nécessité du retour.* Yaoundé: Éditions Ifrikiya.

Fanon, Frantz. 1952. *Peau noire, masques blancs.* Paris: Éditions du Seuil.

Fassin, Didier. 2012. *Humanitarian Reason: A Moral History of the Present.* Translated by Rachel Gomme. Berkeley: University of California Press.

Faye, Gaël. 2013. *Pili-pili sur un croissant au beurre.* Paris: Mercury Records.

Faye, Safi, dir. 1975. *Kaddu Beykat.* Dakar: Safi.

Foucault, Michel. 1990. *The History of Sexuality Volume I.* Translated by Robert Hurley. New York: Vintage.

Frankema, Ewout, and Marlous van Waijenburg. 2018. "Africa Rising? A Historical Perspective." *African Affairs* 117 (469): 543–68.

Frémaux, Anne. 2011. *La nécessité d'une écologie radicale: La pensée à l'épreuve des problèmes environnementaux.* Paris: Sang de la Terre.

Gadgigo, Samba. 1990. *Ecole Blanche—Afrique Noire.* Paris: L'Harmattan.

Garnier, Xavier. 2015. *Sony Labou Tansi: Une Écriture de la décomposition impériale.* Paris: Karthala.

Giguère, Caroline. 2004. "La Vie et demie ou les corps chaotiques des mots et des êtres." *Présence Francophone*, no. 63: 95–107.

Gilroy, Paul. 1993. *The Black Atlantic: Modernity and Double Consciousness.* Cambridge, MA: Harvard University Press.

Glissant, Édouard. 1997. *Traité du Tout-monde.* Paris: Éditions Gallimard.

———. 1999. *Poétique de la Relation.* Paris: Gallimard.

Goldsmith, Edward. 2001. "Development as Colonialism." *The Case against the Global Economy: And for a Turn Toward the Local,* edited by Jerry Mander and Edward Goldsmith, 19–34. New York: Taylor and Francis.

Gomes, Flora, dir. 2002. *Nha Fala.* Paris: Médiathèque des Trois Mondes.

Gouverner par le chaos: Ingénierie sociale et mondialisation. 2014. Paris: Max Millo.

Gyimah-Brempong, Kwabena. 2011. "Education and Economic Development in Africa." *African Development Review* 23 (2): 219–36.

Harrow, Kenneth. 2007. Introduction to *Postcolonial African Cinema: From Political Engagement to Postmodernism.* Bloomington: Indiana University Press.

Hartmann, Ivor W., ed. 2012. *AfroSF: Science Fiction by African Writers.* Zimbabwe: StoryTime.

Harvey, Blane. 2011. "Development Cooperation and Learning from Power in Senegal." *Critical Perspectives on Neoliberal Globalization, Development and Education in Africa and Asia,* edited by D. Kapoor, 187–205. Rotterdam: Sense Publishers.

Hedges, Chris. 2009. *Empire of Illusion: The Death of Literacy and the Triumph of Spectacle.* Toronto: Vintage Canada.

References 319

Heidegger, Martin. 1996. *Being and Time*. Translated by Joan Stambaugh. Albany: State University of New York Press.

Hondo, Med, dir. 1967. *Soleil O*. London: Grey Films.

Honwana, Alcinda. 2005. "Innocent and Guilty: Child-Soldiers as Interstitial and Tactical Agents." *Makers and Breakers: Children and Youth in Postcolonial Africa*, edited by Alcinda Honwana and Flip De Boeck, 31–52. Trenton, NJ: Africa World Press.

Houeto, Colette. 1975. "La femme, source de vie dans l'Afrique traditionnelle." In *La civilisation de la femme dans la tradition africaine*, 51–66. Paris: Présence Africaine.

Huxley, Aldous. 1946. *Brave New World*. New York: Harper & Row.

———. 1990. *The Doors of Perception*. New York: Harper & Row.

Ivanga, Imunga, dir. 2001. *Dôlè*. San Francisco: California Newsreel.

James, William. 1899. *On Some of Life's Ideals*. New York: Henry Holt.

Joslin, Isaac. 2009. "Baroque Practices in Postcolonial African Literature and Theory: From Achille Mbembe's *On the Postcolony*." *International Journal of Francophone Studies* 12, no. 4 (December): 639–54.

———. 2014. "L'écriture Ken Bugul: Pour un 'genre' de roman cinématographique africain." *Nouvelles Études Francophones* 28, no. 1 (Spring): 162–75.

———. 2018. "La poétique de Sony Labou Tansi: Pour une écocritique équatoriale égalitaire." *Nouvelles Études Francophonees* 33, no. 1 (Spring): 210–25.

Jules-Rosette, Bennetta. 1998. *Black Paris: The African Writers' Landscape*. Urbana: University of Illinois Press.

Juminer, Bertème. 1968. *La revanche de Bozambo*. Paris: Présence Africaine.

Kahiu, Wanuri, dir. 2009. *Pumzi*. Cape Town: Inspired Minority Pictures.

Kane, Cheikh Hamidou. 1961. *L'aventure ambiguë*. Paris: Julliard.

Kavwahirehi, Kareseka. 2011. "L'exil/diaspora comme lieu de discours critique et de reconfiguration du monde." In *Exils et migrations postcoloniales: De l'urgence du depart à la nécessité du retour*, edited by Pierre Fandio and Hervé Tchumkam, 41–62. Yaoundé: Éditions Ifrikiya.

Keto, C. Tsehloane. 1989. *The Africa Centered Perspective of History and Social Sciences in the Twenty First Century*. Blackwood, NJ: K. A. Publications.

Kobhio, Bassek Ba. 1990. *Sango Malo*. San Francisco: Diaphana Films and California Newsreel.

———. 1995. *Le Grand Blanc de Lambaréné*. San Francisco: California Newsreel.

———. 2003. *Le Silence de la forêt*. San Francisco: California Newsreel.

Kolawole, Mary Ebun Modupe. 1997. *Womanism and African Consciousness*. Trenton, NJ: Africa World Press.

Kourouma, Ahmadou. 2004. *Quand on refuse on dit non*. Paris: Éditions du Seuil.

———. 2006. *Allah Is Not Obliged*. Translated by Frank Wynne. New York: Anchor Books.

320 References

Kramo-Lanciné, Fadika, dir. 1994. *Wariko*. San Francisco: California Newsreel.

Kristeva, Julia. 1988. *Étrangers à nous-mêmes*. Paris: Fayard.

Lafay, Denis. 2019. "Michael Serres: 'Grâce aux NTIC, le temps est d'amour.'" *La Tribune*, June 4. https://acteursdeleconomie.latribune.fr/debat/2014 -02-11/michel-serres-grace-aux-ntic-le-temps-est-d-amour.html.

Laye, Camara. 1953. *L'enfant noir*. Paris: Plon.

"'Le mariage de l'Afrique avec Molière a été un échec total': Entretien avec Boubacar Boris Diop." 2014. *Africultures*, November 4. http://africultures .com/le-mariage-de-lafrique-avec-moliere-a-ete-un-echec-total-12521/.

Lewis, Martin Deming. 1962. "One Hundred Million Frenchmen: The 'Assimilation' Theory in French Colonial Policy." *Comparative Studies in Society and History* 4, no. 2 (January): 129–53.

Liking, Werewere. 1983. *Elle sera de jaspe et de corail*. Paris: L'Harmattan.

Lionnet, Françoise. 1995. *Postcolonial Representation: Women, Literature, Identity*. Ithaca, NY: Cornell University Press.

Loba, Aké. 1960. *Kocoumbo: L'étudiant noir*. Paris: Flammarion.

Loewenstein, Antony. 2015. *Disaster Capitalism: Making a Killing Out of Catastrophe*. Brooklyn, NY: Verso.

Loum, Daouda. 2008. "Métis et métissages: L'éclairage littéraire en miroir." *French Colonial History* 9: 79–102.

Lux, Christina. 2010. "Fluid Attachment: Reframing Peacebuilding through Ahmadou Kourouma's *Allah n'est pas obligé*." *International Journal of Francophone Studies* 13 (1): 57–74.

Lyotard, Jean-François. 2001. *Soundproof Room: Malraux's Anti-Aesthetics*. Translated by Robert Harvey. Stanford, CA: Stanford University Press.

Maathai, Wangari. 2006. *Unbowed*. New York: Anchor Books.

Mambety, Djibril Diop, dir. 1994. *Le Franc*. San Francisco: California Newsreel.

———, dir. 1999. *La petite vendeuse de Soleil*. San Francisco: California Newsreel.

———, dir. 2013. *Touki Bouki*. New York: Criterion Collection.

Maran, René. 1988. *Batouala*. Translated by Adele Szold. London: Heinemann.

Martin-Granel, Nicolas. 2000. "'*Le quatrième côté du triangle*,' or Squaring the Sex: A Genetic Approach to the 'Black Continent' in Sony Labou Tansi's Fiction." *Research in African Literatures* 31 (3): 69–99.

Mazrui, Ali. 1986. "Where Is Africa?" In *The Africans: A Triple Heritage*, 23–39. Boston: Little, Brown.

Mbembe, Achille. "Afropolitanisme et Afrofuturisme." https://www.college-de -france.fr/site/alain-mabanckou/symposium-2016-05-02-17h30.htm.

———. 2000. *De la postcolonie: Essai sur l'imagination politique dans l'Afrique contemporaine*. Paris: Karthala.

———. 2001. *On the Postcolony*. Translated by A. M. Berrett, Janet Roitman, Murray Last, and Steven Rendall. Berkeley: University of California Press.

References

———. 2003. "Necropolitics." Translated by Libby Meintjes. *Public Culture* 15 (1): 11–40.

———. 2013. *Critique de la raison nègre*. Paris: Éditions la Découverte.

———. 2017. *Critique of Black Reason*. Translated by Laurent Dubois. Durham, NC: Duke University Press.

———. 2019. *Necropolitics*. Translated by Steven Corcoran. Durham, NC: Duke University Press.

Mbembe, Achille, and Deborah Posel. 2005. "A Critical Humanism." *Interventions* 7 (3): 283–86.

Mbembe, Achille, and Sarah Nuttall. 2004. "Writing the World from an African Metropolis." *Public Culture* 16 (3): 347–72.

McBride, Brooke Baldauf, Carol A. Brewer, Alan R. Berkowitz, and William T. Borrie. 2013. "Environmental Literacy, Ecological Literacy, Ecoliteracy: What Do We Mean and How Did We Get Here?" *Ecosphere* 4 (5): 67.

McClintock, Anne. 1995. *Imperial Leather: Race, Gender and Sexuality in the Colonial Contest*. London: Routledge.

McMahon, Elisabeth, and Corrie Decker. 2020. *The Idea of Development in Africa: A History*. Cambridge: Cambridge University Press.

Mégret, Frédéric. 2009. "From 'Savages' to 'Unlawful Combattants': A Postcolonial Look at International Humanitarian Law's 'Other.'" *International Law and Its Others*, edited by Anne Orford, 265–311. Cambridge: Cambridge University Press.

Memmi, Albert. 1965. *The Colonizer and the Colonized*. Translated by Howard Greenfield. New York: Orion Press.

———. 2006. *Decolonization and the Decolonized*. Translated by Robert Bononno. Minneapolis: University of Minnesota Press.

Meyer, E. Nicole. 1999. "Silencing the Noise, Voicing the Self: Ken Bugul's Textual Journey towards Embodiment." In *Corps/décors: Femmes, orgie, parodie: Hommage à Lucienne Frappier-Mazur*, edited by Lucienne Frappier-Mazur, Catherine Nesci, Gretchen Jane Van Slyke, and Gerald Prince, 191–99. Amsterdam: Rodopi.

Miller, Christopher L. 1998. *Nationalists and Nomads: Essays on Francophone African Literature and Culture*. Chicago: University of Chicago Press.

Minh-ha, Trinh T. 1989. *Woman, Native Other. Woman, Native Other: Writing Postcoloniality and Feminism*. Bloomington: Indiana University Press.

Mohanty, Chandra Talpade. 2003. *Feminism without Borders: Decolonizing Theory, Practicing Solidarity*. Durham, NC: Duke University Press.

Mongo-Mboussa, Boniface. 2002a. *Désir d'Afrique*. Paris: Gallimard.

———. 2002b. "La littérature des Africains de France, de la 'postcolonie' à l'immigration." *Hommes et Migrations*, no. 1239: 67–74.

Moser, Keith. 2016. *The Encyclopedic Philosophy of Michel Serres: Writing the Modern World and Anticipating the Future*. Augusta, GA: Anaphora Literary Press.

———. 2018. "Decentering and Rewriting the Universal Story of Humanity: The Cosmic Historiography of J. M. G. Le Clézio and Michel Serres." *Green Letters: Studies in Ecocriticism* 22 (2): 129–47.

Moss, Todd J. 2011. *African Development: Making Sense of the Issues and Actors.* Boulder, CO: Lynn Rienner.

Moynagh, Maureen. 2011. "Human Rights, Child-Soldier Narratives, and the Problem of Form." *Research in African Literatures* 42 (4): 39–59.

———. 2017. "The War Machine as Chronotope: Temporality in Child-Soldier Fiction." *Comparative Literature* 69 (3): 315–37.

Moyo, Dambisa. 2009. *Dead Aid: Why Aid Is Not Working and How There Is a Better Way for Africa.* New York: Farrar, Straus and Giroux.

Mudimbé, Valentin Yves. 1985. "African Gnosis Philosophy and the Order of Knowledge: An Introduction." *African Studies Review* 28 (2/3): 149–233.

———. 1988. *The Invention of Africa: Gnosis, Philosophy and the Order of Knowledge.* Bloomington: Indiana University Press.

N'Diaye, Christiane. 1998. "De la permutation des mots et des choses dans *La vie et demie* de Sony Labou Tansi." *Présence Francophone*, no. 52: 53–68.

———. 2006. "La mémoire discursive dans *Allah n'est pas obligé* ou la poétique de l'explication du 'blablabla' de Birahima." *Études françaises* 42 (3): 77–96.

NDiaye, Marie. 2009. *Trois femmes puissantes.* Paris: Gallimard.

Ndoye, Mamadou. 1997. "Globalization, Endogenous Development and Education in Africa." *Prospects* 27 (1): 79–84.

Negus. 2010. "Sur les pirogues de la mort." In *À l'ombre de la lune.* Johannesburg: Reck Shoppe Tunez.

Ngal, Georges. 1984. *Giambatista Viko ou le viol du discours africain.* Paris: Hatier.

Nkrumah, Kwame. 1966. *Neocolonialism: The Last Stage of Imperialism.* London: Thomas Nelson and Sons.

Nnaemeka, Obioma. 1997. "Urban Spaces, Women's Places." *The Politics of (M)Othering: Womanhood, Identity, and Resistance in African Literature,* edited by Obioma Nnaemeka, 162–91. London: Routledge.

Okoi, Obasesam, and Tatenda Bwawa. 2020. "How Health Inequality Affects Responses to the COVID-19 Pandemic in Sub-Saharan Africa." *World Development* 135 (2020): https://doi.org/10.1016%2Fj.worlddev.2020.105067.

Orwell, George. 1981. *1984.* New York: New American Library.

Oyono, Ferdinand. 1956. *Une vie de boy.* Paris: Julliard.

Paré, Joseph. 1997. *Écritures et discours dans le roman African francophone postcolonial.* Ouagadougou: Éditions Kraal.

Perry, Alex. 2013. "In and Out of Africa." *Time* 181 (4): 20–23. https://content.time.com/time/subscriber/article/0,33009,2134520,00.html.

Prabhu, Anjali. 2011. "*Aux États-Unis d'Afrique* de Abdourahman Waberi: Narration dialogique ou Dialectique?" *Œuvres & Critiques* 36 (2): 79–92.

References 323

Reade, Orlando. 2012. "Africa as Science Fiction." *Africa Is a Country* (website). https://africasacountry.com/2012/05/africa-in-science-fiction.

Riesz, János. 2000. "From L'état sauvage to L'état honteux." *Research in African Literatures* 31 (3): 100–128.

Rigouste, Matthieu. 2005. "L'immigré, mais qui a réussi." *Le monde diplomatique*, July 8.

Rocheleau, Diane E., Barbara P. Thomas-Slayter, and Esther Wangari, eds. 1996. *Feminist Political Ecology, Global Issues and Local Experiences.* London: Routledge.

Rodney, Walter. 2011. *How Europe Underdeveloped Africa.* Baltimore, MD: Black Classic Press.

Rollefson, J. Griffith. 2013. "From 'Myth-Science' to 'Robot Voodoo Power': Sun Ra's Afrofuturist and Anti-Anti-Essentialist Legacy," with French translation by Erwan Jégouzo. In *Lili Reynaud Dewar: Interpretation,* edited by B. Thorel and A. Szymczyk, 96–105. Paris: Paraguay Press.

Sadji, Abdoulaye. 1988. *Nini, mulâtresse du Sénégal.* 3rd ed. Paris: Présence Africaine.

Said, Edward. 1993. *Culture and Imperialism.* New York: Alfred A. Knopf.

———. 1994. "From *Orientalism.*" *Colonial Discourse and Post-colonial Theory,* edited by Patrick Williams and Laura Chrisman, 132–49. New York: Columbia University Press.

Sankara, Thomas. 1988. "Dare to Invent the Future." In *Thomas Sankara Speaks: The Burkina Faso Revolution 1983–87,* translated by Samantha Anderson and edited by Michel Prairie, 111–44. New York: Pathfinder Press.

Sansal, Boualem. 2015. *2084: La fin du monde.* Paris: Gallimard.

Sarr, Felwine. 2016. *Afrotopia.* Paris: Phillippe Rey.

———. 2019. *Afrotopia.* Translated by Drew S. Burk and Sarah Jones-Boardman. Minneapolis: University of Minnesota Press.

Sauvaire, Jean-Stéphane, dir. 2008. *Johnny Mad Dog.* Toronto: Momentum Pictures.

Scott, Paul, and Antje Ziethen, eds. 2019. "La science-fiction en langue française: Du merveilleux scientifique à l'afrofuturisme." *Oeuvres et Critiques* 44, no. 2 (2019): 5–14.

Seck, Amadou Saalum, dir. 1988. *Saaraba.* San Francisco: California Newsreel.

Sembène, Ousmane. 1956. *Le docker noir.* Paris: Présence Africaine.

———. 1960. *Les bouts de bois de Dieu.* Paris: Présence Africaine.

———, dir. 1963. *Borom Sarret.* Dakar: Filmi Domirev.

———, dir. 1966a. *La noire de . . .* Dakar: Filmi Domirev.

———. 1966b. *Vehi-Ciosane ou Blanche-Genèses, suivi du Mandat.* Paris: Présence Africaine.

———, dir. 1992. *Guelwaar.* Dakar: Filmi Domirev.

———, dir. 2002. *Faat Kiné.* Dakar: Filmi Domirev.

—, dir. 2004. *Moolaadé*. Dakar: Filmi Domirev.

Sene, Nar. 2001. *Djibril Diop Mambety, La caméra au bout . . . du nez*. Paris: L'Harmattan.

Serres, Michel. 1972. *Hermès II: L'Interférence*. Paris: Éditions de Minuit.

—. 2001. *Hominescence*. Paris: Éditions le Pommier.

—. 2003. *L'Incandescent*. Paris: Éditions le Pommier.

—. 2014. "Grâce aux NTIC, le temps est d'amour." *La Tribune*, June 4. https://region-aura.latribune.fr/debat/2014-02-11/michel-serres-grace -aux-ntic-le-temps-est-d-amour.html.

Sharife, Khadija. 2016. "The Myth of the Offshore: How Africa Lost \$1 Trillion to Tax Havens." *New African*, no. 561: 30–35.

Shizha, Edward. 2011. "Neoliberal Globalisation, Science Education and African Indigenous Knowledges." *Critical Perspectives on Neoliberal Globalization, Development and Education in Africa and Asia*, edited by D. Kapoor, 15–31. Rotterdam: Sense Publishers.

Sissako, Abderrahmane, dir. 2002. *Heremokono*. Los Angeles: Duo Films.

—, dir. 2006. *Bamako*. New York: New Yorker Films.

Slaughter, Joseph. 2007. *Human Rights, Inc.: The World Novel, Narrative Form, and International Law*. New York: Fordham University Press.

Socé, Ousmane. 1937. *Mirages de Paris*. Paris: Nouvelles Éditions Latines.

—. 1948. *Karim*. Paris: Nouvelles Éditions Latines.

Sow, Alioune. 2004. "L'enfance métisse ou l'enfance 'entre les eaux': *Le chercheur d'Afriques* de Herni Lopes." *The Child in French and Francophone Literature*, edited by Norman Buford, 67–79. Vol. 31. Amsterdam: Rodopi.

Spivak, Gayatri Chakravorty. 1988. "Can the Subaltern Speak?" In *Marxism and the Interpretation of Culture*, edited by Cary Nelson and Lawrence Grossberg, 267–310. Urbana: University of Illinois Press.

—. 2012. *An Aesthetic Education in the Era of Globalization*. Cambridge, MA: Harvard University Press.

Stibbe, Arran. 2015. *Ecolinguistics: Language, Ecology, and the Stories We Live By*. London: Routledge.

Stiglitz, Joseph. 2003. *Globalization and Its Discontents*. New York: W. W. Norton.

Strange, Susan. 2016. *Casino Capitalism*. Manchester: Manchester University Press.

Suberchicot, Alain. 2012. *Littérature et environnement: Pour une écocritique comparée*. Paris: Champion.

Succab-Goldman, Christiane, dir. 1995. *À Bamako les femmes sont belles*. Ivry-sur-Seine: ISKRA.

Surrealist Group. "Murderous Humanitarianism." 1970. Translated by Samuel Beckett. In *Negro: An Anthology*, edited by Nancy Cunard, 352–53. New York: Frederick Ungar.

References 325

Tadjo, Véronique. 1990. *Le royaume aveugle*. Paris: L'Harmattan.

Tansi, Sony Labou. 1979. *La vie et demie*. Paris: Éditions du Seuil.

———. 1981. *L'État honteux*. Paris: Éditions du Seuil.

———. 1983. *L'Anté-peuple*. Paris: Éditions du Seuil.

———. 1995. *Une vie en arbre et chars . . . bonds*. No. 128. Manage, Belgium: Éditions Lansman.

———. 1998. *Monologues d'or et noces d'argent pour douze personnages et Le Trou*. Collection Beaumarchais, no. 237. Manage, Belgium: Éditions Lansman.

———. 2005. *Paroles inédites*. Edited by Bernard Magnier. Montreuil, France: Éditions théâtrales.

———. 2011. *Life and a Half*. Translated by Alison Dundy. Bloomington: Indiana University Press.

Tcheuyap, Alexie. 2003. "De l'aliénation à la libération." *Présence Francophone*, no. 60: 128–49.

Téno, Jean-Marie, dir. 1990. *Afrique, je te plumerai*. San Francisco: California Newsreel.

———, dir. 2004. *Le malentendu colonial*. San Francisco: California Newsreel.

Thiong'o, Ngugi wa. 1982. *Devil on the Cross*. Translated by Ngugi wa Thiong'o. London: Heinemann.

———. 1986. *Decolonizing the Mind: The Politics of Language in African Literature*. London: Heinemann Educational Press.

———. 2012. *Globalectics: Theory and the Politics of Knowing*. New York: Columbia University Press.

Thomas, Greg. 2011. "Hyenas in the Enchanted Brothel: 'The Naked Truth' in Djibril Diop Mambéty." *Black Camera* 2 (2): 8–25.

Tirolien, Guy. 1969. "Prière d'un petit enfant nègre." *Anthologie de la nouvelle poésie nègre et malgache*, edited by Léopold Sédar Senghor, 86–87. Paris: Presses universitaires de France.

Touré, Moussa, dir. 2012. *La Pirogue*. Issy-les-Moulineaux: ARTE France Cinéma.

2Pac. 1998. "Changes." *Greatest Hits*. Beverly Hills, CA: Death Row Records.

Verschave, François-Xavier. 1998. *La Françafrique, le plus long scandale de la République*. Paris: Éditions Stock.

———. 2004. *De la Françafrique à la Mafiafrique*. Marche-en-Famenne, Belgium: Éditions Tribord.

Waberi, Abdourahman. 2006. *Aux États-Unis d'Afrique*. Paris: Éditions Jean-Claude Lattès.

Walker, Keith. 1999. "The Blossoming of the Undefined Self: Ken Bugul et Le Baobab fou." In *Countermodernism and Francophone Literary Culture: The Game of Slipknot*, 173–209. Durham, NC: Duke University Press.

Walsh, John. 2008. "Coming of Age with an AK-47: Ahmadou Kourouma's *Allah n'est pas obligé*." *Research in African Literatures* 39 (1): 185–97.

Williams, James S. 2017. "Neoliberal Violence and Aesthetic Resistance in Abderrahmane Sissako's *Bamako* (2006)." *Studies in French Cinema* 19 (4): 294–313.

Womack, Ytasha L. 2013. *Afrofuturism: The World of Black Sci-fi and Fantasy Culture*. Chicago: Lawrence Hill Books.

Wright, Handel Kashope. 2004. *A Prescience of African Cultural Studies: The Future of Literature in Africa Is Not What It Was*. New York: Peter Lang.

Yaméogo, Eléonore, dir. 2011. *Paris mon paradis*. Paris: Overlap Films.

Yaméogo, Pierre, dir. 2003. *Moi et mon blanc*. Paris: Dunia Productions.

Zwick, Edward, dir. 2007. *Blood Diamond*. Burbank, CA: Warner Bros. Entertainment.

Index

Absa, Mousa Sene, 123, 287n36
Achebe, Chinua, 4, 5, 97
Adiaffi, Jean-Marie, 9, 17–18, 31, 34–35, 41–45, 64, 159, 185, 307n19
Adichie, Chimamanda Ngozi, 24
Aduaka, Newton, 87, 95–100, 282n36
Aesthetic Education in the Eras of Globalization, An (Spivak), 73
Afghanistan, 86
Africa(n): ambivalent construct of, 81; Anglophone, 38; artificial borders, 243; assimilation, 170; battle over, 78–79; -centered perspective, 29; colonial/ colonized, 33, 56, 64, 68, 80–81; conceptual space of, 81, 279n8, 288n43, 289n49; consciousness, 34; cosmologies, 189; cultural expressions, 8, 28, 30–31, 36–37, 41, 221; cultural histories, 165; cultural narrative of inherent inequality, 162; cultural studies, 266n42; cultural values, 245; decolonizing, 81, 167; development, 7, 28, 41, 168–69, 265n36, 280n10, 301n5, 311n65; economy, 41, 207, 265n36, 280n10, 310n57; education, indigenous, 17–19, 39–40, 46, 165–68, 185–87, 265n35, 281n19; as an enunciatory space, 106–8; Francophone, 29–31, 36–39, 49–77, 109–62, 284–85nn6–7, 285n16; future-oriented view of, 28, 220–21; generalizations about, 35; global inequality in, 109–62; griots, 122–24; humanist expressions, 26; identity, 16; intellectuals, 23–24, 34; literature studies, 5–6, 20, 46; modernities, reconstruction of, 72; mythologies, 26, 29, 33, 36, 288n43, 289n49, 299n39; nationalist ideology,

27–28; orality, 187; "Oriental," 161; pan-, 26, 29, 284n2; as paradise, 110, 160; philosophy, 9, 30; plurality of, 220; political construct of, 83; postcolonial, 9–10, 41, 46, 248; precolonial, 310n57; racialized terms of, 106; reality, 47, 161–62, 189; regional destabilization, 83, 84, 88–89; self-determination, 33; systems of authority, 51; utopian, 80; wealth extracted from, 119–20; womanism, 242
"Africa as Science Fiction" (Reade), 32
Africa-Centered Perspective of History and Social Science, The (Keto), 307n16
Africa for the Future (Bekolo), 1, 5, 17, 30–31, 217, 245; subtitle, 245
Africa Paradis (Amoussou), 38, 155
Afrocontemporaneity, 50, 220
Afro-Diasporic French Identities (Éroké), 287n35
Afrofuturism: The World of Black Sci-Fi and Fantasy Cultures (Womack), 26
Afrofuturism/Afrofuturist, 1, 30, 43, 189, 223, 228–29, 232, 248, 252, 270n49; collective empowerment of, 28–29; critique(s), 160, 196; critique of humanity, 216; cultural productions, 41; definition of, 8–9, 26, 28, 268n18; ecohumanist philosophy of experience, 247–56; ecolinguistics, 25–48; environmental issues in, 23, 240; expression, 47; framework, 255; gender dynamics in, 23; imaginings, 75, 114, 165, 254, 260; narratives, 13, 92; perspective, 44; philosophy of, 230; repudiation of the idea of "man," 45; subjectivity, 88; thinkers, 3–4; women writers of, 49–77

328 Index

Afropolitanism, 29

Afrotopia (Sarr), 1, 6, 25, 31, 49, 163, 217

Afrotopos, 33

Ainsi meurent les anges (Absa), 123

Alessandri, Brigitte, 296n16

Algeria, 29, 81

alienation, 16, 54, 56–57, 59, 61–62, 109–62, 192–93, 200, 235, 237, 292n87; capitalism and, 113, 192; definition of, 192; dis-, 248; geopolitical manifestations, 112; of humanity, 214

Allah n'est pas obligé (Kourouma), 87; Birahima's family, 88; dictionaries, 88; Fanta, 91; narrative, 88, 91; Petit Birahima, 87–89, 91; publication of, 89; temporality in, 89, 91

Amoussaaou, Sylvestre, 38, 155

Anderson, Reynaldo, 27, 28

animism, 35, 184, 253

Ansar Dine, 280n16

Anthropocene, 230, 245, 246; transcending, 249

Anzaldúa, Gloria, 285n9

apocalyptic media obsession, 238

AQIM (al-Qaeda in the Islamic Maghreb), 82, 280n16

Asante, Molefe Kete, 266n3

Ashanti, 18, 221

Aux États-Unis d'Afrique (Waberi), 14–15, 38, 155; consumerism in, 14; reviews of, 14–15

Bâ, Mariama, 10, 50, 52, 56–60, 63, 76–77, 154, 273n31, 293n93

baay-fall, 303n19

Back to the Future, 44

Baker, Josephine, 138, 141

Ba Kobhio, Bassek, 17–18, 40, 165, 166, 169, 174–75, 180–86, 188, 252, 298n27, 307n18

Bamako (Sissako), 195–98, 202; debt as a theme in, 196–98; defense of global financial institutions, 197; trial in, 196

Bamba, Amadou, 303n29

Bamboté, Makombo, 247

Barça ou Barseq, 121

Bathily, Abdoulaye, 289n50, 293n94

Batouala (Maran), 256–57; administrator, 256; science versus magic in, 256–57

Battuta, Ibn, 3

Baudelaire, Charles, 22, 110, 190–91; on drug consumption, 202–4

Baudrillard, Jean, 113, 214

BBC, 302n14

Beah, Ismael, 12, 87, 93–95, 96, 282n34, 282n37

Bekolo, Jean-Pierre, 1, 5, 17, 24, 27, 30–31, 121, 159, 161, 165, 217, 222, 245, 286n26, 297n21, 299n50, 301n8, 304n38; on capitalism, 193–95, 213–14; on education, 172–74, 178, 186; view of cinema, 47–48

Benin, 18

Benin Home, 93

Benjamin, Walter, 284n5

Benna, Zyed, 293n89

Beti, Mongo, 23, 60, 166, 174

Beyala, Calixthe, 10–11, 13, 64, 133, 264n17, 281n29

Beyond Good and Evil (Nietzsche), 93

bias, 219; cultural-linguistic, 7, 9, 162; epistemological, 182; gendered, 5; quantophrenic, 7, 174, 231; racialized, 5; Western, 167, 218

Bidema, Jean-Godefroy, 30, 220

Biko, Steve, 24

biopower, 191, 192, 249

birth, 10, 49–77; as a feminine locus of power, 52

Black Atlantic, The (Gilroy), 153

Black Hawk Down, 83

Black Panther, 34

Black Speculative Arts Movement, 27

Blake, Cecil, 27–28

Blood Diamond, 282n37

Bofane, Koli Jean, 255–56

Boganda, Barthémély, 183

Boigny, Félix Houpouët, 304n35, 304n38

Bois d'ébène (Roumain), 296

Boko Haram, 81

Bolya, Baenga, 64

Bongo, Omar, 212, 304n38

Boni, Tanella, 236

Borderlands / La fronteria (Anzaldúa), 285n9

Borom Sarret (Sambène), 124

Boto, Eza. *See* Mongo Beti

Boulaga, 35

Brave New World (Huxley), 223, 234

Bugul, Ken, 10, 50, 52, 60–63, 65, 76, 249, 273n24, 277n87; pseudonym, 275n59

Index

329

Burkina Faso, 84, 87, 122
Butler, Octavia, 4, 225

Cabort-Masson, Guy, 169–70, 186
Cahier d'un retour au pays natal (Césaire), 122, 187
Cake-States, 286n26
Cameroon, 10, 29, 121, 152, 169, 173–74, 178–79, 193, 218, 297n18
Camus, Albert, 11, 284n3
Candide (Voltaire), 14
Cantet, Laurent, 297n20
capitalism, 82, 84, 216, 264n20; alienation and, 113, 192; culture and, 194–95; democratic ideological terms, 7; global, 2–3, 16, 208, 254; imperialism, 21; narrative conflation of money, 193–94; neoliberal, 28; poverty and, 21; twentieth century, 3, 254; Western model of, 21
Caplan, Bryan, 298n23
Carrington, André, 4–5
Cazenave, Odile, 10, 51–52
Césaire, Aimé, 4, 24, 26, 122, 169, 187, 264n21
CFA franc, 118, 204, 302n14, 303n28
Chad, 87
Chamoiseau, Patrick, 306n12
"Changes" (2Pac), 1
Cherki, Alice, 106
child soldiers, 11–12, 250; agency, 280n18; complicity of, 13; as a construction of the media, 108; developmental limbo of, 89, 90–91, 281n20, 282n39; as embodiments of humanitarian reason, 104–8; empathy for, 93; identitary dislocations, 88, 104; identity construction, 105; initiation, 96; innocence of, 13; liberation of, 280n17; mediating conflicting interests, 92–93, 104; narratives, 79–80, 89, 91–92, 102, 104–5; narratives, subtext, 104–5; recruitment, 86–87; reintegration into society, 95; subjectivity of, 88; sympathy for, 93
Cinderella, 287n27
Cissé, Souleymane, 27
civilization of the universal, 57, 76
Clarke, Arthur C., 35
Cold War, 84

Colonial Exposition of 1931, 56
colonialism, 15, 33, 64, 78, 167–68, 192; development and, 20; language and, 260; legacies, 12; literature and, 6, 24; social engineering through, 107; social inequalities, 41; as "thingification," 264n21; twenty-first century, 105–6; worldview, 3; zombification through, 133
Colonizer and the Colonized, The (Memmi), 102
Coltrane, John, 38, 270n38, 277n73
"Coming of Age with an AK-47" (Walsh), 282n40
Congo Inc. (Bofane), 255–56; artificial paradise promised in, 256; forest in, 255; Isookanga, 255–56; *Raging Trade* video game, 255
Conrad, Joseph, 78
consumerism, 192, 255
Contras' City (Mambety), 303n29
Côte d'Ivoire, 29, 68, 82–83, 90, 195, 201, 208, 210, 236, 281n28, 285n8; coup d'état, 90, 277n74
"Critical Humanism, A" (Mbembe, Posel), 278n101
cultural schizophrenia, 61
Culture and Imperialism (Said), 78

Dadié, Bernard, 60, 154, 285n8, 287n27
d'Almeida, Irène, 277n84
Damas, Léon-Gontran, 53
Danquah, J. B., 267n7
Dastile, Nontyatyambo, 266
Dau, John Bul, 94
Dead Aid (Moyo), 21
Dead Prez, 297n22
Debord, Guy, 113, 214, 308n25
"Decentering and Rewriting the Universal Story of Humanity" (Moser), 249
De Certeau, Michel, 171
Decolonization and the Decolonized (Memmi), 21
decolonizing, 24, 279n5
De Gaulle, Charles, 243
Deleuze, Gilles, 56, 157, 230, 266n5, 271n3, 280n14
Democratic Republic of the Congo, 18, 29, 52, 84, 87, 185, 222, 232, 255
Derrida, Jacques, 259

330 Index

Descartes, René, 213, 215
deterritorialization, 158, 160–61, 261, 271n3
development, 1, 45, 218–19, 242–43,
269n31; Africa, 7, 28, 168–69, 265n36,
280n10, 301n15, 311n66; colonization
through, 20; communal arts in global,
185–89; cultural-linguistic biases of,
7; decolonizing, 167–68; dehuman-
izing, 7; discourse, international, 26;
economic, 5–7, 17, 41, 168–69, 227;
education and, 163, 165–69; human-
istic, 5, 17; reconceptualizing, 5, 8,
17, 187–88, 218; sustainable, 217, 246;
understanding, 6; uneven, 266n37
"Development Cooperation and Learning
from Power in Senegal" (Harvey),
269n31
Devil on a Cross (Thiong'o), 195, 198–99
diaspora/diasporic, 26–28; American, 29;
displacement, 16; European, 29
digital humanities, 9, 25, 48, 113, 214
Diome, Fatou, 16, 23, 114, 123, 153–60, 251,
291n72, 293n100
Diop, Birago, 53, 307n19
Diop, Boubacar Boris, 121, 289n50
Diop, Cheikh Anta, 127, 167, 169, 267n7
Diop, Ibrahima, 289n50
Dioula, 208
Disaster Capitalism (Loewenstein), 286n25
Discourse on Colonialism (Césaire), 264n21
Djibouti, 29
Dôlè (Ivanga), 195, 211–13; Ada, 212;
Akson, 212; Baby Lee, 212–13; Charlie,
212–13; ending, 213; Jean-Robert, 211;
Joker, 212; lottery in, 212–13; Mougler,
211; Mougler's father, 212; Mougler's
mother, 212, 304n37; postcolonial
agency in, 212; promise of wealth in,
212–13
Dongala, Emmanuel, 12, 38, 68, 87, 100–
104, 170n38, 170–71, 180, 250, 276n73,
282n37, 283n46; father of, 170–71, 180
Doors of Perception, The (Huxley), 190
DuBois, W. E. B., 4
Dunbar, Laurence, 4
Dundy, Alison, 31
Duparc, Henri, 122, 293n97

Eboussi-Boulaga, Fabien, 9, 24, 152
ecofeminism, 255, 264n22; societal ethics, 22

École Blanche-Afrique noire (Gadjigo), 166
École Supérieure Édouard-Renard, 171
ecoliteracy/ecolinguistics, 7, 8, 161, 222,
312n10; Afrofuturist, 25–48; bias, 9;
degrowth, 221, 246; radical, 221
Economic Community of West African
States, 204
economy: African, 41, 207, 265n36,
280n10, 310n57; ambivalent repre-
sentational, 214; global, 22, 165, 192,
196–99, 216; growth, 218, 265n36;
inegalitarian, 264n20; necropolitical,
85–86, 102, 144, 180, 234, 250, 299n40;
312n15; relational economy, 45, 72–73,
191–92, 195, 208, 211, 215–16, 249, 254;
sociopolitical, 249
Ecrire en pays dominé (Chamoiseau),
306n12
écrivain engagé, 279n4
education, 17, 252, 296n10, 296n16, 300n51;
aesthetic, 73, 219–20, 252; African
cultural studies, 266n42; alien, 18–19,
254; alternative pedagogies and epis-
temologies, 163–89, 220; arts, 186–87;
colonial, 166, 169–71, 173–74, 185–86,
254; development and, 163, 165–69; for
humanistic development, 17; imperial
conquest through, 165–66; inaccessi-
bility of, 174; incarceration and, 172–
75; inclusive, 189; indigenous African,
17–19, 39–40, 46, 165–68, 185–87,
265n35, 281n19; knowledge production,
17, 166; language instruction, 166–67;
lived experiences and, 180; new critical
pedagogies, 218; Occidentalism, 17;
planetary, 253; postcolonial, 174, 254;
science, 166–67, 169; signaling, 298n23;
slavery and, 19; social performativity
and, 252; socioeconomic advancement
and, 163–65, 174, 189, 252; utility
of, 188; violence and pedagogy, 166;
Western, 166–67
Elalamy, Youssouf Amine, 16, 114, 123,
142–53, 290n67, 292n82
ELF (petroleum corporation), 286n21
Elle sera de jaspe et de corail (Liking), 50,
71–75; Babou, 71; education in, 73–74;
friendship in, 74; Grozi, 71; journal
in, 71–74; language in, 71–72, 75; the
misovire, 71–74; prophesy of a new

Index

race, 71, 74–75; temporality in, 72–73

Ellison, Ralph, 75, 288n41

Emerson, Ralph Waldo, 247

emigration, 113–14; geopolitics of, 115–22

Empire Writes Back, The, 23, 267n7

Entre les murs (Cantet), 297n20

enunciation, 106–8

estrangement, 109–62

Étoké, Nathalie, 287

Étrangers à nouse-mémes (Kristeva), 15, 171; alienation in, 15

European Enlightenment, 3; individualist egoism, 215

existentialism, 30

Ezra (Aduaka), 87, 95–100; DRPA, 95–96; drugs in, 98; Economic Community of West African States Monitoring Group (ECOMOG), 99; Ezekiel, 99; Ezra, 96–100, 284n52; Ezra's parents, 96; flashbacks, 97; justice in, 97–98; Mariam "Black Diamond," 97, 98, 99, 283n46; Moses, 95; narrative, 97; Onitcha, 96, 98; Rufus, 98; Truth and Reconciliation Commission (TRC), 96–99; Western man, 98

Faat Kiné (Sembène), 287n37

Facebook, 26

Fall, Aminata Sow, 16, 24, 114, 116–20, 251, 286n26

Fall, Ibra, 303n29

Fanon, Frantz, 4, 24, 54, 59, 65, 71–72, 78, 81, 106, 159, 169, 273n21, 296n14

Fassin, Didier, 83–84, 101–2, 107, 109–10, 119, 214, 250–51, 283n47, 295n5, 311n4

Faye, Gaël, 49, 109, 160, 275n56, 288n39, 289n52

feminism/feminist, 22–23, 237–40, 273n30, 310n52; critiques, 10; divine, 229; ecofeminism, 255, 264n22; gender inclusivity derived from, 11; societal ethics, 22

Feminism without Borders (Mohanty), 273n30

FESPACO (Festival Panafrican du Cinéma et de la révévision de Ouagadougou), 196

FNLA, 280n16

Foccart, Jacques, 243

Fontaine, Nasio, 97

Foucault, Michel, 7, 102, 191

Françafrique, 21, 58, 202, 228, 243, 273n28, 286n21, 302n16, 304n35, 304n38; ecocriticism of, 240–46

"Francophone Literature as an Ecology of Knowledge" (Sarr), 6

Frankema, Ewout, 265n36

Frémaux, Anne, 221

Gabon, 29, 195, 201, 211

Gaddafi, Muammar, 82, 279n6

Gadjigo, Sama, 166

Gaiacene, 246

Gant, Richard, 99

Garnier, Xavier, 238, 241

Garvey, Marcus, 26, 169, 284n2

Gbagbo, Laurent, 82, 92

Ghana, 83

Ghana Empire, 2

Giambatista Viko (Ngal), 13, 37–38, 55, 258; folklore basis of, 37; narrative, 55, 272n17, 273n24; occidental framework of, 37; orality in, 37; Professor Giambatista Viko, 37, 46–47, 55, 157; Viko's spouse, 37

Giguère, Caroline, 309n48

Giles, Christopher, 302n14

Gilroy, Paul, 153

Glissant, Èdouard, 67–68

Globalectics (Thiongo), 25

global/globalism/globalization, 20, 48, 63, 246; alter-, 228, 244; capitalism, 2–3, 16, 208, 254; civilization, 3, 231; cultural order, 4; development, 185–89; dystopic, 36; economy, 22, 165, 192, 196–99, 216; finance, criminality of, 196–99; humanitarianism, 83; inequality, 109–62; market forces, 12; neoliberal, 104; reductive tendencies of, 108; societal pressures of, 208; socioeconomic order, 4; transculturation, 50; values of, 72

Goldsmith, Edward, 20, 167–68

Gomes, Flora, 122–23

Goncourt Prize, 64

Goodman, Jack, 302n14

Gouverner par le chaos, 42, 274n43

Green Letters: Studies in Ecocriticism (Moser), 248–49

Index

Guattari, Felix, 157, 271n3, 280n14
Guinea-Bissau, 122, 177, 300n52
Gulf War, 86

Hall, Stuart, 24
Harrow, Kenneth, 284n4
Harvey, Blane, 269n31, 296n12
Heart of Darkness (Conrad), 78
Heremakono (Sissako), 16, 114, 123, 128–33,
 152; Abdallah, 128–30, 132, 288n40;
 Abdallah's mother, 128–29; alienation
 in, 129; ambition in, 132; Chinese
 merchant, 130; death in, 131–32;
 emigration in, 128, 130–31, 133; ending,
 131–32; Ethmane, 131; flashbacks in,
 130; happiness in, 131–33; Khatra, 129,
 131–32, 288n40; language in, 128–30;
 light bulb in, 129, 131–32, 288n40;
 Maata, 129, 131, 288n40; Makan,
 130–33; Michael, 130–31; Nana,
 129–30; Omar, 130–31; utopia in, 128;
 Vincent, 130
History of Sexuality, The (Foucault), 191
Hondo, Med, 122
Honwana, Alcinda, 96, 280n18, 281n20,
 282n39, 284n52
Hotel Rwanda, 101
Houeto, Colette, 51
Houseboy (Oyono), 299n41
How Europe Underdeveloped Africa
 (Rodney), 6
Hughes, Langston, 4
humanitarian/humanitarianism, 16, 21,
 164; agencies, 12, 104; aid, 94–95,
 101, 103–4, 119; ambiguities, 87,
 104; ambivalence of, 95; causes and
 justifications of, 84, 105, 251; child
 soldiers and, 104–8; crises, 110; criti-
 cal, 162; French, 164, 280n10; global,
 83; hierarchies of humanity, 83–84,
 102, 105–6, 119, 164, 281n25, 281n28,
 283n43, 283n47, 295n5; interventionist
 policies, 94, 250; law, 283n45; military
 interventions, 84, 101; organizations,
 international, 85; reason, 104–8,
 282n33; social crises, 108
Humanitarian Reason (Fassin), 109
humanities/humanistic, 1; literary analysis
 of African fictions, 7; nonverbal, 189;
 sustainable, 223

human rights, 11; banalization of, 105;
 discourses, 12, 87, 89, 94, 104; law, 94;
 policies, 79–80
"Human Rights, Child-Soldier Nar-
 ratives, and the Problem of Form"
 (Moynagh), 89
Huxley, Aldous, 189, 190, 203, 223, 234,
 300n55

identity: African, 16; collective, 248; indi-
 vidual, 247–48; métis, 53; postcolonial
 construction, 10
"Ideologies for Otherness" (Mudimbé),
 169
Imago (Butler), 225
immigration, 114; clandestine, 110, 118–19,
 152; discourses, 110; policies, 251;
 voicing in cinema, 122–24
imperialism, 79, 278n101; education and,
 164, 166; expansionism, 192; language
 and, 260
"Indépendance" (Ngande), 179
Industrial Revolution, 32
International Criminal Court, 82
International Day of Child Soldiers, 86
international development discourse, 26
International Monetary Fund, 21, 197
Invention of Africa, The (Mudimbé), 32
Invisible Children's campaign, 87
Invisible Man, The (Ellison), 75, 288n41
Iraq, 86
Islam, 3–4, 81, 82, 280n16, 302n15
Ivanga, Imunga, 21, 195, 211–13, 254
Ivory Coast. *See* Côte d'Ivoire

James, William, 247
"Ja Pars" (Faye), 109
"Jazz et vin de palme" (Jazz and palm wine;
 Dongala), 38, 68, 270n38, 276n73
Johnny Mad Dog (Dongala), 87, 100–104,
 282n37, 283n41; Aunt Tanisha, 101;
 ending, 103; film adaptation of, 103;
 Fofo, 102; General Giap, 100; High
 Commission for Refugees (HCR),
 101; Johnny Mad Dog, 100–101,
 103, 250, 283n44, 283n46, 284n52;
 Katelijne, 102; Laokolé, 100–103,
 283n46; Laokolé's mother, 101–2;
 Lovelita, 103, 283n46; Mélanie, 101–2;
 narrative, 100–101; reality in, 101; the

Index

333

Roaring Tigers, 100–101; Tamila, 102; Tanisha, 102
Juminer, Bertème, 38

Kagame, Alexis, 169, 267n7
Kahiu, Wanuri, 22, 222–26, 246
Kane, Cheikh Hamidou, 16, 54, 60, 114–16, 127, 154, 166, 171, 285n8
Katiyo, Brigitte, 31
Kavwahirehi, Kareseka, 171
Keita, Modibo, 304n35
Kenya, 29, 83, 111, 195; refugee camps, 282n35
Keto, C. Tsehloane, 29, 266n3, 307n16
Kierkegaard, Søren, 247
Kikuyu, 111, 172, 224, 297n18
Kipling, Rudyard, 93
Kiswahili, 223
Kocoumbo: L'étuiduant noir (Loba), 285n8
Kolawole, Mary Ebun Modupe, 22, 273n30
Kom, Ambroise, 24
Kony, Joseph, 87
Kool Keith, 268n17
Kosovo, 86
Kourouma, Ahmadou, 11, 87–92, 100, 250, 277n87, 281n25, 281n28, 283n44
Kramo-Lanciné, Fadika, 21, 195, 202, 208–11, 254, 304n35
Kristevas, Julia, 15, 160, 171, 292n87

La carte d'identité (The Identity Card; Adiaffi), 17–18, 34–35; Bettié, 18; Catholicism in, 42; creative power of naming in, 44; Ebah Ya, 18, 42–44, 46; education systems in, 18; "Holy Monday" section, 307n19; magic mirror in, 42, 44, 46; Mélédouman, 17–18, 34, 41–42, 43–44, 45, 64, 258, 265n34; Mélédouman's widow, 44; power of art in, 42; reality in, 43–44; Robot Voodoo Power in, 43; tone of discovery and awakening in, 46; translation, 31; writing style, 45–46
Lafay, Denis, 221
"La femme, source de vie dans l'Afrique traditioneele" (Houeto), 51
"La fête gâchée" (Fall), 16, 114, 116–20; Bineta, 118; canoes of death, 117–18; humanitarian agencies in, 117–18; Massata, 117, 119; poverty in, 117; Soda, 117–18; Yérim, 118

LaFleur, Ingrid, 26
language, 18, 37; cinematic, 17; cultural identity and, 172; differences, 35; dominant patriarchal culture, 50; ecolinguistics, 7–8, 25–48, 161, 222, 312n10; education, 17, 167, 296n10; human consciousness and, 7; imperialism and, 260; indigenous, 166, 172, 185; postcolonial society and, 71–72, 172; taking possession of, 271n5; unreal reality of, 222
"Language of Nativism, The" (Minh-ha), 300n57
La noire de . . . (Sembène), 139
L'anté-peuple (Tansi), 226, 229, 235–36, 238; alienation in, 235; bush resistance fighters, 235; Dadou, 235–36, 309n51; ecological themes in, 22; ending, 236; femininity in, 22–23; love commodified in, 236; Yaeldara, 235–36
La petite vendeuse de Soleil (Mambety), 302n17, 304n32
La philosophie négro-africaine (Bidima), 220
La rue publique de mai 68 (Diop), 289n50
L'aventure ambiquë (Kane), 16, 54, 60, 114–16, 154; Adèle, 116; alienation in, 16; coming-of-age story in, 116; education in, 115–16; La Grande Royale, 115; language in, 116; le vieux maître Thierno, 115; métisse logics in, 115; Samba Diallo, 16, 115–16, 122, 127, 171, 285n12
La vie et demie / Life and a Half (Tansi), 12–13, 31, 39, 226–29, 252; alienation in, 237; Assabrou, 237; assimilation as a theme in, 240; censored histories in, 13; Chaïdana, 39, 236–40, 252, 310n52; Chaïdana's brother, 238; cultural dissonance in, 39; ecological themes in, 22; femininity in, 22–23, 237–40, 310n52; forest in, 236–40; Granicheta, 233; Jean Calcium, 39; Jean-Coeur-de-Père, 252; Katamalanasie, 232–33, 235–36, 239, 253; language in, 239; logocentric rationalism in, 252; Martial, 39, 236, 238, 310n52, 312n15; Pygmies, 39, 238–39; science in, 39; spaces of survival in, 12; spirituality in, 237–39; time dilation in, 13; war in, 12; warning of, 234

334 Index

"*La vie et demie* ou les corps chaotiques des mots et des êtres" (Giguère), 309n48

Laye, Camara, 10, 53–54, 60, 171, 282n40

Le baobab fou (Bugul), 50, 60–63, 65; abortion in, 61, 76; alienation in, 61–62; identity in, 62–63; Ken, 61; Ken's grandmother, 61; Louis, 61; métis in, 62; rejection of society in, 62–63

Lebou, 288n45

Le chercheur d'Afriques (Lopes), 53–54, 267n11; André, 53; Joseph, 53–54

Le Clézio, J. M. G., 249, 305n3

Le docker noir (Sembène), 156

Lee, Spike, 4

Le Franc (Mambety), 195, 204–8, 304n32; critiques of neocolonialism in, 206; debt as a theme in, 205–7; global inequalities portrayed in, 206; Langouste, 205, 206; lottery in, 202, 205–7, 210–11; Marigot, 205–7, 210; Marigot's landlady, 205–6; opening scenes, 204–5; Yaadikoone, 205–6

Le Malentendu colonial (Téno), 162

Le mandate (Sembène), 195, 200

"L'enfance métisse ou l'enfance entre les eaux': *Le chercheur d'Afriques* de Henri Lopes" (Sow), 52–54

"L'enfant de l'instituteur" (Dongala), 180

L'enfant noir (Laye), 53–54, 60, 171, 282n40

"Le pagne noir" (Dadié), 287n27

le pleurer-rire (laughing cry), 4

Le royaume aveugle (Tadjo), 50, 68–70; Akissi, 69, 70, 75, 77, 277n82; the Blind, 68–70, 75, 77; Blind Kingdom, 68–69; colonial symbolism in, 68–69; Karim, 69–70, 77, 277n74, 277n82; Karim's grandmother, 69; Karim's mother, 77; King Ato IV, 69, 77; mask ritual, 69, 77; métis in, 69, 76–77; the Others, 68–70, 77; power of the individual in, 70; segregation in, 69–70; twins, 70, 75, 77

Les bouts de bois de Dieu (Sembène), 307n19

Les clandestins (Elalamy), 16, 114, 123, 142–53, 290n67; Abdou "Minuit," 146; Abid, 148; alienation and exile in, 148–51; Alvaro, 149, 292n82; Anouar, 148–49; Chama, 149–51; Chama's father,

150; Charaf "N'joum," 148; corpses, 142–51; corpses, media portrayal of, 143; emigration in, 16, 151; Hogga, 147; humanitarian discourse in, 143–44, 151; Jaafar "Houlioud," 146–47; Jibril, 150–51; Lbatoul, 145; Louafi, 144; Louafi's mother, 144; media-based politics in, 290n67; Moh, 142; Moulay Abslam, 144–45; narrative, 143, 150; Omar, 142, 149–50, 292n82; photographs, 143; promise of paradise in, 16, 142, 149; Ridouane, 145; Salah "Sbania," 147–48; Slimane, 145–46; unfulfilled love in, 145–46, 150–51; Yasmine, 146; Zaynab, 150; Zouheïer, 149

Les contes d'Amadou Koumba (Diop), 53

Les damnés de la terre (Fanon), 106, 273n21, 296n14

"Le signe du destin" (Cabort-Masson), 169–70, 186

Le Silence de la forêt (Ba Kobhio), 17, 165, 174–75, 180–85, 186, 252, 307n18; education in, 181–83, 307n18; epistemological hierarchies in, 182; ferryman, 180; Gonaba, 175, 180–84, 299n42, 307n18; indigenous worldview in, 183–84; Kali, 182–84; Lema, 184; Manga, 181–82, 299n42; Paul, 181; Pygmies, 181–84, 307n18; title, 184–85; Touka, 182; village patriarch, 184

Les Paradis artificiels (Baudelaire), 22

Les Saignantes (Bekolo), 27

Les Sept Solitudes de Lorsa Lopes (Tansi), 307n22

L'etat honteaux (Tansi), 229, 307n15

Le temps de Tamango (Diop), 289n50

Le ventre de l'Atlantique (Diome), 16, 114, 123, 153–60; alienation and exile in, 153–54, 158, 160; deterritorialization and reterritorialization in, 158–59; emigration in, 154–57, 159; Gnarelle, 154; guilt in, 159; Jean-Charles Sauveur, 156; literary references in, 154; Madické, 153–57; Monsieur Ndétare, 154–55, 157; Monsieur Sonacotra, 155–56, 293n100; Moussa, 156–57, 294n101, 294n104; myth of Europe in, 154–57; narrative, 158–59; obsession with celebrity in, 153, 155–56, 291n72; Salie, 153–55, 157–59

Index

335

Lewis, Martin Deming, 273n23

L'exil et le royaume (Camus), 284n3

L'Homme Primitif et sa religion (Van der Leeuw), 35

"L'hôte" (Camus), 110

Liberia, 51, 83, 88

Libya, 82, 86

life in suspension, 193

Life on Earth (Sissako), 196

Liking, Werewere, 10, 24, 50, 52, 71–76, 249, 277n84, 300n51

"L'internationale" (Pottier), 296n14

Lionnet, Françoise, 10, 50, 271nn4–5

"Living in the Positive" (Dontaine), 97

Loba, Aké, 285n8

Loewenstein, Anthony, 286n25

Long Way Gone, A (Beah), 87, 93–95, 103; Beah's uncle, 94; New York in, 94; Sierra Leone in, 94

Lopes, Henri, 4, 10, 53–54, 267n11

Lord's Resistance Army, 87

Lost Boys of Sudan, 94

lottery, 22, 190–216, 254, 264n20; addiction of, 203–4; artificial paradise of, 202–8, 210, 254, 256; experience of lottery player, 203–4; exploitive economics of, 195, 208; motivations for maintaining, 208; promise of liberation through, 195

Loum, Daouda, 57–58, 275n58

Lucas, George, 267n7

Lumumba, Patrice, 84

lunatic writing, 10–11, 133

Lux, Christina, 12, 88–89, 92, 100, 282n33

Lyotard, Jean-Francois, 78

Maathai, Wangari, 24, 172, 297n18

Mafeje, Archi, 266n3

magic, 35, 39; reality and, 36; versus science, 35–36, 256

Magnier, Bernard, 298n30

Mai 68 à Dakar ou la révolte universitaire et la démocratie (Bathily), 289n50

Mali, 29, 87, 195, 280n16, 304n35; Bamako, 82, 196; crisis, 81–84; Dogon, 81; Peulh, 81; social movements, 51; Timbuktu, 83; Tuareg, 81, 82; women in, 51

Mali Empire, 2; oral traditions of, 5

Mambety, Djibril Diop, 4, 16, 21, 114, 123, 127, 133–41, 195, 202, 204–8, 210, 251, 288nn43–45, 302n17, 303–4nn29–32

Mandabi (Sembène), 200–202; Abdou, 200–202; Abdou's mother, 201; Aram, 201; Ibrahima Dieng, 200–201; liberation and emancipation as a theme, 201; Madiagne Diange, 201; Maïssa Fall, 201; Manding, 18; Mbarka, 201; Mbaye, 201; Mety, 201; money order, issues with, 200–202

Maran, René, 35, 256–57

Martin-Granel, Nicolas, 307n22

Martinique, 169–70

Marvel, 34

Marx, Karl, 113, 154, 167, 175, 192, 214

Massemba-Débat, 298n30

Matthew 6:26, 207

Mauritania, 29, 122, 196

Mbembe, Achille, 4, 8, 12–13, 24, 32, 35–36, 43, 45, 105, 107, 153, 218, 231, 264n11, 268n18, 278n101, 281n19, 282n32, 303n31; alienation, 192–93; "Black reason," 84–85, 284n51; capitalism, 216; fable of foreign aid, 119–20; necropolitical economy, 85–86, 102, 144, 180, 234, 250, 299n40, 312n15; necropower, 269n33; on race, 275n48, 280n12; schizophrenic objects, 85; society of enmity, 211; space of exclusion, 106; war machines, 79–88, 280n14; will to kill versus will to care, 103

Mégret, Frédréric, 283n45

Memmi, Albert, 19–20, 102, 159, 219, 283n43

"Métis" (Faye), 49, 275n56

métissage, 10, 49–77, 249, 271n4, 273n27; ambiguities, 64; biological, 50; child-symbol of, 63, 75–77; cultural, 10, 50; false, 63; in its Francophone literary cultural context, 52–56; mothers of, 51–52; murderous, 56–60

métisse, 157; births, 10; childhood, 54–55; children, 10, 75–77; consciousness, 69; cultural, 141; logics, 10, 22, 50; myths regarding, 56; pregnancies, 10; society, 11; thoughts, 67–68

Miano, Léonora, 23

migrant/migrations: discourses on, 111–12; experiences, 13; literary trope of, 15; mass, 110, 121

336 Index

Mille plateaux (Deleuze, Guattari), 157–58, 271n3

Miller, Christopher, 55–56, 57, 131, 273n27

Minh-ha, Trinh, 85, 222, 280n12, 300n57

Mirages de Paris (Socé), 10, 15, 55, 57, 154, 195, 199–200; alienation in, 200; Ambrousse, 199–200; casino, 199–200; debt as a theme in, 199; ending, 200; Fara, 55, 56, 199–201, 303n19; Jacqueline, 55–56, 199–200, 303n19; liberation and emancipation as a theme, 201; métis in, 55–56; Sidia, 55

MNLA (Nationalist Movement for the Liberation of Azawad), 82, 280n16

Mohanty, Chandra Talpade, 273n30

Moi en mon Blanc (Yaméogo), 122–23

Mongo-Mboussa, Boniface, 53

Monologue d'or et noces d'argent (Tansi), 241, 310n60

Moolaadé (Sembène), 287n37

Moore, Thomas, 32

Moser, Keith, 248–49, 305n3, 307n23, 308n29

Moynagh, Maureen, 12, 89, 91, 93, 104, 282n35

Moyo, Dambisa, 21, 302n16

Mudimbé, Valentin Yves, 9, 23, 32, 34, 169, 171, 267n7

"Murderous Humanitarianism" (Surrealist Group), 266n38, 279nn5–6

Mvet, 299n39

nationalism, extreme, 251

nature / natural realm, 223, 309n41; appreciation of, 231; degradation of, 230; dignity, 23; disassociation from, 231; Disneyfication of, 241; forest as a place of solitude, 238; granting independence to, 243; humanity's relationship with, 236–37, 243; indifference toward nature, 230; sacred forests, 228–30

Ndiaye, Christiane, 309n48

NDiaye, Marie, 10, 16, 50, 52, 63–68, 76, 114, 120–22, 251

Ndoye, Mamadou, 165–66

necropolitics, 12, 85–88, 102, 144, 180, 234, 250, 299n40, 312n15; antieconomy of, 13, 85–86

Necropolitics (Mbembe), 144

"nègré," 82–83

negritude, 26, 29, 277n84

Neo-colonialism: The Last Stage of Imperialism (Nkrumah), 296n11

neocolonial/neocolonia, 20, 58, 249–50, 304n38; capitalism, 28; legacies, 12; reactionary, 59

neoliberalism, 35–36; capitalism, 2; expansionism, 7

Ngal, Mbwil a Mpanga (Georges), 9, 13, 37–38, 45–46, 55, 77, 157, 272n17, 273n24, 277n87

Ngande, Charles, 179

Nha Fala (Gomes), 122

Nietzsche, Friedrich, 93

Nigeria, 81, 87

1984 (Orwell), 194, 203, 242, 257, 258, 312n11

Nini, mulâtresse du Sénégal (Sadji), 53, 57, 65, 275n58; assimilation in, 57; métissage in, 57, 275n58

Nkrumah, Kwame, 20–21, 24, 58, 169, 296n11

Nnaemeka, Obioma, 22, 57, 273n31

Nobel Peace Prize, 171

Nuttall, Sarah, 218

ñuulul xeesul, 60, 62–63, 70, 157, 274n41

Nyerere, Julius, 167

Occidentalism, 17, 37, 158, 161

Okorafor, Nnedi, 8, 24

On Some of Life's Ideals (James), 247

On the Postcolony (Mbembe), 144, 282n32

oral traditions / orature, 5, 17, 25, 37, 72, 187; griotic, 5; indigenous African, 72; literature, studying, 5–6; Mali, 5; subversion of, 46–47

Orientalism, 114, 121, 158–59, 161

Orlando, Valérie, 10

Orwell, George, 77, 105, 194, 203, 242, 257–58, 312n11

Other, the, 43, 64, 75, 121; alterity of, 112, 280n12; dehumanized, 250; externalized, 232

Oyono, Ferdinand, 10, 54, 64, 171, 293n100, 299n41

Pan-Africanism, 26, 29, 284n2

Panama Papers, 197

Index

Pantagruel (Rabealais), 80
Paradis Artificiels (Baudelaire), 190
paradise: Africa as, 110, 160; artificial, 17, 21–22, 112, 190–216; dreams of, 109–10; fiscal, 197; individual emancipation and, 191
Paré, Joseph, 273n24
"Paris, Paris, Paris" (Baker), 138, 141
Paris mon paradis (Yaméogo), 287n35
Parliament-Funkadelic, 268n17
Partant, François, 167
Peau noir, masques blanc (Fanon), 65
perpetual war, 79–88, 105
Perry, Alex, 81
Pili sur un croissant au beurre (Faye), 49
planetarity/planetary, 23, 124, 189, 251, 260; accidents, 111; being, 23, 36, 73, 188, 213–16, 223, 227, 253; civilizations, 217; education, 253; embeddedness, 251; Gaiacene spaces for, 245–46; humanity, 245–46; imaginary, 110–11; relational processes, 41; shared experiences, 161; thought, 23, 184, 269n28
"Political Economy of the Internet in African Society" (Wright), 26
polygamy, 273n31, 274n34, 293n93
Posel, Deborah, 278n101
postcolonialism, 144, 255; African thought, 248; cultural exchanges, 15; France's legacy, 122; narratives on immigration, 161; societal schism, 10; subjectivity, 46; violence, 85; Western intervention, 21, 85
Postcolonial Representation: Women, Literature, Identity (Lionnet), 50, 271nn4–5
Pottier, Eugène, 296n14
Prabhu, Anjali, 14–15
Prescience of African Cultural Studies, A (Wright), 5
"Prière d'un petit enfant nègre" (Tirolien), 163
Prix Goncourt, 120
Profiles of the Future (Clarke), 35
Pumzi (Kahiu), 22, 223–26; Asha, 223–26, 246; dream suppressants in, 223–24; dream tree, 223–26; humanity in, 223; "mother seed," 224–25, 246; opening sequence, 224; self-sacrifice in, 225

Quand on refuse on dit non (Kourouma), 87; dictionaries used in, 90; Fanta, 91; language used in, 90; lost childhood in, 91; narrative, 91; nationalism in, 90; Petit Birahima, 87, 89–92, 94, 102, 282n37; temporality in, 97; violence in, 90–92

Rabelais, 80
racism, 3, 80; legacies of, 4; scientific, 27
Rapp, Jean-Philippe, 263n3
Reade, Orlando, 32
"Reality Check: Does the CFA Franc Keep Some African Countries Poor?" (Giles, Goodman), 302n14
real/reality: accepted, 36; African, 47, 161–62, 189; ecology of, 238; education and, 252; ever-evolving, 7; inner significance, 247; of language, 222; lived, 231; magic and, 36; media's distortion of, 244; perceived, 248; *regard neuf* and, 38; rhetorical preconditions of, 222; subjective impressions of, 247; subverting, 47–48; understanding, 36; virtual, 14, 33, 223, 230–31, 255
regard neuf, 38
relationality, 250–51
reterritorialization, 158, 160–61, 250–51, 261
Revolutionary United Front, 94
Riesz, János, 309
Rilke, Rainer Maria, 115
Rimbaud, Arthur, 109–10, 152
Robbe-Grillet, Alain, 55
Robot Voodoo Power, 36, 43, 267n17
Rodney, Walter, 6, 166, 266n37, 301n5
Rollefson, J. Griffith, 36, 267n17
Romeo and Juliet (Shakespeare), 58
Rostov-Luanda (Sissako), 196
Roumain, Jacques, 296n14
Rousseau, Jean-Jacques, 183
Rwanda, 280n10

Saaraba (Seck), 16, 114, 123–28, 141; airport scenes in, 124; Daba, 125; Demba, 125, 127–28; *député*, 125–28; education in, 127; escape in, 127–28; Lissa, 125–26, 128; Massa, 126; music in, 128, 141; paradise in, 127–28; portrayal of Senegalese society in, 124–27;

Index

Saaraba (Seck) (*cont.*)
Rugi, 127; Sidi, 126, 128; social class
structure in, 126–27; Tamsir, 124–26,
128, 141; Tamsir's father, 124–26;
Tamsir's uncle, 124, 126–28; theme of
a fatherless generation, 125; Thiam,
125; Yoro, 125, 127–28
sacred forests, 228–30
Sadji, Abdoulaye, 53, 57, 65, 275n58
Said, Edward, 78, 114, 121, 158
Saint-Cyr, 170
Sango Malo (Kabhio), 17, 165, 175–80;
aborted independence as a theme
in, 179; "artificial paradise" promised
in, 178; Department of Agriculture
representative, 177; education in, 17,
174–78, 228; Erna, 176, 178; hope as a
theme in, 178; Malo, 175–78, 228–29;
Mbog, 178; Ngo Bakang Edwidge,
178; practical utility in, 177; sacred
forest in, 228–29; school director,
177; shopkeeper, 177; village chief,
176, 178
Sankara, Thomas, 1, 84, 263n3
Sanko, Foday, 281n25
sankofa, 221
Sansal, Boualem, 257–60, 306n11
Sarr, Felwine, 1, 4, 6–7, 17, 24, 25, 31, 33,
49, 108, 161–62, 164, 167, 179, 182, 187,
192, 194, 207, 215, 217, 220–21, 229,
231, 235, 253, 270n41, 305n5, 310n57,
311n65; African cultural practices,
72; Afrocontemporaneity, 50; on
development, 242–43, 245, 268n25;
on education, 163, 174, 188–89;
floral arranging analogy, 72–73; on
language, 185; relational economy, 45,
191–92, 195, 208, 211, 215–16, 249, 254;
temporality, 72–73
Sartre, Jean-Paul, 112
Sauvaire, Jean-Stéphane, 103
Schweitzer, Albert, 298n27
science/scientific, 35, 36, 47; basis of
global systems, 36; definition, 264n16;
education, 166–67, 169; indigenous
knowledge, 186–87; post-rational, 253;
versus magic, 35–36, 256; Western
modality, 162
science/speculative fiction, 3, 4, 9, 27, 38–
39, 229; African cultural expressions

and, 8, 33; global Blackness in, 5;
history of, 32; redefining the "science"
of, 25–48; stylistic qualities of, 47;
utopias in, 32; Whiteness of, 4
Seck, Amadou Saalum, 16, 114, 123–28, 141
self-estrangement, 171–72
Sembène, Ousmane, 21, 124, 139, 154, 156,
195, 200–202, 284n4, 286n21, 287n37,
288n39, 293n93, 307n19
Sene, Nar, 133, 138–39, 288n45, 289n52
Senegal, 29, 63, 114, 121, 123, 195, 201,
204–5, 288n43, 293n93, 296n12,
297n18, 304n35; Dakar, 140, 204,
268n26, 293n94; humanitarian aid in,
119; independence, 156; postcolonial,
136–37; poverty in, 118–19
Senghor, Léopold Sédar, 10, 53, 57, 60, 76,
169, 304n35
Serres, Michel, 22, 113, 214, 221, 227, 230,
232, 244, 249, 305n3, 307n23, 308n29
Shakespeare, William, 58
shame, 309n40; arguing against, 217–46;
morbidity and modern, 234–37;
societal, 23; of the state, 217–46
Sharife, Khadija, 197, 302n16
Shizha, Edward, 39, 167–68, 295n10,
300n52
Sierra Leone, 29, 83, 88–90, 94, 282n36;
education in, 17, 174–75
simulacrum, 238, 243
Sissako, Abderrahmane, 16, 114, 123, 128–
33, 141, 152, 195–96, 202, 251, 288n42,
302n15, 302n18
Slaughter, Joseph, 11, 94, 105, 163–64,
302n18
slave/slavery: dehumanization of, 193;
education and, 19; populations in the
New World, 110; trade, 15
Socé, Ousmane, 10, 15, 55–57, 154, 195,
199–200
society of the spectacle, 113, 214
sociopolitical theory, 26
Soleil O (Hondo), 122
Somalia, 83, 87
Songhai Empire, 2
"Souffles" (Diop), 307n19
*Soundproof Room: Malraux's Anti-
Aesthetics* (Lyotard), 78
Sow, Alioune, 52–54
Speculative Blackness (Carrington), 4–5

Index

Spivak, Gayatri, 23, 36, 85, 110–11, 184, 188–89, 227, 250–51, 268n19, 272n13, 278n93, 280n12; on education, 73, 219–20, 252–53; on "planet-thought," 184, 253, 269n28

Stibbe, Arran, 161, 222

Stibbe, Arran, 312n10

Stiglitz, Joseph, 196–97

Suberchicot, Alain, 22, 226

Sudan, 87; North, 82; South, 82

Sun Ra, 267n17

Surrealist Group, 266n38, 279nn5–6

Tadjo, Véronique, 10, 50, 52, 68–70, 75–77, 249

Tansi, Sony Labou, 4, 9, 12–13, 22–23, 31, 39, 185–86, 222–23, 226–29, 231–32, 240–41, 244, 252–53, 269n30, 299n37, 307n15, 307n22, 310n60; on commodification of love, 236; death of, 241; ecocriticism, 227, 230, 233–35, 237, 239–42, 246, 255, 310n52; education, 185–86, 298n30; grandmother, 185–86; worldview, 245; on writing, 237, 309n48

Tcheuyap, Alexie, 166

temporality: chronic, 89; relational, 231; spatial reorganization, 92; suspended, 89, 90, 161; time travel, 92

Téno, Jean-Marie, 162, 173

"They Schools" (Dead Prez), 297n22

Things Fall Apart (Achebe), 97

Thiong'o, Ngugi wa, 4, 23, 25, 111, 167, 195, 198–99, 278n87

third space, 141, 209

Timbuktu (Sissako), 302n15

Time (magazine), 81, 82

I Timothy 6:10, 190

Tirolien, Guy, 163, 179–80

Touaregs, 280n16

Touki Bouki (Mambety), 16, 114, 123, 133–41, 302n17; *Ancerville*, 134–40; Anta, 123, 133–40, 289n47; Anta's mother, 134, 136; Charlie, 138–39, 289n47; colonialism as a metaphor in, 133–37, 139–40; corruption of love in, 134–35, 139; cow skull in, 138, 140, 288n43; emigration in, 133–37, 139–40; ending, 134; fetishes in, 137–38; hyena metaphor in, 133, 141; Mory, 123, 127,

133–40, 289n51; narrative, 133; paradise in, 133, 137–39; racism in, 139–40; role of women in, 138–39

Touré, Samory, 90

Touré, Sékou, 176–77

Traoré, Bouna, 293n89

Traoré, Moussa, 51

Trois femmes puissants (Ndiaye), 16, 50, 63–68, 114, 120–22; Abel Descas, 65; assimilation in, 65; border crossing in, 120–22; cultural ambiguity in, 67; Djibril, 66–67; Fanta, 66–67; Jakob, 65; Khady Demba, 120–22, 287n27; Lamine, 120; Manille, 65–66; *métissage* in, 64–65, 67; migration in, 16; Norah, 64–65; Norah's family, 64; poverty in, 16; power dynamics in, 67; Rudy Descas, 65–67; Rudy's mother, 66; Salif, 67; self-loathing in, 65; Sony, 64–65; White guilt in, 67

Tu t'appelleras Tanga (Beyala), 10–11, 264n19; identity doublings in, 13; Tanga, 10–11

2084, La fin du monde (Sansal), 257–60; Abi, 257; Abigouv, 257; Abilang, 258; Abistan, 257, 259; the "Apparatus," 257–58; Ati, 258–60; Balis, 258–95; Bigaye, 259; book of Gkabul, 257; Koa, 258; museum of nostalgia, 259–60, 306n11; symbolic language in, 258–59; Toz, 259, 306n11

Twitter, 26

2Pac, 1

Ubangi-Chari, 35

ubuntu, 17, 215

Uganda, 87

Unbowed (Maathai), 172

Un chant écarlate (Bâ), 50, 56–60, 273n31; Ali, 59; alienation in, 56–57, 59; assimilation in, 58; feminism in, 57; Gorgui, 59–60; Guillaume, 57–58; infanticide in, 60, 76; intercultural marriage in, 56–59, 76; Lamine, 58; masculinity in, 59–60; *métissage* in, 59; Mireille, 56–63, 76; Mireille's father, 56; negrophilism in, 57, 59; *ñuulul xeesul*, 60; Ouleymatou, 57–59, 76; Ousmane, 56–61, 76, 273n31; Pierrette, 58; postcolonial metaphors in, 58, 76;

340 Index

Un chant écarlate (Bâ) *(cont.)*
racism in, 57, 58–59; rejection of
society in, 62–63; Soukeyna, 59–60;
Yaye Khady, 57–59, 77
Une couleur café (Duparc), 122, 293n97
Une saison en enfer (Rimbaud), 110
Une si longue lettre (Bâ), 154, 273n31
Une vie de boy (Oyono), 54; alienation
in, 54; Toundi-Joseph, 54, 64, 171,
293n100
Une vie en arbres et chars . . . bonds
(Tansi), 240–41
Unis d'Afrique (Waberi), 13; fictionalized
fact-checking in, 15; immigrants in, 15
United Nations, 281n25; Children's Fund
(UNICEF), 86, 93
Universal Declaration of Human Rights,
164
Un nègre à Paris (Dadié), 60, 154, 285n8
"Urban Spaces, Women's Places" (Nnae-
meka), 273n31
utopia, 123; Africa as, 80; dystopian,
124–28
Utopia (Moore), 32

Van der Leeuw, Gerard, 35
Van Waijenburg, Marlous, 265n36
Verne, Jules, 32
Verschave, Francois-Xavier, 58, 197, 243,
280n10, 286n21, 302n16, 304n38
Ville cruelle (Beti), 60–61
Voltaire, 14

Waberi, Abdourahmane, 13–14, 38, 155
Waiting for Happiness (Sissako), 196
Walker, Keith, 61, 275n59
Walsh, John, 282n40
Wariko (Kramo-Lanciné), 195, 208–11;
Ali, 202, 208, 210; Ali's father, 210;

Ali's son, 209; Awa, 208; Ivanga, 202;
large man, 209–10; lottery ticket, 202,
208–11; movement of money in, 209;
talking drum, 208–9
war machine(s), 79–88
"War Machine as Chronotope, The"
(Moynagh), 91
Wells, H. G., 137
"What Has Literature Got to Do with
It?" (Achebe), 5
Williams, James, 302n18
Wolof, 60, 121, 123, 274n41, 275n59,
297n18
Womack, Ytasha, 26, 229
womanism, 10, 223, 228, 241–42, 273n30;
African, 242
Womanism and African Consciousness
(Kolawole), 273n30
women: Afrofuturist writers, 49–77;
mothers of *métissage,* 51–52; resistance
and, 51–52; role in creation of the
future, 11; as a symbol of life, 51
Women of Liberia Mass Action for Peace,
51
World Bank, 21, 197
World War II, 243, 267n7
Wretched of the Earth, The (Fanon), 78
Wright, Hendel Kashope, 5, 20, 25–26, 41,
46, 187, 218, 265n35, 266n42

X, Malcolm, 4
Xala (Sembène), 154

Yaméogo, Elénore, 287n35
Yaméogo, Pierre, 122–23
Yeelen (Cissé), 27
YouTube, 26

Zimbabwe Publishing House, 31